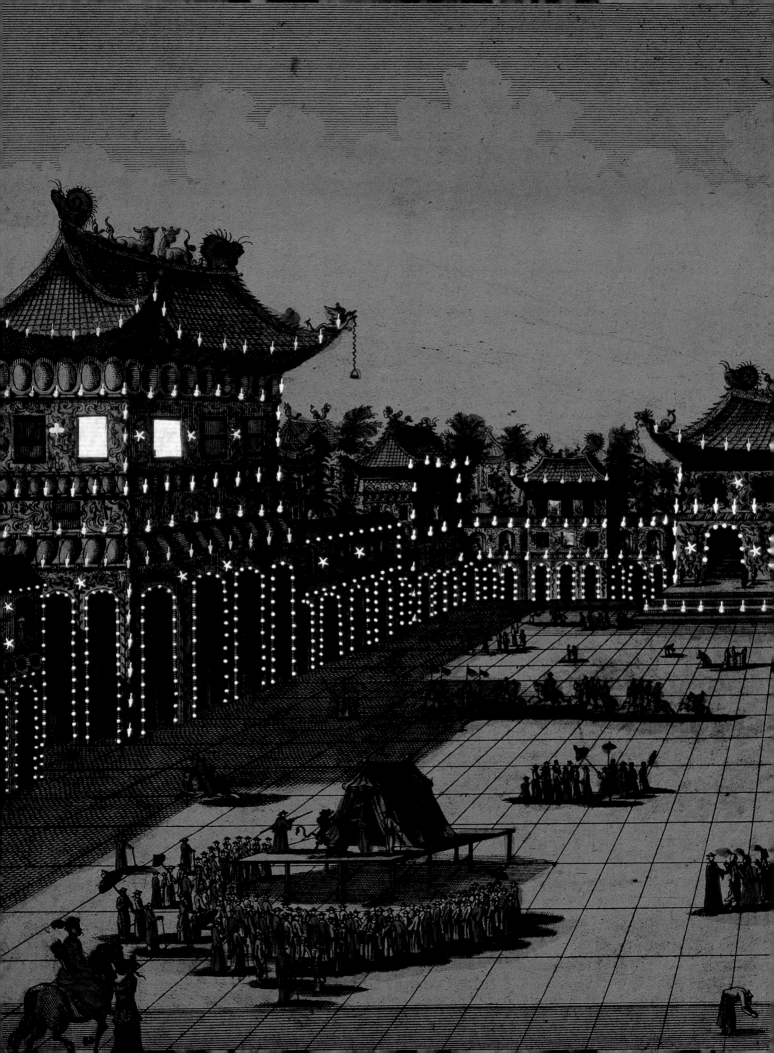

CHINA ON PAPER

European and Chinese Works
from the Late Sixteenth to the Early Nineteenth Century

Edited by
Marcia Reed and Paola Demattè

Published by the Getty Research Institute

The Getty Research Institute Publications Program
Thomas Crow, *Director, Getty Research Institute*
Gail Feigenbaum, *Associate Director, Programs*
Julia Bloomfield, *Head, Publications Program*

Jeffrey M. Hurwit, Jacqueline Lichtenstein, Alex Potts, and Mimi Hall Yiengpruksawan,
Publications Committee

China on Paper: European and Chinese Works from the Late Sixteenth to the Early Nineteenth Century
Elisabetta Corsi, *Editorial Consultant*
Michelle Bonnice, *Manuscript Editor*

This volume accompanies the exhibition *China on Paper: European and Chinese Works from the Late Sixteenth to the Early Nineteenth Century,* held at the Getty Research Institute, 6 November 2007–10 February 2008

Published by the Getty Research Institute, Los Angeles
Getty Publications
1200 Getty Center Drive, Suite 500
Los Angeles, California 90049-1682
www.getty.edu

11 10 09 08 07 5 4 3 2 1

Frontispiece: Georg Balthasar Probst, after P. van Blankaert, after Johannes Nieuhof,
Le dedans du palais de l'empereur de Chine à Peking (backlit detail), 1766–90. See FIGURE 4

Library of Congress Cataloging-in-Publication Data
China on paper : European and Chinese works from the late sixteenth to the early nineteenth
 century / edited by Marcia Reed and Paola Demattè.
 p. cm.
 Accompanies an exhibition held at the Getty Research Institute, Nov. 6, 2007–Feb. 10, 2008.
 Includes bibliographical references and index.
 ISBN 978-0-89236-869-3 (hardcover)
 1. China — Civilization — Western influences. 2. East and West. 3. Europe—Relations—China.
4. China—Relations—Europe. I. Reed, Marcia, 1945– II. Demattè, Paola, 1962–
 DS 721.C48757 2007
 303.48'251040903 — dc22
 2006052861

CONTENTS

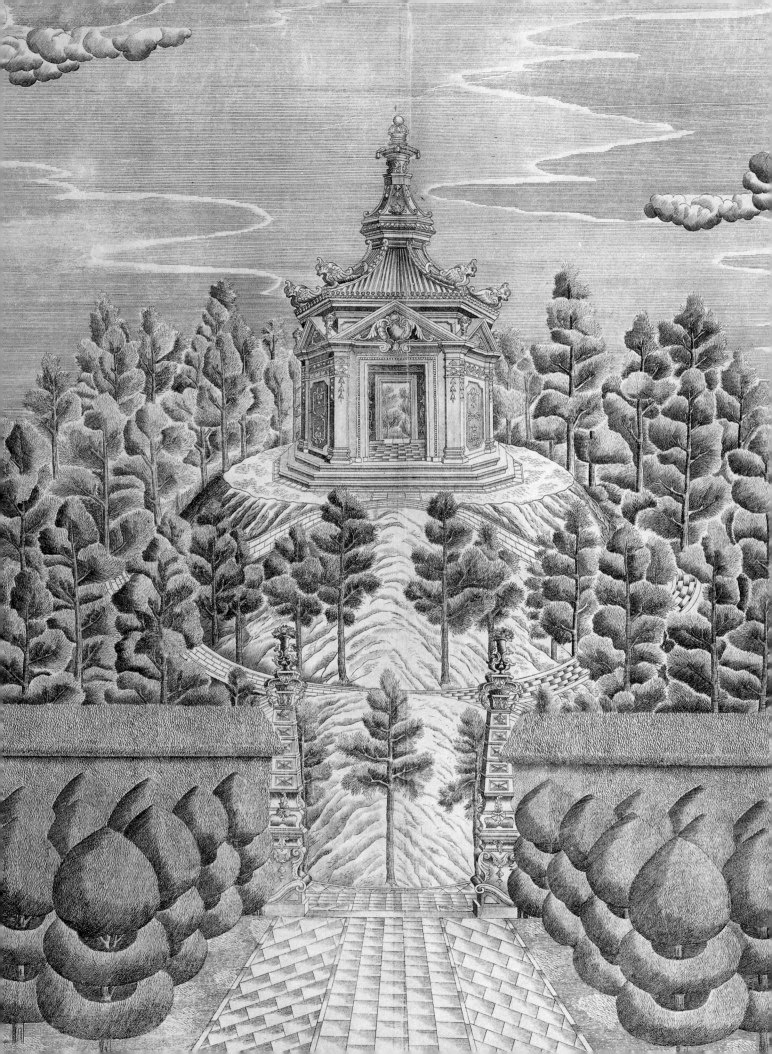

SOMETIMES A SINGLE ACQUISITION can lead in an entirely new direction. This was the case for the Research Library at the Getty Research Institute in 1989, after a rare-book dealer unwrapped a portfolio of engravings depicting the European Pavilions (Xiyang-lou) built by Jesuit missionaries at the request of the Qianlong emperor for the Garden of Perfect Clarity (Yuanmingyuan) in Beijing. At the time, the Research Library's collections were focused on the traditional categories of Western art history from Greek and Roman antiquity to the twentieth century. But those present as the suite of Chinese prints was displayed were immediately impressed not only by its visual beauty but also by the new vistas it opened for research and critical understanding. These engravings inaugurated the Research Library's collections documenting East-West contacts, an acquisitions initiative that has resulted in significant holdings on Asia, including early photographs of China, Japanese artwork of the post–World War Two era, and the diverse works featured in *China on Paper*.

To create the Chinese-inflected European-style pavilions portrayed in these prints, Jesuits looked to engraved depictions of baroque French palaces and Renaissance Italian villas, an approach reminiscent of the way in which most Europeans then learned about China—by viewing images of that distant land on paper and on objects decorated with Chinese motifs. As *China on Paper* reveals, the suite depicting the European Pavilions holds a unique place in the textual and visual tradition that extends from the earliest European descriptions of China, such as Johannes Nieuhof's and Athanasius Kircher's illustrated books, to popular eighteenth-century prints of Chinese-style gardens in Europe, such as the monumental series issued by the French publisher Georges-Louis Le Rouge. Likewise, these works on paper form a natural link to the J. Paul Getty Museum's decorative arts holdings, which include the splendid set of seventeenth-century French tapestries known as *The Story of the Emperor of China*.

The prints of the European Pavilions paved the way for a second major acquisition by the Research Library: the Flemish Jesuit Ferdinand Verbiest's illustrated record of the Western scientific instruments installed under his supervision at the imperial astronomical observatory in Beijing. The strength of his images, which presented visual translations of the principles of Western astronomy and applied technology, propelled plans for this exhibition. Verbiest's work demonstrates that the two cultures—Chinese and European—affected each other in subtle ways extending beyond the obvious arenas of commerce and religion. Rather than the Western phenomenon of chinoiserie, *China on Paper* explores the reciprocal curiosity that the people of China and Europe had for one another's cultures. It tells how each came to know about the other by means of works on paper that were frequently the product of intercultural collaboration.

As the content of this catalog was being finalized, an opportunity came to acquire the Italian Jesuit Martino Martini's *Novus Atlas Sinensis* (New atlas of China), which was based on Chinese cartographic sources and published by the leading European mapmaker Johannes Blaeu. Remarkably, even the vignettes embellishing Martini's maps inspired chinoiserie decorations in European palaces, a perfect example of the dynamic cultural exchanges that transformed both East and West.

Gail Feigenbaum, Associate Director, Getty Research Institute

Detail of FIGURE 48, no. 18

ACKNOWLEDGMENTS

ACCORDING TO AN OLD SAYING, China is a sea that salts all the waters that flow into it. Equally so, significant contributions by many people have commingled during the lengthy preparations for this exhibition catalog. The rare books, prints, and maps that record and illuminate the interactions of Chinese hosts and European travelers were the principal ingredients, and we are grateful to the Getty Research Institute's Leadership Team for its continuing support of the Research Library's collection development program. Each director of the Research Institute — Kurt W. Forster, Salvatore Settis, and Thomas Crow — has understood the growing importance of Asia to the framing of art history and thus to the purview of the Research Library's holdings.

At the Getty Research Institute, Gail Feigenbaum, Associate Director of Programs, and Susan M. Allen, Chief Librarian, supported this catalog and the related exhibition and offered good counsel, as did Julia Bloomfield, Head of the Publications Program, and Barbara Anderson, Head of Exhibitions. Members of the departments of Special Collections, Collection Development, Research Services, and Conservation at the Research Library afforded valuable aid as we worked, with Gang Song, Kathleen Svetlik, and Nina Damavandi supplying dedicated research assistance. Exemplary pictures of books, prints, and maps were taken by the highly skilled photographers of Visual Media Services.

The Rhode Island School of Design provided Paola Demattè with funds and relief from teaching duties to conduct research in China, Italy, and the United States. Thanks for their kind help are due to the staff at the National Library of China and at the Palace Museum, both in Beijing; Clara Yu Dong at the Biblioteca Apostolica Vaticana in Rome; Amy Tsiang at the Richard C. Rudolph East Asian Library at the University of California, Los Angeles; and James Cheng at the Harvard-Yenching Library in Cambridge. At the Peabody Essex Museum in Salem, Massachusetts, staff at the Phillips Library were generous guides to the excellent collections on trade between China and the West, and William Sargent, Curator of Asian Export Art, and Bruce McLaren, Associate Curator of Chinese Art, drew our attention to volumes of special interest. Our colleagues at the University of California, Los Angeles, professors James Tong, Hung-hsiang Chou, and Richard E. Strassberg, were sources of invaluable advice and information as the project progressed.

We are grateful for the skilled editorial assistance of Michelle Bonnice, Michele Ciaccio, Dominique Loder, Jennifer Ott, Jannon Stein, and Jonlin Wung. The book's designer, Jim Drobka, and production coordinator, Anita Keys, both of Getty Publications, have our appreciation for producing a work on paper that is both user-friendly and beautiful as an object.

Finally, we thank our husbands, Michael Morrison and Richard Lesure, for their steadfast support during the years of research and writing.

Marcia Reed and Paola Demattè

Starting with the Ming dynasty, the Chinese emperor was commonly referred to by his reign era rather than by one of his several given names. Thus, for instance, the form "the Kangxi emperor" is employed here, rather than "Emperor Kangxi," because "Kangxi" is a reign era.

The principal dynastic periods and their approximate dates are listed below, along with the reign eras for emperors who make an appearance in this exhibition catalog:

Xia dynasty (legendary), ca. 1950–ca. 1600 B.C.

Shang dynasty, ca. 1600–1046 B.C.

Zhou dynasty, 1046–256 B.C.

Qin dynasty, 221–206 B.C.

Han dynasty, 206 B.C.–A.D. 220

Three Kingdoms, 220–80

Jin dynasty, 265–420

Southern and Northern dynasties, 420–581

Sui dynasty, 581–618

Tang dynasty, 618–906

Five dynasties, 906–60

Liao dynasty, 916–1125

Song dynasty, 960–1279

 Northern Song, 960–1127

 Southern Song, 1127–1279

Jin dynasty (Jurchen), 1115–1234

Yuan dynasty (Mongol), 1279–1368

Ming dynasty, 1368–1644

 Yongle (1402–24)

 Wanli (1572–1620)

 Chongzhen (1628–44)

Qing dynasty (Manchu), 1644–1911

 Shunzhi (1644–61)

 Kangxi (1661–1722)

 Yongzheng (1722–35)

 Qianlong (1735–96)

 Xianfeng (1850–61)

The Pinyin system for romanizing Chinese characters is used here for Chinese personal names, places, and titles of works, except for words adopted into English and commonly known place-names such as

Canton (pinyin: Guangzhou)

Macau (pinyin: Aomen)

Yangtze River (pinyin: Changjiang)

Chinese personal names are given in the traditional Chinese order, surname first, unless the individual resides primarily in the West and adopts the Western order of surname last.

For civil service titles and departments, we have followed Charles O. Hucker, *A Dictionary of Official Titles in Imperial China* (Stanford: Stanford Univ. Press, 1985).

Under the Qing dynasty, the linear unit *li* equaled 0.36 miles or 0.576 kilometers.

Readers are encouraged to consult the Research Library's online catalog for additional information on specific works and for recent acquisitions, among which there are already several rare books that arrived too late for catalog entries to be included. Written by Marcia Reed (MR), Paola Demattè (PD), and Richard E. Strassberg (RS) for many of the books and prints central to the exhibition, the catalog entries aim to situate each item historically by focusing on the individuals who created it and portraying the culture in which it was produced.

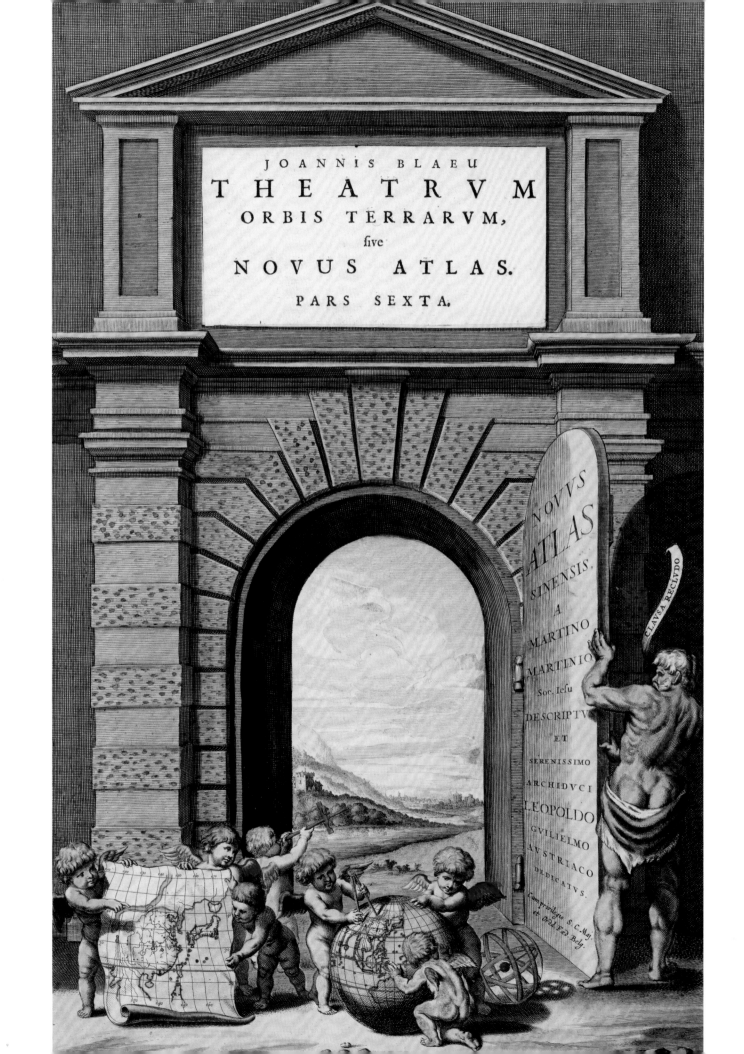

JOANNIS BLAEU

THEATRVM

ORBIS TERRARVM,

five

NOVVS ATLAS.

PARS SEXTA.

NOVVS
ATLAS
SINENSIS,
A
MARTINO
MARTINIO
Soc. Iesu
DESCRIPTVS
ET
SERENISSIMO
ARCHIDVCI
LEOPOLDO
GVILIELMO
AVSTRIACO
DEDICATVS.

Cum privilegio S. C. Maj.
et Ordd. Fæd. Belg.

CLAVSA RECLVDO

In Search of
Perfect Clarity

Marcia Reed and Paola Demattè

IN TIMES WHEN FEW PEOPLE traveled great distances, China and Europe, while on the opposite sides of the same landmass, were envisioned as strange places with even stranger cultures. Beginning in the sixteenth century, following the newly discovered sea routes around Africa and South America to ports in Asia, European merchants and Catholic missionaries initiated more than two centuries of productive interaction with their Chinese counterparts. Energized by visions of new buyers and suppliers and new converts to Christianity, these encounters grew from isolated contacts to increasingly elaborate embassies. Between the sixteenth and nineteenth century, several thousand Europeans journeyed east to visit China, where the majority stayed in port cities such as Macau or in the capital, Beijing. In the same period, some three hundred Chinese, most of them Christian converts, ventured west to Europe, their religious vocations taking them to Rome or Naples.[1] The influence exerted by this wave of Sino-European interaction was incalculable. Confucian ideals and luxury goods flowed west from the sophisticated and prosperous Chinese empire. Christian teachings and scientific knowledge flowed east from the small but developing nations of Europe. Economically, politically, and culturally, both sides were profoundly and permanently affected.

Given the distances and dangers of sea voyages in this era, most Europeans learned about China principally from books and prints that described its peoples, places, and customs and from export goods such as ceramics, textiles, and lacquerware.[2] Strange or emblematic objects from China were displayed in early collections and cabinets of curiosities assembled for the instruction and amusement of the educated upper classes of Europe, and Westerners of all classes gained an impression of China from designs on imported porcelain—which they called "china." The Chinese acquired information about Europe not only from thousands of books and prints brought to China by Catholic missionaries[3] but also from illustrated religious books and maps with Western-style motifs produced locally by European priests and their Chinese friends and converts. The books and prints featured in *China on Paper* are among the hundreds of notable printed works that described and illustrated China for European readers and presented Western concepts of science, religion, and art to educated Chinese.

FIGURE I
Title page, [1655], hand-colored engraving and etching,
43.3 × 27.2 cm (17 × 10⅝ in.)
From Martino Martini, *Novus Atlas Sinensis* ([Amsterdam: Johannes Blaeu, 1655])

1

The chronological bounds of the exhibition are set by two very different works. One of the first significant publications on China was *Dell'historia della China* (1586) (cat. no. 1) by Juan González de Mendoza, initially published in a Spanish edition of 1585. This unillustrated but comprehensive volume had been written at the behest of Pope Gregory XIII by an Augustinian who had worked in Mexico but never saw China for himself. Mendoza offered a descriptive and geographical survey of China's history and culture based on the author's correspondence with colleagues in the Philippines as well as accounts by recent visitors to China such as Galeote Pereira, Gaspar da Cruz, and Martín de Rada. The book's topical and largely positive coverage generally set the tone for the next century of European descriptions of China for Western audiences.

Two centuries later, the twenty prints by the Manchu artist Yi Lantai depicting the European Pavilions (Xiyanglou) (cat. no. 30) at the Yuanmingyuan witnessed the sophisticated collaborative relationship that developed during the final period of the Jesuit mission in China among Europeans and Chinese at the imperial court. These prints are notable on two fronts. On the one hand, they are the earliest copperplate engravings designed and printed by a Chinese artist in China. On the other hand, they depict the extraordinary architecture and landscape designs of the European Pavilions, which occupied a small section of the Yuanmingyuan, the vast imperial complex located in the northern periphery of Beijing. Known to early European travelers as the "Jardin de la clarté parfaite," or Garden of Perfect Clarity, the Yuanmingyuan began in 1709, in the forty-eighth year of the Kangxi emperor's reign, as a present to his fourth son, Yinzhen, the future Yongzheng emperor. It would serve as a center of imperial power for five successive Qing-dynasty rulers, until its destruction by Anglo-French forces in 1860.[4] The engravings of the European Pavilions show the Sino-European mélange of architecture, landscaping, and fountains designed, for the most part, by the Jesuits Giuseppe Castiglione and Michel Benoist for the pleasure of the Qianlong emperor. These buildings and gardens, their printed representations, and the nineteenth-century photographs of their ruins epitomize centuries of interactions between European visitors and Chinese hosts, documenting a history of mutual curiosity and mixed communications that have sought but never achieved perfect clarity.

CONTACTS BETWEEN CHINA AND THE WEST existed as early as the first centuries A.D., when small groups of merchants and missionaries from various nations traveled the Eurasian land routes known as the Silk Road. The first Christians to venture to the Far East were Nestorians from Persia, who arrived in China in 635, during the Tang dynasty.[5] Much later, Marco Polo told of traveling with his father and uncle to a place he called "Cathay." There, for nearly seventeen years, from 1275 to 1292, he served as an agent of the Mongol court of Kublai Khan, who ruled China between 1260 and 1294 and proclaimed himself the first emperor of the Yuan dynasty. Around the same time, several Franciscans reached the Mongol court as papal envoys. In spite of opposition from the Nestorian community, which was already competing with the advocates of Taoism, Buddhism, Judaism, and Islam, the Franciscans established themselves at the capital Khanbalik (modern Beijing), setting up the first bishop's seat.

Just as Europeans ventured east, Chinese ventured west. These travelers were mostly traders on the Silk Road or religious pilgrims such as the monks Faxian (fl. 399–414) and Xuanzang (602–64), who made storied journeys to Central Asia and India to study Buddhism, returning home in 412 and 645, respectively. Further Chinese exploration

took place during the early Ming dynasty, when the Yongle emperor commissioned the voyages of Zheng He. Between 1405 and 1433, in the course of seven sizable naval expeditions to Southeast and South Asia and across the Indian Ocean, he landed in India and reached the Arabian peninsula as well as the eastern coast of Africa.[6] But these sea voyages west from China would have no sequel under subsequent Ming emperors, and the Silk Road itself would be abandoned, effectively isolating China from the wider world for almost two centuries.

In the sixteenth century, another significant change took place in Sino-European relations as both regions were drawn into the emerging world economic system fueled by the West's discovery of the Americas and European colonial expansion. In 1493, Pope Alexander VI divided the known world beyond Europe in two, giving Spain responsibility for evangelizing the western half—defined in 1494 by the Treaty of Tordesillas as roughly the Philippines east to about São Paulo in modern Brazil—and Portugal jurisdiction over the eastern half. This geopolitical investiture of royal patronage (*patronato real,* or *padroado*) allowed the Iberian powers to control both trade and clerical appointments in their respective areas of influence. The Portuguese trading network stretched across Asia to the Spice Islands (Moluccas), with strategic centers located at the Indian port city of Goa and at the trading colony at Macau, established in 1557 on the southeastern coast of China.

From Macau, which survived as a Portuguese colony until it was absorbed by China in 1999, the Portuguese established themselves as mercantile middlemen between China and Japan and between China and Europe, transporting Asian luxury items to rapidly growing markets in the West. These commodities were primarily porcelain from China and lacquerware from Japan but also included silk, tea, spices, and pearls. Portuguese profits from this lucrative China trade were instrumental in establishing the Catholic mission in the Far East. Among the missionaries active in Macau, the most visibly successful were the members of a recently founded religious order, the Society of Jesus. Highly educated and committed to a militant but accommodative propagation of the Catholic faith, the Jesuits not only supported the Portuguese colonial enterprise in the East but also became the foremost European presence at the Chinese imperial court for the next two centuries.

At the beginning of the seventeenth century, Portugal and Spain's dominance of the Asian markets was challenged by competing European trade initiatives. In 1600, the East India Company was founded by a group of London merchants to foster British trade with India and capture a share of the East Indian spice trade. Two years later, the Dutch East India Company (byname of the Vereenigde Oost-Indische Compagnie) was established. The Dutch soon displaced the Portuguese from the Indonesian archipelago, the Spanish from Taiwan, and both nations from Japan. Unlike the Portuguese and the Jesuits, the representatives of the Dutch and British East India companies were neither subject to papal authority nor interested in accessing the China trade by learning Chinese or adapting to Chinese ways of doing business.

By 1700, the Portuguese and the Dutch were eclipsed in the East by other European powers. With the decline the *patronato real,* the French monarchy exercised increasing influence in the selection of Jesuit and other Catholic missionaries to China. Admiring and positive in their approach to Chinese culture, the French Jesuits established a direct line of communication between Louis XIV and the Qing imperial court. Missionary mathematicians and geographers sent by the French king helped the Kangxi emperor

survey his vast empire. The Chinese imperial collections were increased by gifts of objects and printed works offered by the Jesuits and various European embassies, while the Chinese court sent books, maps, and reports on Qing society and culture to France. By the end of the seventeenth century, substantial collections of Chinese books and prints were held by European libraries. The French royal collection, the Königliche Bibliothek zu Berlin, and the Collegio Romano each had hundreds of volumes, and even private scholars owned works on China. The German philosopher Gottfried Leibniz owned more than fifty books on Asian subjects, and, further afield, there were Chinese books at the university library in Copenhagen and Chinese objects in the famous collection of the Danish physician Ole Worm.[7]

By the nineteenth century, Britain, with its voracious appetite for tea, dominated the China trade, and the complex relationship between China and Europe entered a more confrontational phase. As Europeans became more invested in Far Eastern commerce and sought to expand their trading privileges, China's unwillingness to accede to such expansion or agree to direct negotiations between European ambassadors and the Chinese emperor contributed to negative Western perceptions of the country and its culture. Increasingly, China was seen by Western intellectuals, traders, and politicians as a backward and difficult country led by a despotic and isolationist ruler.

SINO-EUROPEAN CONTACTS were always intricate and multifaceted. As citizens of various countries and members of different corporate groups, European traders and missionaries were not unified in their activities or ambitions, and they often acted in competition with one another. The Chinese likewise had varied and sometimes disjointed perspectives on foreign relations and trade, but they did not play a passive or subordinate role in these exchanges, as sometimes suggested. When Europeans began arriving by sea during the late Ming dynasty, the emperor was a distant presence, isolated in the imperial palace complex in Beijing by his retinue of eunuchs and courtiers. The visitors from afar found a more receptive audience elsewhere, among the elites of the prosperous lower Yangtze River delta (known as the Jiangnan area, encompassing important cities such as Nanjing and Hangzhou). Troubled by the disarray of the Beijing court and other signs of dynastic decay, members of the educated upper class seized the opportunity afforded by imperial neglect to learn about the world beyond China.

It was among this group that Matteo Ricci and other Jesuits found their entrée into Chinese society, first in Canton and other southern provinces and later in the cities of Nanjing and Beijing. There they successfully introduced themselves not as missionaries but as intellectuals and scientists. Some scholars, such as the eminent Ming official Xu Guangqi, who converted to Christianity in 1601, were attracted to the Jesuits for their proficiency in sciences and mathematics, in part because of the decline of Chinese scientific expertise. Interest in astronomy was particularly strong among the literati because the Ming calendar was known to require reform, and Chinese astronomers were at loss on how to address the problem. This matter held particular urgency because the emperor's political authority was undergirded by the imperial calendar's accuracy. Other fields of inquiry that offered opportunities for the exchange of ideas between Chinese and Jesuit scholars were geography, cartography, and cosmology.

These intellectual pursuits were halted by the fall of the Ming dynasty to the invading Manchu in 1644. This northern Asian group established the Qing dynasty, adding another layer of complexity to Sino-European cultural exchanges. The Manchu rulers—

well aware of their foreign origins—had a difficult relationship with the native Han Chinese. However, like the Mongol rulers of the Yuan dynasty before them, they were not averse to employing foreign advisors, including the Jesuits, who were appointed to senior positions at the imperial Directorate of Astronomy. Under the Qing, the missionaries' situation changed radically. The relationships the Jesuits had forged with Han Chinese scholars during the late Ming dynasty gave way to a close collaboration between the priests and the Qing imperial court. Many missionaries abandoned the Jiangnan area and converged on Beijing to offer their services to the new regime. This shift severely reduced Jesuit ties with the Chinese scholar class, many of whom found Qing rule difficult to accept. A new phase began as the missionaries at court catered to the calendrical, cartographic, and military needs of the early Qing rulers, particularly the Shunzhi and the Kangxi emperors, as the Manchu sought to pacify and administer their new territories. The result, in the secular domain at least, was an era of mutually satisfactory cross-cultural encounters, which peaked between 1644 and 1705. The Jesuits applied their considerable abilities to accomplishing the varied tasks set by the emperor in hopes of gaining China for Christendom from the top down, while the emperor and his court were happy to accept their services to the extent that they furthered imperial ends.

Following the Jesuits' work on the reform of the Chinese calendar during the Shunzhi and Kangxi periods and the completion of a Jesuit-supervised geographic survey in 1717 for the Kangxi emperor, subsequent Qing rulers were less concerned with applications of Western science and less tolerant of the Christian mission. The Kangxi emperor's son, the Yongzheng emperor, appreciated art and prized the work of Giuseppe Castiglione and other Jesuit court artists, but he reversed the edict of tolerance for Christianity his father had issued in 1692. In 1726, he suppressed Christianity as a heterodox sect and permitted only the Jesuits and other foreign Christians who were useful to the court to remain in Beijing. His son, the Qianlong emperor—a notable patron of collaborative scholarly ventures and of all forms of art and literature—was engaged far more by the aesthetic than the scientific contributions of the Jesuits attached to his court. Under this emperor's patronage, the Jesuits were employed as artists, artisans, musicians, architects, and engineers. Jesuit publications in Chinese on intellectual or religious topics accordingly declined, while the Jesuits' artistic production soared. In addition to executing trompe l'oeil decorations for palace interiors and countless portraits of the emperor, Jesuit artists designed the European Pavilions as well as a spectacular series of engravings commemorating the Qianlong emperor's political and military successes.

Works on paper have received far less attention than Chinese export commodities in marking this period of cultural transmission. This exhibition reminds us that books and prints were central to the ways in which Europeans and Chinese communicated in the centuries between 1500 and 1800; in fact, such works on paper frequently provide the documentation that is used to contextualize artifacts in other media. The early impact of China in the West—especially its mediated appearance in chinoiserie and in appreciative writings by Europeans in the sixteenth through the eighteenth centuries—has been the subject of much scholarly scrutiny in Europe and the United States. In this catalog and exhibition, the focus is elsewhere, on texts and images produced in China or by those Europeans who had been there.

These books and prints targeted different audiences in two distinct cultures and explored a variety of topics. While the majority of the works in this catalog were instigated by European missionary and trade activities, they were substantially shaped by Chinese

literati culture, imperial patronage, and individual converts. In China, European texts were translated into Chinese and their content sometimes considerably altered to accord with local conceptions. Such texts introduced Western scientific theories into China as well as new technology such as telescopes, cannons, and steam engines. They also described or demonstrated new artistic techniques such as linear perspective, oil painting, and copperplate engraving. The effect of these works on Chinese science and culture has at times been downplayed, either by suggesting that Western scientific knowledge simply replaced Chinese science or by claiming that Western imagery had little or no impact on the visual arts in China. In fact, as this exhibition shows, Western works on paper exerted a subtle yet significant influence on Chinese scientific and artistic understanding.

The cross-cultural nature of both the content and the media of these productions should be stressed. The first printed works resulted from deliberate efforts to communicate ideas between cultures. The Jesuits translated Christian texts to aid in the instruction of Chinese converts as well as Confucian texts to aid in the European understanding of China. Martino Martini and Matteo Ricci, among others, sent geographic data and historical accounts from China to Europe, while their successors attempted to recast specific cultural narratives for new audiences. In 1788, for example, the French printmaker and publisher Isidore-Stanislaus-Henri Helman produced versions of Jesuit works that were, in turn, based on popular Chinese illustrated texts recounting the life of Confucius and the historic deeds of ancient Chinese rulers. At his hands, exemplary Chinese biographies became luxury editions for French collectors. As intercultural collaborations and exchanges of ideas intensified, not only did texts and images migrate and marry but techniques and styles also changed as artists worked together, teaching one another, experimenting with new formats, media, and processes, and executing important commissions such as those produced by Chinese and European artists for the Qianlong emperor. For example, the set of images depicting the Chinese conquest of the peoples of what is now the western region of Xinjiang was designed by Jesuits in China, engraved and printed in France, and finally returned to the Chinese emperor, who had commissioned the suite of sixteen engravings in 1765. The twenty views depicting the European Pavilions of the Garden of Perfect Clarity that appeared a decade later marked an even more complex stage of cross-cultural exchange: commissioned by the emperor and inspired by European architectural models, they were designed by a Jesuit-trained Manchu court artist in a medium introduced from Europe, engraved and printed in China, and then distributed as an indication of imperial favor.

In the mid-nineteenth century, such productive cultural communication and exchanges effectively ceased. The continued failure of European powers to progress in their trade negotiations with China led to hostilities between the British and the Chinese. At the end of the second Opium War in 1860, the Garden of Perfect Clarity, including the European Pavilions, was burned and pillaged by Anglo-French forces under the command of James Bruce, 8th Earl of Elgin. Ironically, these officers and soldiers were from countries where, a century earlier, people had been eager to learn about Chinese culture and had been fascinated by chinoiserie. Never especially valued or cherished by the Chinese until recent decades, today the ruins of the European Pavilions are a poignant reminder that the appealing Chinese ideal of "perfect clarity" eventually fell victim to more pressing political realities.

Notes

1. D. E. Mungello, *The Great Encounter of China and the West, 1500–1800,* 2nd ed. (Lanham, Md.: Rowman & Littlefield, 2005), 77–81. Some 920 Jesuits participated in the China mission between 1552 and 1773, when the order was (temporarily) dissolved by Clement XIV.

2. See, for example, the British diarist John Evelyn's description of a shipment "sent from the Jesuits of Japan and China" in 1664, which is cited in Jonathan D. Spence, *The Chan's Great Continent: China in Western Minds* (New York: W. W. Norton, 1998), 63–64.

3. Hubert Verhaeren, "Aperçu historique de la Bibliothèque du Pét'ang," in *Catalogue de la bibliothèque du Pé-T'ang* (Beijing: Imprimerie de Lazariste, 1949), v–xxxiii.

4. Chiu Che Bing, *Yuanming yuan: Le Jardin de la clarté parfaite* (Besançon: Éditions de l'Imprimeur, 2000), 66–80.

5. The stele on which this assertion is based was published (including an illustration and translation) in Athanasius Kircher, *China Monumentis, qua Sacris quà Profanis, . . . Illustrata* (Amsterdam: apud Joannem Janssonium à Waesberge & Elizeum Weyerstraet, 1667), 1–45. A plaster cast of the stele is reproduced in *From Beijing to Versailles: Artistic Relations between China and France,* exh. cat. (Hong Kong: Urban Council of Hong Kong, 1997), 110–11 (cat. no. 29 by Jean-Paul Desroches). See also Pénélope Riboud, "Tang," in Nicolas Standaert, ed., *Handbook of Christianity in China* (Leiden: Brill, 2001), 1:3–4, 18–21.

6. Zheng He apparently commanded some three hundred ships and twenty-eight thousand men on one of these voyages. China had had an active foreign trade since at least the first century B.C., but Confucian bias against commerce as well as China's overall self-sufficiency meant that voyages such as Zheng's had little follow-up. See Richard E. Strassberg, "Introduction: The Rise of Chinese Travel Writing," in idem, ed. and trans., *Inscribed Landscapes: Travel Writing from Imperial China* (Berkeley: Univ. of California Press, 1994), 426 n. 20; and Mungello, *Great Encounter* (note 1), 2, 3, 5, 84.

7. See Monique Cohen, "A Point of History: Chinese Books Presented to the National Library in Paris by Joachim Bouvet, S.J., in 1697," *Chinese Culture* 32, no. 4 (1990): 39–48; Danielle Elisseeff-Poisle, "Arcade Hoang, Bibliothekar des Königs. Ludwig XIV. und die Ferne Osten," in *Europa und die Kaiser von China,* exh. cat. (Frankfurt am Main: Insel, 1985), 96–101; Eva Kraft, "Die chinesische Büchersammlung des Großen Kurfürsten und seines Nachfolgers," in *China und Europa: Chinaverständnis und Chinamode im 17. und 18. Jahrhundert,* exh. cat. (Berlin: [Schloss Charlottenburg], 1973), 18–25; David E. Mungello, *Leibniz and Confucianism, the Search for Accord* (Honolulu: Univ. Press of Hawaii, 1977), 7; and Ole Worm, *Museum Wormianum; seu, Historia Rerum Rariorum . . .* (Leiden: apud Johannem Elsevirium, 1655), 3, 153, 165, 372.

ANANAS

A Perfume
Is Best from Afar:
Publishing China
for Europe

You must say this about Europeans:
they love strangers. — KO (GAO LEISI)[1]

MARCO POLO AND THE EMPEROR OF CHINA Two iconic figures set the pattern in late medieval Europe for centuries of European travel descriptions of China. Marco Polo, a thirteenth-century Venetian trader, and the "Emperor of China," a fabulous Oriental potentate, were signal characters — more legend than fact — who seemingly epitomized the two cultures, defining the European perspective on China.

The Emperor of China was presented from the sixteenth century on as a static and hieratic figure who embodied the splendors of China and the power he held over the vast and diverse lands of distant Asia. Possibly owing to Europeans' difficulty with Chinese, they rarely referred to the emperor by name. Indeed, this contributed to making him a stranger. A monumental presence who occasionally received and entertained important visitors and foreign embassies, from whom he expected tribute, the Emperor of China was seldom seen and never traveled outside his own territories. By contrast, the acquisitive Western world, personified by Marco Polo, was always moving farther afield, searching for new entrepreneurial opportunities that could increase commerce as well as furnish curiosities and novel entertainments. In the wake of the successful circumnavigation of the earth, the establishment of Catholic missions in Asia, and the development of mercantile operations such as the East India companies of the Netherlands, France, and Britain, Europeans developed a strong interest in the newly expanded world. A symbol of the European drive to explore and conquer lands that did not welcome strangers,[2] Marco Polo played the role of the engaged observer, immersing himself in Chinese culture and, for nearly seventeen years, working as an agent for the great Mongol emperor Kublai Khan.[3]

From 1299 on, Marco Polo's *Travels* circulated among European readers, in manuscript and printed versions and in a dozen languages, keeping ideas about China alive in times when there was little direct contact.[4] In the sixteenth century, however, the flourishing European publishing industry would make possible the dissemination of documentary reports by Western travelers to the Far East as well as compilations of their letters and journals. In addition to legends and fantastical travelers' tales, rather more serious accounts of China now began to reach a range of new readers.

Detail of FIGURE 55

CHINA DESCRIBED The first descriptions of China read in the West were traders' accounts, ships' logs, and missionaries' reports. Such firsthand sources formed the basis for the initial wave of European publications on China, many of which were compendia by authors who had never been to China themselves. One of the earliest comprehensive accounts was *Historia de las cosas mas notables, ritos y costumbres del gran reyno de la China* (History of the most remarkable things, rites, and customs of the great kingdom of China, 1585) (cf. cat. no. 1) by the Augustinian friar Juan González de Mendoza, published in Rome in 1585. Mendoza, who traveled to Mexico but never to Asia, brought together accounts by Franciscan, Dominican, and Augustinian brothers based in the Philippines, including Gaspar da Cruz's *Tractado em que se côtam muito por estêso as cousas da China* (Treatise that relates a great many things about China, 1569–70) and Martín de Rada's "Relación de las cosas de China que propriamente se llama Taybin" (Relation of things about China, which is properly called *Taybin,* 1576).[5] Cruz had been allowed to visit Canton for a month in 1555 or 1556; Rada had not only traveled in southeastern China in 1575 but also translated a number of Chinese books with the help of Chinese traders in the Philippines.[6] Although Mendoza was a missionary, his *Historia* featured details about the resources and culture of China, perhaps reflecting the prevailing Western interest in commerce. An English translation, *The Historie of the Great and Mightie Kingdome of China, and the Situation Thereof,* appeared in 1588. By 1600, Mendoza's book was available in seven European languages, and it ran to some thirty-three editions by 1613.[7]

Such descriptive compendia on China were soon joined by selections from the annual letters sent by Jesuit missionaries in foreign lands to their superiors in Rome. In 1615, the French Jesuit missionary Nicolas Trigault published *De Christiana Expeditione apud Sinas Suscepta ab Societate Jesu* (On the Christian mission among the Chinese undertaken by the Society of Jesus) based on the reports and papers of Matteo Ricci, the Italian who carried the Jesuit mission in China beyond the Portuguese trading colony at Macau to the mainland. Ricci lived and worked in Canton and Nanjing, among other places, and died in Beijing in 1610.[8] This chronicle about the Western mission in China from 1583 to 1611 also provided a systematic portrait of contemporary Chinese society as perceived by Ricci, who was fluent in Chinese and exhibited both a sympathetic interest in Chinese culture and an erudite perspective on the Jesuits' accomplishments. *De Christiana Expeditione* was among the most important and widely read books on China published during the seventeenth century. French, German, Spanish, and Italian translations quickly appeared, but not English. Although most descriptions of China were quickly translated for English readers, only excerpts from Ricci's work were published by Samuel Purchas in 1625 in his compilation of travelers' reports.[9]

CHINA ILLUSTRATED The sole illustrations in Ricci's volume were its foldout plan of the Jesuits' monastery in suburban Beijing and its engraved title page, on which Ricci and the pioneering Jesuit missionary Francis Xavier flank a map of eastern China and the East China Sea (fig. 2). But as publications on China and the West flourished, they became increasingly visual. Travel books in particular were designed with complementary relationships among texts, images, and maps. Some of the first images were title pages featuring portraits of the emperor, maps, and vignettes of Chinese people in local dress engaged in characteristic occupations. Large maps unfolded to give visual salience to distances, topography, and geographic adjacencies. Their cartouches showed regional customs, plants, and animals.

FIGURE 2
Wolfgang Kilian (German, 1581–1662), **Title page with Francis Xavier and Matteo Ricci,** 1615, engraving, 17 × 12.7 cm (6¾ × 5 in.) From Matteo Ricci, *De Christiana Expeditione apud Sinas Suscepta ab Societate Jesu,* trans. Nicolas Trigault (Augsburg: apud Christoph Mangium, 1615)

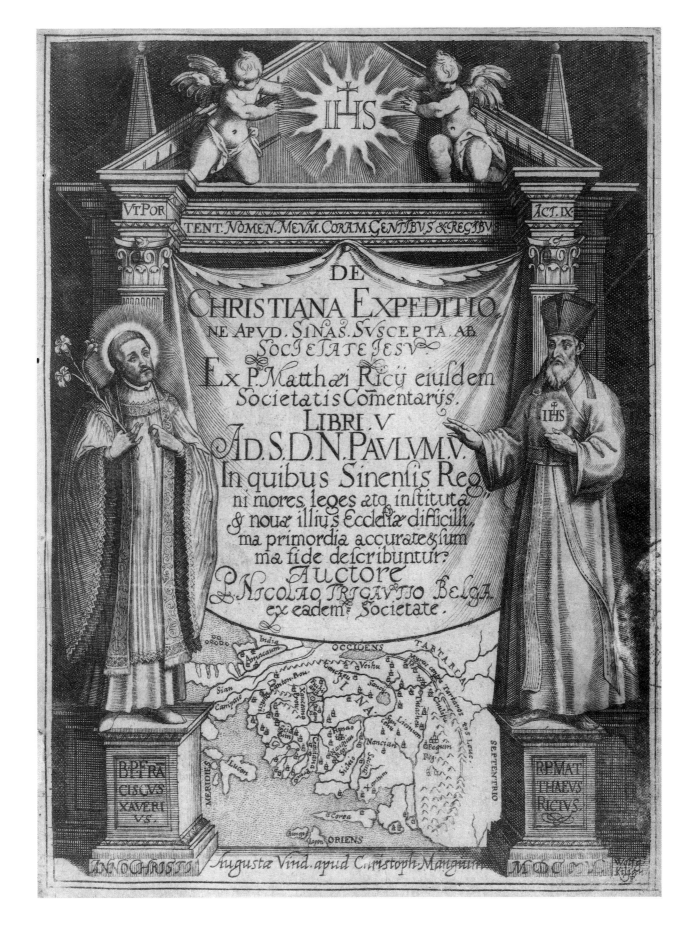

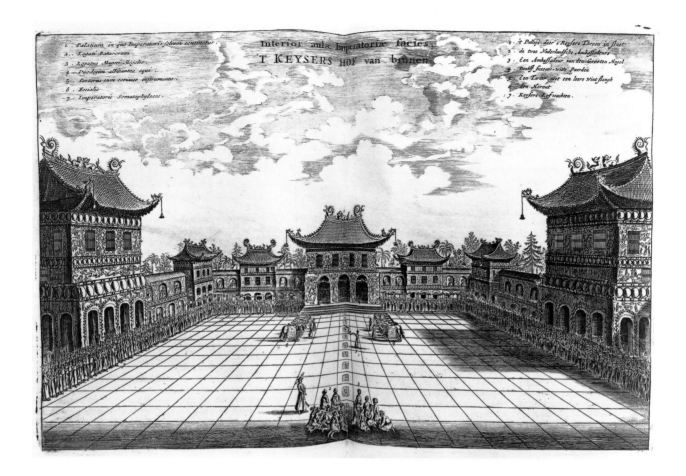

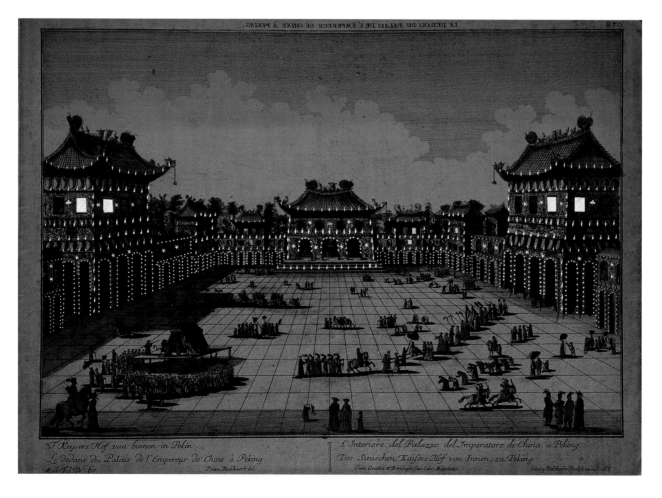

Johannes Nieuhof's account of his experiences as a member of the first embassy of the Dutch East India Company to Beijing in the years 1655 to 1657 was the first illustrated book describing China (cf. cat. nos. 2, 3). Published in 1665, Nieuhof's book was one of a series of illustrated folios produced by the bookseller and art dealer Jacob van Meurs in the 1660s and 1670s that document the far corners of the known world. Other volumes published by Meurs included Olfert Dapper's works on Africa, the Middle East, India, and China (cat. no. 4); and Arnoldus Montanus's accounts of Japan and Latin America.

While their generously illustrated folios followed Nieuhof's format, Dapper and Montanus were armchair travelers who never saw for themselves the places they described. By contrast, Nieuhof was conscious of his role as a writer and artist whose practical observations were corrections to the wondrous tales and exaggerations of previous authors. He relied on others for information on regions that he had not visited,[10] but for the most part his book is an eyewitness account, with no missionary agenda, written in a direct style that describes the people and places depicted in illustrations based on his own sketches. Because the members of the embassy were seldom allowed to disembark during their trip to Beijing, the etchings often feature scenes of the shoreline, their compositions similar to typical Dutch city views or the approach to ports from the sea. Nieuhof shows cities and landscapes as seen from the ships on which he traveled: distanced views that depict China's buildings and people from afar, beyond the dark foreground where the visitor is presumably standing. In contrast to Ricci's reports, which reveal the perspective of an interested insider and a resident versed in China's culture and language, Nieuhof's descriptions and views define a foreigner's perspective. He enacts the role of the outside observer, for whom China is a place with a unique culture, not like home.

Although typical of the numerous travel books being produced by Dutch publishers to promote Dutch navigational and commercial accomplishments, Nieuhof's volume broke ground by providing a range of arguably more accurate and undoubtedly more varied and compelling images of China and its people for Western consumption. His illustrations were reproduced widely, not only reappearing in other books and prints but also serving as models for decorative designs on ceramics, lacquerware, silver, textiles, and interiors.[11] They took on a life of their own, separate from Nieuhof's text, representing China long after their original time of production. For example, the image of an inner courtyard at the emperor's palace (fig. 3)—the one fronting the Hall of Supreme Harmony (Taihedian), where the emperor received foreign dignitaries and envoys in the Forbidden City—reappeared, in reverse, four years later in a version produced by Wenceslaus Hollar for the first English translation of Nieuhof's book.[12] In the eighteenth century, a version of Nieuhof's image copied from Hollar's reversed print was used as the first of the twenty plates of *The Emperor of China's Palace at Pekin, and His Principal Gardens* (cat. no. 31), which was published in London in 1753.[13] Having removed the dignitaries of the Chinese court and Dutch embassy that appeared in Nieuhof's original, the engraver populated the entry with chinoiserie figures, so that the context of an imperial reception was lost. The same print was copied several decades later for a *vue d'optique* (perspective view) by the Augsburg printmaker Georg Balthasar Probst (fig. 4). *Vues d'optique* were hand-colored etchings to be viewed through a convex lens, such that the viewer saw a reversed and seemingly three-dimensional scene. Intended for domestic entertainment, many, like this one, were pricked and colored paper glued behind cutout areas so that the view could be backlit for dramatic effect, changing a daylight view

FIGURE 3
Interior Aulae Imperatoriae Facies (Interior view of the imperial courtyard), 1665, etching, 19.9 × 29.6 cm (7⅞ × 11⅝ in.) From Johannes Nieuhof, *Legatio Batavica ad Magnum Tartariae Chamum Sungteium, Modernum Sinae Imperatorem…*, trans. Georg Horn (Amsterdam: apud J. Meursium, 1668), before p. 159

FIGURE 4
Georg Balthasar Probst (German, fl. 1700s), after P. van Blankaert, after Johannes Nieuhof (Dutch, 1618–72), **Backlit view of Le dedans du palais de l'empereur de Chine à Peking** (The interior of the emperor of China's palace in Beijing), 1766–90, hand-colored etching and engraving, 31.8 × 44.5 cm (12½ × 17½ in.)

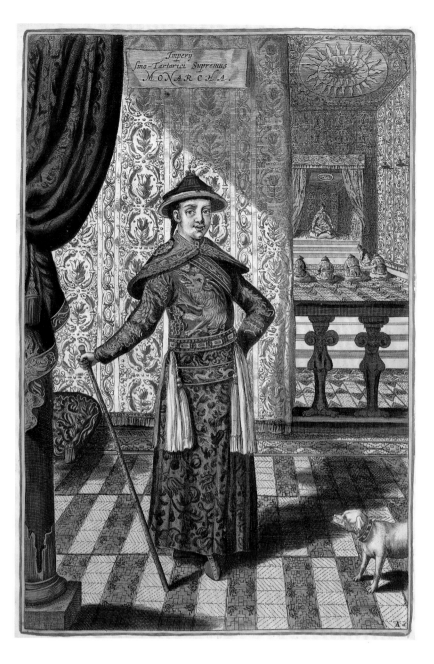

into a night scene. Along with other European printmakers, Probst published hundreds of *vues d'optique* that adapted other artists' views of distant lands.[14] Cut-up colored prints of Chinese subjects taken from travel books by Nieuhof, Dapper, Montanus, and others were also used in Europe for decoupage of furniture and other decorative objects. When heavily varnished, the items imitated Asian lacquerware.[15]

The English translation of Nieuhof's work included selections from another recently published work on China: Athanasius Kircher's *China Monumentis, qua Sacris quà Profanis, nec non Variis Naturae et Artis Spectaculis, aliarumque Rerum Memorabilium Argumentis Illustrata* (1667) (cat. no. 5).[16] Kircher had never been to China, but his preface credits as sources fellow Jesuits who had made the journey—Martino Martini, Michel Piotr Boym, Johann Grueber, and Albert Dorville, among others. Whereas Nieuhof had focused on what he had observed during his sojourn in China, providing contextual descriptions of Chinese culture, Kircher's work is more theoretical, a reflection of his interests as a Jesuit priest, humanistic scholar, scientific researcher, and collector of natural artifacts and

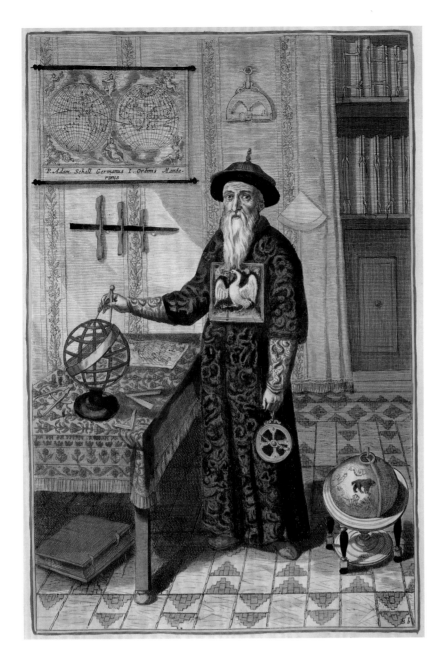

cultural oddities. The text presents Chinese customs, ceremonies, and language in rela-
tion to ancient Mediterranean civilizations, classical antiquity, early Christianity, and
the hermetic tradition to show China's presumed relationship to other cultures, espe-
cially Egypt. Kircher's passion for natural history is seen in the book's depictions of the
flora and fauna of China, from pineapples to bats and flying turtles, while his fascination
with cultural phenomena prompts images ranging from local dress to deformed beg-
gars and criminal punishments. Prints depicting natural marvels and bizarre customs
in China mirrored the arcane contents of the European cabinets of curiosities of the
day, appealing to the burgeoning interest in the exotic and the extraordinary.[17] Kircher
claimed that the illustrations were based on sketches sent by the Jesuits from China, but
even so they are obviously and ineluctably rooted in the European graphic tradition.
The visual kinship of the similarly composed portraits of the emperor of China (most
likely the Shunzhi emperor) and Adam Schall von Bell (the aged Jesuit astronomer who
was that emperor's trusted advisor) seems both telling and deliberate (figs. 5, 6). These

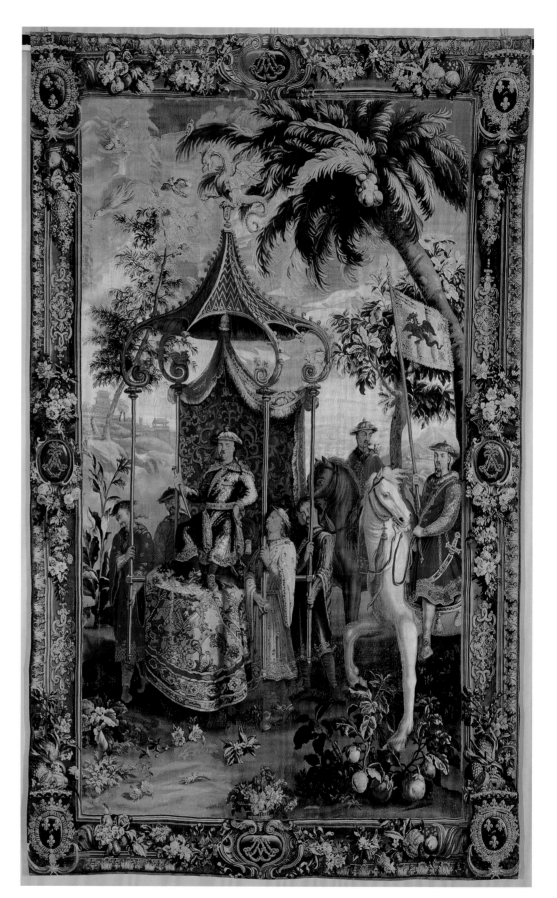

FIGURE 7
Beauvais Tapestry Manu-
factory; woven under the
direction of Philippe Béhagle
(Flemish, 1641–1705), after
cartoons by Guy-Louis
Vernansal (French, 1648–1729)
and Jean-Baptiste Monnoyer
(French, 1636–99) and
Jean-Baptiste Belin de
Fontenay (French, 1653–1715),
The Emperor on a Journey,
wool and silk, 421.4 × 254 cm
(166 × 100 in.)
From the series *The Story of the
Emperor of China,* ca. 1697–1705

FIGURE 8
Beauvais Tapestry Manu-
factory; woven under the
direction of Philippe Béhagle
(Flemish, 1641–1705), after
cartoons by Guy-Louis
Vernansal (French, 1648–1729)
and Jean-Baptiste Monnoyer
(French, 1636–99) and
Jean-Baptiste Belin de
Fontenay (French, 1653–1715),
The Astronomers, wool and silk,
424 × 319 cm (167 × 125½ in.)
From the series *The Story of the
Emperor of China,* ca. 1697–1705

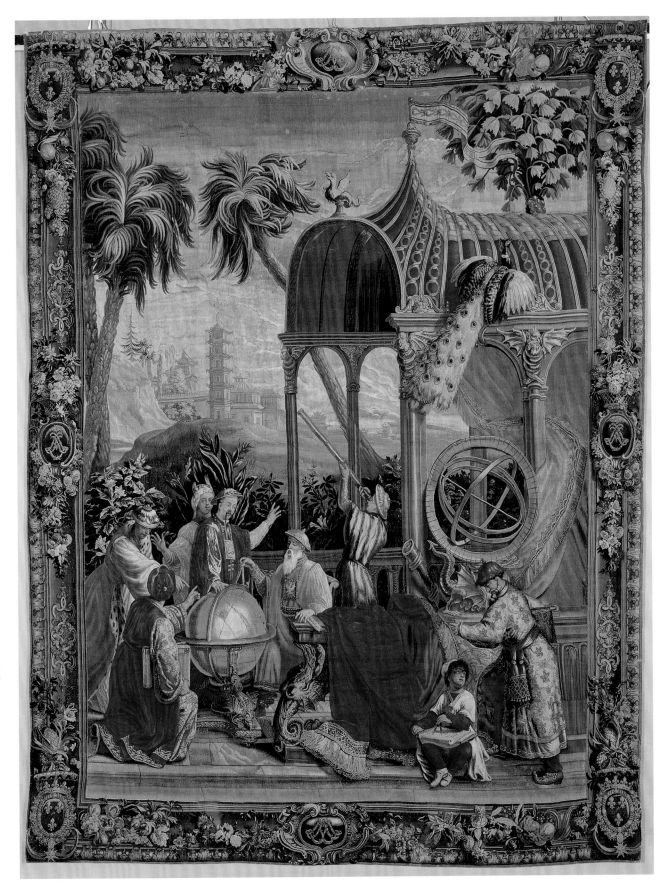

men from disparate worlds are similarly posed among characteristic objects denoting their status and occupations. Dressed in the silk robes of a Qing mandarin (the white crane indicates his imperially authorized rank) and holding compasses and a mariner's astrolabe, Schall stands in front of shelves of books and a world map. The emperor with his staff is flanked by a council chamber and a cushion. The European scholar and missionary emerges as a figure whose scale is equal to the Chinese emperor's. The pictorial parallels of these portraits, which appear close to one another in Kircher's book, implicitly support the author's own interests in Chinese civilization and its significance for European culture.

Numerous adaptations of illustrations from volumes by Nieuhof, Dapper, and Kircher reveal how widely these books were known.[18] In the series of ten Beauvais tapestries known as *The Story of the Emperor of China* (French, ca. 1697–1705), several figures and motifs are identifiably based on Nieuhof's or Kircher's images.[19] For example, the enthroned emperor in *The Audience of the Emperor* tapestry is related to the depiction on the title page of Nieuhof's volume (see fig. 54), and the emperor in *The Emperor on a Journey* (fig. 7) and *The Return from the Hunt* and the bearded astronomer conversing with the emperor in *The Astronomers* (fig. 8) are allied to the images of the emperor and Schall in Kircher's book. As a whole, the series witnesses the transformation from the Chinese imperial splendor of Nieuhof's prints to a theatrical stage-setting *à la chinoise* based on European baroque court models.

In tandem with images of people, cities, flora, and fauna, maps were important elements in early travel books and were published and sold by the same printers and dealers. Several of the first descriptions of China employed cartographic images on illustrated title pages. Maps of China appeared on the title pages of Ricci's and Kircher's volumes (see figs. 2, 58), and the emperor of China supports a globe turned toward China on Nieuhof's engraved title page (see fig. 54). Large foldout maps introduced texts, showing, for example, Nieuhof's route in his work and the missionary itineraries of Dorville and Grueber in Kircher's. Martini's highly visual *Novus Atlas Sinensis* (1655) (cat. no. 25), which was based on Chinese sources and Martini's own experiences in China,[20] set a standard to be emulated by later cartographic works. Such maps provided visual exposition of the topographic features of China, its vast area, and adjacencies, providing the reader with a sense that "You are here." Often the frames and cartouches of maps were ornamented with vignettes featuring views of Chinese cities or monuments or genre scenes (see fig. 78), some of which were copied in other media. As a further embellishment, the maps, costume prints, and plates of plants and animals in illustrated books on China frequently were hand-colored.

THE POWER OF PUBLISHING By the beginning of the eighteenth century, Europeans could access an extensive repertoire of texts and visual sources that presented several distinct views of China. Descriptions by Jesuit missionaries in China tended to offer positive portrayals of Chinese society, stressing the authority of China's rulers and the enlightened political and social philosophy underpinning that authority. Cannily deploying the power of publishing to spread word of their accomplishments, the Jesuits were careful to emphasize the value of cultural and economic interactions with China to the ultimate goal of proselytization. Less favorable accounts came from navigators and traders, particularly the Dutch and the English, who were not interested in learning Chinese or accommodating Chinese culture and, accordingly, were far less successful than

the Jesuits in gaining entrance to the court and comprehending Chinese ways of doing business. These Europeans merely desired access to China's markets and trade goods. Having achieved this goal in other regions by means of military conquest or colonial strategies, they found the Chinese regime's extremely restrictive policies on travel and trade frustrating and its explicitly exclusionary attitude toward foreigners offensive. In addition, Europeans in China had a competitive relationship among themselves. From early on, the (Protestant) Dutch complained that they had been edged out of the picture by the (Catholic) Portuguese and their cohort, the Jesuits who had made substantial inroads at the court and in the higher echelons of Chinese society. As Montanus wrote in 1671, "in *Peking* were many subtile Jesuits and Priests, who bore great spleen to the *Hollanders,* and sought to scandalize and make them seem odious to the Emperor, because of the difference in Religion among themselves, and likewise for the War maintained by the *Hollanders* against the two Mighty Kings of *Spain* and *Portugal* to whom these Jesuits and Priests were confessors."[21]

This state of affairs held in 1723 (with the caveat that the Jesuits were increasingly allied with France rather than Portugal), when *Ceremonies et coutumes religieuses des tous les peuples du monde* (1723–43) (see cat. no. 7) began to appear. This multivolume work was the fruit of a collaboration between the French graphic artist Bernard Picart and the Amsterdam bookseller Jean-Frédéric Bernard. Having left France for religious reasons (raised a Catholic, Picart had Jansenist leanings),[22] the artist may have had personal as well as commercial motives for producing a comprehensive illustrated work that demonstrated that the Catholic church was not the sole spiritual authority and that its elaborate ceremonies paralleled the practices of other world religions. One of the set's volumes on "idolatrous peoples" contains a section on Chinese religious customs with descriptions and images based on earlier publications. The thirty-odd illustrations are as notable for their liveliness as for their obvious lack of factual foundation. They are inventive copies or highly imaginative recraftings of prints published in earlier illustrated books, primarily those of Kircher, Nieuhof, and Dapper.[23] In the hands of the accomplished artist Picart, visual documentation of travel was transformed into a new genre that, like the *vue d'optique,* created a theater of the world. *Ceremonies* offers a characteristically eighteenth-century encyclopedic treatment of its subject, yet the illustrations of China are fanciful rather than factual. Picart paid particular attention to the extraordinary, depicting strange deities, exotic temples, elaborate rites, and curiously costumed priests, along with religious penitents, sorcerers, and charlatans. His artful presentation of things Chinese heralds a new genre that would flourish in the course of the late eighteenth and early nineteenth centuries, as seen in the suites of prints elaborating chinoiserie themes and ornaments as well as popular series of views, costumes, and customs published by William Alexander, George Henry Mason, and Jean Baptiste Joseph Breton de la Martinère, among others.[24] At this same time, the Leiden publisher Pieter van der Aa continued the tradition of reproducing images from Nieuhof and other travel books with his encyclopedic compilation of maps and prints, *La galerie agréable du monde* (The pleasurable gallery of the world, 1700–1729), which offered more than three thousand images in sixty-six volumes .

The dissemination of images of China was paralleled by a steady increase in specialized and scholarly knowledge that gave specificity to the European idea of China. The emperor of China gained not only a name but a face, his empire was mapped on a modern scientific basis, and various treatises on discrete subjects such as Chinese military

science, music, and gardens were produced.[25] Editors reprinted excerpts from earlier travel books and published translations of Chinese texts on topics such as bamboo or silk; they issued volumes of poetry, fiction, and theater based on Chinese originals.[26] Well-read scholars felt that they could claim a comprehensive knowledge of China, and they were confident enough to bring China to bear on particular issues and debates of the day. *De la philosophie des Chinois* (On Chinese philosophy) by Denis Diderot, extracted from Jean Le Rond d'Alembert and Diderot's *Encyclopédie* (Encyclopedia, 1751–80), expounds at length on Confucianism, referencing *Confucius Sinarum Philosophus* (1687) (cat. no. 17), which included translations of several Confucian classics as well as lengthy commentary by Jesuits of the China mission.[27] Some French scholars have argued that the *Encyclopédie* was inspired, in part, by the collections of Chinese manuscripts at the Bibliothèque royale in Paris.[28]

Indeed, eighteenth-century records reveal that Diderot had borrowed the Bibliothèque royale's copy of the standard source on China, Jean-Baptiste Du Halde's encyclopedic four-volume survey, *Description geographique, historique, chronologique, politique, et physique de l'empire de la Chine et de la Tartarie Chinoise* (1735) (cat. no. 8).[29] Du Halde had developed both interest and expertise in the subject of China in his capacity as the editor, starting in 1708, of the *Lettres édifiantes et curieuses, écrites des Missions étrangères, par quelques missionnaires de la Compagnie de Jésus* (Edifying and curious letters, written from the foreign missions, by some missionaries of the Society of Jesus, 1703–76). These volumes, issued regularly by the Society of Jesus, presented selections from correspondence and reports written by Jesuit missionaries then scattered around the globe, and the sections on China systematically summarized the country's history, religion, economy, and customs.[30] Like Martini's *Novus Atlas Sinensis*,[31] Du Halde's *Description* gives pride of place to geographical information. Its forty-three maps were drawn by the French geographer Jean-Baptiste Bourguignon d'Anville based on a nationwide survey of China commissioned by the Kangxi emperor. This complete survey of every corner of the empire was conducted using Western triangulation methods by nine missionaries and their Chinese assistants between 1708 and 1717. The results were compiled in Beijing by the French Jesuit Pierre Jartoux in an atlas featuring maps printed from copperplates engraved by the Italian Jesuit Matteo Ripa.[32] The atlas, given to the emperor in 1718, was published in Chinese as the *Guangyu guanlan tu* (Complete atlas of the imperial territories). The maps were sent to Paris, where they became essential elements of Du Halde's *Description*.[33] Having no personal experience of China, Du Halde compiled his diverse survey from contemporary European and Chinese sources, and the final version was corrected by Cyr Contancin, a French Jesuit who had just returned from China. The work was favorably reviewed, widely discussed, and well publicized in both the French and the foreign press.[34]

Like the *Lettres édifiantes*, the sixteen-volume *Mémoires concernant l'histoire, les sciences, les arts, les moeurs, les usages, etc. des Chinois; par les missionnaires de Pe-kin* (Reports concerning the history, sciences, arts, mores, customs, etc. of the Chinese; by the missionaries in Beijing, 1776–1814) combined correspondence, travel accounts, and translations of original Chinese texts.[35] The force behind this long-term publishing project was a collector and aficionado of Chinese art and literature, the *petit ministre* Henri-Léonard-Jean-Baptiste Bertin, who would serve the regime of Louis XV as controller general, secretary of state, and minister of agriculture.[36] Bertin—whose official titles do no justice to his influential position at court and to the central role he played in late-

eighteenth-century French culture—was also closely involved in several related publication projects: *Faits mémorables des empereurs de la Chine, tirés des annales chinoises* (1788) (cat. no. 20), *Abrégé historique des principaux traits de la vie de Confucius, célèbre philosophe chinois* ([1788?]) (cat. no. 21), and *Conquêtes de l'empereur de la Chine* (1785) (cat. no. 29), all of which mention his collections on their title pages.

The preface to the first volume of the *Mémoires* tells the story of two Chinese converts, Ko (Gao Leisi) and Yang (Yang Dewang), who had accompanied a group of Jesuit missionaries traveling to France in 1763.[37] They came to study European languages and Western science and extended their stay in order to learn about French arts and industries. They returned to China in 1766 with the intention of corresponding regularly with their European sponsors. Unfortunately, this project to facilitate an ongoing exchange of information between France and China had been conceived without taking Chinese protocol into consideration. By the time Ko and Yang arrived in Beijing bearing important gifts from French officials, the two men had been away without permission for many years. Moreover, they were Christian converts and not of a rank high enough to present the gifts at court. Their study and training went for naught in China; indeed, their preparations put them in certain jeopardy. The French Enlightenment interest in comparative cultures was never shared by the Chinese state. But while the *Mémoires* contained little else from Ko and Yang, the volumes did publish much new information from the Jesuit missions in China, as well as translations of Chinese texts, primarily by Joseph-Marie Amiot and Pierre-Martial Cibot.

The last decade of the eighteenth century saw unsuccessful embassies by the British and the Dutch seeking to break through Chinese restrictions on the activities of foreigners and the trade in foreign goods. The purpose of Lord Macartney's journey to China, which took three years, starting in 1792, was to negotiate more favorable trading rights for Britain and to set up a permanent British office in Beijing. It was thought that "a British Ambassador would be a new spectacle; and his mission a compliment, that would possibly be well received."[38] Much has been made of Macartney's refusal to kowtow and the embassy's lack of success—the Chinese asserted that they had no need for European goods, and the court ostensibly treated the ambassador's presents as tribute—yet copious documentation and visual information came from it. From 1795 through the early 1800s, a succession of books were published by members of the embassy, including William Alexander, Aeneas Anderson, George Leonard Staunton (cat. no. 9), and John Barrow (cat. no. 10).[39] They were joined by *Voyages à Peking, Manille et l'Île de France, faits dans l'intervalle des années 1784 à 1801* (cat. no. 11), which was published in 1808 by Chrétien Louis Joseph de Guignes, the son of the French sinologist Joseph de Guignes. A lengthy commentary recounting the younger de Guignes's seventeen years in Southeast Asia, the *Voyages* focused on his journey to Beijing as an interpreter for the Dutch embassy led by Isaac Titsingh and Andreas Everardus van Braam Houckgeest in the years 1794 and 1795.

CONSUMING CHINA The collecting and display of prints after European travelers' sketches as well as Chinese export prints and watercolors testified to Europe's continuing fascination with China. It paralleled its growing consumption of China's natural resources, especially tea, silk, and pearls, as well as its continuing appetite for ceramics and lacquer. Prints originally intended as book illustrations emerged from their auxiliary context; they were sold separately as single sheets and collected in suites.

It was as if the images of the emperor and his subjects on Nieuhof's congested title page were isolated and made into individual scenes and figures. The puzzling fact is that at the same time that artistic renderings became more beautiful and decorative prints proliferated, the political situation between China and Europe was turning increasingly sour. As in France, so in England, in both art and politics, there was a lack of realistic assessment of Chinese culture and foreign relations. In the decorative arts and interior design, artistic production spun off into fantastic chinoiseries that had little to do with China per se. In effect, the trivial, sometimes denigrating caricatures could indicate that Europe did not really know China or take its culture seriously. It seemed that Europeans liked strangers, but from a distance, and portrayed in generic terms.

Describing China primarily in pictures, the collections of genre scenes compiled by Alexander and Mason provided similar glosses on China.[40] Following Mason's *The Costume of China* (cat. no. 12) of 1800, the publisher William Miller issued Alexander's *The Costume of China* (fig. 9) in 1805 as the first volume in a series on national costumes. Mason's *The Punishments of China* (cat. no. 13) came out in 1801. Among publications devoted to the description of distant lands and foreign customs, the extended portrayal of criminals and judicial torture is unique to China. Indeed, the subject had been a staple since the sixteenth century, as witnessed by various travel descriptions and by prints by Nieuhof, among others. Somewhat perversely, Mason's engravings are uniformly colored in light and lovely colors: blues, lavenders, deep red (fig. 10; see also fig. 66). Posed without backgrounds or contextual surroundings, the odd postures and ingenious cruelties of *The Punishments* burnished the image of China as a very strange and distant land.

Whereas Alexander both sketched and produced the prints that appeared in his collection, no source was cited for the twenty-two engravings by J. Dadley in Mason's *The Punishments,* and the sixty engravings by Dadley in Mason's *The Costume of China* purportedly were based on watercolors executed by "Pu-Quà, Canton." If in fact they were by a Cantonese artist by the name of Pu-Quà, the corroborative and documentary value of the images of Chinese people is equivocal. The originals were in all likelihood massproduced by Chinese artists specifically for the export market at Canton[41] and, as such, depicted Chinese subjects in a manner adapted to Western tastes and expectations. A foreigner is shown on a wharf selecting pictures from a Chinese vendor in the cartouche on the map of Canton in Du Halde's *Description* (fig. 11). The vignette depicts one means by which artworks made expressly for foreigners, hybrid productions at best, made their way into Western collections on China. Mason's and Alexander's books and single prints derived from them continued to be issued through the early nineteenth century. Given the numerous copies still extant, they must have circulated widely, as did works such as Breton's *China: Its Costume, Arts, Manufactures, etc.* (1812) (cat. no. 14) that were the precursors to modern travel guides, those parallel publications to the incipient genre of literary travel narratives describing foreign places.

But why publish descriptions and images of distant lands and their people at a time when most Europeans did not travel far from home? Obviously such works were useful to the navigators, merchants, and missionaries who actually went to China, but this does not explain the character or the immense popularity of volumes on China from the early sixteenth through the early nineteenth centuries. Apart from economics, the lure of the exotic seems key. Serving as geographical potboilers, these books with their striking and occasionally sensational illustrations featured material that was ostensibly true

FIGURE 9
William Alexander (British, 1767–1816), *A Soldier of Chu-san, Armed with a Matchlock Gun, etc.,* 1804, aquatint, page: 25 × 33.5 (9⅞ × 13¼ in.) From William Alexander, *The Costume of China* (London: William Miller, 1805), [no. 45]

FIGURE 10
J. Dadley (British, fl. 1700s), *Punishment of the Swing,* 1801, colored stipple engraving, page: 34.6 × 26 cm (13⅝ × 10¼ in.) From George Henry Mason, *The Punishments of China...* (London: printed for W. Miller, by W. Bulmer, 1801), pl. 6

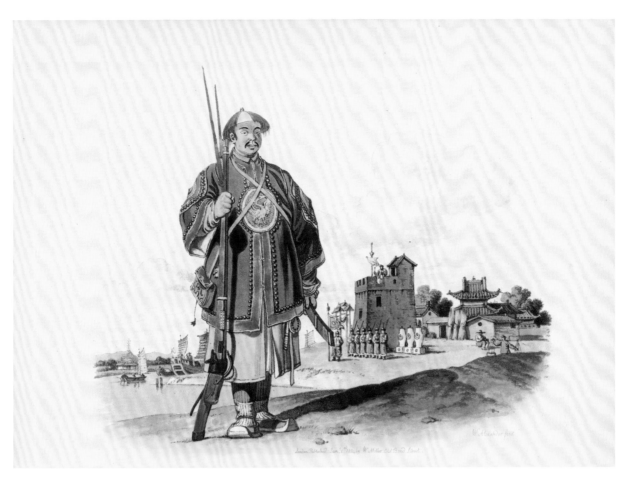

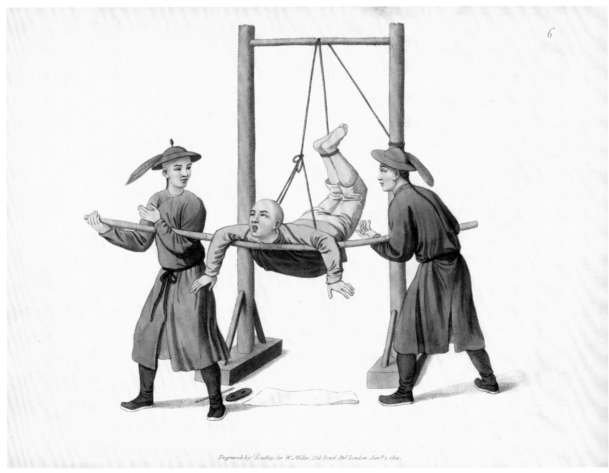

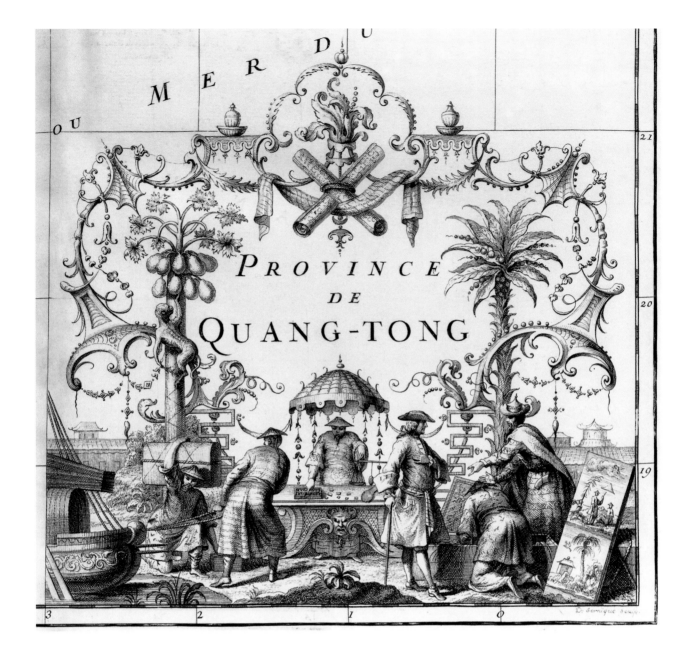

FIGURE 11
Dominique Sornique (French,
ca. 1707–56), **Title cartouche
for *Province de Quang-Tong***
(Province of Guangdong),
1735, etching, cartouche:
19 × 20.7 cm (7½ × 8⅛ in.)
From Jean-Baptiste Du Halde,
*Description geographique,
historique, chronologique,
politique, et physique de l'empire
de la Chine et de la Tartarie
Chinoise . . .* (Paris: P. G. Le
Mercier, 1735), vol. 1, after
p. 220

but truly extraordinary, that is, outside the frame of daily life in the West. In effect, publications on China were books of wonders collected for — and sometimes by — armchair travelers. They also functioned as reference books for new generations of adventurous scholars who saw China as a vital element in the search for comprehensive knowledge. Travel writing proceeds along the intertwined paths of culture and wonder. For Europeans (and a growing American audience), there is no question about the attraction of books, maps, and prints on China that came from both East Asian and European sources. "A perfume is best from afar,"[42] no matter if pleasant or strange.

Notes

1. Ko (Gao Leisi), "Essai sur l'antiquité des Chinois," *Mémoires concernant l'histoire, les sciences, les arts, les moeurs, les usages, etc. des Chinois; par les missionnaires de Pe-kin* 1 (1776): 9: "Il faut rendre cette justice aux Européens: ils aiment les etrangers."

2. On difficulties of communication and trade with China, see Arnoldus Montanus, *Atlas Chinensis: Being a Second Part of Relation of Remarkable Passages in Two Embassies from the East-India Company of the United Provinces...* (London: printed by Tho. Johnson for the author, 1671), [1]:

> Many Years are past since several *Europeans,* especially the *English, Spaniards, Portuguese,* and *Hollanders,* have with indefatigable Endeavors persever'd towards the acquiring a free and unmolested Trade in *CHINA...* their whole Undertakings have prov'd little better than a Labor in vain; for the *Chinese* priding in the Subsistence of their own Product, and too strictly observing an Ancient Law, prohibiting the Admission of any Strangers into their Countrey, excepting such onely as bringing Tributes from the adjacent Borders, paid Homage to their Emperor, as Supreme Lord of the World; or else Foreign Embassadors, under which pretence many drove there a subtile Trade, have shut out and abhorr'd all Correspondency abroad; which *Trigaut* affirms, saying, The *Chinese have a Law that forbids Strangers to come amongst them; but if any such be found, the onely Penalty is, That he must dwell there, and never return.*

3. See Jonathan D. Spence, "The Worlds of Marco Polo," in idem, *The Chan's Great Continent: China in Western Minds* (New York: W. W. Norton, 1998), 1–18.

4. The more than one hundred manuscript versions of Marco Polo's text, now generally known in English as *The Travels of Marco Polo,* are classified into two or three groups. The long-vanished urtext for *Il milione* (literally, "The million"—its popular title) or *Divisament dou monde* (literally, "Description of the world"—its original title) was dictated by Marco Polo in Franco-Italian to the Pisan writer of chivalric romances Rustichello (or Rusticiano) in 1298 and 1299, while they were both imprisoned in Genoa. For a sampling of editions and published excerpts, see John Lust, *Western Books on China Published up to 1850, in the Library of the School of Oriental and African Studies, University of London: A Descriptive Catalogue* (London: Bamboo, 1987), nos. 285–95.

5. Published in Charles R. Boxer, ed., *South China in the Sixteenth Century: Being the Narratives of Galeote Pereira; Fr. Gaspar da Cruz, O.P.; Fr. Martín de Rada, O.E.S.A. (1550–1575)* (London: printed for the Hakluyt Society, 1953), who indicates (p. xviii) that Cruz's work was partly based on the narrative by Galeote Pereira.

6. See Lust, *Western Books* (note 4), no. 23; and Boxer, *South China* (note 5), xviii.

7. See Lust, *Western Books* (note 4), no. 23; and David Porter, *Ideographia: The Chinese Cipher in Early Modern Europe* (Stanford: Stanford Univ. Press, 2001), 35, who cites Boxer, *South China* (note 5), xvii.

8. For a full list of the several titles and numerous editions of Ricci's letters and reports, Trigault's translation, and other publications, see Augustin de Backer and Aloys de Backer, *Bibliothèque de la Compagnie de Jésus,* ed. Carlos Sommervogel, rev. reprint ed. (Héverlé-Louvain: Éditions de la Bibliothéque S.J., 1960), 6:1792–95, 8:239–41 (no. 6); and Lust, *Western Books* (note 4), nos. 836–41. For more on Ricci, see Paola Demattè's "Christ and Confucius: Accommodating Christian and Chinese Beliefs," this volume, pp. 29–31.

9. See Samuel Purchas, *Hakluytus Posthumus; or, Purchas His Pilgrimes, Contayning a History of the World, in Sea Voyages, and Lande Travells, by Englishmen and Others* (London: printed by William Stansby for Henrie Fetherstone, 1625), vol. 3, bk. 2, chap. 7, pp. 380–411; and Matteo Ricci, *China in the Sixteenth Century: The Journals of Matthew Ricci, 1583–1610,* trans. Louis J. Gallagher (New York: Random House, [1953]).

10. See Dawn Odell, "The Soul of Transactions: Illustration and Johan Nieuhof's Travels in China," in Karel Bostoen, Elmer Kolfin, and Paul J. Smith, eds., *"Tweelinge eener dragt": Woord en beeld in de Nederlanden (1500–1750)* (Hilversum, The Netherlands: Verloren, 2001), 229; and Friederike Ulrichs, *Johan Nieuhofs Blick auf China (1655–1657): Die Kupferstiche in seinem Chinabuch und ihre Wirkung auf den Verleger Jacob van Meurs* (Wiesbaden: Harrassowitz, 2003).

11. See, for example, Daniëlle Kisluk-Grosheide, "'Cutting Up Berchems, Watteaus, and Audrans': A *Lacca Povera* Secretary at the Metropolitan Museum of Art," *Metropolitan Museum Journal* 31 (1996): 92–94, 97 n. 37; Leslie B. Grigsby, "Johan Nieuhoff's *Embassy:* An Inspiration for Relief Decoration on English Stoneware and Earthenware," *The Magazine Antiques,* January 1993, 172–83; Gudmund Boesen, "'Chinese' Rooms at Rosenborg Castle," *Connoisseur,* January 1979, 34–39; and Carl Christian Dauterman, "Dream-Pictures of Cathay: Chinoiserie on Restoration Silver," *Metropolitan Museum of Art Bulletin,* n.s., 23 (1964): 11–25.

12. Johannes Nieuhof, *An Embassy from the East-India Company of the United Provinces; to the Great Tartar Cham, Emperour of China...,* trans. John Ogilby (London: printed by John Macock for the author, 1669). This edition includes excerpts from Athanasius Kircher's book on China (see cat. nos. 2, 3, 5, 6).

13. Eighteen of the prints in this collection were adaptations of engravings by Matteo Ripa. The Bowles family also adapted prints from Chinese originals in another publication. See, for example, *The Rice Manufactury in China: From the Originals Brought from China* (London: printed for Carington

Bowles, John Bowles, & Robert Sayer, [1770]); and Richard E. Strassberg, "War and Peace: Four Intercultural Landscapes," this volume, pp. 91, 95, 96.

14. The Research Library at the Getty Research Institute holds several more *vues d'optique* based on Nieuhof's illustrations and produced in Augsburg and Paris. These include views of a triumphal arch on a street in Canton (2005.PR.82*), the city of Nanxiong (2005.PR.83*, 93.R.118), the Porcelain Tower at Nanjing (2005.PR.84*), and a lake and village in Vietnam (2005.PR.81*). See also Frances Terpak, "Vues d'optique," in Barbara M. Stafford and Frances Terpak, *Devices of Wonder: From the World in a Box to Images on a Screen,* exh. cat. (Los Angeles: Getty Research Institute, 2001), 344–54.

15. Kisluk-Grosheide, "'Cutting Up Berchems'" (note 11), 81–97, esp. 92–94. Ostensibly a manual on lacquerware, John Stalker's *A Treatise of Japaning and Varnishing* (Oxford: printed for the author, 1668) has crude versions of prints by Nieuhof (pls. 7, 18, 19, 21), among others.

16. The privilege is dated 14 November 1664 in the Latin edition published in 1667, 19 January 1665 in the Dutch edition of 1668.

17. On cabinets of curiosities, see Barbara M. Stafford and Frances Terpak, *Devices of Wonder: From the World in a Box to Images on a Screen,* exh. cat. (Los Angeles: Getty Research Institute, 2001), 6–20, 148–57; see also p. 18, where the analogous treasure boxes of the Qianlong emperor are mentioned.

18. See Ying Sun, *Wandlungen des europäischen Chinabildes in illustrierten Reiseberichten des 17. und 18. Jahrhunderts* (Frankfurt am Main: Peter Lang, 1996).

19. Charissa Bremer-David, "Six Tapestries from *L'histoire de l'empereur de la Chine,*" in idem, *French Tapestries and Textiles in the J. Paul Getty Museum* (Los Angeles: J. Paul Getty Museum, 1997), 80–97; and Edith A. Standen, "The Story of the Emperor of China: A Beauvais Tapestry Series," *Metropolitan Museum Journal* 11 (1976): 103–17.

20. Martino Martini, *Novus Atlas Sinensis: Tavole,* ed. Riccardo Scartezzini, Giuliano Bertuccioli, and Federico Masini (Trento: Centro Studi Martino Martini, Università degli Studi di Trento, 2003); and David E. Mungello, *Curious Land: Jesuit Accommodation and the Origins of Sinology* (Honolulu: Univ. of Hawaii Press, 1989), 116–17.

21. Montanus, *Atlas Chinensis* (note 2), 89.

22. Odile Faliu, "Bernard Picart, Dessinateur et graveur (1673–1733)," in idem, *Cérémonies et coutumes religieuses de tous les peuples du monde, dessinées par Bernard Picart* (Paris: Heuscher, 1988), 9–14.

23. For example, Picart's *Matzou* (after p. 222) embroiders on the image of the same idol in Dapper (pt. 1, after p. 44), and Picart's view of a funeral procession (see this volume, fig. 60) is loosely based on the image *Lyckstaetsie der groten, The Station and Cerimonies Used at the Funeralls of Great Persons* that appears, in reverse, in Dapper (pt. 1, after p. 421). Likewise, Picart's portraits of various sorts of Chinese clerics (after p. 226) elaborate on Nieuhof's originals (see pp. 53, 55 ff.).

24. William Alexander, *The Costume of China* (London: William Miller, 1805); Mason, *The Costume of China* (1800) (cat. no. 12); Mason, *The Punishments of China* (1801) (cat. no. 13); and Breton, *China: Its Costume, Arts, Manufactures, etc.* (1812) (cat. no. 14). See Lust, *Western Books* (note 4), nos. 1118, 712, 1243.

25. For instance, Joseph-Marie Amiot, *Art militaire des Chinois; ou, Recueil d'anciens traités sur la guerre . . .* (Paris: chez Didot l'aine, [1772]); Joseph-Marie Amiot, *De la musique des Chinois, tant anciens que modernes* ([Paris: Stoupe, 1779]); and Jean-Denis Attiret, *A Particular Account of the Emperor of China's Gardens near Pekin . . . ,* trans. Harry Beaumont (London: printed for R. Dodsley, 1752).

26. Pierre-Martial Cibot published prose translations of fourteen Chinese poems in volume 13 (1788) of the *Mémoires concernant l'histoire, les sciences, les arts, les moeurs, les usages, etc. des Chinois; par les missionnaires de Pe-kin* (Paris: Nyon, 1776–1814), and volume 11 (1786) carried an advertisement as well as four translations of "Poésies chinoises" by Madame du Boccage; William Hatchett's unperformed *The Chinese Orphan: A Historical Tragedy* (1741) was adapted from texts in Du Halde's *Description* (including the Jesuit Joseph Henri-Marie de Prémare's French translation, titled *L'orphelin de la maison de Tchao,* of a thirteenth-century Chinese play attributed to Ji Junxiang); and Voltaire's *Orphelin de la Chine* (1755) was translated from the French by Arthur Murphy and performed as *The Orphan of China* in 1759 at the Theatre Royal in Drury Lane, London. For other works, see Lust, *Western Books* (note 4), nos. 1107, 1109, 1110, 1116.

27. The Getty Research Institute's copy of *De la philosophie des Chinois* is bound in contemporary paper covers with Denis Diderot's *Traité du beau* (Amsterdam: [n.p.], 1772).

28. Madeleine Pinault Sørensen, "La fabrique de l'*Encyclopédie,*" in *Tous les savoirs du monde: Encyclopédies et bibliothèques, de Sumer au XXIe siècle,* exh. cat. (Paris: Flammarion, 1996), 395. Sørensen references Jean Adhémar, "Les illustrations," in Andrea Calzolari and Sylvie Delassus, eds., *Essais et notes sur l'Encyclopédie de Diderot et d'Alembert* (Milan: F. M. Ricci, 1979), 21–33.

29. Pinault Sørensen, "La fabrique" (note 28), 395.

30. Jian-jun Li, "*Lettres édifiantes et curieuses* de China: De l'édification à la propagande" (Ph.D. diss., Harvard University, 1990).

31. Mungello, *Curious Land* (note 20), 116–17.

32. Henri Cordier, "Du Halde, et d'Anville (Cartes de la Chine)," in *Recueil de mémoires orientaux: Textes traductions publiés par les professeurs de l'école à l'occasion du XIVe Congrès international des orientalistes, réuni à Alger, avril 1905* (Paris: Impr. Nationale,

1905), 391–92; and Song Liming, "An Evaluation of the Chinese Maps in the Possession of the Società Geografica Italiana," in Claudio Cerreti, ed., *Carte di Riso: Far Eastern Cartography with a Complete Catalogue of the Collection of Chinese and Japanese Maps Owned by the Società Geografica Italiana* (Rome: Società Geografica Italiana, 2003), 101–2. The missionaries involved in the survey were the Jesuits Joachim Bouvet (1656–1730), Jean-Baptiste Régis (1664–1738), Pierre Jartoux (1669–1720), Ehrenbert-Xavier Fridelli (1673–1743), François-Jean Cardoso (1676–1723), Pierre-Vincent de Tartre (1669–1724), Joseph-Marie-Anne de Moyria de Mailla (1669–1748), and Romain Hinderer (1669–1744) and an Augustinian by the name of Bonjour (n.d.).

33. Original versions of the maps are held by the Bibliothèque nationale de France; see Cordier, "Du Halde" (note 32), 399.

34. A reader in Paris recommends it to English friends in the November 1735 issue of *Gentleman's Magazine:* "You also know the Book written by Father le Comte, a Missionary *Jesuit* in *China,* which however it may be valued for its Entertainment, ought not to be esteemed as a regular Account, so compleat and exact as *Pere du Halde's,* who, tho' he never was in *China,* has for a great number of Years been compiling his History from a prodigious Variety of Memoirs sent to him from that very Country" (p. 668). *Gentleman's Magazine* also summarized the contents of the English translation; see *Gentleman's Magazine,* June 1742, 320–23; July 1742, 353–57; September 1742, 485–86.

35. Lust, *Western Books* (note 4), no. 96; and Henri Cordier, *Bibliotheca Sinica: Dictionnaire bibliographique des ouvrages relatifs à l'Empire chinois,* 2nd ed. (Paris: E. Guilmoto, 1904–8; reprint, New York: B. Franklin, 1968), 1:54–56.

36. See Jacques Silvestre de Sacy, with Michel Antoine, *Henri Bertin dans le sillage de la Chine (1720–1792)* (Paris: Éditions Cathasia, 1970), 158–70.

37. "Préface," *Mémoires concernant l'histoire, les sciences, les arts, les moeurs, les usages, etc. des Chinois; par les missionaires de Pe-kin* 1 (1776): i–vi.

38. George Leonard Staunton, *An Authentic Account of an Embassy from the King of Great Britain to the Emperor of China . . .* (London: printed by W. Blumer & Co. for G. Nicol, 1797), 1:17.

39. Alexander, *Costume of China* (note 24); William Alexander, *Picturesque Representations of the Dress and Manners of the Chinese* (London: printed for John Murray by W. Bulmer, 1814); Aeneas Anderson, *A Narrative of the British Embassy to China, in the Years 1792, 1793, and 1794; containing the Various Circumstances of the Embassy, with Accounts of Customs and Manners of the Chinese; and a Description of the Country, Towns, Cities, etc. etc.* (London: printed for J. Debrett, 1795); Staunton, *Authentic Account* (note 38); and John Barrow, *Travels in China: Containing Descriptions, Observations, and Comparisons, Made and Collected in the Course of a Short Residence at the Imperial Palace of Yuen-Min-Yuen, and on a Subsequent Journey through the Country from Pekin to Canton* (London: printed by A. Strahan for T. Cadell & W. Davies, 1804) (cf. cat. no. 10).

40. Alexander's *Costume of China* (note 24) was issued in many editions in the early nineteenth century. Barrow's *Travels in China* (note 39) is illustrated with prints after Alexander's sketches. See also William Alexander and George Henry Mason, *Views of Eighteenth-Century China: Costumes, History, Customs* (London: Studio Editions, 1988)—a recent facsimile edition that intersperses prints from Alexander's and Mason's books on costumes.

41. Craig Clunas, *Chinese Export Watercolours* (London: Victoria & Albert Museum, 1984), esp. 7, 33–42, 76.

42. This phrase is the title of plate 11 in *The Emperor of China's Palace at Pekin, and His Principal Gardens* (1753) (cat. no. 31).

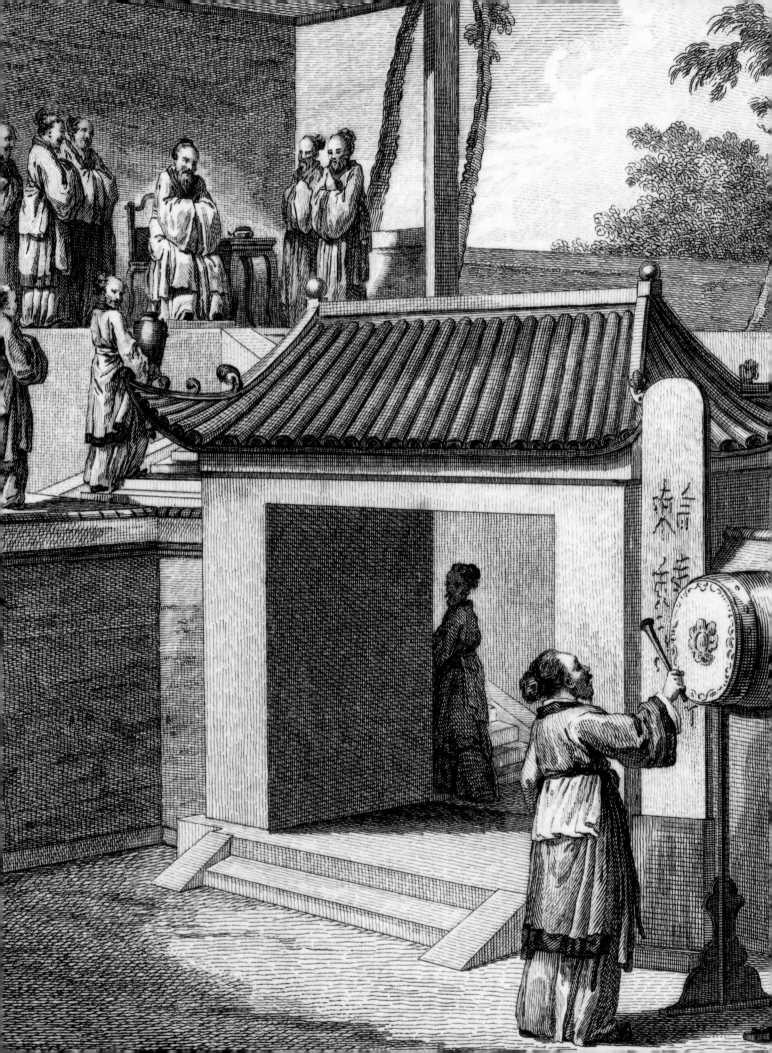

Christ and Confucius: Accommodating Christian and Chinese Beliefs

Paola Demattè

Among the diverse regions they set out to proselytize, the Jesuits had from the beginning of their history a strong interest in China. Shortly after Ignatius de Loyola established the Society of Jesus in 1539, a gifted member of this new order, Francis Xavier, set out for the East, traveling to India, Southeast Asia, and Japan and getting within sight of the Chinese empire.[1] Though Xavier never reached mainland China, by 1575 the first Chinese Catholic diocese was established in Macau, a Portuguese trading colony on China's southern coast. From then on, Macau served as Catholic Christianity's gateway into China, and it was the place where the Jesuit mission in China took shape.

Initially, Jesuits sent to Macau to Christianize the Chinese population disregarded local culture and required converts to conform to European customs. This approach yielded few converts and did not gain the missionaries greater access to the empire or its people. The situation altered after Alessandro Valignano was appointed visitor of the Jesuit order's missions in the Far East in 1574. Arriving in Macau in 1578, he soon instituted the requirement that Jesuits in Macau learn Chinese and adapt to native ways as much as possible. The first to implement this policy of accommodation was the Italian Michele Ruggieri, who came to Macau in 1580 and in a year learned enough Chinese to communicate, eventually receiving permission from Chinese officials to spend time in Canton and earning the esteem of the educated Chinese he encountered during his trips there.[2]

Another Italian Jesuit, Matteo Ricci, would refine this approach. Reaching Macau in 1582, he quickly understood that intellectual sophistication was key in converting the educated elites, who were the Jesuits' primary intended audience in China as elsewhere. Through his exchanges with members of the elite in southern China, Ricci developed a genuine interest in Chinese civilization, immersing himself in its culture and etiquette as well as gaining the respect and friendship of several scholars. Responding to his Chinese contacts' interest in science and mechanical novelties, Ricci began to expound European scientific knowledge and to display exotic objects such as mechanical clocks and glass prisms. As a result of the Jesuits' adaptive approach, Ricci and other priests eventually obtained permission to leave the Portuguese enclave of Macau to reside in mainland China—a right granted to few Europeans at the time.[3]

Detail of FIGURE 73

GOD AND HEAVEN As part of their new policy of accommodation, Ricci and his confreres donned Chinese dress. Initially, they assumed the robes of the Buddhist clergy, whom the Jesuits regarded as similar to themselves in social standing and avocation. They later realized, however, that Confucian scholars, not Buddhist monks, were the educated elite of China, and they accordingly transformed themselves into Confucian literati, both in their dress and by presenting their mission in terms of the prevailing national ideology of China.

Studies of Jesuit accommodation to Chinese culture emphasize that the missionaries felt closer in spirit to "Confucianism" (or, as it is known in China, the "School of the Scholars," or *Rujia*) than to Taoism or Buddhism and for that reason decided to adapt this teaching to Christianity, and vice versa.[4] In fact, the Jesuits were allying themselves not simply with the School of the Scholars but with the larger Chinese ideological system underpinning the state and the family, which ultimately transcended "Confucianism" to encompass elements of the most ancient Chinese belief system such as Heaven (*Tian*) or the God on High (*Shangdi*) and veneration of family ancestors. Therefore, the "Confucianism" that the Jesuits adapted extended beyond the teachings of Confucius and his diverse followers to the overall socially conservative and paternalistic moral philosophy with politico-religious overtones that had shaped the ruling bureaucracy of China since the early imperial period. "Confucianism" in the strict sense was also regarded by some Jesuits in China much like the pre-Christian classical philosophy that was adapted in the medieval Scholastic synthesis—as a teaching that foreshadowed the Christian revelation.[5]

Given the importance of this state ideology in Chinese society, its endorsement by Ricci and its identification as a moral teaching consistent with the values of Christianity were fundamental steps in the history of the mission. This move allowed Ricci and his followers to facilitate conversion by accommodating Catholicism to Chinese mores and the Chinese state's politico-religious ideology to the Catholic Church's doctrines. Already by Ricci's time, the missionaries were aware that imperial power and the sciences of heaven and earth were symbolically tied within the traditional Chinese system of belief. Central to this ideology, with its cosmic and agricultural concerns and focus on family relations, was the view of Heaven (*Tian*) and Earth (*Di*) as a familial dyad (Heaven, the Father; Earth, the Mother) ruling the cosmos and granting the emperor (considered the "Pivot of Heaven," or Polaris, and known as the "Son of Heaven" [*Tianzi*]) his legitimacy.

An initial step in the accommodation was the effort to construe the Chinese concepts of *Shangdi* and *Tian* as prefigurations of the revealed God, thus relying on these terms for the translation of his name. This particular attempt at accommodation was not well received in China (or in Europe), so the translation was shifted to *Tianzhu,* "Lord of Heaven." The new term, apparently suggested by a Chinese convert,[6] was used for the first time by Ruggieri in his *Tianzhu shicheng* (The Ten Commandments of the Lord of Heaven, 1583/84). Still, many Jesuits, including Ricci, continued to use *Tian* and *Shangdi*. In his *Tianzhu shiyi* (The true meaning of the Lord of Heaven, 1603), a debate between two scholars—one Western and the other Chinese—on Christian and Chinese teachings, Ricci concluded that while Taoism and Buddhism are idolatry, Confucianism shares fundamental principles with Christianity, such as the original belief in one deity.[7] The ambiguous use of the term *Tian* likewise appears time and again in early Jesuit publications in Chinese—for example, in the *Tianxue chuhan* (First collection of the learn-

ing from heaven, 1626), edited by the convert Li Zhizao, which contains both scientific and Christian material.[8] The linguistic vagueness attendant on using *Tian* for both the Christian God and the Chinese Heaven also played a part in the interaction between the Jesuits and the Chinese emperor. In *Confucius Sinarum Philosophus* (1687) (cat. no. 17), one of the most famous Jesuit texts on Confucianism, the missionaries reported that when the Kangxi emperor visited their church in Beijing in 1675, he gave them a piece of calligraphy with the inscription "Jing Tian" (Revere Heaven)—an equivocal injunction whose object could be either the Chinese Heaven or the Christian Heavenly Father. On this occasion and others, the Jesuits were criticized for their willingness to blur essential theological points for the sake of accommodating important Chinese beliefs. Eventually, their critics succeeded in prohibiting the use of such loaded terms.

Nonetheless, though taboo, the terms *Tian* and *Shangdi* continued to be used in China by both missionaries and converts. In 1723, Joseph Henri-Marie de Prémare wrote to the Jesuit general Michelangelo Tamburini, "we should stick to the method of the venerable Father Ricci" who had explained to the Chinese from the beginning of the mission that "the true God... was exactly the same as the *Tian* and *Shangdi* they knew from their own old books."[9] The Jesuits' accommodative policy on Chinese terms (especially the name of God) and rites of veneration (especially the ancestor and state ceremonies that the Jesuits generally tolerated as civil and social acts) was opposed by other missionaries in China and even by some dissenting Jesuits. Each side argued its position in letters and learned publications, and advocates traveled between China and Rome to defend one or the other side of the question. This ecclesiastical debate, known as the "rites and terms controversy," culminated with Pope Clement XI's decree banning ancestral rites among Chinese converts, which helped undermine the Jesuit mission in China.[10]

JESUIT TEXTUAL AND VISUAL PRODUCTION Early Jesuit texts and images in Chinese and European publications dealing with religious and philosophical issues provide ample evidence of the cultural dialogue promoted by the mission's policy of accommodation. The effort was two-sided: European works introduced Western concepts adapted to a Chinese worldview, and Chinese works were transformed to appeal to Europeans. Nonetheless, the audiences for these productions were fairly limited: other than a modicum of Christian instructional material aimed at the less-educated Chinese masses, most Jesuit publications were intended for the upper classes, whether Chinese or European. Their adaptation to European or Chinese taste was both visual and intellectual, as the works illustrated in this volume reveal. Philosophical or historical arguments were not simply translated as faithfully as possible. They were recast and reframed within an established discourse, be it that of seventeenth- and eighteenth-century Europe or late Ming and early Qing China. Likewise, images were reworked to align with local aesthetic conventions yet maintain the basic iconography of the original. This method of adaptation facilitated the transmission of ideas across the cultural divide, because the revised figures and arguments, rather than looking foreign, appeared as extensions of something familiar.

The texts and images produced as part of this philosophical and religious exchange were created by the collaborative and cumulative efforts of Jesuits in China, Chinese converts and artists, and European scholars and illustrators in contact with the missionaries. They ranged from religious instruction and devotional texts to works of science, philosophy, history, and hagiography. Their content, language, and presentation

depended on the intended audience, which was largely envisioned as the literate upper classes: Christian texts translated into vernacular or simple classical Chinese were prepared for catechumens; Western philosophical and scientific texts written in classical Chinese were designed for literati; Chinese philosophical texts published in Latin or French were aimed at European intellectuals; and illustrated books depicting China and its people—usually with short narrative captions (mostly in French)—were assembled to delight aristocratic European collectors.

CHRISTIAN TEXTS FOR CHINA An early example of the accommodation of European religious and philosophical ideas to a Chinese audience is a late Ming publication that contains two Catholic texts, *Tianzhu shengjiao qimeng* ([ca. 1619–23]) (cat. no. 15) and *Song nianzhu guicheng* ([ca. 1619–23]) (cat. no. 16). Both works are attributed to João da Rocha, a Portuguese Jesuit who arrived in China in 1598 and died there in 1623, but are often associated with another Portuguese Jesuit, Gaspar Ferreira, who was in China between 1604 and 1649.

The *Tianzhu shengjiao qimeng* is a Chinese version of *Doutrina Christâa ordenada a maneira de dialogo para ensinar os meninos* (Christian doctrine in dialogue form for the instruction of the young, 1566), or *Cartilha,* a Portuguese catechism popular with Jesuit missionaries.[11] Twelve of the Chinese text's thirteen chapters are close translations of the Portuguese original, while one was crafted specifically for the Chinese edition to address the concept of the soul. This was an essential issue for the missionaries, since Chinese and Christian beliefs on this matter differed significantly.[12] Traditionally, the Chinese believed in the duality of the soul, which was thought to have an earthly (*po*) and a heavenly (*hun*) component. This concept, which is allied with yin-yang dualism and the related idea of self-creation (without the intervention of an external God), were at odds with the view of the God-given soul put forth by the Jesuits. Likewise, the Jesuits found the Buddhist theory of retribution and reincarnation very problematic. Its contention that actions carried out during one's life determined the higher or lower status of one's next incarnation was based on the concept (unacceptable for the missionaries) of the soul's transmigration between different living forms, including between humans and animals.[13] The Jesuits found equally disturbing the neo-Confucian belief that humans have the same basic nature and substance as all things in the universe, rather than humans being of an essentially different order. None of this accorded with the fundamental Christian belief in an immortal soul created by God and unique to each human.

The *Tianzhu shengjiao qimeng*'s thirteenth chapter, which takes the form of a dialogue between a master and a pupil, therefore addressed local beliefs and presented what the Jesuits considered the correct view on the human soul: what it was, what it was not, whence it came, and where it went after death. It opens with this exchange (see fig. 68):

> Master: How many souls does a person have?
> Pupil: Only one. It is the rational soul.
> M: Where does this soul come from?
> P: It is made by God.
> M: What did God use to make it?
> P: God is all powerful. He creates the souls one by one out of no matter.
> M: When does God create a person's soul?
> P: God grants a soul to a body when it is created.

M: Where is the soul given to a person?

P: In utero, forty days after conception if it is a boy, and eighty days after conception if it is a girl.

M: Does the human soul survive after death?

P: The human soul is immortal. . . .

M: Where does it go after death?

P: Those of the good ascend to heaven to enjoy eternal bliss, those of the evil descend to hell to suffer eternal damnation.

Further on, the author approaches the issue of reincarnation by having the master ask: "Can the human soul change into an animal or transfer from a male to a female body?" The pupil's reply, that each person has a unique soul, sets in motion a discussion of the theory of three souls drawn from Aristotle's treatise *De anima* (On the soul).[14] When asked whether animals and plants have souls, the pupil explains that they do but that their souls (the *anima sensitiva* of animals and the *anima vegetativa* of plants) are fundamentally different from the immortal and God-given *anima rationalis* of humans. Overall, it is clear that this chapter of the *Tianzhu shengjiao qimeng* was written not only to challenge specific beliefs such as the duality of the soul and Buddhist transmigration, which the Jesuits could not accept, but also to introduce fundamental European philosophical concepts that could be used to engage a Chinese intellectual in dialogue.

In contrast to the unillustrated *Tianzhu shengjiao qimeng,* the second part of the volume, the rosary book *Song nianzhu guicheng,* is visually oriented (see figs. 12, 69). Its brief opening dialogue on Catholic rosary practice is followed by fifteen short chapters, each accompanied by an image of one of the mysteries of the lives of the Virgin Mary and Jesus along with instructions for prayer and meditation. The rosary, an intense devotional practice that had developed in late medieval Europe, consisted of the daily recitation of fifteen decades of Hail Marys and an Our Father between each decade, with each decade devoted to pious meditation on one of the mysteries. Rosary books accordingly featured texts and figures to guide and focus the meditative process.[15] Meditation and spiritual exercises were central to Jesuit religiosity and were envisioned as a contemplative dialogue between the believer and Christ that should rouse the soul to a life of religious coherence. Since images could play an important part in this process of inner transformation, the Society of Jesus was generally supportive of religious instruction supplemented by visual aids.[16] Moreover, such practices were not alien to the Chinese. The use of images for meditation and the process of prayer recitation had counterparts in Chinese religions, particularly Buddhism. For instance, Amidism (Pure Land Buddhism), a form of East Asian Buddhism popular in China, required extended prayer as well as visualization exercises in front of elaborate Buddhist iconography to help the devotee bring into view the Buddhist Pure Land paradise.[17]

The images in *Song nianzhu guicheng* are Chinese woodcuts adapted from the *Evangelicae Historiae Imagines* (Illustrations of the Gospel stories, 1593), a set of engravings for Jerónimo Nadal's *Adnotationes et Meditationes in Evangelia* (Notes and meditations on the Gospels, 1594), in which they appeared, alongside comments on the Gospel passages used during Mass, in the order of readings used in the liturgical year.[18] Nadal's work was popular in its time due, in part, to the excellence of its engraved illustrations,[19] and archival records indicate both that the Jesuit mission in China had requested it from Rome and that several copies were received.[20] Aware of the attraction luxury editions

FIGURE 12
Annunciation, ca. 1619–23,
woodcut, 21.6 × 12.1 cm
(8½ × 4¾ in.)
From [João da Rocha], *Song
nianzhu guicheng* ([Nanjing:
Society of Jesus, ca. 1619–23]),
3b

FIGURE 13
Hieronymus Wierix (Flemish,
1553–1619), after Bernardino
Passeri (Italian, ca. 1540–96),
Annunciatio, 1593, engraving,
22.9 × 14.1 cm (9 × 5½ in.)
From Jerónimo Nadal,
*Evangelicae Historiae Imagines
ex Ordine Evangeliorum, quae
Toto Anno in Missae Sacrificio
Recitantur, in Ordinem Temporis
Vitae Christi Digestae* (Antwerp:
[Society of Jesus], 1593), pl. 1

A. *Conuentus Angelorum, vbi declarat Deus*
 Incarnationem Chrísti, & designatur
 Gabriel legatus.
B. *Veniens Nazareth Gabriel, sibi ex aëre*
 corpus accommodat.
C. *Nubes è cælo, vnde radij ad Mariam*
 Virginem pertinent.
D. *Cubiculum, quod visitur Laureti in agro*
 Piceno, vbi est Maria.

E. *Ingreditur Angelus ad Mariam Virgi-*
 nem; eam salutat; assentitur Maria:
 fit Deus homo, & ipsa Mater Dei.
F. *Creatio hominis, quo die Deus factus est homo.*
G. *Eadem die Chrístus moritur, vt homo*
 perditus recreetur.
H. *Pie credi potest, Angelum missum in*
 Limbum, ad Chrísti incarnationem
 Patribus nunciandam.

and compelling images had for the educated classes, the Jesuits were eager not only to use Nadal's work for religious ends but also to show off the artistic skill of the West as seen in the techniques of copperplate engraving and linear perspective.

While their European origin is evident, the fifteen images in the *Song nianzhu guicheng* are a Chinese interpretation of Christian iconography. In some of the prints, European architecture or dress is preserved but most of the figures, buildings, landscapes, and visual conventions are steeped in the flourishing Ming tradition of book illustration with touches from Buddhist hagiography. Some images are so changed that their source is hardly recognizable. The illustration of the Annunciation provides a case in point (figs. 12, 13), as it takes on the appearance of a classic scene in the women's quarters of an upper-class Ming household. The Virgin Mary kneels inside a traditional Chinese timber structure with latticed windows. Both the Holy Ghost descending in the form of a dove and the archangel Gabriel presenting Mary with a lily float on auspicious clouds executed in a style associated with the apparition of Taoist or Buddhist holies. The furniture is that of a typical Chinese elite house: behind Mary is a screen painted with a bare landscape in the style of the fourteenth-century painter Ni Zan. And just outside the house, behind the auspicious clouds, is a garden with rocks and a banana tree. Other representations, such as the Agony in the Garden of Gethsemane, retain the basic compositional structure of the original in the *Evangelicae Historiae Imagines* while changing almost all the stylistic aspects. The image of the Crucifixion (see fig. 69) is based on Nadal's print (no. 129) but introduces elements such as the horseman from the image of the death of Jesus on the cross (no. 130), strips out elements such as the two criminals crucified with Jesus, and adds a Chinese-style landscape setting.

CHINESE HISTORY AND PHILOSOPHY
FOR EUROPEAN SCHOLARS

A parallel example of accommodation but one designed for a European audience is *Confucius Sinarum Philosophus* (cat. no. 17). This volume translates three of the *Sishu* (Four Books), a collection of Confucian classics edited by the twelfth-century philosopher Zhu Xi, whose reinterpretation of the Confucian tradition dominated Chinese institutions and intellectual life in late imperial China. The four Jesuit editors of *Confucius Sinarum Philosophus*—Prospero Intorcetta, Christian Herdtricht, François de Rougemont, and Philippe Couplet—supplemented the translations with materials meant to inform and educate their European readers: an extended introduction, notes and commentaries, a brief life of Confucius, a comparative chronology of Christian and Chinese history, a map of China, and a genealogical table. As in many other Jesuit publications, the translations themselves were the result of a cumulative effort. Classic Chinese texts had been used as language primers for incoming missionaries since Ricci's era, and consequently the translations had been subject to modification and correction for nearly a century.[21]

By 1687, the Jesuits were engulfed in the rites and terms controversy that was to doom their enterprise in the next century. With *Confucius Sinarum Philosophus*, they attempted to create a view of Confucianism acceptable to their European readers and sponsors. To this end, in the *Proemialis Declaratio* (Introductory exposition), Philippe Couplet dismissed Taoism and Buddhism, which he saw as religions competing with Christianity, and hailed Confucianism as a teaching compatible with Christianity. Still, the Jesuits' acceptance of Confucianism was not complete and unproblematic: the missionaries struggled particularly with the advocates of neo-Confucianism (called

"neoterics" by the Jesuits), a metaphysical and potentially atheistic tradition that had informed Confucianism since the Song dynasty.[22] The Jesuits saw neo-Confucianism as a deviation from the original Confucian tradition that could undermine their efforts to present *Tian* or *Shangdi* as ancient monotheistic concepts germane to Christianity.

Nonetheless, the Jesuits were influenced by the theories of Zhu Xi and other neo-Confucians, which the missionaries absorbed mostly through the works of the Ming official Zhang Juzheng. In the 1570s, Zhang (called "Cham Colai" by the Jesuits) was grand secretary and imperial tutor to the Wanli emperor, who had ascended to the throne as a nine year old. Among the simplified classical Chinese texts that Zhang wrote for the young emperor's instruction was *Sishu zhijie* (Explications of the Four Books, late 1500s), a commentary that the Jesuits cited approvingly in *Confucius Sinarum Philosophus,* and an illustrated book of imperial examples, the *Dijian tushuo* (Illustrated discussion of the emperor's mirror, 1573) (cf. cat. no. 20). Written in a simple classical style, Zhang's interpretative text was stylistically attractive to the Jesuits, who, as foreigners and linguistic pioneers, had difficulty mastering classical Chinese. However, language was not the only reason the Jesuits adopted the work of Zhang Juzheng. While he followed Zhu Xi, Zhang was critical of many aspects of Ming neo-Confucianism. In his writings, he advocated not only a return to the older Confucian tradition but also an emphasis on the practical aspects of government, a position that was perceived as a form of domesticated Legalism, the harsh authoritarian philosophy of reward and punishment enacted in the third century B.C. by the First Emperor of Qin.[23] Zhang's interest in the actualities of government and his reticence on metaphysical issues helped the Jesuits in China to successfully navigate the space between faith and experience. In China, they could argue that European science had a role to play in supporting good government and the Chinese order, while in Europe, they could present this form of Confucianism as a civil doctrine that was no threat to Christianity.

Confucius Sinarum Philosophus contains two important prints: a portrait of Confucius (fig. 14), and a map of the Chinese empire (see fig. 70). The portrait, which was often reproduced in later publications,[24] shows the philosopher standing imposingly before a structure that combines elements of a Chinese temple and a European library. In keeping with Chinese iconographical tradition, Confucius is bearded, wears a lotus-bud headdress and a long flowing robe, and holds a tablet. The pediment-like roof element is embellished with dragons and the Chinese characters *guo xue* (imperial academy) along with an old romanization (*qǔě hiǒ*) and the Latin translation *Gymnasium Imperii.*[25] The interior terminates with an arch opening to a garden; six characters that identify the figure as "Zhongni, the first teacher of the empire" are inscribed on the back inside wall.[26] Below the image, a narrative caption summarizes the philosopher's accomplishments and influence.[27]

As a teacher, Confucius is represented within a library-shrine, but this interior setting is related not to any actual Chinese structure but to sixteenth- and seventeenth-century European prints representing cabinets of curiosities, libraries (fig. 15), or theater stages. This connection is made clear by the use of perspective and by the setup of the space. Nonetheless, the lower shelves display, instead of curios, ancestral tablets for eighteen illustrious followers of Confucius. The volumes on the upper shelves are bound in the European manner but they bear the names, in clumsy Chinese characters and romanization, of the Five Classics (*Wujing*) and Four Books (*Sishu*) of Confucianism, along with the Great Appendix (*Ta chuan*) to the *Yijing* (Book of changes; also known as

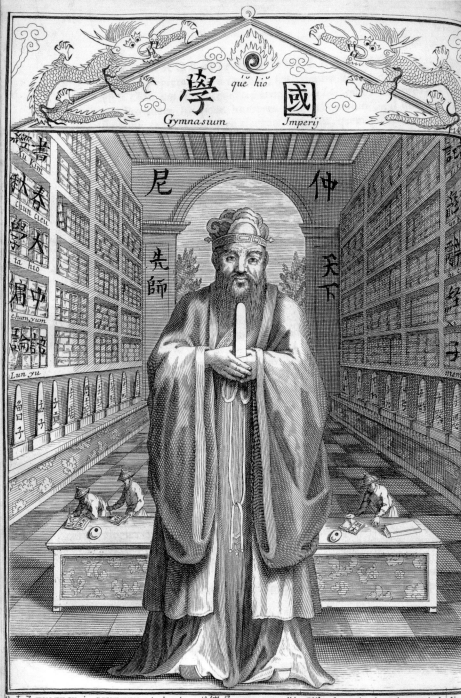

FIGURE 14
Cum Fu Çu sive Confucius
(Kong fu zi or Confucius),
1687, engraving, 32.1 × 21.3 cm
(12⅝ × 8⅜ in.)
From Prospero Intorcetta et
al., trans. and ed., *Confucius
Sinarum Philosophus; sive,
Scientia Sinensis Latine
Exposita*... (Paris: apud
Danielem Horthemels, 1687),
116

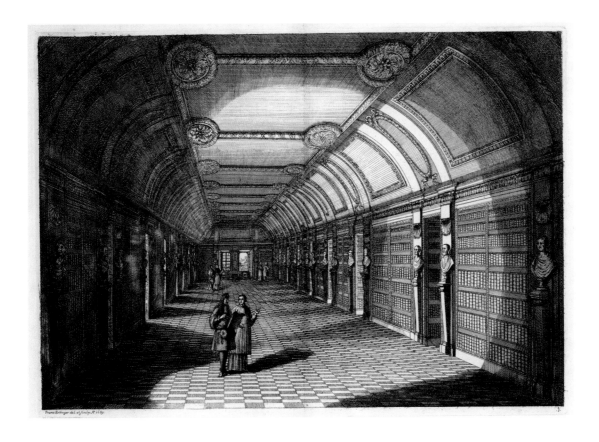

CONFUCIUS.

De la feule Raifon falutaire interprête,
Sans éblouir le Monde éclairant les efprits,
Il ne parla qu'en Sage, et jamais en Prophête:
Cependant on le crut, et même en fon pays.
VOLTAIRE,

FIGURE 15
Franz Ertinger (German, 1640–ca. 1710), *La bibliotéque en perspective* (Perspective view of the library), 1689, etching, 30.8 × 43.6 cm (12⅛ × 17⅛ in.) From Claude du Molinet, *Le cabinet de la Bibliotheque de Sainte Genevieve: Divisé en deux parties: Contenant les antiquitez de la réligion des chrétiens, des Egyptiens, et des Romains*...(Paris: Antoine Dezallier, 1692), pl. 1

FIGURE 16
Isidore-Stanislaus-Henri Helman (French, 1743–ca. 1809), *Confucius,* ca. 1785, engraving and etching, page: 26.9 × 18.4 cm (10⅝ × 7¼ in.) From Isidore-Stanislaus-Henri Helman and Joseph-Marie Amiot, *Abrégé historique des principaux traits de la vie de Confucius*...(Paris: l'auteur & M. Ponce, [1788?]), pl. 1

the *I-ching*).[28] A certain disjuncture is apparent between the European-style background and the figure of the philosopher. There is little relationship of scale between the two: Confucius looms large in the foreground, while the scholars practicing calligraphy in the background are tiny. This implies that the large figure is not the man Confucius but a statue of the sage within his temple. While it is plain that the figure of the sage derives from a Chinese prototype, it is not clear from what Chinese source the Jesuits derived this image, because no extant statues correlate to this likeness. The statue of Confucius in his temple at Qufu, his birthplace, shows him seated on a throne, a portrayal that the Jesuits used on other occasions (fig. 16), and two-dimensional images such as paintings or prints traditionally represent the sage in three-quarter rather than frontal view.[29] It is possible, however, that the Jesuits used as a source a statue of the philosopher that is now lost.[30]

During their years of activity in China, the Jesuits published several other Chinese classics for European readers. One of their most important translations was that of the *Shujing* (Book of history), one of the Five Classics of antiquity.[31] This text was rendered into French by Antoine Gaubil, an accomplished Jesuit sinologist who worked in Beijing from 1722 until his death in 1759. Gaubil's preoccupation with the *Shujing* was reflected in letters he wrote from China. He mentioned his translation repeatedly, explaining that he was working on it or about to send it, and later worrying that it was not getting published.[32] Indeed, though Gaubil sent several manuscripts to France for publication as early as 1739, he never saw his work printed. Joseph de Guignes, a French orientalist to whom Gaubil had sent the manuscript, eventually published it in Paris in 1770 as *Le Chou king, un des livres sacrés des Chinois, qui renferme les fondements de leur ancienne histoire, les principes de leur gouvernement et de leur morale* (cat. no. 18).

Gaubil's interest in the *Shujing* stemmed from his engagement with issues of comparative historical chronology that related to astronomy. Some sections of the *Shujing* mention astronomical phenomena (eclipses, planetary conjunctions, comets), providing absolute dates for Chinese historical events, which could be correlated with Western records of a similar kind to link the Chinese and the biblical chronology. Since 1650, Europeans had increasingly accepted the new, Vulgate-based dating of Creation to 4004 B.C., placing the Flood that destroyed everyone save for Noah and his companions in the mid-third millennium B.C.[33] Records from China posed problems for this chronology, because the Chinese traditionally placed their earliest kings some six hundred years before the supposed date of the biblical Flood without registering an interruption in China's historical development.[34] Some Jesuit scholars tried to rationalize the discrepancies by rejecting the earliest Chinese records as myths.[35] Rather than dismissing the Chinese sources, Gaubil thought there were problems with the calculation of the biblical chronology and suggested that it should be lengthened. Indeed, the Jesuits requested and received permission to employ the less-fashionable Septuagint-based dating of Creation to about 5200 B.C. and the Flood to about 2957 B.C.[36] This Jesuit debate on chronology was part of a larger eighteenth-century European intellectual dispute over the origins of humanity and the place of biblical accounts between humanists and biblical literalists.[37]

In addition to the translated text, *Le Chou king* contains sections by other Jesuits and by de Guignes. De Guignes, who tried to appropriate Gaubil's work by indicating that he had revised the manuscript and added missing information, may be responsible for the presence of four engraved plates normally absent from Chinese editions. These images derive from Chinese ritual texts and represent ceremonial implements, diagrams, and

garments used in official state rites.[38] Plate 4 (see fig. 71) of *Le Chou king* shows several well-known and ritually significant patterns related to cosmology and astronomical phenomena, including the eight trigrams of the *Yijing* (at bottom right of fig. 71) and the *Hetu* (Yellow River pictures; at top right) and *Luoshu* (Luo River writing; at top left) tablets. The trigrams are abstract representations of basic manifestations of nature with different active (*yang*) and passive (*yin*) energies, while the tablets are presumed to be symbolic and numerological diagrams that may also record idealized positions of stars in relation to earth. Objects and texts with a similar focus on ritual cosmography were popular in late imperial China. The use of celestial phenomena as decorative elements was common in imperial and religious iconography, particularly on official robes and ritual paraphernalia. A series of especially ornamental examples appear in the so-called *Kangxi dengtu* (late 1700s–early 1800s) (cat. no. 19), an album of twenty-two lantern designs, probably created for imperial use during the reign of the Kangxi or the Qianlong emperor, that feature multicolored suns, moons, constellations, and Buddhist symbols (see fig. 72).

CHINESE ILLUSTRATED ALBUMS FOR
EUROPEAN ARISTOCRATS

In addition to drawing on Zhang Juzheng's commentaries on the Four Books for *Confucius Sinarum Philosophus,* a century later the Jesuits were involved in the French edition of his *Dijian tushuo*. Conceived as an illustrated primer on the morality of history for Zhang's ten-year-old charge, the Wanli emperor, the *Dijian tushuo* portrayed eighty-one good deeds by emperors for the young ruler to emulate and thirty-six bad imperial actions for him to avoid. The exemplars entail demonstrating filial piety, supporting education, listening to upright ministers, promoting the welfare of the people, and avoiding self-indulgence. The cautionary tales show rulers shirking their responsibilities, relying on unworthy favorites, spending lavishly for their own gratification, or overindulging in Buddhism.[39] Presented to the European audience in abridged form under the title *Faits mémorables des empereurs de la Chine, tirés des annales chinoises* (1788) (cat. no. 20), the French version consisted of twenty-four prints engraved by Helman and their accompanying narrative captions.

In Ming and Qing China, the *Dijian tushuo* was a popular work, with at least three different publishers issuing copies only months after its initial publication at court. The French version resulted from the Qianlong emperor's request for an edition with Western-style illustrations. The images were redrawn by the Jesuit painter Jean-Denis Attiret and his drawings sent to France for engraving and printing. The copperplates and the prints produced under the supervision of Charles-Nicolas Cochin II were supposedly reserved for the Chinese emperor, but the French minister Henri-Léonard-Jean-Baptiste Bertin was able to obtain drawings or prints for his collection. These copies were the basis for the reduced prints of the *Faits mémorables,* which focused on examples and behaviors to which the European public could relate.[40] The didactic scope of the *Dijian tushuo* is lost in this French version, but its content appealed to Western curiosity about Chinese history and the values it advocated encouraged eighteenth-century Europe's perception of China's enlightened, self-regulating government.

An example of good behavior features the legendary emperor Yao, who placed a writing tablet and a drum outside his palace and asked his subjects to record their concerns and then pound the instrument to receive attention (see fig. 73). An example of bad behavior points to the debauched last emperor of the Shang dynasty, Zhouxin, and

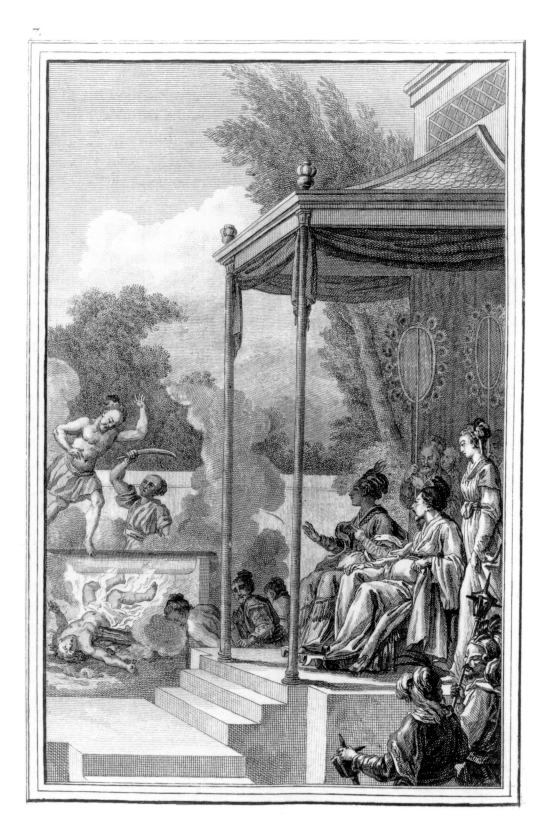

FIGURE 17
Isidore-Stanislaus-Henri
Helman (French, 1743–ca.
1809), after Jean-Denis Attiret
(French, 1702–68), **Zhouxin
and Danji,** 1788, engraving
and etching, 26.4 × 18.1 cm
(10⅜ × 7⅛ in.)
From Isidore-Stanislaus-Henri
Helman, *Faits mémorables des
empereurs de la Chine, tirés des
annales chinoises...* (Paris:
l'auteur & M. Ponce, 1788),
pl. 7

FIGURE 18
Danji haizheng (Danji harms
government), 1573, woodcut,
each half: 19.5 × 14.4 cm
(7⅝ × 5⅝ in.)
From Zhang Juzheng, *Dijian
tushuo* ([China: n.p., 1573]),
vol. 9, sec. 2, fol. 7a–b

his evil concubine, Danji. Seated at Danji's side, the emperor watches as she orders prisoners to walk on a rotating log set over a fire, a torture she devised as entertainment (figs. 17, 18). The *Dijian tushuo,* informed by Confucian gynophobia, blames Zhouxin's complacency on the wiles of a wicked woman, and the French version follows suit. Both the Chinese and the French text explain that the emperor had been a good man but Danji's nefarious influence had turned him into a hated despot whose actions eventually led to his death and the end of his dynasty. This was a standard warning to Chinese emperors, who with their extensive harems were prone to lose interest in government affairs. The appearance of such misogynistic tales in the French edition is somewhat curious, however, given that Helman dedicated it to Marie Joséphine Louise de Savoie, or "Madame," the intellectually inclined and bookish sister-in-law of Louis XVI (fig. 19). Published in Paris just a year before the French Revolution, perhaps the volume was meant as a veiled criticism not only of Louis XVI's policies but also of his wife, Marie-Antoinette, whom Marie Joséphine, like the revolutionaries, disliked for her political meddling. Interestingly, the French print shows Danji dressed like a European aristocrat and sporting a peacock feather in her exotic headdress.

Similar in style to the *Faits mémorables* is the *Abrégé historique des principaux traits de la vie de Confucius, célèbre philosophe chinois* ([1788?]) (cat. no. 21), a collection of twenty-four engravings by Helman based on the fifteenth-century illustrated biography of Confucius known as *Shengji tu* (Illustrated traces of the sage).[41] According to the title page of the *Abrégé historique,* the original drawings were sent from Beijing by the Jesuit missionary Joseph-Marie Amiot to Bertin, the collector who was also involved in the production of the *Faits mémorables.* The Jesuits may well have been attracted not only by the popularity of the *Shengji tu* in eighteenth-century China but also by its hagiographic character, which presented the life of Confucius in much the same way as European publications described the lives of Christian saints or the mysteries of Jesus. In the *Shengji tu,* miraculous signs precede and follow the philosopher's birth, and the child Confucius engages in precocious ritual activities. In adult life, the philosopher struggles to reform China's rulers, supports the ritual system, and encounters misfortunes, and, in death, he is mourned.

Several images deal with matters relating to the birth of Confucius, which, like the birth of Jesus, is presented as miraculous and foreshadowed by propitious signs. In what could be seen as a parallel to the Annunciation, Lady Yan, Confucius's mother, strolling in her garden, is approached by a *qilin* (Chinese unicorn) who brings her a jade tablet with the following inscription: "Un enfant pur comme le crystal naitra sur le declin de le Tcheou, il sera Roi mais sans aucun Domaine" (A baby pure as crystal will be born at the decline of the Zhou dynasty; he will be king without a kingdom). This inscription and the rest of the caption are patterned closely on the Chinese model, but some aspects of the image are departures from Chinese tradition. While Chinese images typically show Lady Yan standing with a servant or two in front of the garden pavilion of a house compound, in the French version she is strolling by a stream in a vast open garden (figs. 20, 21). The waterway, arched bridge, picturesque trees, distant pavilions, and hazy mountains in the French version compose the Chinese garden according to the European imagination, while in the foreground Confucius's mother and her servant look like eighteenth-century pastoral figures somewhat frightened by the appearance of the dragonlike *qilin.* As in the Chinese-style depiction of the Annunciation in da Rocha's rosary book, this image has been transformed to suit the expectations of a new

À Madame.

Madame,

La protection éclairée que vous accordez aux Arts, m'a enhardi à vous présenter cet hommage tiré des Annales du plus ancien Peuple de l'Univers. La bonté avec laquelle vous avez daigné l'accepter, est pour moi, Madame, le plus honorable et le plus flatteur des encouragemens. Permettez moi de mettre a vos pieds mes faibles talens et mon eternelle reconnaissance.

Je suis avec le plus profond respect,

Madame,

Votre très humble et très Obéissant Serviteur

Helman.

麒麟玉書
孔子未生有麒麟吐
玉書於鄹大夫家其
文曰水精子繼衰周
而為素王顏母異之
以繡綴繫麟角信宿
而去

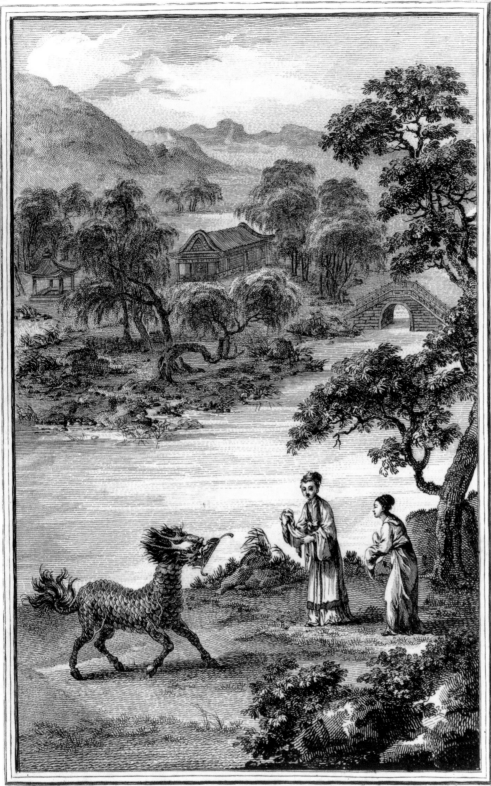

Helman, Sculp.

FIGURE 20
Qilin yushu (The qilin's jade
tablet), 1592, woodcut, page:
34.5 × 57 cm (13⅝ × 22½ in.)
From *Shengji tu: 1 juan*
([China]: He Chuguang,
Kong Hongfu, 1592), pl. 3

FIGURE 21
Isidore-Stanislaus-Henri
Helman (French, 1743–ca.
1809), **Qilin delivers the jade
tablet to Confucius's mother,**
ca. 1785, engraving and
etching, page: 26.9 × 18.4 cm
(10⅝ × 7¼ in.)
From Isidore-Stanislaus-Henri
Helman and Joseph-Marie
Amiot, *Abrégé historique des
principaux traits de la vie de
Confucius*...(Paris: l'auteur &
M. Ponce, [1788?]), pl. 2

audience. Europeans imagined all Chinese gardens to be like those of the Chinese emperor as depicted in French and English publications promoting the fashion of the "Oriental" garden;[42] they had no acquaintance with the smaller gardens at the houses of the gentry that were typically represented in popular publications such as the *Shengji tu.* Europeans were also used to the representation of upper-class women in pastoral settings, but Chinese viewers were not: in Ming and Qing China, upper-class women had bound feet and were not supposed to wander around the countryside. Chinese readers knew the *qilin* as an auspicious animal to be encountered happily, while Europeans saw it as a dragon: the somewhat defensive postures of Lady Yan and her maid in the French print thus contrast with the Chinese original, in which Confucius's mother gladly extends her hands to take the tablet.

Toward the end of the *Abrégé historique,* there is a print of the now-aged philosopher receiving celestial approval from the high god Shangdi for having reorganized the Six Classics (*Liujing:* the extant Five Classics plus the *Yuejing* [Book of music]) (see fig. 74). Like the *Shengji tu,* the French image depicts the ceremonial and astronomical dimensions of native Chinese religion: Confucius kneels in front of an altar set with the six volumes and ritual vessels, and a ray of light descends from the Big Dipper as a sign of Shangdi's appreciation. Images such as this reinforced the idea put forth by the Jesuits that Confucianism and Christianity shared a belief in a high celestial god. It also recalls the close connection existing between Chinese religious ideology and the fields of astronomy and calendrics, which played central roles in the Jesuits' conversion activities in China.

CONCLUSION The process of cultural adaptation documented in these printed works continued up to 1773, when Clement XIV suppressed the Society of Jesus and the Jesuits lost control over the Catholic mission to China.[43] Then, as now, adaptation of beliefs and visual expressions during cultural encounters was not exceptional. What is remarkable is that in the climate of European expansionism during the sixteenth, seventeenth, and eighteenth centuries the Jesuits generally approached the Chinese as the equals of Europeans, both in the discourse they framed for European audiences and by their behavior in China. Though there were dissenters from this approach in their ranks, and though European perceptions of China generally became more negative over time, the Jesuits continued to profess a respect for Chinese culture that was rarely displayed by Europeans confronted by alien ways. It is possible that the Jesuits' esteem for the Chinese was sincere or that they were simply seduced by Chinese culture, but it is more likely that they believed in the efficacy of their accommodationist approach. Indeed, as foreign residents in China and interlocutors with the elites, they had few viable options. Moreover, the missionaries could justify their service to the pagan ruler of a distant country to their fellow Europeans only if that country was as powerful and as civilized as Europe. Their approach led to an intellectual and visual production that proposed China and Europe as mirror civilizations: mutually distant and exotic but with common moral values and equally long histories. In this context, if the pictures of Christ and the Virgin Mary could Christianize the literati of China, those of Confucius and his mother could secularize the scholars of Europe.

Notes

1. David Mitchell, *The Jesuits: A History* (London: Macdonald, 1980), 78–85.

2. Ruggieri was ostracized by other missionaries in Macau for his study of Chinese; see George H. Dunne, *Generation of Giants: The Story of the Jesuits in China in the Last Decades of the Ming Dynasty* (Notre Dame: Univ. of Notre Dame Press, 1962), 18–21.

3. On the early Jesuit mission and Matteo Ricci, see Pasquale M. D'Elia, *Fonti Ricciane: Documenti originali concernenti Matteo Ricci e la storia delle prime relazioni tra l'Europa e la Cina (1579–1615),* 3 vols. (Rome: Libreria dello Stato, 1942–49); Matteo Ricci, *De Christiana Expeditione apud Sinas…,* trans. Nicholas Trigault (Leiden: H. Cardon, 1616); and Matteo Ricci, *Opere storiche del P. Matteo Ricci, S.J.,* ed. Pietro Tacchi Venturi, 2 vols. (Macerata: Giorgetti, 1911–13).

4. The term *Confucianism* lacks an exact counterpart in China. It was the Jesuits who created the name Confucius and shaped the idea of Confucianism. In China, Confucius (551–479 B.C.) is known as Kongzi (Master Kong) or, rarely, as Kongfuzi, a form that was Latinized by the Jesuits as Confucius. See Paul A. Rule, *K'ung-tzu or Confucius? The Jesuit Interpretation of Confucianism* (Boston: Allen & Unwin, 1986).

5. See Prospero Intorcetta, Christian Herdtricht, François de Rougemont, and Philippe Couplet, trans. and ed., *Confucius Sinarum Philosophus; sive, Scientia Sinensis Latine Esposita* (Paris: apud Danielem Horthemels, 1687), lxxxxix.

6. See Rule, *K'ung-tzu or Confucius?* (note 4), 8:

 The origin of the use of this term is ascribed in Ricci's memoirs to one of the first converts "Cim Nicò" (Ch'en?), who during Ruggieri's absence from Chao-ch'ing [Zhaoqing] in mid-1583 had looked after the missionaries' altar. "When at the time of our return we went to visit him, we found that he had placed the altar in a little room in his house, and, having no other image, had written on a tablet in the middle of the wall, two huge Chinese letters that said 'to the Lord of Heaven.'"

7. Matteo Ricci, *True Meaning of the Lord of Heaven (T'ien-chu Shih-i),* ed. Edward J. Malatesta, trans. Douglas Lancashire and Peter Hu Guozhen (Taipei: Institut Ricci, 1985).

8. See Paola Demattè, "From Astronomy to Heaven: Jesuit Science and the Conversion of China," this volume, pp. 55–56.

9. Knud Lundabaek, "Joseph Prémare and the Name of God in China," in David E. Mungello, ed., *The Chinese Rites Controversy: Its History and Meaning* (Nettetal, Germany: Steyler, 1994), 137.

10. On the rites and terms controversy, which began in earnest after Ricci's death in 1610 and lasted nearly a century, see David E. Mungello, *The Chinese Rites Controversy: Its History and Meaning* (Nettetal, Germany: Steyler, 1994).

11. There were versions of the *Cartilha* in other languages, such as Kikongo. See François Bontinck and D. Ndembe Nsasi, *Le catéchisme kikongo de 1624* (Brussels: Académie Royale des Sciences d'Outre-Mer, 1978).

12. Erik Zürcher, "Key Theological Issues," in Nicolas Standaert, ed., *Handbook of Christianity in China* (Leiden: Brill, 2001), 1:632–52.

13. Strictly speaking, Buddhism does not support the idea of a soul.

14. In 1624, Francesco Sambiasi and Xu Guangqi published a version of *De anima* based on the Coimbra commentary on Aristotle's text as *Lingyan lishao* (Humble attempt at discussing matters pertaining to the soul). This text was not very close to Aristotle's original work, but it introduced its basic ideas. Later the *Lingyan lishao* was included in the *Tianxue chuhan* (First collection of the learning from Heaven, 1626), edited by the convert Li Zhizao. See Nicolas Standaert and Adrian Dudink, "Apostolate through Books," in Nicolas Standaert, ed., *Handbook of Christianity in China* (Leiden: Brill, 2001), 1:606–7. On *De anima,* see Vincent Shen, "From Aristotle's *De Anima* to Xia Dachang's *Xingshuo,*" *Journal of Chinese Philosophy* 32 (2005): 575–96.

15. See Anne Winston-Allen, *Stories of the Rose: The Making of the Rosary in the Middle Ages* (University Park: Pennsylvania State Univ. Press, 1997), esp. 13–30.

16. Visual instruction was tightly controlled, however, and often the emphasis was on nonvisual forms. See Pierre-Antoine Fabre, *Ignace de Loyola: Le lieu de l'image: Le problème de la composition de lieu dans les pratiques spirituelles et artistiques jésuites de la seconde moitié du XVIe siècle* (Paris: Librairie Philosophique J. Vrin, 1992); Pierre-Antoine Fabre, "Les *Exercices spirituels:* Sont-ils illustrables?" in Luce Giard and Louis de Vaucelles, eds., *Les jésuites à l'âge baroque (1540–1640)* (Grenoble: J. Millon, 1996), 197–209; and Elisabetta Corsi, "'Dar a otro modo y orden' (EE2,1): Wu Li's Education in Christian Visuality" (paper presented at the Macau Ricci Institute symposium "Culture, Art, Religion: Wu Li [1632–1718] and His Inner Journey," Pousada de Mongha, Macau, China, 27 November 2003).

17. Wu Hung, "Reborn in Paradise: A Case Study of Dunhuang *Sutra* Painting and Its Religious, Ritual, and Artistic Context," *Orientations* 23 (1992): 52–60.

18. The *Adnotationes et Meditationes in Evangelia* consists of 153 chapters relating to the 153 annotated engravings in *Evangelicae Historiae Imagines.* The texts and images illustrate and explain the lives of Jesus and Mary and are meant to guide the worshipper in meditation and spiritual exercises.

19. Nino Benti, introduction to Jerónimo Nadal, *Immagini di storia evangelica: Riproduzione intergrale*

in facsimile dell'originale, Anversa MDXCIII, didascalie di A. Vivaldi, Roma MDXCIX, ed. Nino Benti (Bergamo: Edizioni Monumenta Bergomensia, 1976), 5–29; Thomas Buser, "Jerome Nadal and Early Jesuit Art in Rome," *Art Bulletin* 58 (1976): 424–33; and Albert Chan, *Chinese Books and Documents in the Jesuit Archives in Rome: A Descriptive Catalogue, Japonica-Sinica I–IV* (Armonk, N.Y.: M. E. Sharpe, 2002), 112. Nadal selected the biblical scenes to be included, commissioned and directed the layout of the illustrations, and composed notes to accompany each scene. With the cooperation and support of the Antwerp publishers Christophe Plantin and Martinus Nutius, 153 engravings were eventually produced by six engravers (Hieronymus, Johan, and Anton Wierx; Adriean and Jan Collaert; and Karl van Mallery) after originals attributed variously to Bernardino Passeri, Maarten de Vos, and Hieronymus or Anton Wierix.

20. Niccolò Longobardi asked for a copy in 1598. By 1605, Ricci had acknowledged receipt of a volume of Nadal's work for the southern residences and requested another for the Beijing mission. See Pasquale M. D'Elia, *Le origini dell'arte cristiana cinese (1583–1640)* (Rome: Reale Accademia d'Italia, 1939), 79–81.

21. David E. Mungello, *Curious Land: Jesuit Accommodation and the Origins of Sinology* (Honolulu: Univ. of Hawaii Press, 1989), chap. 8; and Lionel M. Jensen, *Manufacturing Confucianism: Chinese Traditions and Universal Civilization* (Durham: Duke Univ. Press, 1997), chap. 2.

22. Neo-Confucianism is an expression of the Confucian tradition that emerged in the Song period as a result of influences from Chan Buddhism and Taoism. Unlike traditional Confucianism, it had a distinct metaphysical dimension. It flourished into the Ming period but came under increasing criticism during the Qing dynasty. Its various schools of thought are known in China by different names, the most notable being the *Lixue* (learning of principle) of the Song period philosopher Zhu Xi and the *Xinxue* (learning of the mind-and-heart) of the Ming period thinker Wang Yangming.

23. Robert Crawford, "Chang Chu-cheng's Confucian Legalism," in William Theodore de Bary, ed., *Self and Society in Ming Thought* (New York: Columbia Univ. Press, 1970), 367–413.

24. A modified version of this image appears in Jean-Baptiste Du Halde, *Description géographique, historique, chronologique, politique, et physique de l'empire de la Chine, et de la Tartarie chinoise...* (Paris: P. G. Lemercier, 1735), 2:325.

25. *Guo xue* can be translated as national or imperial academy, and *gymnasium imperii* as school or academy of the empire. See also Mungello, *Curious Land* (note 21), 272.

26. Zhongni was Confucius's first name; his last name was Kong. Mungello translates the phrase as

"Zhongni, preeminent teacher of the world"; see Mungello, *Curious Land* (note 21), 272.

27. This caption reads (translation by Michele Ciaccio):

Cum Fu Çu, or Confucius, who is also called by the courtesy name Zhongni; foremost of the Chinese philosophers; he was born in the town Qufu in the province of Shandong, he had a father, Shuliang He, the superintendent of the district of Zou, and a mother called Chim [Yan?], from an exceptionally noble family. He was born in the twenty-first year of the ruler Lingwang (who was the twenty-third ruler from the third imperial house Zhou), in 551 B.C. He had three thousand students, of whom seventy-two were remarkable; and of these, ten most select, whose names, written on their tablets, were displayed in the academy of the emperor. Having abandoned the reform of his times and leaders after ineffectual attempts and efforts, he died at age seventy-three in the forty-ninth year of the twenty-fifth ruler Jingwang. His lineage has continued by uninterrupted succession, to this year 1687. From which the grandson [who] in the sixty-eighth generation with the title of duke [*yansheng gong*] resides in the place of Confucius's birth reckons 2,238 years.

28. On the left are, from the top, *Shujing* (Book of history), *Chunqiu* (Spring and autumn annals), *Daxue* (Great learning), *Zhongyong* (Doctrine of the mean), *Lunyu* (Analects). On the right are *Liji* (Rituals), *Yijing* (Book of changes), *Xici* (Appended remarks [on the *Yijing*]), *Shijing* (Book of odes), *Mengzi* (Mencius).

29. Julia K. Murray, "Portraits of Confucius: Icons and Iconoclasm," *Oriental Art* 47, no. 3 (2001): 17–28.

30. With the Ming reforms of 1530, Confucian temples were prohibited from displaying the image of the sage. Only Confucius's ancestral shrine in Qufu had his likeness; the other temples in China had tablets inscribed with his name. See Julia K. Murray, "Illustrations of the Life of Confucius: Their Evolution, Functions, and Significance in Late Ming China," *Artibus Asiae* 57 (1997): 73–129.

31. In addition to the *Shujing*, the Five Classics comprise the *Yijing* (Book of changes), *Shijing* (Book of odes), *Liji* (Rituals), and *Chunqiu* (Spring and autumn annals).

32. See, for example, Antoine Gaubil to Michel-Ange-André Le Roux Deshauterayes, 17 November 1754; published in Antoine Gaubil, *Correspondance de Pékin, 1722–1759*, ed. Renée Simon (Geneva: Librairie Droz, 1970), 794–95 (no. 305).

33. Various dates were proposed, including 2347, 2349, 2366, and 2535 B.C. See Jean-Pierre Duteil, *Le mandat du ciel: Le rôle des jésuites en Chine, de la mort de François-Xavier à la dissolution de la Compagnie de Jésus (1552–1774)* (Paris: AP Éditions Arguments,

1994), 305; and Mungello, *Curious Land* (note 21), 103, 127.

34. Chinese history has its own record of the flood, which is set at the time of the mythical hero Yu of the Xia dynasty. The dates for this legendary dynasty are now thought to be circa 1950 to 1600 B.C., but in the seventeenth century, the Chinese literati would have put its start some two hundred years earlier; see Mungello, *Curious Land* (note 21), 103 (citing Gabriel de Magalhães's *Nouvelle relation de la Chine: Contenant la description des particularitéz les plus considerables de ce grand empire; composée en l'année 1668,* trans. Claude Bernou [1688]). The Chinese dating of the flood was therefore not so different from the Vulgate dating. But the aftermath was different: in the Bible, humanity was almost completely destroyed, and Noah's descendants repopulated the earth; according to the Chinese, Yu controlled the raging waters, and his people continued to live in the land with no outside influx of population and no break in the historical record.

35. The so-called figurists saw ancient Chinese historical events, figures, and texts as symbols deriving from biblical texts. See Claudia von Collani, "Figurism," in Nicolas Standaert, ed., *Handbook of Christianity in China* (Leiden: Brill, 2001), 1:668–79.

36. See Mungello, *Curious Land* (note 21), 127; and Antoine Gaubil, *Traité de la chronologie chinoise* (Paris: Treuttel & Würtz, 1814), 283–85.

37. Duteil, *Le mandat du ciel* (note 33), 305–11.

38. De Guignes may have obtained these images from Chinese ritual texts sent to France or from other Jesuit works on China.

39. Julia K. Murray, "From Textbook to Testimonial: *The Emperor's Mirror, an Illustrated Discussion* (*Di jian tu shuo / Teikan zusetsu*) in China and Japan," *Ars Orientalis* 31 (2001): 65–101.

40. Henry Cohen, *Guide de l'amateur de livres à gravures du XVIIIe siècle,* ed. Seymour de Ricci, 6th ed., 2 vols. (Paris: Librairie A. Rouquette, 1912), s.v. "Helman."

41. Murray, "Illustrations of the Life" (note 30), 77.

42. See Richard Strassberg, "War and Peace: Four Intercultural Landscapes," this volume, pp. 121–32.

43. Following pressure on Clement XIV from various European rulers (especially those of Spain, Portugal, France, and Austria), the Society of Jesus was suppressed with the brief *Dominus ac Redemptor,* dated 8 June 1773. The order was reestablished in 1814 by Pius VII with the bull *Sollecitudo Omnium Ecclesiarum.*

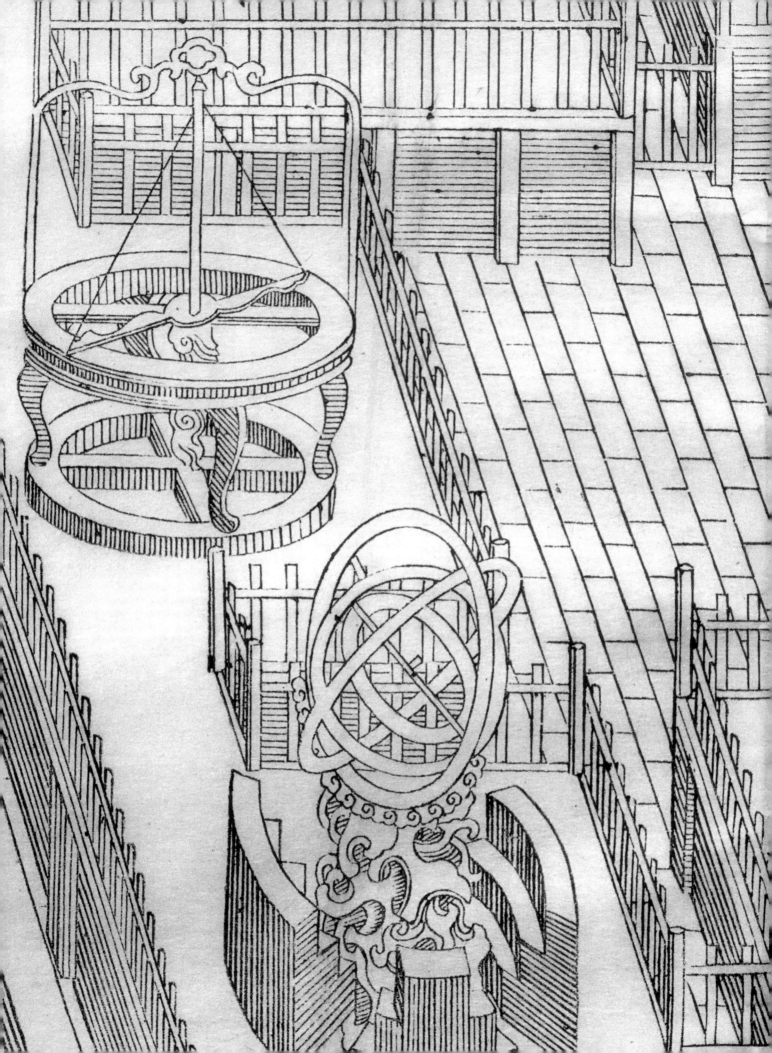

From Astronomy to Heaven: Jesuit Science and the Conversion of China

Paola Demattè

RELIGION, COSMOLOGY, AND SCIENCE The central role played by the concept of a supreme power, Tian (Heaven), in the traditional Chinese belief system allowed the Jesuit missionaries in China to liken this entity to the Christian God, the Father in Heaven. This act of accommodation was primarily geared toward the Jesuits' European audience and was meant to establish that the Chinese were not "idolaters" but a people whose originally monotheistic principles were later tainted by unorthodox beliefs such as Buddhism. For their Chinese audience, the Jesuits adopted another approach. They not only likened Tian and the Christian God and framed Christianity as a movement to restore Confucianism to its pre-Buddhist purity but they also employed science (particularly astronomy and cartography) to demonstrate that Christianity was a superior teaching and that those who followed its doctrines could solve practical problems. Though at times this strategy has been portrayed as a shrewd Jesuit plan to astonish a passive Chinese counterpart with European science, evidence suggests that the situation was more complex, involving ongoing feedback between the two parties. Scientific evangelization began as a response to the overall Chinese belief system and to specific political circumstances communicated to the missionaries by Chinese friends and converts. Only later (and amid significant opposition from their colleagues) was science accepted by many Jesuits in China as a tool for religious conversion. As individuals, Jesuit scientists pursued science for essentially the same intellectual reasons as their lay European counterparts. As Mordechai Feingold has noted, their "motivations rarely involved considerations of extending by other means the religious aims of the order."[1] It is clear, however, that once the Chinese interest in European science was recognized and its potential for encouraging conversion noted, the Jesuit administration undertook to send to China the missionaries with the best scientific training.

Scientific knowledge gained the Jesuits a hearing both among Chinese scholar-officials and at the imperial court because in China sciences such as astronomy, geography, and agronomy were connected to a belief system and a state ideology in which nature played a pivotal role. Astronomy (and astrology) related to the cult of Tian, geography to that of Di (Earth), and agronomy to the pervasive agricultural cults. Tian was both the symbolic father of the emperor, who was conceptualized as the son of Heaven (*Tianzi*), and

Detail of FIGURE 76

FIGURE 22
Thomas Child (British,
1841–98), *No. 96 Covered Altar,
Temple of Heaven,* ca. 1875–85,
photograph, 19 × 23.5 cm
(7½ × 9¼ in.)

the regulatory entity that allowed a dynasty the right to rule by granting its emperors the Mandate of Heaven (*Tianming*). As the son of Heaven, the emperor was responsible for the accuracy of the calendar and the harmony of celestial movements. Both were regarded as reflecting the strength of his virtue and his mandate and as crucial for the stability of a dynasty. Failed celestial forecasts (especially of eclipses) or discrepancies between the calendar and actual astronomical events (such as solstices and equinoxes) were taken as bad omens that foreshadowed abnormal weather patterns or catastrophic natural events. Such anomalies could throw into question the legitimacy of the emperor and his dynasty.

Similarly, as the son of Heaven, the emperor was responsible for caring for Tian's feminine counterpart, Di, and the people who lived in his domains. In imperial ideology, Di was the mother to whom the emperor made yearly sacrifices so that her soil, fertilized by Heaven's rain, yielded agricultural fruits to feed the people. She was also the land of the empire, which was to be controlled, taxed, defended, and expanded by Heaven's representative on Earth. To these ends, maps and geographic knowledge were practical and symbolic tools of imperial rule.

This nature-based conception was associated with a cosmology represented symbolically in the urban plan of Beijing, the imperial capital during the Yuan, Ming, and Qing dynasties.[2] Altars dedicated to cosmic entities were located just outside the older rectangular walls of the so-called Tartar city: the Temple of Heaven (Tiantan) in the south, the Temple of Earth (Ditan) in the north, the Temple of the Sun (Ritan) in the east, and the Temple of the Moon (Yuetan) in the west.[3] The Temple of Heaven was central to the imperial ceremonies in honor of Tian that were performed regularly at solstices and

equinoxes.[4] The concern for cosmological correctness is also visible in the layout of the temples. In keeping with the Chinese cosmological tradition that saw heaven as round and earth as square, the main structures of the Temple of Heaven were circular (fig. 22), while those of the Temple of Earth, at the opposite end of the city, were square. While the Jesuits had no objection to a circular heaven, which they rationalized as the crystalline spheres of Aristotle and the Ptolemaic system, they could not accept a square earth and expressly stated in their Chinese publications that the earth was a sphere.

APPROACHING THE LITERATI: JESUIT AND CONVERT SCIENTISTS IN THE LATE MING ERA The commingling of religion and science that became the hallmark of the Jesuit mission in China was set in place by Matteo Ricci. While he was more humanist than scientist, Ricci had studied mathematics and the physical sciences at the Collegio Romano with Christopher Clavius, the foremost mathematician of the Society of Jesus and the senior astronomer on the commission that led to the Gregorian calendar reform of 1582.[5] The realization of the important role science could play in converting the Chinese came to Ricci somewhat by chance. In 1584, two years after his arrival in China, he produced a world map with annotations in Chinese that described the various countries he had visited on his way to Macau and expounded the sphericity of the earth, a concept not accepted in China. Given the climate of intellectual ferment in late Ming China, the map attracted the attention of the literati, who had never seen its like, and it was eventually reproduced in Ming-era publications such as Zhang Huang's *Tushu bian* (Compendium of illustrated texts, 1613).[6] As demand for copies of his maps grew, Ricci sought additional means to engage the scholars who visited him, seeing them as a way into the Ming court. In his residence, he also displayed oil paintings, illustrated books, mechanical clocks, and astronomical instruments, and he entertained guests by explaining the principles of construction and use of the latter devices.[7] Catering to the interests of the scholarly elites of southern China proved a successful strategy for the missionaries. Xu Guangqi and Li Zhizao, two high-ranking Ming-dynasty officials who were interested in science and saw it as a means for political reform, converted to Christianity.[8]

Ricci went on to produce other world maps, culminating with the *Kunyu wanguo quantu* (Complete map of all nations of the world, 1602), an elaborate work that adhered to the Ptolemaic system and introduced Christian cosmology. This map reached the Wanli emperor, who requested copies for his own use. Ricci was waiting for this opportunity. Influenced by his understanding that the Christianization of the Roman Empire followed the conversion of the emperor Constantine, Ricci believed that the conversion of China would likewise happen from the top down with the emperor's sanction. Pleased to have an opening at court, in 1608 Ricci printed an imperial version of the world map that included additional Christian teachings.[9]

Ricci was not the only Jesuit engaged in this scientific and religious enterprise. Though trained scientists were to play a more significant role later, during the early Qing period, Jesuits with scientific expertise such as Manuel Dias the Younger, Giulio Aleni, Sabatino de Ursis, Diego de Pantoja, and Francesco Sambiasi were at work in China during the late Ming dynasty. Collaborating with local scholars, these missionaries wrote Chinese adaptations of Western works on astronomy, mathematics, geography, philosophy, and religion. Chinese converts also contributed independent works that at times blended Chinese and Western scientific concepts. Several of these early publications were

eventually included in the *Tianxue chuhan* (First collectanea of heavenly studies, 1626), one of the first major Chinese-Jesuit projects, which was edited by the convert Li Zhizao. The choice of title and the combination of science and religion make the *Tianxue chuhan* a volume that embodied the early Jesuit agenda of melding various concepts of heaven.[10] Among its nineteen treatises were religious and philosophical works such as Aleni's *Xixue fan* (Summary of Western learning, 1623), which outlined the European university curriculum, and Ricci's *Tianzhu shiyi* (The true meaning of the Lord of Heaven, 1603). Also included were scientific works such as Li Zhizao's *Hungai tongxian tushuo* (Illustrated explanations of cosmological patterns, 1607),[11] which introduced ideas on the earth's sphericity derived from Clavius's *Astrolabium* (On astrolabes, 1593), and Dias's *Tianwen lüe* (On the firmament, 1615). The latter, a discourse on the Ptolemaic heavenly spheres, theories of eclipses, and the seasons, also contained an appendix on Venus's phases, Saturn's rings, and Jupiter's moons based on the telescopic discoveries of Galileo Galilei.

World maps and astronomical publications provoked interest in Western science among the educated Chinese, who encouraged Ricci to contribute to the reform of the Chinese calendar. Though his engagement in that endeavor never materialized, Ricci paved the way for his successors. Aware of the inroads his confreres could make at the imperial court with science, Ricci pleaded with Rome to send astronomers and mathematicians, and several Jesuit scientists were sent to China after Ricci's death in 1610. Nicolas Trigault, who later published Ricci's writings, led a group that landed in Macao in 1619 carrying seven thousand books and various scientific instruments. By 1623, the three leading scientists in this party of Jesuits—the Swiss Johann Terrenz Schreck, a member of the Roman Accademia dei Lincei and a friend of Galileo; the Italian Giacomo Rho; and the German Adam Schall von Bell—were in Beijing working on the new calendar and translating Western astronomical books into Chinese.

As the Jesuits became more formally invested in their scientific activities in China, they progressively lost their freedom as independent scholars, and their scientific publications, as imperially sponsored research, no longer included explicitly Christian references. An example of the shift in content in Jesuit publications is the *Chongzhen lishu* (Calendar compendium of the Chongzhen reign, 1631–35), an encyclopedic collection documenting the first official attempt to reform the Chinese calendar using the so-called Western method.[12] It was edited by Xu Guangqi, Schreck, and Schall on orders from the Ming-dynasty Chongzhen emperor, who in 1629 had appointed Xu to the directorship of the Calendar Section and charged him and the Jesuits with the revision of the calendar. The *Chongzhen lishu* comprised twenty-two separate works and two star catalogs. Included in this collection was Schall's *Yuanjing shuo* (On the telescope, 1626), the first text in Chinese to introduce Galileo's new instrument, which had been brought to China by Trigault in 1619 and was depicted in a woodcut. The *Chongzhen lishu* not only replaced the Ptolemaic system with the Tychonic[13] but also introduced the system of ecliptic coordinates (as opposed to the Chinese equatorial coordinates), the 360° circle (versus the Chinese 365°25′ circle), and new astronomical instruments (mostly based on ecliptic rather than equatorial coordinates). Yet this work did not place this knowledge within a Christian framework—not even mentioning the theological implications of the Tychonic view, in which the planets other than the earth rotate around the sun, which in turn rotates around the earth. Ironically, this massive project came too late to benefit the ailing Ming dynasty, but the resulting calendar was adopted (albeit under a different name) by the succeeding Qing dynasty.

APPROACHING THE COURT: JESUIT SCIENTISTS
AND THE EARLY QING EMPERORS

After the fall of the Ming dynasty to the invading Manchu, who founded the Qing dynasty in 1644, the Jesuits became closely associated with the imperial Directorate of Astronomy, propagating Western science with a program of translation, publication, and research. Problems with the calendar had been acknowledged since the late Ming period, but they became more of an issue for the new Qing rulers. The Manchu realized that, as foreigners, they would have a difficult time convincing their predominantly Han Chinese subjects of the legitimacy of their rule. Thus, recalibrating the calendar was not only a practical necessity but also a culturally significant step that would place the newly established dynasty on firm symbolic ground. These political realities strengthened the Jesuits' belief that the emperor and his court could be converted if Western science and Christianity were linked: the truthfulness of the latter would be manifested through the accuracy of the former. For these reasons, Schall and Ferdinand Verbiest—who became court astronomers and enjoyed a close relationship with the Shunzhi and the Kangxi emperors, respectively—focused on astronomy and geography. In the unstable political climate of the early Qing era, these sciences, with their intimate connection to Chinese imperial ideology and ritual, were of particular interest to the Manchu emperors, and Jesuit scientific successes could influence the future of the Christian mission. However, the Jesuits' shift into state positions came at a price. Their proximity to the emperor, who was not Chinese, isolated them from the Han scholarly class who had been the focus of early Jesuit efforts beginning with Ricci, while their acceptance of official status exacerbated dissent within the ranks of the mission by those who viewed the subordination of faith to science with suspicion.[14]

Schall, who had worked for the Ming emperor, played a prominent role during the transition to Qing rule. In 1644, he was in Beijing, where he witnessed the establishment of the Manchu. Unlike the Jesuits who fled the capital with the Ming imperial family and appealed to the pope to send military aid to the failing dynasty, Schall seemed to have no qualms about serving China's new masters. He offered his services to the Qing and was appointed to the Directorate of Astronomy by Dorgon, the regent for the Shunzhi emperor. Shortly thereafter, Schall republished the *Chongzhen lishu* under the title *Xiyang xinfa lishu* (Calendrical collection according to the new Western method, 1645).[15] Schall also developed a close bond with the young Shunzhi emperor (see fig. 5), who eventually accorded the missionary an official rank. While Schall's favored position at court may have been the result of the emperor's genuine respect, politics certainly played a dominant role in the Jesuit scientist's rise: the emperor wanted an accurate calendar to secure the imperial seat he had gained in 1650, at the age of twelve, upon the death of Dorgon. The idea of Schall serving at the Chinese court caught the Western imagination, and his portrait appeared in European publications. In Kircher's *China Monumentis* (1667) (cat. no. 5), Schall, wearing the robes of a Qing astronomer-mandarin, holds compasses to a sphere with his right hand and a mariner's astrolabe in his left; a world map hangs on the back wall and various astronomical instruments surround him (see fig. 6). This portrait in turn inspired chinoiserie such as *The Astronomers* (see fig. 8), a French tapestry from the cycle *The Story of the Emperor of China* (ca. 1697–1705).[16] In the idealized Chinese setting of the tapestry, a seated European astronomer modeled on Schall also holds compasses to a celestial globe, apparently explaining a calculation to the emperor

of China, who stands talking to him. Other astronomers, attendants, and astronomical instruments surround the two.

In the years between 1644 and 1661, Schall was intent on consolidating Jesuit influence at the Directorate of Astronomy. In 1660, he called Ferdinand Verbiest (a Jesuit scientist who had arrived in China two years earlier) from Xi'an to Beijing. Once there, Verbiest began working with Schall, but the missionaries soon ran into serious opposition. After the Shunzhi emperor died unexpectedly in 1661, the regents for the young Kangxi emperor shifted their support to the Chinese and Muslim astronomers who had been marginalized by the Jesuits. Amid the factional struggles that characterized the eight years of the Oboi regency, the Jesuits were unable to sustain a leading role at the Directorate of Astronomy.[17] Worse, various memorials presented by the Chinese astrologist Yang Guangxian (1597–1669) against Western astronomy and Christianity led to Schall, Verbiest, and other Jesuits and Chinese converts being placed on trial for having provided an inauspicious date for the funeral of an imperial prince. As a result of the accusations, Schall and others were sentenced to death.[18] The sentence was later revoked for the Europeans, but the Chinese converts were executed in 1665. The Jesuits were jailed for months and then placed under house arrest for years. Badly shaken in his advanced age, Schall died in 1666, but Verbiest lived to see the young Kangxi emperor oust the regents and reinstate the missionaries at the Directorate of Astronomy in 1669. In addition to punishing Yang Guangxian for promulgating a faulty calendar, the Kangxi emperor conferred mandarin rank on Verbiest and gave him the directorship of the Calendar Section, where the Jesuit oversaw the reform of the Chinese calendar for nearly two decades.

Verbiest was a polymath, and his publications ranged from theology to science to the humanities.[19] He is best known for a Chinese world map (*Kunyu quantu,* 1674) (cf. cat. no. 26), the revised Chinese calendar, and various astronomical works in Latin and Chinese. Verbiest and other Jesuit scientists have been criticized for introducing outdated cosmological theories and astronomical instruments in China, presumably to avoid contradicting the geocentrism supported by the Catholic Church.[20] Indeed, Verbiest, who was aware of Copernicus's heliocentric theories and Galileo's telescope, continued throughout his life to adhere to the geocentric cosmological theories of the Danish astronomer Tycho Brahe and to use Tychonic instruments. Though in retrospect it is clear that Verbiest promulgated an imperfect science, his actions must be judged in the context of history. When he left Rome for China in the mid-seventeenth century, the Copernican theory was not widely accepted in Europe, and the Tychonic system was popular, particularly among Jesuit scientists.[21] It was shortly after his departure that new instrumentation and observations led to a wider acceptance of the Copernican system, propelling European astronomy to further advances. Though aware of these radical changes in instrumentation and theories, Verbiest probably could not implement them in China. Unlike his colleagues in Europe who were relatively free to pursue their research, Verbiest was working directly for the Chinese emperor on the calendar, an endeavor with profound political implications. He was subject to restrictions in his projects and had to focus on astronomical observations that were directly relevant to the calendar or to the prediction of specific phenomena such as planetary conjunctions and eclipses. From this practical point of view, it was enough for Verbiest that the Tychonic system was more accurate than the Ptolemaic system and allowed reliable predictions.[22]

POLITICAL AND RELIGIOUS PROPAGANDA:

VERBIEST'S PUBLICATIONS Three publications by Verbiest in Chinese and in Latin featured in this volume describe his accomplishments in astronomy and calendrical studies. Their contents range in genre from instructional manuals to official records and, irrespective of language, they retain a distinct propagandistic flavor, though their intended audiences were radically different. The two texts in Chinese were written for the emperor, court, and state officials, while the one in Latin addressed new recruits to the Society of Jesus and actual and potential sponsors of the China mission.

One of the rarest of Verbiest's works is the *Qinding xinli ceyan jilüe* (1669) (cat. no. 22), an eclectic compilation of Chinese documents describing the astronomical competition between the Jesuit and the Chinese and Muslim astronomers. Set up by the Kangxi emperor to determine who could produce the more precise calendar, this series of tests was held in Beijing between December 1668 and February 1669 and resulted in the reinstatement of the Jesuits at the Calendar Section after a hiatus of some eight years. Verbiest's text is both an official memoir and a partisan analysis of the political and factional scheming surrounding astronomy at the Chinese court. It was meant to cast the Jesuits' opponents in a bad light while highlighting the effectiveness of the so-called Western method (*xifa*) and associated Christian religion. The tests focused on gnomon experiments (the calculation of the length of a shadow cast by the sun at a specific time on a specific day given an arm of a sundial of a certain height) and on predictions of the exact position of planets and stars in the night sky on a given date. Twelve wood-block prints explaining the various experiments are appended at the end of the text, giving a visual dimension to the argumentation (see fig. 75). Figure 12 (fig. 23) of the *Qinding xinli ceyan jilüe* explains the newly discovered phases of Venus within a characteristically Tychonic universe, in which the planet circles the sun, which in turn rotates around the earth.

The 118 woodcut illustrations of Verbiest's *Yixiang tu* (1674) (cat. no. 23) are instructional and propagandistic images presenting a visual record of the refurbishing of the Imperial Observatory in Beijing with new bronze instruments (see figs. 24–26, 28, 76). In China, where it was printed for an audience of court officials and literati, the *Yixiang tu* was combined with the *Xinzhi lingtai yixiang zhi* (Essay on the newly constructed instruments for the observatory, 1674), which contained the textual explanations in Chinese. In Europe, the same images were given the title *Liber Organicus* and accompanied by the relevant notes, in Latin, from the *Compendium Latinum* (1671–74) (cat. no. 24).

In the *Yixiang tu,* Verbiest's choice of instruments, quest for accuracy, and focus on the Imperial Observatory indicate that he was inspired by Tycho's *Astronomiae Instauratae Mechanica* (Instruments for the restoration of astronomy, 1602), a volume that illustrated and described twenty-two of Tycho's instruments as well as his newly built observatory at Uraniborg castle on the island of Hven, near Copenhagen. Nonetheless, the *Yixiang tu* and the companion *Xinzhi lingtai yixiang zhi* are not simply translations of the *Mechanica*. Verbiest both introduced modifications to Tycho's instruments and provided thorough visual instructions for the construction of tools and instruments not discussed in the *Mechanica*. Differences and similarities in the instruments and in the conventions used to represent them are apparent when comparing, for example, Verbiest's sextant (fig. 26) with Tycho's (fig. 27): the two are similar in concept but not identical in design. Verbiest's mechanical gears (shown next to the instrument) and his use of the pulley and tackle (moved by hands emerging from clouds) were advances on Tycho's globe mount that made this instrument for ascertaining the altitude of celestial

太白伏見之圖其餘四星倣此

太白在伏見輪從東而西即從右而左有本行約一年零七個月隨行太陽左右上下因有朔望上下弦如太陰然其餘四星亦然

第十二圖

Figur. 12ª

南午

凌游

東卯 平 地心 地 酉西

子北

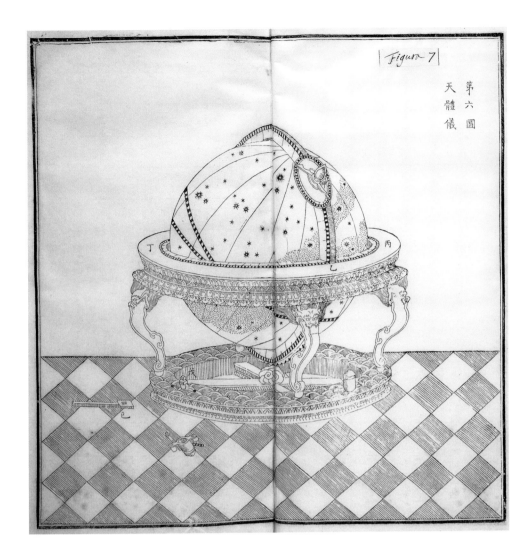

第
六
圖

天
體
儀

Figura 7

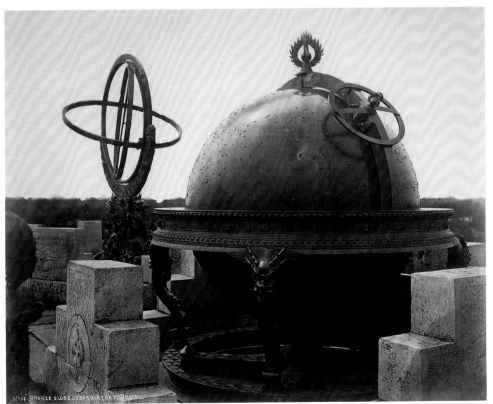

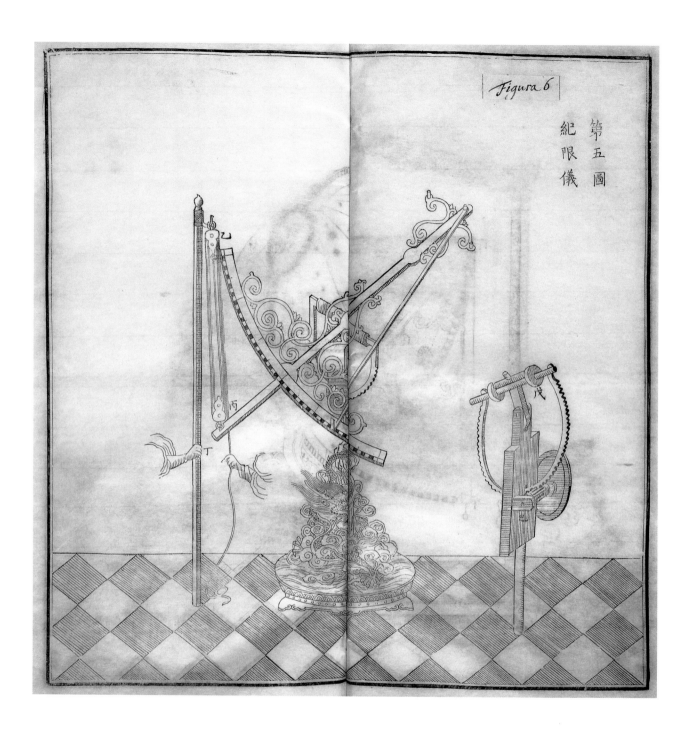

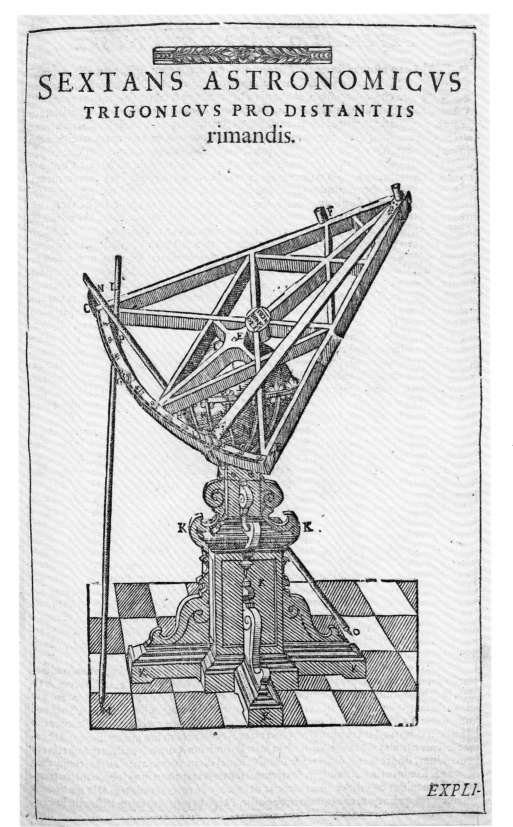

FIGURE 26

Jixian yi (Sextant), 1674, woodcut, 31.2 × 31.2 cm (12¼ × 12¼ in.) From Ferdinand Verbiest, *Yixiang tu . . .* ([Beijing: Society of Jesus, 1674]), vol. 1, fig. 5 (handwritten fig. 6)

FIGURE 27

Sextants Astronomicus Trigonicus pro Distantiis Rimandis (Triangular astronomical sextant for measuring distances), 1602, woodcut, 27.4 × 16.2 cm (10¾ × 6⅜ in.) From Tycho Brahe, *Astronomiae Instauratae Mechanica* (Nuremberg: apud Levinum Hulsium, 1602), fol. D5

objects more stable and precise.[23] Verbiest also modified the armillary spheres whose rings show the different planes of the celestial sphere as well as the paths of important celestial bodies: his had fewer rings (fig. 28) and were lighter than those used by Tycho. In addition, Verbiest's work illustrated devices (such as the horizontal azimuth, which measures the direction of a celestial object clockwise around the observer's horizon) that are not in the *Mechanica*. In general, Verbiest preferred instruments devoted to a single task, because they were more precise and stable than multiple-use apparatuses: the heavier an instrument and the more complex its setup, the more likely it was to malfunction.[24] Verbiest's instruments are sometimes described as essentially European, but their deliberate simplicity and precision may have been the result of local influence. As early as 1276, the Chinese court astronomer Guo Shoujing (1231–1316) had simplified the armillary sphere by discarding the ecliptic ring as well as the outer double rings and had constructed single-task instruments.[25] Chinese tradition accounts as well for the system of dismountable sighting tubes on Verbiest's armillary spheres[26] and for the bronze stands flamboyantly decorated with dragons, clouds, and lions—proof of the technical and artistic virtuosity of Chinese artisans—that support Verbiest's spheres, globe, quadrant, and sextant.[27]

The detail with which mounts, instruments, and manufacturing methods (fig. 29) are represented reveals the focus on visuality in the *Yixiang tu,* and its combination of Chinese format and European artistic conventions betrays its hybrid nature. The *Yixiang tu* is a Chinese illustrated technical text, a genre commonly employed in late imperial China to explicate an art or a trade by giving abundant details concerning the production processes (cf. cat. no. 27). Within this Chinese format, the images adopt some of the characteristic features of seventeenth-century European scientific illustration, such as the hands that emerge from little clouds to move mechanisms and the display of disassembled instruments next to operational ones. Meant to indicate the use and structure of the instruments, these conventions appear in the *Yixiang tu*'s representations of the celestial globe, armillary spheres, sextant, and horizontal azimuth.

Another stylistic trait of the *Yixiang tu*'s prints is the haphazard use of linear perspective and chiaroscuro shading. The perspectival distortions are very apparent when Verbiest's images are compared with those in Tycho's volume, where perspective is employed correctly in the representation of instruments, mounts, and checkerboard floors. In the *Yixiang tu*'s figures that adopt the same floor pattern as Tycho's, the checkerboard is flattened rather than receding into the distance, and the instruments are not always correctly shaded (see figs. 26, 27). These elements indicate that the woodcuts were produced by Chinese artisans not versed in the principles of European drawing after plans drawn by someone who was familiar with perspective. Most likely the latter was Verbiest himself.[28] The Archivio di Stato di Roma preserves nine unsigned handdrawn figures of astronomical instruments.[29] Due to their similarities to some of the illustrations in the *Yixiang tu* and to references to such drawings in a letter sent by Pope Innocent XI to Verbiest, they have been attributed to Verbiest.[30]

If Verbiest's scientific publications in Chinese were meant for China's educated upper classes, those in Latin addressed Europe's aristocrats and religious elites, providing information on the scientific activities of the Jesuit missionaries in China. Like Ricci before him, Verbiest stressed to Europeans that science, and astronomy in particular, offered an ideal means for the introduction of Christianity into China. The publications in Latin had two objectives: they glorified the mission in the eyes of European aristocrats, who

FIGURE 28
Huangdao yi (Armillary sphere), 1674, woodcut, 31.8 × 31.8 cm (12½ × 12½ in.) From Ferdinand Verbiest, *Yixiang tu*... ([Beijing: Society of Jesus, 1674]), vol. 1, fig. 1 (handwritten fig. 2)

FIGURE 29
Polishing a newly cast bronze ring with a donkey-powered mill, 1674, woodcut, 31.8 × 31.8 cm (12½ × 12½ in.) From Ferdinand Verbiest, *Yixiang tu*... ([Beijing: Society of Jesus, 1674]), vol. 1, fig. 36

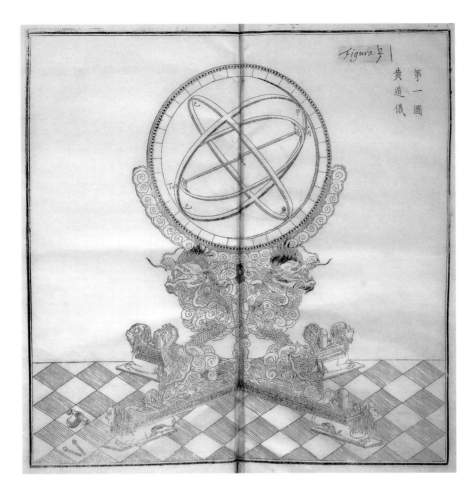

第
一
圖

黄
道
儀

Figura

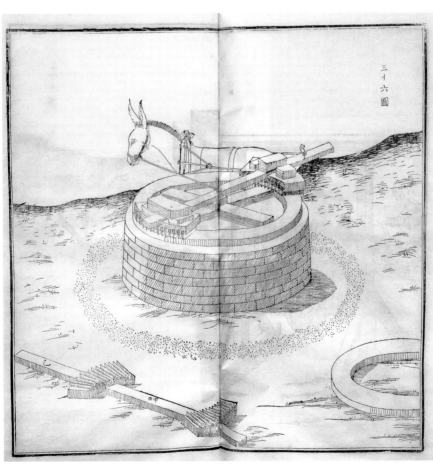

三
十
六
圖

supported it economically; and they encouraged Jesuit novices to study science in view of a future mission to China.

Verbiest's *Compendium Latinum* embodies this double promotional purpose. This pamphlet explained the illustrations of the *Qinding xinli ceyan jilüe* and *Yixiang tu* to Europeans, foreshadowing the larger propagandistic scope of Verbiest's Latin summary of his scientific accomplishments in China, the *Astronomia Europaea* (European astronomy, 1687).[31] In its preface, Verbiest extols his own achievements and his friendship with the emperor and attacks his enemies, the former head of the Directorate of Astronomy Yang Guangxian and the Muslim astronomer Wu Minghuan (fl. 1657–69):

> Here follow our astronomical observations of the years 1668 and 1669 at the Beijing observatory, which were attended by the grand secretary to the emperor and by many prominent dignitaries of the court. They were sent by order of the Chinese-Manchu Kangxi emperor, as eyewitnesses to our observations. As soon as it was proven that these corresponded exactly to my calculations, European astronomy triumphed over the envy and calumny of the Chinese and Moslem or Arabic astronomers, with the appointment of Father Ferdinand as Supreme Director of the Astronomical Academy in China. This happened during a council of imperial princes, dignitaries, and mandarins of the whole city of Beijing (convened four times for this matter!), and the Christian religion finally reappeared in public, in the fifth year of her persecution, and most churches in almost all the provinces of this very vast empire were again opened, as they used to be.[32]

In addition to these astronomical works, Verbiest published geographic treatises and maps. In this field, his major contribution was the *Kunyu quantu* (Complete map of the world), which, along with the *Kunyu tushuo* (Illustrated explanations of the world, ca. 1672), a pamphlet explaining the map, continued the Jesuits' cartographic tradition.[33] As with astronomy, if geography was important to Chinese emperors for both symbolic and practical purposes, it was even more so for the Manchu emperors of the early Qing era, who needed to define, pacify, and control their newly acquired empire.

HEAVEN AND EARTH Jesuit secular activities in China during the early Qing period suggest that the Manchu emperors were equally impressed by the priests' astronomical expertise and by their cartographic abilities. With his interest in the sciences of heaven and earth, the Kangxi emperor in particular exemplifies the symbiosis that developed between the missionaries and the Chinese court. At the effective start of his reign, he utilized the Jesuits' astronomical skills to reform the Chinese calendar and help legitimate Qing rule; later, he helped maintain that legitimacy by employing the missionaries in mapping the world and his empire.[34]

During the early Qing era, the emperors generally displayed interest in the missionaries' scientific, military, artistic, and linguistic skills but not in their religion. At the same time, the Jesuits were, unlike their Ming era predecessors, unable to generate much interest in Christianity among the scholarly class. From this point of view, the Jesuits' strategy of converting China from the top down was not very successful. Despite their skills at adaptation, the Qing-era Jesuits were unable or unwilling to deal with the fundamentally religious aspects of Chinese politico-religious culture. As their critics claimed, the Chinese ancestral and state rites were indeed part of a competing belief system.

Moreover, the Chinese emperor could never convert to Christianity because his place in this belief system was instrumental in making him ruler of the empire. He might support a religion in his private life (as many did with Buddhism or Taoism), but as the son of Heaven he could not be subject to a higher power other than Tian. Submitting to papal authority was simply out of the question, and the power of the Christian God could not even be acknowledged unless Tian and God could unequivocally be equated. Yet that was unacceptable under Catholic doctrine.

Though the emperor could not convert, it is possible that a focus on the literati, following Ricci's strategy during the late Ming era, would have borne more fruit. In fact, it is likely that the Jesuits lost wider support in China because they agreed to serve the new foreign dynasty rather than stand with the scholarly class that had been their original base. The transition from Ming to Qing rule was a painful period for the Chinese elites, many of whom refused to collaborate with the new rulers and were persecuted for their loyalty to the Ming. The Jesuits, foreigners serving foreigners, could not have been liked by those who saw the Qing as oppressors.

Though the Jesuits essentially failed in their goals for the conversion of China, the mission remains an enlightened phase for East-West cultural interaction.[35] Not only did the missionaries introduce European science and art to China but they also acquired varied knowledge that they transmitted to Europe. For them, astronomy, geography, botany, linguistics, and other sciences were not simply means to a religious end but grounds for intellectual research and discussion as well. New geographic information about China was eagerly sought and soon disseminated in Europe, where maps and atlases were quickly published in the wake of colonial expansion. Chinese astronomical and historical records were used in the debate over biblical chronology, and Chinese philosophy and government became some of the many threads that informed Enlightenment thought.

Notes

1. Mordechai Feingold, "The Ground for Conflict: Grienberger, Grassi, Galileo, and Posterity," in idem, ed., *The New Science and Jesuit Science: Seventeenth Century Perspectives* (Dordrecht: Kluwer Academic, 2003), 123.

2. Romeyn Taylor, "Official Religion in the Ming," in Denis Twitchett and Frederick W. Mote, eds., *Cambridge History of China: Ming Dynasty 1368–1644* (Cambridge: Cambridge Univ. Press, 1998), 8(2):840–45. Beijing became the capital of Ming China in 1421; the Ming capital had previously been Nanjing.

3. Susan Naquin, *Peking: Temples and City Life, 1400–1900* (Berkeley: Univ. of California Press, 2000), 3–11, 128–48, 324–31.

4. The most important sacrifice of the Chinese imperial ritual system (*jiao*) was in honor of Tian and was held annually at the circular Altar of Heaven on the day of the winter solstice. See Li Yuanlong, *Temple of Heaven,* trans. Han Rongliang (Beijing: Morning Glory, 1999), 2–3, 146–60.

5. Nicolas Standaert, "The Transmission of Renaissance Culture in Seventeenth-Century China," *Renaissance Studies* 17 (2003): 367–91; see also François de Dainville, *L'éducation des Jésuites (XVIe–XVIIIe siècles),* ed. Marie-Madeleine Compère (Paris: Éditions de Minuit, 1978).

6. Cordell D. K. Yee, "Traditional Chinese Cartography and the Myth of Westernization," in J. B. Harley and David Woodward, eds., *Cartography in the Traditional East and Southeast Asian Societies* (Chicago: Univ. of Chicago Press, 1994), 170–202, esp. 172 (fig. 7.1).

7. Pasquale M. d'Elia, ed. and trans., *Il mappamondo cinese del p. Matteo Ricci, S.J.,* 3rd ed. (Vatican City: Biblioteca Apostolica Vaticana, 1938), 16.

8. Xu Guangqi (1562–1633), Li Zhizao (1565–1630), and Yang Tingyun (1557–1627), an intellectual attracted by the religious and philosophical aspects of the Jesuits' teachings, are known as the Three Pillars of early Chinese Christianity, as they used their social standing to lay the foundations of Catholicism in their country. See Nicolas Standaert, "Chinese Christians: Well-Known Individuals," in idem, ed., *Handbook of Christianity in China* (Leiden: Brill, 2001), 1:404–20; and Johanna Waley-Cohen, *The Sextants of Beijing: Global Currents in Chinese History* (New York: W. W. Norton, 1999), 64–70.

9. D'Elia, *Il mappamondo cinese* (note 7), 53–83.

10. The *Tianxue chuhan* contains nineteen works by Chinese and European Jesuits on the field of "heavenly studies," an ambiguous term that includes Christian dogma, Western philosophy, and science. The works are divided into two groups: nine works discussing the *li* (principle) and ten works dealing with *qi* (things/objects). Philosophy and religion fell under *li,* while science was covered in the *qi* section. See Catherine Jami, "Science and Technology: General Reception," in Nicolas Standaert, ed., *Handbook of Christianity in China* (Leiden: Brill, 2001), 1:692–93, 698.

11. Jami, "Science and Technology" (note 10), 1:693–94; and Nicole Halsberghe and Keizō Hashimoto, "Astronomy," in Nicolas Standaert, ed., *Handbook of Christianity in China* (Leiden: Brill, 2001), 1:712.

12. The *Chongzhen lishu* was reworked and published with different titles during the Qing dynasty. See Isaia Iannaccone, "The *Xiyang Xinfa Lishu:* The Translation of Scientific Culture from Ricci to Aleni, Schreck, Rho, and Schall," in Tiziana Lippiello and Roman Malek, eds., *Scholar from the West: Giulio Aleni S.J. (1582–1649) and the Dialogue between Christianity and China* (Brescia: Fondazione Civiltà Bresciana, 1997), 573–92.

13. This system was devised by the Danish astronomer Tycho Brahe (1546–1601). Tycho kept the earth at the center of the universe but made the five known planets rotate around the sun, which in turn orbited the earth. See Michael Hoskin, "From Geometry to Physics: Astronomy Transformed," in idem, ed., *The Cambridge Concise History of Astronomy* (Cambridge: Cambridge Univ. Press, 1999), 101–3.

14. The Portuguese Jesuit Gabriel de Magalhães (1610–77) was highly critical of Schall's actions as head of the imperial Directorate of Astronomy and with the support of other Jesuits in China sent a memoir to Rome to try to remove him from his position. See Antonella Romano, "Observer, vénérer, servir: Une polémique jésuite autour du Tribunal de mathématiques de Pekin," *Annales: Histoire, Sciences Sociales* 59 (2004): 729–56.

15. Later *Xiyang* (Western) was dropped and the collection published as *Xinfa lishu* (Calendrical collection according to the new method, 1661).

16. See Charissa Bremer-David, "Six Tapestries from *L'histoire de l'empereur de la Chine,*" in idem, *French Tapestries and Textiles in the J. Paul Getty Museum* (Los Angeles: J. Paul Getty Museum, 1997), 80–97 (no. 9).

17. On the calendar controversy, see Chu Pingyi, "Scientific Dispute in the Imperial Court: The 1664 Calendar Case," *Chinese Science* 14 (1997): 7–34.

18. Yang Guangxian's best-known petition, *Budeyi* (I cannot do otherwise, 1665), makes use of Christian imagery (the Entry into Jerusalem and the Crucifixion) to show that Jesus Christ was a troublemaker and a convicted criminal. Yang suggested that astronomy was a cover for Christian proselytizing and portrayed Christianity as a religion that caused unrest and threatened Confucian orthodoxy. See Yang Guangxian, "Bude yi," in Wu Xiangxiang, ed., *Tianzhu jiao dong chuan wenxian xu bian* (Documents on the Eastern transmission of Catholicism) (Taipei: Xuesheng Shuju, 1966), 3:1090–122.

19. Verbiest, who compiled the first Manchu language grammar in Latin, *Elementa Linguae Tartaricae* (Elements of the Tartar language, 1687), learned Manchu at the insistence of the Kangxi emperor, who wanted to be taught European science and mathematics in his own language.

20. Roger A. Blondeau, "Did the Jesuits and Ferdinand Verbiest Import Outdated Science into China?" in John W. Witek, ed., *Ferdinand Verbiest (1623–1688): Jesuit Missionary, Scientist, Engineer and Diplomat* (Nettetal, Germany: Steyler, 1994), 47–54.

21. Hoskin, "From Geometry to Physics" (note 13), 117.

22. On the issue of geocentrism versus heliocentrism in the Society of Jesus, see Ugo Baldini, *Legem impone subactis: Studi su filosofia e scienza dei gesuiti in Italia, 1540–1632* (Rome: Bulzoni, 1992), 123–28, 217–81.

23. Allan Chapman, "Tycho Brahe in China: The Jesuit Mission to Peking and the Iconography of European Instrument-Making Processes," *Annals of Science* 41 (1984): 417–43.

24. Chapman, "Tycho Brahe" (note 23), 420.

25. *Ancient China's Technology and Science* (Beijing: Foreign Language Press, 1983), 29.

26. Nicole Halsberghe, "The Resemblances and Differences of the Construction of Ferdinand Verbiest's Astronomical Instruments, as Compared to Those of Tycho Brahe," in John W. Witek, ed., *Ferdinand Verbiest (1623–1688): Jesuit Missionary, Scientist, Engineer and Diplomat* (Nettetal, Germany: Steyler, 1994), 85–92.

27. Isaia Iannaccone, "Syncretism between European and Chinese Culture in the Astronomical Instruments of Ferdinand Verbiest in the Old Beijing Observatory," in John W. Witek, ed., *Ferdinand Verbiest (1623–1688): Jesuit Missionary, Scientist, Engineer and Diplomat* (Nettetal, Germany: Steyler, 1994), 93–117.

28. In fact, Verbiest may have learned the principles of optics and linear perspective at the college at Louvain. One of the teachers there had been François d'Aguilon (1567–1617), the author of the treatise *Opticorum Libri Sex Philosophis juxta ac Mathematicis Utiles* (Six books of optics, useful to philosophers and mathematicians alike, 1613). See Elisabetta Corsi, "Insegnare la prospettiva lineare in Cina: Trattati europei di prospettiva nella biblioteca dei Gesuiti di Bei Tang," *Archives internationales d'histoire des sciences* 52, no. 148 (2002): 122–46.

29. Archivio di Stato di Roma (Biblioteca), MS 493, Busta D (carta 152–58) and Busta Cina (nos. 105, 106). The drawings are reproduced in Nöel Golvers, *Ferdinand Verbiest, S.J. (1623–1688) and the Chinese Heaven: The Composition of the Astronomical Corpus, Its Diffusion and Reception in the European Republic of Letters* (Leuven, Belgium: Leuven Univ. Press, 2003), 621–35 (ills. 8–15).

30. Golvers, *Ferdinand Verbiest* (note 29), 114–21.

31. See Ferdinand Verbiest, *The "Astronomia Europaea" of Ferdinand Verbiest, S.J. (Dillingen, 1687): Text, Translation, Notes and Commentaries*, ed. and trans. Nöel Golvers (Nettetal, Germany: Steyler, 1993), 96–99, 130–32: "On the grand authority and prestige the missionaries gained in China by means of the above-mentioned sciences."

32. Translation adapted from Nöel Golvers's translation of chapter 12 of the *Astronomia Europaea*; see Verbiest, *The "Astronomia Europaea"* (note 31), 87.

33. See Gang Song and Paola Demattè, "Mapping an Acentric World: Ferdinand Verbiest's *Kunyu Quantu*," this volume, and cat. no. 26; and Hartmut Walravens, "Father Verbiest's Chinese World Map (1674)," *Imago Mundi* 43 (1991): 31–47 (fig. 2).

34. Catherine Jami, "Imperial Control and Western Learning: The Kangxi Emperor's Performance," *Late Imperial China* 23, no. 1 (2002): 28–49.

35. The Jesuits still managed to convert or influence important figures at the court, including court artists such as Jiao Bingzhen (1662–1720) and Nian Xiyao (d. 1738) as well as a member of the Kangxi-era royal family named Sunu, and some members of Sunu's family. Catholic communities also continued to exist, particularly in southern China, even after the demise of the Jesuit enterprise in China, when the dissolution of the Society of Jesus was promulgated there in 1775. I am grateful to Elisabetta Corsi for this information.

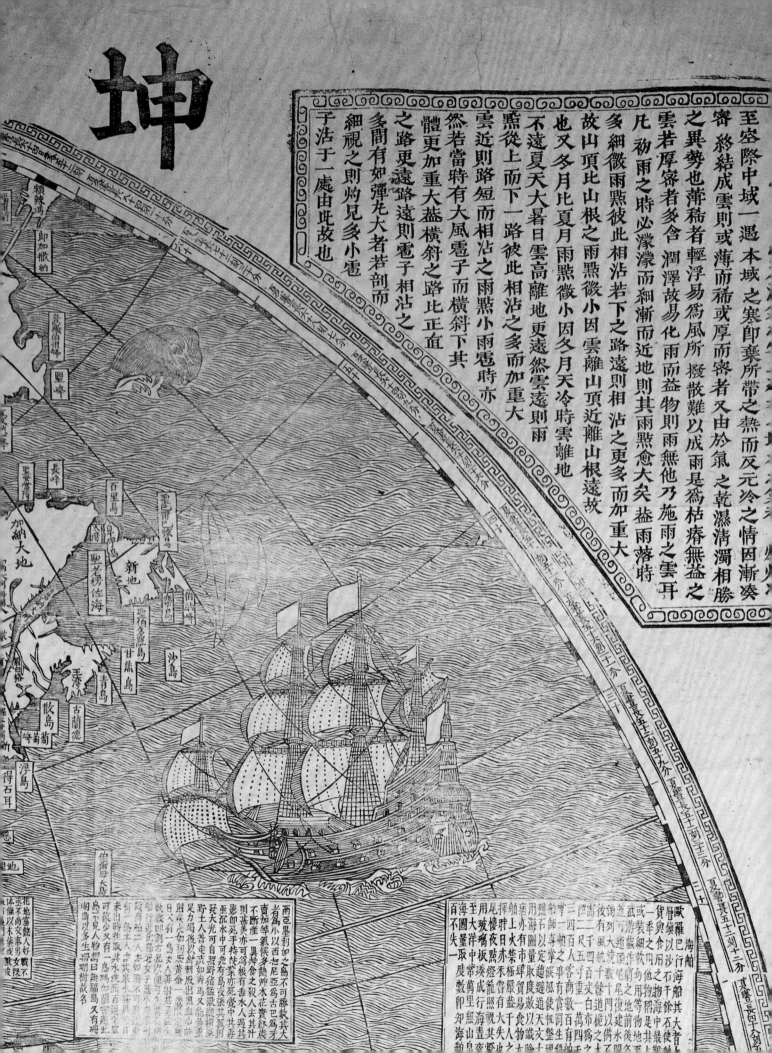

坤

至空際中域一遇本域之寒卽襄所帶之熱而反元冷之情因漸湊
終結成雲則或薄而稀或厚而密者又由於氣之乾濕清濁相勝
之異勢也薄稀者輕浮易為風所撥散難以成雨是爲枯瘠無益
之雲若厚密者多含潤澤故易化雨而益物則雨無他乃施雨之雲耳
凡初雨之時必濛濛而細漸而近地則其雨點愈大矣益雨落時
多細微雨點彼此相沾若下之路遠則相沾之更多而加重大
故山頂比山根之雨點微小因雲離山頂近離山根遠故
也又冬月比夏月雨點微小因冬月天冷時雲離地
不遠則夏天大暑日雲高離地更遠然雲遠則雨
雲近則路短而相沾之雨點微小因
然若當時有大風電子而橫斜下其
體更加重大蓋橫斜之路比正直
之路更遠路遠則電子相沾之
多間有如彈丸大者若剖而
細視之則灼見多小電
子沾于一處由此故也

（地名）
額綸馬　即加撒的
荒波伯怛峰
聖峰
加納大地
長峰
聖母常灣
百里島　大灣
雲霄霧寨湖
新地
聖若楞佐海
聖多禄島
甘焦島　沙島
青島
秀山　古蘭德
散島葡
嶺峰
浮島
得石耳
伯雷尼大島

Mapping an Acentric World: Ferdinand Verbiest's Kunyu Quantu

GANG SONG AND PAOLA DEMATTÈ

IN 1674, THE FLEMISH JESUIT FERDINAND VERBIEST, whose Chinese name was Nan Huairen, presented to the Kangxi emperor his *Kunyu quantu* (Complete map of the world) (cf. fig. 79), a monumental map annotated in Chinese that displayed the earth's eastern and western hemispheres. Far from being a completely original work, the *Kunyu quantu* was the result of a cumulative cartographic endeavor begun by the Italian Jesuit Matteo Ricci nearly a century before.

In 1583, while living in the southern city of Zhaoqing, Ricci made a world map, annotated in Latin and depicting the earth's surface in a single oval projection. It was probably modeled on the *Typus Orbis Terrarum* (Image of the world) from the first modern atlas, Abraham Ortelius's *Theatrum Orbis Terrarum* (Theater of the world, 1570). Soon translated into Chinese as *Yudi shanhai quantu* (Complete world map of mountains and seas, 1584), Ricci's map presented his Chinese contacts with an entirely new view of the world: where their maps showed the world as flat and square and occupied largely by the Chinese empire, Ricci's showed the world as a globe covered largely by water and China as one nation among many. Ricci went on to produce terrestrial globes and other projections, of which the best known was the *Kunyu wanguo quantu* (Complete map of all nations of the world, 1602). Expansively named to differentiate it from traditional Chinese world maps, this oval world map was bordered by astronomical diagrams and geographic projections that explained Christian cosmology and the Ptolemaic universe. Its numerous cartouches give information on various lands or carry dedications by prominent Chinese officials in praise of Ricci's cartography.[1]

A decade after Ricci's death in 1610, Giulio Aleni made the *Wanguo quantu* (Complete map of all nations, 1620), an oval projection that bears features similar to Ricci's larger *Kunyu wanguo quantu*. This map is bordered at the top by a brief preface, which begins by discussing cosmology and ends by comparing man's nature to God's, and at the bottom by two polar projections of the earth.[2] In 1623, Aleni created a new world map for his *Zhifang waiji* (Unofficial records on foreign countries), a treatise on the lands beyond China. The same year, Manuel Dias the Younger and Niccolò Longobardi made a lacquered terrestrial globe with Chinese explanatory notations, place-names, and decorative sea monsters. Incorporating geographic knowledge gained since Ricci's time, this

Detail of FIGURE 79 (right)

71

is the earliest extant globe of the earth to be made in China.[3] The Jesuit astronomer Adam Schall von Bell made a world map that was published in 1636 as part of a treatise on the armillary sphere.[4] While he was in Canton in 1648, Francesco Sambiasi produced a hand-colored oval world map modeled on Aleni's first world map but including a few ships and sea creatures as ornamental elements as well as six didactic cosmological and astronomical diagrams on the structure of the cosmos, the spherical shape of the earth, the phases of the moon, and eclipses.[5] Another Jesuit geographic work that preceded and probably influenced Verbiest's map was Martino Martini's *Novus Atlas Sinensis* (1655) (cat. no. 25). Published by Johannes Blaeu (as part six of his new world atlas, *Theatrum Orbis Terrarum; sive, Atlas Novus,* ca. 1635–62), Martini's atlas contained seventeen maps (a general one of China, Korea, and Japan [see fig. 61]; one for each of the fifteen Chinese provinces; and one for Korea and Japan) and was based on Chinese sources.[6]

All these works bear witness to the ongoing role played by cartography in the Sino-European cultural encounter of the sixteenth and seventeenth centuries, when Western sciences were employed by Jesuit missionaries to introduce European cosmology and Christianity to China.[7]

THE KUNYU QUANTU: THE WORLD DESCRIBED Printed on a monumental scale from a series of wood blocks, the *Kunyu quantu* consists of eight vertical panels displaying two hemispheres (each five feet in diameter) and fourteen explanatory cartouches.[8] The eight panels, individually measuring approximately seventy inches in height and twenty-one inches in width, are assembled, from right to left, as follows: one panel with four vertically arranged cartouches, the western hemisphere on three panels, the eastern hemisphere on three panels, and one panel with four vertically arrayed cartouches. Six cartouches appear on the six inner sheets, with three of these internal cartouches disposed along the top edge, flanking and between the two hemispheres, and three similarly disposed along the bottom edge. The eight external cartouches have scrolled baroque frames, while the six internal ones are enclosed in simple ovals. Each hemisphere is annotated with place-names and descriptions as well as images of animals and of three-masted ships sailing the high seas. Copies of the map exist in monochrome and in color. The latter versions, which are hand-painted, show the various continents in different tints and convey a striking sense of three-dimensionality. The map may originally have been designed to fit on a pair of folding screens, and it was to be read, as is clear from the four characters of the title inscribed across the top, from right to left.[9]

The fourteen cartouches provide the philosophical and scientific framework for the map. The four external cartouches on the right serve as an introduction to various aspects of Western cosmology. The first discusses the Aristotelian theory of the four elements (fire, air, water, and earth), explaining how each has a "natural" locus in the cosmos and a round shape. Here, Verbiest makes an attempt at scientific argument, giving specific, materially grounded reasons (weight or lightness, sympathy or repulsion, and observation) to prove the fixed order and the shape of the four elements. This differs from the decidedly religious explanation of the four elements provided by Ricci in his map and in writings such as the *Qiankun tiyi* (On the structure of heaven and earth, ca. 1608), where he says that the four elements were among the first created by God.[10]

The three cartouches below the first criticize the traditional Chinese view of a round heaven enclosing a square earth, explaining that the earth is a sphere positioned at the center of the heavens. Ricci had previously introduced a similar concept, though

FIGURE 30
Tiandi dingwei zhitu
(Positioning heaven and earth),
1721, woodcut, image:
ca. 15.5 × 17.8 cm (6⅛ × 7 in.)
From Wei Mingyuan, *Xinzeng
xiangji beiyao tongshu* (n.p.: Li
Yan Tang, 1721), vol. 1, 4b–5a

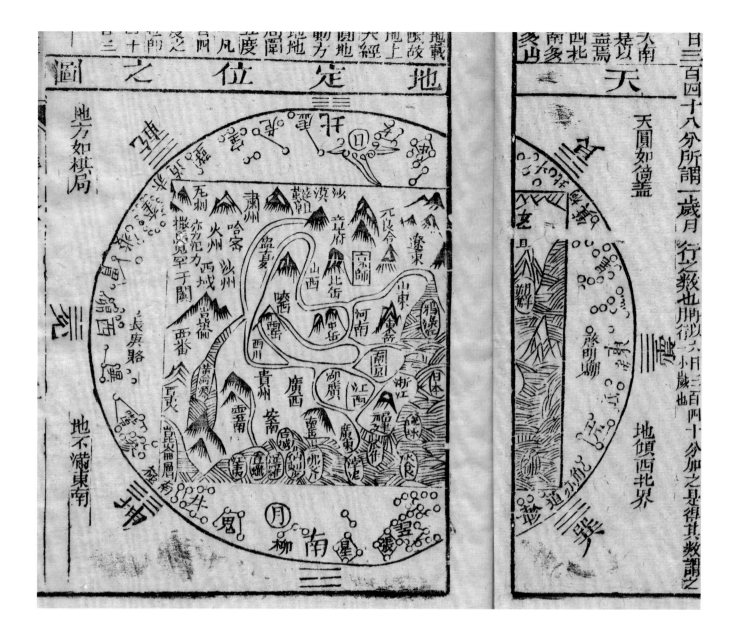

he framed it in the Ptolemaic system, not in the Tychonic system that Verbiest generally adopted. Drawing on the Chinese *huntian* (celestial sphere) theory of the relation between heaven and earth, Ricci had stated in the preface to his map of 1602 that the earth is a globe in the middle of the celestial spheres, like the yolk of an egg.[11] Though some Confucian intellectuals were aware of Ricci's views, the concept of the spherical earth did not have wide credibility in China by Verbeist's time or even later. Wei Mingyuan's diagram, *Tiandi dingwei zhitu* (Positioning heaven and earth) (fig. 30), which appeared in an almanac of "auspicious images" published in 1721, well after the publication of the *Kunyu quantu,* evinces that scholars maintained the traditional view of the cosmos in their cartography. Four sentences in the diagram's corners state the ancient Chinese cosmological beliefs that "Heaven is round like a canopy," "Earth is square like a chessboard," "Earth bends upward in the northwest," and "Earth disappears in the southeast." Along the rim of the circular heaven are the eight trigrams used in divination and the twenty-eight lunar asterisms of Chinese astronomy, which were used to track the moon's monthly movement across the sky.[12]

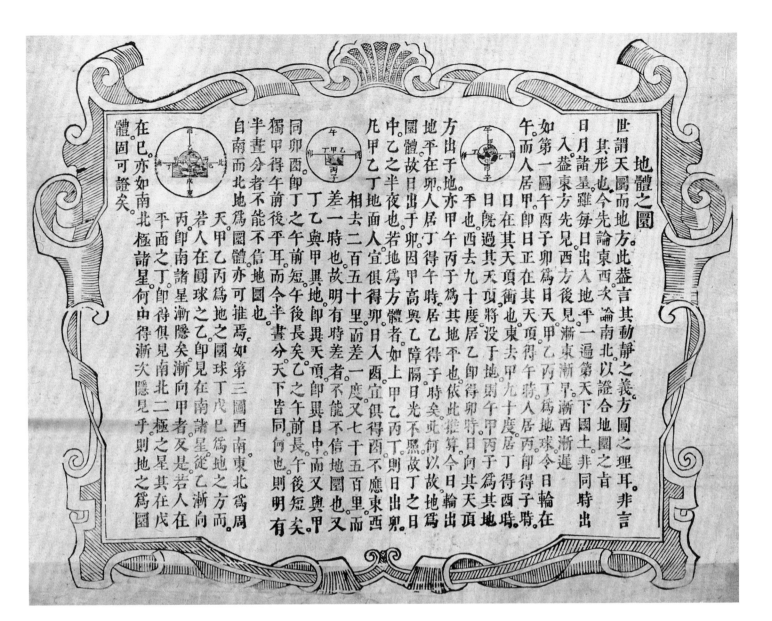

地體之圓

世謂天圓而地方。此蓋言其動靜之義方圓之理耳。非言
其形也。今先論東西次論南北以證合地圓之旨
日月諸星雖每日出入地平一遍第天下圓土非同時出
入蓋東方先見西方漸東漸遲非同時
如第一圖午酉子卯為日天甲乙丙丁為地球令日輪在
午而人居甲。即日正在其天頂。亦得午時。人居乙。日輪在
日既過其天頂。將沒于地則乙得午後時矣。向其天頂
平也。甲午丙子丁于為其地平。也依此推算今日輪在
地平在于卯。亦人居丁得午時。居乙得子時。居丙得酉時。
方出于地。居甲人居丁得午時。此以故地為圓體者如
中乙之半夜也。若地為方體。則日出卯。日入酉。日出卯。
凡甲乙丁地面人宜得卯日入酉宜俱得酉不應
相去二百五十里而差一度。又七千五百里而
差一時也。故明有時差者。不能不信地圓也。
丁乙與甲異地。即異天頂。即異日中。而又與甲
獨甲得午前後平耳。而今半晝分天下皆同何也。則明有
同卯酉卯丁之午前午後長矣。乙之午前長午後短矣。
自南而北地為圓體。亦可推焉。如第三圖西南東北為周
天甲乙丙為地之圓球丁戊巳為地之方而
半晝分者不能不信地圓也。
若人在圓球之乙。即見在南諸星從乙漸向
丙。即南諸星漸隱矣。漸向甲者。反是若人在
平面之丁。即得俱見南北二極之星其在戊
在巳。亦如南北極諸星何由得漸次隱見乎。則地之為圓
體。固可證矣。

Verbiest's three cartouches challenge this Chinese view of the world without dismissing it. In the bottom cartouche (fig. 31), he writes that the "round heaven and square earth" concept "refers to their nature in terms of activity and stability . . . and not to their shapes," and he employs three diagrams derived from Sabatino de Ursis's *Biaodu shuo* (Explanation of the gnomon, 1614) to demonstrate that the earth is spherical. In the diagram on the right, Verbiest depicts the earth as a globe marked with four points and explains that because of the earth's spherical shape, people at these various points experience different times. In the middle diagram, Verbiest displays the earth as a square marked with the same four points and argues that on a flat earth, people in different locations would observe the same hour—something contradicted by daily experience. Finally, in the diagram on the left, Verbiest compares the spherical earth with the square earth by combining them and declaring that a person on the round earth sees the stars appear and disappear, whereas a person on the flat earth should see all the stars at all times. Verbiest concludes by asserting that the appearance and disappearance of the stars proves that the earth is spherical.

Following this introduction, the viewer moves to the central portion of the map. The three cartouches at the top edge report on atmospheric phenomena (rain and clouds, winds, and air), while those at the bottom concern the sea (tides, currents, and their causes). About air, Verbiest writes: "If one says that the air does not exist because it has no color and shape, then will he say that all invisible things—the sound of wind, smell, ghosts, and souls of human and other species—do not exist? When the external eyes cannot see, the internal eyes of reason will understand." Like other Jesuit scientists in China, Verbiest deploys here medieval scholastic reasoning to "prove" that *qi xing* (air as an element) is material in nature and void does not exist. In the first of six arguments, he dismisses the Chinese belief that celestial bodies float in the void, which we now hold as true: "the space within heaven would be empty without air. How came the earth to be suspended there in the middle? . . . Since things can support and protect each other only by means of a connected whole, emptiness is unacceptable and should not be thought of." While he avoided discussing the traditional Chinese concept of *qi* (air, breath, vital energy) by using a slightly different term (*qi xing*), he was effectively proposing a different interpretation of the structure of the cosmos—one that was not necessarily more accurate than that held by the Chinese.[13]

The two hemispheres, drawn in equatorial stereographic projection,[14] are presented in an order that reversed European practice, such that the western hemisphere is on the right and the eastern hemisphere on the left. This layout allowed Verbiest to place China as close as possible to the center of the map without compromising the overall idea of the spherical earth. This choice continued a tradition set by Ricci, Aleni, and Sambiasi, who had centered their oval projections of the world on the Pacific Ocean rather than the Atlantic, in an accommodative acknowledgment of the Chinese tradition that China was the center of the world. Verbiest also placed the prime meridian over Beijing, the capital of the Qing empire, but his accommodation could go no further, because the *Kunyu quantu*'s hemispheric layout implicitly resists a fixed center. The meridians are counted eastward, to 360°, with the numbers marked at the equator, and the ecliptic (showing the apparent path of the sun's annual motion) runs across the hemispheres. Each hemisphere is edged by several sets of circles, the inner one marking latitudes, the middle one noting the duration of the longest summer day and the longest winter night for eighteen different zones, from the equator to the pole, and the outer being a decorative band of abstract designs (these circles are visible in the detail on page 70).[15] Two

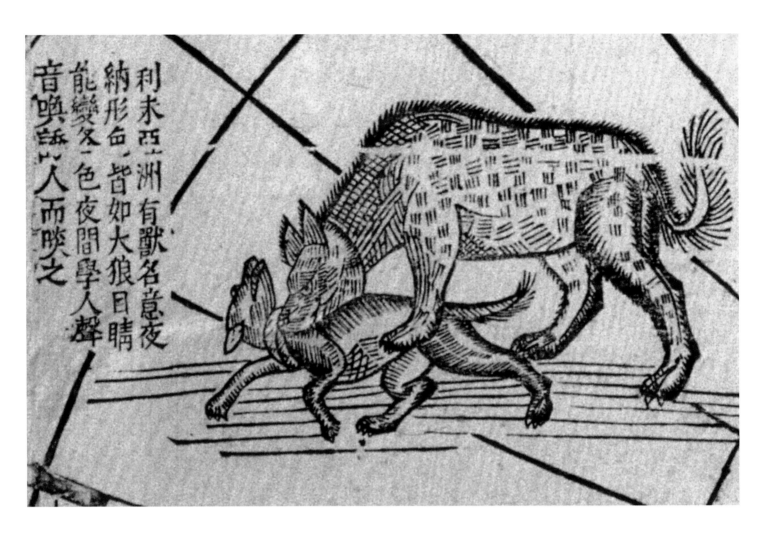

利未亞洲有獸名意夜
納形血，皆如大狼目睛
能變各一色夜間學人聲
音喚誘以人而啖之

colophons adjacent to the hemispheres identify Verbiest (by his Chinese name and rank) as the author of the map and give the date of publication.[16]

Within the bounds of the hemispheres, short texts provide not only place-names but also information on the natural resources, peoples, and customs of continents as well as countries. The landmasses of the eastern hemisphere are covered with labels relaying details about Europe, Africa, and Asia. The information on China is up to date, for it includes the latest administrative changes deriving from the political transition from the Ming to the Qing dynasty.[17] By contrast, the Americas are sparsely described, indicating the lack of knowledge about this continent. Australia and Antarctica (called "Magellanica"), then barely known, are roughly sketched and filled with images of real and fantastic animals from other lands. The rhinoceros, chameleon, salamander, alligator, giraffe, lion, ostrich, unicorn, flying fish, and turkey are accompanied by short descriptions introducing their habitats, bodily features, diets, or behaviors. In the oceans, whales, sea horses, and mermaids cavort alongside European sailing ships.

The use of ships and exotic animals to visually enhance maps was a European tradition. However, the animals decorating Verbiest's world map do not derive from earlier maps made by the Jesuits in China. Only some of those maps carry such illustrations, and they show fewer and different animals (mainly sea creatures) than the *Kunyu quantu*.[18] It seems that Verbiest derived most of his animal images from the woodcut illustrations in Konrad Gesner's *Historiae Animalium* (History of animals, 1551–87) (figs. 32, 33), a

drupedis nō
ꞓegrinæ & i=
Græcis Latí=
s, non folū
quadrupedí
d etiam mul=
yęnæ, aliâs
iâs piſci attri
a quadrupe
illis animali
ſiue diuerſa
e ſaltem dif=
nisꝗ uſurpa
uel barbaris
pio, zilio.
nomen, He=
ꞓna ſerpen=
s dicam. Hyęnam alij glanum appellant, Ariſtoteles interprete Gaza

monumental compendium of information concerning animal life that sought to distin-
guish observed facts from myths and popular errors.[19] Compared with Gesner's extended
and detailed texts, Verbiest's descriptions are perforce simplified, and they focus on the
animals' unusual features. Concerning the hyena, whose image appears on Antarctica
in the eastern hemisphere, Verbiest writes, "In Africa there is a beast called *hyena* [*yi ye
ha*]. Its shape and appearance are like a big wolf. The eyes change to different colors. At
night it can imitate a person's voice to lure people and eat them."

The final panel of the *Kunyu quantu* displays four cartouches that deal with, top to
bottom, earthquakes, humanity, rivers, and mountains. In the cartouche titled *Renwu*
(People) (fig. 34), Verbiest describes our spiritual nature (*lingxing*) as a gift from a higher
entity and the shared ground of all people despite their physical differences. This is a
clear reference to the soul, but the use of the term *lingxing,* with its references to Con-
fucian debates about human nature, implies that Christianity is ultimately compatible
with Confucianism on matters of morality and social order:

> What all people under heaven have in common is their spiritual nature. Though
> they may differ in terms of complex or simple regulations for the five moral
> relations, strict or loose laws, and elegant or simple manners, they all share this
> principle. People have a common nature but differ in faces and voices. Animals
> of the same species are similar in appearance, but humans are all different from
> one other. Any person can be recognized by his or her unique appearance. This

FIGURE 32
Hyena
From the eastern hemisphere
of Ferdinand Verbiest, *Kunyu
quantu,* ca. 1860, wood-block
print on bamboo paper, sheet:
153.5 × 202 cm (60⅜ × 79½ in.)

FIGURE 33
De Hyaena (On the hyena),
1551, hand-colored woodcut,
8 × 10.3 cm (3⅛ × 4 in.)
From Konrad Gesner,
Historiae Animalium, vol. 1,
De Quadrupedibus Viviparis
(Zurich: apud Christ.
Froschoverum, 1551), 624

人物

天以下週圍大地無不有人居焉古者多疑赤道及南北二極下之地皆無人居蓋以其甚暑甚寒故也然航海者每週全地而驗之處處皆有人居足以知舊說之非是矣欲明其義然則見於空際格致論中從東而西凡離赤道之南北一般遠之地則人物大同小異若其離赤道近遠大不同之地則人物亦隨之而大不同矣蓋天下變化之功大槩從日月五星自東而西周天之運動而生其四元行之情如冷熱乾溼隨之而變然日月五星皆依黃道而行而黃道之平分在於赤道也普天之下人人所公同者即靈性也其五倫規矩之纂簡法度之踈密禮貌之華朴雖有不同終無以出于理外者蓋所同者其性而其所不同者則面貌及聲音也益凡物傳類者如禽獸等容貌多相同獨人不然人各一貌皆容貌聲音無二人全同者此其中有主宰天下者之大意存焉蓋惡面貌以判彼此燹倫所係齊治攸關原非細故假使人面皆同必至夫嫡庶父子皆不相識不能辨人各肆志任情姦宄叢生無所不至雖欲治得乎彼禽獸大率同類相似者豈非以其無燹倫齊治關係故哉而貌異矣又復別以聲音蓋以人目異等又或夜遇無從識認更有此以證佐之也云爾

is the case in the whole world, in a country, in a region, and even within a family. No two persons are alike in features and voice. This is the design of the One Who Dominates All under Heaven.[20] It is no small thing that people can recognize each other through appearance. This is related to the [teachings of] moral relations and is crucial to good government. If people had the same appearance, husbands and wives could not recognize each other, and fathers and sons could not distinguish each other. People would indulge in their desires and emotions, and disorder would appear everywhere. How could one control this though he wished to?

Though not physically placed at the end of the texts, this cartouche seems almost to summarize the implicit religious significance of the geographic and astronomic notions put forth in the *Kunyu quantu*. By openly mentioning the Creator in relation to humanity, Verbiest reveals here his ultimate intent, the evangelization of China.

VERBIEST'S OTHER GEOGRAPHIC WORKS In addition to the *Kunyu quantu*, in the 1670s Verbiest produced other world maps and some explanatory geographic treatises. Several of these relate directly to the *Kunyu quantu* and were produced seemingly as precursors or supplements to the map itself. Circa 1672, probably while assembling the *Kunyu quantu*, he wrote the *Kunyu tushuo* (Illustrated explanations of the world). This was Verbiest's revision of the *Zhifang waiji*, a work that Aleni had composed fifty years earlier as an elucidation for users of Ricci's world map, and in fact the one-volume first edition of Verbiest's treatise still carried Aleni's preface.[21] The *Kunyu tushuo* was issued in two volumes shortly thereafter. This later version contains the texts of the cartouches of the *Kunyu quantu* in the first volume and the annotations on continents, people, customs, and exotic animals in the second.[22] It also includes illustrations of the Seven Wonders of the Ancient World and the Roman Colosseum, which do not appear on the *Kunyu quantu*.[23]

In 1674, while working on the large world map, Verbiest made two smaller versions of it.[24] These reductions are structurally very close, apparently differing only in mounting and coloring. Compared with the larger *Kunyu quantu*, they have similar but simplified continental outlines (islands such as Sicily and Sardinia are missing, for example), fewer place-names and explanations, and no decorative animals except sea creatures. The reduced maps are thought to have been made for the administrative and military departments of the Qing government.

One of the small versions is a monochromic woodcut headed *Kunyu tushuo* and comprising two hemispheres and an introduction.[25] The three parts of the work are mounted vertically, with the introduction at the top, the eastern hemisphere in the middle, and the western hemisphere at the bottom. The introduction is a summary of the explanatory cartouches and continental insets printed on the larger *Kunyu quantu*. A twenty-two character colophon giving the date as 1674 and identifying the author of the map as Verbiest follows the text of the introduction. This colophon is identical in content to the two colophons of the *Kunyu quantu*. The other small version is a hand-colored woodcut titled *Kunyu quantu* and comprising an introduction with the two hemispheres mounted horizontally below. Within the hemispheres, each continent is outlined in a different color, and the sea creatures are also tinted.[26]

FIGURE 34
Cartouche: *Renwu* (People) From Ferdinand Verbiest, *Kunyu quantu*, ca. 1860, wood-block print on bamboo paper, sheet with eastern hemisphere: 153.5 × 202 cm (60⅜ × 79½ in.)

Two additional works derived from Verbiest's *Kunyu tushuo* — the *Kunyu waiji* (Additional notes on [things in] the world, n.d.) and *Kunyu gezhi lüeshuo* (Brief introduction to the [scientific] study of the world, 1676) — appeared within a few years of the *Kunyu quantu*, providing additional paths of dissemination for the information on Verbiest's world map.[27]

SOURCES FOR THE *KUNYU QUANTU* Many sources contributed to the overall design of the *Kunyu quantu*, including other Jesuit geographic works in Chinese or Latin, European maps and illustrated books, and Chinese geographic treatises and maps. In the *Kunyu tushuo*, Verbiest acknowledged his Jesuit predecessors: "Western scholars such as Matteo Ricci, Giulio Aleni, Alfonso Vagnone, and Sabatino de Ursis were well versed in the principles of heaven and earth, longitude and latitude. They discussed these issues in detail. Since a long time has passed from the publication of their *Kongji gezhi*, *Zhifang waiji*, and *Biaodu shuo*, etc., I will now summarize their writings and add some new arguments. With this I intend to uncover truths about the earth not revealed by previous scholars."[28]

The principal sources for the *Kunyu quantu* cartouches are Alfonso Vagnone's *Kongji gezhi* (Studies on natural phenomena, 1633) and de Ursis's *Biaodu shuo*. The first, the discussion of the four elements, combines two sections — *Xing zhi xu* (On the order of the four elements) and *Xing zhi xing* (On the shape of the four elements) — from Vagnone. The following three cartouches on geocentrism and the earth's sphericity take their illustrations and explanations from de Ursis's *Biaodu shuo*.[29] The remainder of the texts, with the exception of *Renwu*, are copied or adapted from Vagnone's work.

The annotations on the *Kunyu quantu*'s hemispheres derive from Aleni's *Zhifang waiji*. Most place-names are identical in both works, and the texts describing the countries are very close. The caption for Chile that appears on the *Kunyu quantu* is roughly the same as those appearing in the *Zhifang waiji* and in the *Kunyu tushuo*. The *Kunyu quantu*'s version reads:

> Chile is the country of tall people. The place is very cold. People are about one
> *zhang* [11 ft.] tall, and hair covers their bodies. In antiquity, there were even
> taller and bigger men. Someone dug up a Chilean's tooth three fingers wide and
> four fingers long, from which the size of the body can be judged. The Chileans
> carry bows and arrows. The arrows are six *chi* [6½ ft.] long. To demonstrate
> bravery, the men insert arrows into their mouths until the whole feather part
> disappears. Men and women decorate their faces with colorful designs.

For countries not described by Aleni, Verbiest often, though not consistently, borrowed names and descriptions from Ricci's well-known *Kunyu wanguo quantu*. For example, Verbiest's description of Japan is identical to Ricci's, but Verbiest opted to use Chinese transliterations of Latin place-names derived from a European source rather than the Sino-Japanese (kanji) place-names that Ricci used on his map.[30]

It is generally argued that Verbiest based the visual aspects of the *Kunyu quantu* on the edition dating to 1648 of Johannes Blaeu's *Nova Totius Terrarum Orbis Tabula* (New map of the entire world).[31] The Dutch cartographer's world map and the *Kunyu quantu* do share certain elements — namely, Blaeu's Latin place-names (in Chinese transliteration), equatorial stereographic projection in two hemispheres, and outlines of some landmasses. But these features are insufficient to demonstrate that Blaeu was Verbiest's

main source. Place-names were generally similar in European maps (and a Chinese transliteration cannot highlight minor spelling differences), and world maps with two hemispheres in equatorial stereographic projection were common in the early to mid-seventeenth century. A firmer link between the two is Verbiest's characteristic representation of California. While many mapmakers from the 1620s on showed California as an island, Verbiest represented it as an island with three prongs extending from its northern section, exactly like Blaeu. Another point in favor of Blaeu being Verbiest's principal source is that the Dutch cartographer, as publisher of Martini's *Novus Atlas Sinensis,* had had extensive contact with Jesuits working in China.

Conspicuous differences between the world maps by Verbiest and Blaeu do exist, however. On the grand scale, the *Kunyu quantu* includes whole landmasses not on Blaeu's map. The latter lacks Antarctica, the northwestern section of North America, and the imaginary islands of the Artic. For these, Verbiest may have followed Rumold Mercator's *Orbis Terrae Compendiosa Descriptio* (Compendious representation of the world, 1587)—a reworking in two hemispheres of his father Gerard Mercator's *Nova et Aucta Orbis Terrae Descriptio* (New and augmented representation of the world, 1569)—which Ricci had probably used as well.[32] The contours Rumold Mercator's map shows for these three areas are similar to those on both Verbiest's map and previous Jesuit world maps. It stands to reason that Verbiest would want to avoid eliminating landmasses that had appeared for decades on the world maps the Jesuits had been displaying in China. Changes of such magnitude in the earth's contours could cast reasonable doubt on the missionaries' claims about the accuracy and superiority of Western cartography.

On a smaller scale, the most conspicuous differences between the *Kunyu quantu* and Blaeu's map relate to the depictions of China and its neighbors. The contours of Verbiest's China are more accurate than Blaeu's. Moreover, while various details of Verbiest's China correlate to maps by Ricci or Aleni or Martini, none is a match as a whole. It may well be that Verbiest relied on recent Chinese sources and local experts for updated information on East and Southeast Asia. For China proper, the surveys and maps found in provincial gazetteers were of principal importance. Another Chinese source that Verbiest may well have consulted was Luo Hongxian's *Guangyu tu* (Enlarged terrestrial atlas, 1579), the famous Ming-dynasty atlas of China and neighboring countries used by Ricci and, later, by Martini in compiling his *Novus Atlas Sinensis.*[33] Overall, the *Kunyu quantu* was a brilliant effort at synthesizing diverse and up-to-date cartographic knowledge in an intellectually captivating and visually compelling way.

THE IMPACT OF THE KUNYU QUANTU As a missionary and a scientist, Verbiest continued the century-old Jesuit effort to promote Christian cosmology and European science, combining concepts such as the earth's sphericity with pseudo-scientific ideas such as the four elements and the nested celestial spheres of God's domain. Within this schema, China's size was not particularly impressive, and its geographic position was not at a hypothetical center that entailed a special relationship with heaven. The Chinese empire was neither the largest nor the most favorably positioned land: it was only a small part of the world, at best the largest country in Asia.

Verbiest's description of China on the *Kunyu quantu* shows that, even more than previous Jesuit cartographers, he had intentionally placed China in a global context. Rather than emphasizing its size, the number of its tributary states, or the Jesuit missionaries' accommodation to its culture, all of which could make the case for China's

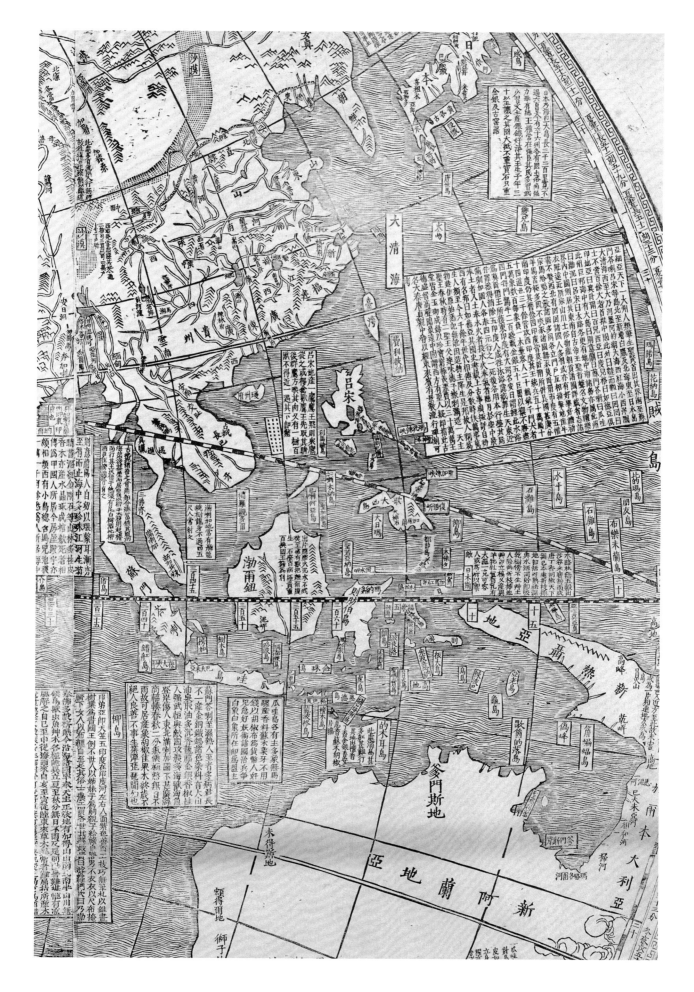

superiority, Verbiest mentioned China only briefly, in his introduction to Asia (fig. 35). He remarked merely that it "lies in the southeast [of Asia]. From ancient times, there have been renowned emperors and sages. [Chinese] culture, rituals, and dress are imitated near and far. Because the mountains, rivers, customs, and products of this country and its tributary states have been recorded in detail in provincial gazetteers, it is unnecessary to repeat such details here."

To buttress this low-key view, Verbiest made a point of discussing cultural, religious, and political centers beyond China, such as Spain and Italy, Egypt, and India, and he made a special effort to promote Europe as a highly civilized counterpart of China.[34] To arouse the interest of Chinese scholars in European culture and religion, Verbiest portrayed Europe in idealized terms. He stressed the dominance of Christianity and correlated its pervasiveness with honest government, open judicial processes, peace, good education, and social welfare.[35] Significantly, he chose to gloss over European political and religious unrest, ignoring events such as the Thirty Years' War and the Reformation.

The *Kunyu quantu* played a subtle role in Qing China. At the highest level of the Chinese social order, the map provided a new vision of the world for the Kangxi emperor, who was eager to acquire information about the lands beyond his empire and to exploit any knowledge (symbolic or practical) that would strengthen his rule and his dynasty. Intelligent and inquisitive, the emperor not only questioned the Jesuits closely about the culture and geography of Europe but also requested that they instruct him in Western methods of astronomy and cartography. In fact, he was not shy about displaying his newly acquired skills in public, at times casting himself as Yu the Great, the mythic ruler who saved the country from floods by surveying the land and dredging new river channels as outlets.[36] Though the Kangxi emperor never publicly endorsed Verbiest's acentric representation of the world, he appreciated the accuracy of Western astronomy and cartography and was critical of Chinese cartographic methods: "All celestial degrees match widths of the earth.... Since ancient times mapmakers have never reckoned the distances on the earth according to celestial degrees, and this is why numerous mistakes appeared."[37] The emperor was aware that China was increasingly part of a wide and potentially threatening world, and he may well have wanted to subtly introduce this reality to his subjects.

Chinese scholars had mixed reactions to Verbiest's map. Initially, its impact on Chinese cartographic practices appears to have been limited.[38] For one, few scholars fully accepted the cosmographic model the Jesuits proposed, and those who did were closely associated with the missionaries. Moreover, the Western geometric and universal representation of space was of limited interest to the highly cultured cartographers of the Chinese empire, who prized the expressive depiction of place. Thus, for the most part, Chinese scholars either dismissed Jesuit cartography and continued with their standard practices or supplemented Chinese geographic models by selectively appropriating the *Kunyu quantu*.[39] These hybrids incorporated newly acknowledged lands into the traditional Chinese schema, representing them as dramatically reduced landmasses surrounding China or citing them in cartouches. With time and increased foreign contact, things began to change. After the mid-eighteenth century, while many scholar-officials continued to voice doubts about the credibility of the Jesuits' maps, Chinese mapmakers began to acknowledge foreign cartography, and Verbiest's world map was frequently, if selectively, copied.[40] Almost two hundred years after its creation, the *Kunyu quantu* was

FIGURE 35
China and its neighbors
From the eastern hemisphere of Ferdinand Verbiest, *Kunyu quantu*, ca. 1860, wood-block print on bamboo paper, sheet: 153.5 × 202 cm (60⅜ × 79½ in.)

reprinted in Canton in 1856. Little known today, this later version of the *Kunyu quantu* may have been the inspiration for the imprint made in Hanyang (Seoul) in 1860 at the behest of the Korean king. Though minor stylistic changes were introduced in the new woodblocks (which are still extant), the Korean version (cat. no. 26) is quite faithful to the Chinese original.[41]

The republishing of the *Kunyu quantu* outside China testifies to the map's historic impact. This late-blooming interest in Verbiest's map, not only in China but also in Korea, is all the more remarkable because by then more accurate world maps were available. In 1761, the French Jesuit Michel Benoist had made a new *Kunyu quantu,* again in the form of two hemispheres in equatorial stereographic projection, to celebrate the fiftieth birthday of the Qianlong emperor. In addition to being geographically up to date, this work finally introduced the Copernican system to China.[42] While it is possible that Benoist's map was not as widely distributed as those of Ricci and Verbiest, and therefore may have received less attention, by 1860 many other world maps were in circulation, any one of which could supply the practical cartographic needs of the East Asian public. It is likely, therefore, that when Verbiest's *Kunyu quantu* was painstakingly carved onto new blocks in Korea, it had lost its role as a purveyor of exact geographic knowledge. It had become instead a historical document and a decorative object, valued more for its visual beauty and its cultural significance than its reckoning of the surface of the earth.

Notes

All translations from Chinese into English are by the authors.

1. Pasquale M. D'Elia, ed. and trans., *Il mappamondo cinese del p. Matteo Ricci, S.J.*, 3rd ed. (Vatican City: Biblioteca Apostolica Vaticana, 1938); and Cordell D. K. Yee, "Traditional Chinese Cartography and the Myth of Westernization," in J. B. Harley and David Woodward, eds., *The History of Cartography*, vol. 2, pt. 2, *Cartography in the Traditional East and Southeast Asian Societies* (Chicago: Univ. of Chicago Press, 1994), 170–77.

2. See Hartmut Walravens, "Father Verbiest's Chinese World Map (1674)," *Imago Mundi* 43 (1991): 31–47. A partial copy is in the Biblioteca Apostolica Vaticana, Vatican City (Barb. or. 151, fasc. 1a); see http://www.ibiblio.org/expo/vatican.exhibit/exhibit/i-rome_to_china/Rome_to_china.html (22 August 2006). A digital reproduction is in the Hong Kong Catholic Diocesan Archives (Photo Gallery, MK 001, 002, 003).

3. This globe is now at the British Museum, London. See Yolande Jones, Howard G. H. Nelson, and Helen Wallis, *Chinese and Japanese Maps: An Exhibition Organized by the British Library at the British Museum*, exh. cat. (London: British Museum for the British Library Board, 1974), no. C7; and Richard J. Smith, *Chinese Maps: Images of "All under Heaven"* (Oxford: Oxford Univ. Press, 1996), 50.

4. Unno Kazutaka, "Tang Ruowang oyobi Jian Youren no sekaizu ni tsuite" (J. A. Schall von Bell's and M. Benoist's Chinese World-Maps), in *Jinbun-Chirigaku no shomondai* (Problems of human geography) (Tokyo: Taimeidō, 1968), 83–93.

5. Copies are in Ghent at the Universiteitsbibliotheek Gent and in London at the Robinson Collection at the British Library. See Ann Heirman, "An Introduction to the World Map of Francesco Sambiasi (1582–1649)," *Annali dell'Istituto universitario orientale* 60–61 (2000–2001): 365–73; *Chine ciel et terre: 5000 ans d'inventions et de découvertes*, exh. cat. (Brussels: Musées Royaux d'Art & d'Histoire, 1988), 406–7 (no. 285); Walravens, "Father Verbiest's Chinese World Map" (note 2), 31–32; and Jones, Nelson, and Wallis, *Chinese and Japanese Maps* (note 3), no. C8.

6. See David E. Mungello, *Curious Land: Jesuit Accommodation and the Origins of Sinology* (Honolulu: Univ. of Hawaii Press, 1989), 116–24.

7. In addition to world maps, the Jesuits were engaged in other geographic endeavors, notably the mapping of the Chinese empire. See Marcia Reed, "A Perfume Is Best from Afar: Publishing China for Europe," this volume, p. 20, and cat. no. 7.

8. The four external cartouches on the right are titled, top to bottom, *Si yuanxing zhi xu bing qi xing* (The sequence and shape of the four elements), *Diqiu nanbei liangji bi dui tianshang nanbei liangji bu li tian zhi zhongxin* (The earth's south and north poles point to heaven's south and north poles, [thus the earth] is at the center of heaven), *Di yuan* (The earth is spherical), and *Di ti zhi yuan* (The spherical body of the earth). The four external cartouches on the left are titled, top to bottom, *Dizhen* (Earthquakes), *Renwu* (People), *Jianghe* (Rivers), and *Shanyue* (Mountains). The internal cartouches along the top edge are titled, right to left, *Yu yun* (Rain and clouds), *Feng* (Winds), and *Qi xing* (Air as an element). Along the bottom edge, the internal cartouches are titled, right to left, *Huowen chaoxi zhi wei* (Reasons for tides), *Hai zhi chaoxi* (Tides of the seas), and *Haishui zhi dong* (Movements of the sea currents).

9. Complete copies of the *Kunyu quantu* of 1674 are at the Library of Congress, Washington, D.C.; Biblioteca Apostolica Vaticana, Vatican City; Bibliothèque nationale de France, Paris (no. 1914); Hebei University Library, Baoding, China (colored); National Palace Museum, Taiwan; and Kobe Municipal Library, Japan (colored). Incomplete copies are at the Hunterian Museum and Art Gallery, Glasgow; Bibliothèque nationale de France, Paris (nos. 1027, 1275, 1915); Uppsala Universitetsbiblioteket; and National Library of Australia, Canberra (colored). See Li Xiaocong, *Ouzhou shoucang bufen zhongwen guditu xulu = A Descriptive Catalogue of Pre-1900 Chinese Maps Seen in Europe* (Beijing: Guoji Wenhua Chuban Gongsi, 1996), 10–12; Lin Tongyang, "Aperçu sur le mappemonde de Ferdinand Verbiest le K'un-yü-ch'üan-tu," in Edward J. Malatesta and Yves Raguin, eds., *Succès et échecs de la rencontre Chine et Occident du XVIe au XXe siècle* (San Francisco: Ricci Institute for Chinese-Western Cultural History, University of San Francisco, 1993), 146–47; and Wang Qianjin, "Nan Huairen kunyu quantu yanjiu" (A study on Ferdinand Verbiest's *Kunyu quantu*), in Cao Wanru et al., eds., *Zhongguo gudai ditu ji* (A collection of ancient Chinese maps) (Beijing: Wenwu Chubanshe, 1997), 3:102–4.

10. See Matteo Ricci, *Qiankun tiyi* (On the structure of heaven and earth), in Ji Yun and Yong Rong, eds., *Siku quanshu* (A complete library of the Four Treasures) (Beijing: Wenyuange Edition, 1773–82; reprint, Taipei: Taiwan Shangwu Yinshuguan, 1983–86), vol. 787, p. 762. The arguments are quite similar in wording to the ones on his world map of 1602, save that the map's denomination of God as *Tianzhu* (Lord of Heaven) is changed in the *Qiankun tiyi* to *Zaowu zhe* (Creator). These explanations seem to expand Ricci's brief introduction of the four elements in his *Tianzhu shiyi* (True meaning of *Tianzhu* [Lord of Heaven], 1596)—for which, see Matteo Ricci, *The True Meaning of the Lord of Heaven (T'ien-chu Shih-i)*, ed. Edward J. Malatesta, trans. Douglas Lancashire and Peter Hu Guozhen (Taipei: Institut Ricci, 1985), 148–51 (para. 138), 192–93.

11. On the *huntian* theory, see Yee, "Taking the World's Measure: Chinese Maps between Observation and Text," in J. B. Harley and David Woodward, eds., *The History of Cartography*, vol. 2, pt. 2, *Cartography in the Traditional East and Southeast Asian*

Societies (Chicago: Univ. of Chicago Press, 1994), 117–24; and Smith, *Chinese Maps* (note 3), 24–25.

12. For more on this map, see Smith, *Chinese Maps* (note 3), 37–38; and John B. Henderson, "Chinese Cosmographical Thought: The High Intellectual Tradition," in J. B. Harley and David Woodward, eds., *The History of Cartography*, vol. 2, pt. 2, *Cartography in the Traditional East and Southeast Asian Societies* (Chicago: Univ. of Chicago Press, 1994), 209. On Chinese cosmological ideas, see Henderson, "Chinese Cosmographical Thought" (this note), 203–27; and Yee, "Taking the World's Measure" (note 11), 117–24.

13. See Gang Song, "Learning from the Other: Giulio Aleni, *Kouduo Richao*, and Late Ming Dialogic Hybridization" (Ph.D. diss., University of Southern California, 2006), sec. 3.2.

14. The stereographic projection is a mapping that projects each point of the globe onto a tangent plane along a straight line that originates at the point directly opposite the point of tangency. See Johannes Keuning, "History of Geographical Map Projections until 1600," *Imago Mundi* 12 (1955): 7–9 (figs. 4, 5).

15. See Walravens, "Father Verbiest's Chinese World Map" (note 2), 33.

16. The differences between the colophons on the original of 1674 and the Korean imprint of 1860 are discussed in this volume, p. 190 (cat. no. 26).

17. For example, the island identified on Dutch maps as Formosa and by Ricci as the Great Ryukyu (*Da liuqiu*) is identified by its new Chinese name of Taiwan, a change that marked the transfer of authority over this island from the Dutch colonialists to the anti-Qing Zheng family in 1662.

18. No animals decorate Ricci's map of 1602, but some do appear on hand-colored copies of the 1608 imperial version (such as that at the Nanjing Museum); see D'Elia, *Il mappamondo cinese* (note 1), pls. XXVII–XXX. The animals on Ricci's map differ from those on Verbiest's.

19. Walravens, "Father Verbiest's Chinese World Map" (note 2), 34.

20. Verbiest uses here *zhuzai tianxia zhe*, a relatively rare Chinese expression certainly referring to the Christian God.

21. Bernard Hung-kay Luk, "A Study of Giulio Aleni's *Chih-fang wai-chi*," *Bulletin of the School of Oriental and African Studies* 40 (1977): 76.

22. Cf. Ferdinand Verbiest, *Kunyu tushuo* (Illustrated explanations of the world), in Ji Yun and Yong Rong, eds., *Siku quanshu* (A complete library of the Four Treasures) (Beijing: Wenyuange Edition, 1773–82; reprint, Taipei: Taiwan Shangwu Yinshuguan, 1983–86), vol. 594, pp. 729–41.

23. Verbiest's source for the Seven Wonders may have been the decorations at the lower margin of

the *Nova Totius Terrarum Orbis Geographica ac Hydrographica Tabula* from Johannes Blaeu's world atlas of 1630.

24. See Louis Pfister, *Notices biographiques et bibliographiques sur les jésuites de l'ancienne mission de Chine, 1552–1773*, vol. 1, *XVIe et XVIIe siècles* (Shanghai: Imprimerie de la Mission Catholique, 1932), pp. 355–56 (notice no. 124 [Ferdinand Verbiest], nos. 14, 15); and Walravens, "Father Verbiest's Chinese World Map" (note 2), 33. Another version, titled *Diqiu quantu* (Complete map of the earth), is reported to exist; see Lin Tongyang, "Ferdinand Verbiest's Contribution to Chinese Geography and Cartography," in John Witek, ed., *Ferdinand Verbiest (1623–1688): Jesuit Missionary, Scientist, Engineer and Diplomat* (Nettetal, Germany: Steyler, 1994), 140.

25. Copies of this first reduced version are in Venice at the Biblioteca nazionale Marciana and in Paris at the Bibliothèque nationale de France. The introduction comprises 1,630 characters (49 lines of 33 characters, 1 line of 13), preceded by the title (4 characters) and followed by the colophon (22 characters). The dimensions of the copy in Venice are 63.5 × 158 cm (25 × 62¼ in.). See Amelia Pezzali, "Un mappamondo del XVII secolo, patrimonio della Marciana," *Ateneo veneto*, n.s., 10 (1972): 45–59; and Christine Vertente, "Nan Huai-jen's Maps of the World," in Edward J. Malatesta and Yves Raguin, eds., *Succès et échecs de la rencontre Chine et Occident du XVIe au XXe siècle* (San Francisco: Ricci Institute for Chinese-Western Cultural History, University of San Francisco, 1993), 257–63.

26. Copies of this second version are in Rome at the Società geografica italiana (no. 15) and in Paris at the Bibliothèque national de France (Res. GE C 5359). The introduction comprises more than 1,600 characters (76 lines of ca. 22 characters each). The dimensions of the copy in Rome are 86.7 × 120 cm (34⅛ × 47¼ in.); those of the copy in Paris are 85 × 110 cm (33½ × 43¼ in.). See *Carte di riso: Genti, paesaggi, colori dell'Estremo Oriente nelle collezioni della Società geografica italiana = Peoples, Landscapes, Colours in the Collections of the Italian Geographical Society*, exh. cat. (Rome: Società Geografica Italiana, 2001), 56–61; Claudio Cerreti, ed., *Carte di riso: Far Eastern Cartography with a Complete Catalogue of the Collection of Chinese and Japanese Maps Owned by the Società Geografica Italiana* (Rome: Società Geographica Italiana, 2003), 197 (no. 15); and Vertente, "Nan Huai-jen's Maps" (note 25), 258–59.

27. On Verbiest's other achievements, see Paola Demattè, "From Astronomy to Heaven: Jesuit Science and the Conversion of China," this volume, pp. 58–66; and Lin, "Ferdinand Verbiest's Contribution" (note 24), 135–36, 142.

28. Verbiest, *Kunyu tushuo* (note 22), vol. 594, p. 731 (*juan* 1).

29. Lin, "Ferdinand Verbiest's Contribution" (note 24), 138–39.

30. See Walravens, "Father Verbiest's Chinese World Map" (note 2), 37–45; and Wang, "Nan Huairen" (note 9), 102–4.

31. See Walravens, "Father Verbiest's Chinese World Map" (note 2), 37. For other sources, see Theodore N. Foss, "A Western Interpretation of China: Jesuit Cartography," in Charles E. Ronan and Bonnie B. C. Oh, eds., *East Meets West: The Jesuits in China, 1582–1773* (Chicago: Loyola Univ. Press, 1988), 214; and Lin, "Ferdinand Verbiest's Contribution" (note 24), 138–40. On Blaeu's map, see Rodney Shirley, *The Mapping of the World: Early Printed World Maps, 1472–1700* (London: Holland, 1983), 392–96 (no. 371).

32. Vertente, "Nan Huai-jen's Maps" (note 25), 257–63. On Mercator maps, see Shirley, *Mapping of the World* (note 31), 179 (no. 157), 137–42 (no. 119).

33. Mungello, *Curious Land* (note 6), 116–24; and Mei-ling Hsu, "An Inquiry into Early Chinese Atlases through the Ming Dynasty," in John A. Wolter and Ronald E. Grim, eds., *Images of the World: The Atlas through History* (New York: McGraw-Hill, 1997), 41–48.

34. Chen Minsun, "Ferdinand Verbiest and the Geographical Works by Jesuits in Chinese, 1584–1674," in John W. Witek, ed., *Ferdinand Verbiest (1623–1688): Jesuit Missionary, Scientist, Engineer and Diplomat* (Nettetal, Germany: Steyler, 1994), 129–31.

35. See the large square cartouche of text titled *Ouluoba zongshuo* (General account of Europe), which is in the lower left quadrant of the eastern hemisphere between the outer edge and the large rectangular cartouche just off the western coast of Africa; cf. this volume, fig. 79 (left).

36. Catherine Jami, "Imperial Control and Western Learning: The Kangxi Emperor's Performance," *Late Imperial China* 23, no. 1 (2002): 28–49.

37. *Qing shengzu shengxun* (Imperial edicts of the Kangxi emperor, vol. 52); cited in Sun Zhe, *Kang-Yong-Qian shiqi yutu huizhi yu jiangyu xingcheng yanjiu* (Studies on mapmaking and territorial formation during the Kangxi, Yongzheng, and Qianlong periods) (Beijing: Zhongguo Renmin Daxue Chubanshe, 2003), 40–41.

38. Yee, "Traditional Chinese Cartography" (note 1), 170–77. For another view, see Joseph Needham with Ling Wang, *Science and Civilisation in China,* vol. 3, *Mathematics and the Sciences of Heaven and Earth* (Cambridge: Cambridge Univ. Press, 1959), 583–90.

39. Song Liming, "An Evaluation of the Chinese Maps in the Possession of the Società Geografica Italiana," in Claudio Cerreti, ed., *Carte di Riso: Far Eastern Cartography, with a Complete Catalogue of the Collection of Chinese and Japanese Maps Owned by the Società Geografica Italiana* (Rome: Società Geografica Italiana, 2003), 102.

40. See, for example, Zhuang Tingfu's *Haiyang waiguo tubian* (An illustrated record of foreign countries in the seas, 1788) and Wei Yuan's *Haiguo tuzhi* (An illustrated gazetteer of maritime countries, 1844). Other scholar-geographers influenced by Verbiest's map were Li Mingche and Xu Jiyu; see Lin, "Ferdinand Verbiest's Contribution" (note 24), 160–61.

41. For details on differences and similarities, see this volume, p. 190 (cat. no. 26). The Musée national des arts asiatiques-Guimet in Paris owns a hand-colored version of the Korean map mounted (with the outermost panels transposed) on a screen; it is illustrated in *From Beijing to Versailles: Artistic Relations between China and France,* exh. cat. (Hong Kong: Urban Council of Hong Kong, 1997), 148–49, 152–52 (cat. no. 47 by Jean-Paul Desroches).

42. A copy of Benoist's map, which measures 191.5 × 372.8 cm (75⅜ × 146⅜ in.), is held by the Zhongguo Diyi Lishi Dang'anguan (First Historical Archives of China) in Beijing; see Cao Wanru et al., eds., *Zhongguo gudai ditu ji— Qing dai = An Atlas of Ancient Maps in China—the Qing Dynasty* (Beijing: Wenwu Chubanshe, 1990–97), 3:33–34, pl. 52.

耕

東皋一犁雨
布穀初催耕
綠野暗春曉
烏犍苦肩赬
我銜勸農字
杖策東郊行
永懷歷山下
往事關聖情

War and Peace: Four Intercultural Landscapes

RICHARD E. STRASSBERG

THROUGHOUT THE SEVENTEENTH AND EIGHTEENTH CENTURIES, the complex cultural encounter between China and Europe not only stimulated aesthetic imaginations on both ends of the Eurasian continent but also made new tools available for political and ideological ends. This essay considers four kinds of landscapes represented in a selection of contemporary rare books and prints. As these works, and others like them, circulated between and within countries, they were used by Chinese and Europeans to construct distinct visions of themselves and of each other, producing portraits with various degrees of cultural hybridity. The reception of this information casts light on the unpredictability of intercultural translation, for the results of these exchanges both conveyed and escaped the intentions of their originators.[1]

THE RURAL LANDSCAPE: ILLUSTRATIONS OF FARMING AND WEAVING No nation has altered its ecology and habitat in pursuit of economic, military, and political stability more radically than imperial China did over the course of several millennia. The construction of a unified China with a strong centralized government was based on sustaining not only huge armies in the field but also urban capitals whose sources of food were usually at a distance. The state gradually accomplished this task by implementing policies to increase the number of farmers, converting forests into arable land, and constructing an infrastructure of waterways for irrigation and transporting goods.[2]

Thus, when the Qing-dynasty Kangxi emperor and his successors, the Yongzheng and Qianlong emperors, issued new, imperial editions of Lou Shou's *Gengzhi shi* (Poems on farming and weaving, 1145), they were participating in a long-standing tradition of state-sponsored ruralism that prioritized agricultural production as fundamental to Chinese statecraft. The original text dates to the years when the Song dynasty was under threat from invaders from the northeast. By 1127, the Jurchen tribes of the area later known as Manchuria had conquered the northern half of Song territory, and the remnants of the Song court had fled to the Jiangnan region of the lower Yangtze River, establishing the Southern Song government in Hangzhou under Emperor Gaozong. It was under such dire conditions that Lou Shou, who was serving as a magistrate near

Detail of FIGURE 80

Hangzhou, produced a set of forty-five poems and illustrations designed to document the proper sequences for the cultivation of rice and the production of silk (sericulture)—two of imperial China's most important economic activities, both distinct to southern China—as well as to bring to Gaozong's attention the accomplishments of one of his loyal officials. Lou's grandsons had this work engraved on stone in 1210, and the poems were published in 1237 with wood-block illustrations by a military officer, Wang Gang. Though no copies of this edition survive today, it was repeatedly recopied and reprinted through the Yuan, Ming, and Qing dynasties.[3]

Ironically, Lou's work received its ultimate formulation as a result of a historic reversal in ethnic power relations. In 1644, four centuries after the original was composed, the Manchus, descendants of the Jurchens, occupied the Ming capital of Beijing and rapidly succeeded in conquering all of China. The social chaos of the latter years of the Ming dynasty, the physical devastation wrought by war, the Manchus' ongoing pacification efforts, and the institution of Manchu rule left significant segments of the majority Han population at odds with one another and their new rulers. It was not until 1684 that the Kangxi emperor felt confident enough to venture south on the first of six inspection tours to the empire's heartland, the Jiangnan region, where he sought to conciliate local gentry and merchants by demonstrating his command and support of Han scholar culture. During the second tour of 1689, at one of the ritualized occasions where gifts were exchanged and imperial largesse dispensed, a member of the local gentry presented the Kangxi emperor with a rare copy of Lou's book. The Kangxi emperor recognized an excellent propaganda tool and an opportunity for the Qing to further legitimate their rule by promoting an icon of Han ruralism. New illustrations were commissioned from a noted court artist, Jiao Bingzhen. Jiao held a position in the imperial Directorate of Astronomy while it was headed by the missionary-astronomer Ferdinand Verbiest, and he may have studied European perspective techniques under Verbiest. He is known to have collaborated with the missionary-artists serving the Kangxi emperor and to have trained a number of court artists in his own version of the Sino-European style. This hybrid style imported realism, modeling with chiaroscuro, and linear perspective into Chinese modes of artistic representation. In the resulting works, physical forms such as faces and trees were more individuated than in traditional Chinese works, while the depiction of space was more three dimensional and the presentation of light and shadow more lifelike. But in a context where traditional painting methods and imagination were valued more than accuracy, the Sino-European style did not take root: patronized by succeeding emperors throughout the eighteenth century, it persisted after the Qianlong emperor's death primarily in Cantonese export art.[4]

In 1696, the initial printing of the *Yuzhi gengzhi tu* (cat. no. 27) was issued. For this edition, Jiao had produced—probably with the aid of his student Leng Mei—forty-six designs that combine shifting and linear systems of perspective while creating an idealized, courtly version of these labor-intensive activities. In this peaceful world whose harmony and abundance proclaimed the emperor's sage rule, the women are attractive, well dressed, and poised, like images of palace women in a garden. The men appear clean and well fed as they carry out their work in an atmosphere of cooperation and sociability.

The Kangxi emperor inserted his imperial persona into the text by adding a preface and his own poems, which are written above each image in large, running-script callig-

raphy and accompanied by his personal seals. Lou's poems, by contrast, are set in small, standard characters within the picture frame. The emperor noted in the preface that model rice fields with rows of mulberry trees planted for sericulture were located beside the imperial Garden of Abundant Fertility (Fengzeyuan) outside the Forbidden City in Beijing and that two special pavilions had been built there so that the emperor could observe these activities close-up. The emperor's tone is one of moral seriousness as he affirms his commitment to supporting these cornerstones of the Chinese economy. Appropriately, he dated the preface to the day of the annual imperial sacrifice to the god of the earth in spring 1696.[5]

The *Gengzhi tu* retained its popularity through the Qing dynasty and into the twentieth century. Not only were imperial editions periodically issued but the work was also released in provincial and other local government editions as well as by commercial publishers. The Yongzheng emperor, following his father's precedent, wrote additional poems and commissioned a unique album in which Jiao's illustrations were reproduced with the emperor and his family represented among the figures.[6] The Qianlong emperor composed a new set of poems and commissioned images for another printed edition in 1739. He also had copies of Jiao's album made by the Sino-Western court painters Leng Mei and Chen Mei. Among the many other editions in circulation at the middle of the eighteenth century was one that contained poems by all three of these emperors. In 1769, the Qianlong emperor ordered a set of forty-five stone engravings of the *Gengzhi tu* from which rubbings could be taken and disseminated. Based on a Yuan-dynasty painted album by Cheng Qi that closely followed Lou's original illustrations and poems, these engravings included poems by the Qianlong emperor in the rhymes used by Lou. The stones were placed in the Pavilion of Crops (Duojiaxuan) in the Garden of Perfect Clarity (Yuanmingyuan).[7]

A comparison of Jiao's version of "Second Molting" (*ermian*) with the rubbing of Cheng's design reveals some of the later artist's innovations (figs. 36, 37). In the earlier, more iconic image, the architecture frames a balanced scene of human intergenerational nurture and the nurturing of silkworms, while the two mulberry trees in the left foreground juxtapose nature and culture. Jiao's image extends both the depth and height of the scene and focuses interest on the expanded group of domestic figures rather than on the sericultural activity. The older, seated woman is now rendered as a relaxed, younger beauty, while the laboring woman behind her moves a tray of silk cocoons—a less strenuous task than rolling up a bamboo shade. The figures are better proportioned physically than in Cheng's depiction, and greater visual interest is created by including another child who pulls at his mother's clothes and a dog playfully peering over a fence on the left. The mulberry trees are banished to behind the house, replaced by a winding stream and a large rock, elements featured in the pleasure gardens of the elite.

Though not intended for export, the *Yuzhi gengzhi tu* was disseminated in Korea, Japan, and the Ryukyu Islands. Individually, the images were reproduced on porcelain and other decorative objects produced in China, some of which found their way into European collections.[8] They also turned up on a variety of chinoiserie works. For example, the motif of the women and children in "Second Molting" appears, heavily modified but still recognizable, on one of a pair of eighteenth-century Sèvres porcelain vases attributed to Charles-Nicolas Dodin (fig. 38). As a set, the images dealing with the production of rice were released in 1760 by John Bowles, a London printseller and publisher who

桑桑初
剪綠紊
羡佰上
歸來日
正遶村
舍家〻
簾幃靜
春蠶新
長再眠
時

二眠
吳蠶一再眠竹屋下簾
幕拍手夫妻兒一笑姑
不惡風來麥秀寒雨過
桑沃若日高蠶未起谷
鳥鳴百箔

FIGURE 36
Zhu Gui (Chinese,
ca. 1644–1717) or Mei Yufeng
(Chinese, fl. ca. 1696), after
Jiao Bingzhen (Chinese,
1662–1720), **Ermian** (Second
molting), 1696, hand-colored
woodcut, 35.6 × 27.9 cm
(14 × 11 in.)
From Jiao Bingzhen,
Yuzhi gengzhi tu (Beijing:
Wuyingdian, 1696), [pl. 25]

FIGURE 37
*Tissage: 5, Deuxième sommeil
des vers* (Weaving: 5, Second
molting of the silkworms),
reproduction of rubbing of
eighteenth-century stone
engraving after Cheng Qi's
Yuan-dynasty painted
illustration for Lou Shou's
Gengzhi shi (1145)
From Paul Pelliot, "A propos
du *Keng Tche T'ou*," *Mémoires
concernant l'Asie Orientale (Inde,
Asie Centrale, Extrême-Orient)* 1
(1913): pl. XXXVII

FIGURE 38
Sèvres Porcelain Manufactory;
painted decoration attributed
to Charles-Nicolas Dodin
(French, 1734–1803), **Vase,**
ca. 1760, soft-paste porcelain;
pink, blue, and green ground
colors, polychrome enamel
decoration, and gilding,
29.8 × 16.5 × 14.6 cm
(11¾ × 6½ × 5¾ in.)

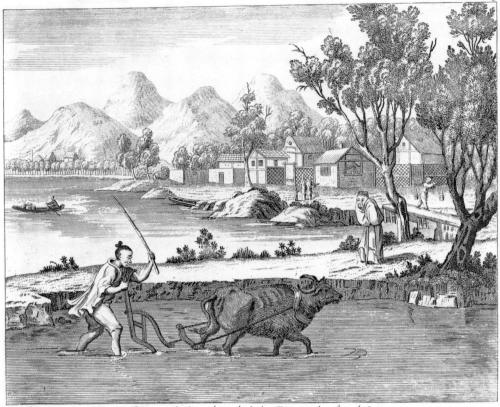

A.H. delin.

Plowing the Ground on which the Rice is to be Sowed?

MONSEIGNEUR LE DAUPHIN LABOURANT

FIGURE 39

Labourage: 2, Labour (Farming: 2, Plowing), reproduction of rubbing of eighteenth-century stone engraving after Cheng Qi's Yuan-dynasty painted illustration for Lou Shou's *Gengzhi shi* (1145)
From Paul Pelliot, "A propos du *Keng Tche T'ou*," *Mémoires concernant l'Asie Orientale (Inde, Asie Centrale, Extrême-Orient)* 1 (1913): pl. XII

FIGURE 40

John June (British, fl. 1740–70), after A. H., ***Plowing the Ground on Which the Rice Is To Be Sowed,*** 1770, engraving, 20.9 × 37.4 cm (8¼ × 14¾ in.)
From *The Rice Manufactury in China: From the Originals Brought from China* (London: printed for Carington Bowles, John Bowles, & Robert Sayer, [1770]), pl. 3

FIGURE 41

François-Marie-Antoine Boizot (French, 1739–81), after Paulin de Fleins, ***Monseigneur le Dauphin labourant*** (The dauphin plowing), 1769, wash manner, 46 × 56 cm (18⅛ × 22 in.)

issued other books about China, including *The Emperor of China's Palace at Pekin, and His Principal Gardens* (1753) (cat. no. 31).[9] Titled *The Rice Manufactury in China,* this work featured engravings by John June that present another version of Lou's images. A comparison of a rubbing of Cheng's *Geng* (Plowing) with the images by Jiao and Bowles provides a study in the transformation of artistic style over time and across traditions (figs. 39, 80, 40). By this time, many Europeans knew that every year the Chinese emperor performed a plowing ritual at the Altar of Agriculture in early spring (see fig. 67). In France, where the Physiocrats were urging agricultural reforms as part of a broader political and social program to preserve the monarchy, China was held up as a model government in part for its high regard for agriculture as essential to the welfare of the state. Libertarian thinkers such as Montesquieu and Jean-Jacques Rousseau dissented from this idealization and judged the Chinese political system oppressive, but Voltaire advised all European monarchs to follow the example of the Chinese emperor as a gesture of support for peasant-farmers. In fact, between 1756 and 1769, several did just that, and prints and descriptions circulated commemorating royalty such as Louis XV, the dauphin (fig. 41), and Joseph II of Austria plowing the fields.[10] Perhaps no other imperially printed book in China enjoyed such wide circulation or was so appreciated for its political, didactic, and artistic significance. It convincingly presented one face of the Qing empire — that of a bucolic, productive, and prosperous land at peace under benevolent rulers.

THE LANDSCAPE OF MULTICULTURAL EMPIRE: THE CONQUESTS OF THE QIANLONG EMPEROR The Manchus, a relatively small, loosely organized group of tribes, arose in northeastern Asia in the same period when great world empires were being assembled by a number of nation-states in Eurasia. Within a few generations, they had occupied Beijing, where the Ming dynasty lay in disarray in 1644 as a result of peasant rebellions. The Manchus then proceeded to rapidly conquer the rest of China, eventually extending their hegemony into Central Eurasia to create a vast multicultural, continental state that some Europeans referred to as Grand Tartary. Essential to the Manchus' success were their organization of the troops that made up the new ruling class into banners,[11] their ongoing alliances with neighboring Mongol tribes, their continuation of the Han Confucian civil service, and their state-building enterprises, which ranged from agricultural reclamation and improved transportation networks to the mapping of the empire.[12] Such strategies enabled the Manchu emperors to dominate the numerically superior Han Chinese and to extend the effective borders of the Qing empire far beyond those of the great dynasties of the past. Under the Qing, Tibet, Xinjiang, Mongolia, Manchuria, and Taiwan now came under a single jurisdiction.

For the Manchus, annexing territories in the west represented the second phase of their expansion after the conquest of China. The competition for hegemony in Central Eurasia among three states — Muscovite Russia, the Zunghar Mongolian confederation, and Qing China — led to almost a century of sporadic warfare, lasting through the reigns of three emperors. During the Qianlong emperor's reign, infighting among the Zunghars provided him with an opportunity to take decisive action, and in 1755, the emperor sent an expeditionary force to what is now northwestern Xinjiang. Thus began the series of battles that are represented in the sixteen engravings of the *Pingding Zhunga'er Huibu desheng tu* (1765–75) (cat. no. 28). Despite some dramatic moments in the campaign, by 1759 the Qing forces were able to decimate the Zunghars as well as

subdue the Turkic Muslim tribes farther south who had suddenly risen in revolt. This brought a large part of what the Chinese traditionally referred to as the Western Region (Xiyu) under Qing control, resulting in the inclusion of a vast domain that was later named "Xinjiang," or "New Territory."[13] Toward the end of his long reign, the Qianlong emperor would consider his consolidation of power over the Western Region among his greatest achievements.[14] In the west, the Qing were only able to defeat their mobile and resourceful nomadic opponents when they mastered the logistics of supplying distant armies for extended periods of time.[15] That the success of the Qianlong emperor in expanding China's agricultural economy assured sufficient supplies for his troops was one of the practical results of Qing state-sponsored ruralism.

The Qing court sought to maintain solidarity with Mongolian and Tibetan allies while also promoting Manchu martial ideals and superiority through the regular performance of elaborate military rituals and the dissemination of propagandistic images and texts.[16] This self-conscious promotion of war and militarism reached peak intensity under the Qianlong emperor, who feared with some justification that many bannermen were losing their sense of Manchu identity and martial vigor as a result of living among the Han Chinese. The celebration of Qing victories in the Western Region was thus concurrent with other policies carried out under the Qianlong emperor that were designed to reinvigorate the Manchu fighting spirit and prevent further acculturation of the Manchu elite.[17] And yet, as Peter Perdue notes, the composition of the Qing forces who won these battles "was truly multiethnic, including Mongol and Manchu generals, Han supply commanders, and even some surrendered Zunghar troops."[18]

As documents glorifying Qing military triumphs, the engravings of the *Pingding Zhunga'er Huibu desheng tu* participated in this cultural campaign. They originated with a set of large wall paintings commissioned by the Qianlong emperor and executed by court artists, including some of the Jesuit missionary-artists, for display in the ceremonial Hall of Imperial Glory (Ziguangge) along with one hundred portraits commemorating the military heroes of the western battles. Located along the Central Sea (Zhonghai), a lake just west of the Forbidden City, the newly renovated hall was used frequently as a site for Qing diplomatic and military rituals celebrating imperial achievements. Indeed, in February 1761, it had hosted a grand banquet honoring the victors whose portraits bedecked its interior (see fig. 81).[19]

When the Qianlong emperor was shown European engravings of panoramic battle scenes after paintings by the German artist Georg Philipp Rugendas I, he was so impressed that he decided to commission a similar series of prints in the European style based on the wall paintings of the western campaigns.[20] In 1765, four of the leading missionary-artists at the court in Beijing—Giuseppe Castiglione, Jean-Denis Attiret, Giovanni Damasceno (né Sallusti), and Ignatius Sichelbart—were instructed to draw reduced versions of the battle paintings in the Hall of Imperial Glory as working designs to be sent to the best European printmakers for execution.[21]

To achieve his vision, the emperor was prepared to spend a considerable sum on production and issued extremely detailed orders regarding the commission. Oversight was entrusted to both the Workshop of the Imperial Household Department and high-ranking members of the government bureaucracy. Originally, Great Britain was to undertake the project, though Castiglione had hoped it would go to Italy. But the French head of the Jesuit mission, seeing an opportunity to increase his country's influence, argued

that France was then the most artistically advanced country in Europe, and the commission was awarded accordingly. The government of Louis XV considered the charge a coup and treated it as a chance to display French technical achievements to the Chinese. Although the Qianlong emperor urged that the project be expedited, it took almost ten years to complete. It was not until the middle of 1775 that the final shipment reached Beijing. The Qianlong emperor presented eighty-one of the two hundred sets he received to imperial relatives and other favorites on five occasions and later ordered that some sets be distributed to various imperial palaces and temples.[22] He had sought to maintain exclusive ownership of the images, insisting that the copperplates be returned together with all prints, but a small number of additional sets remained in France. A few of these were presented to the French king, and others found their way into the hands of leading ministers, court favorites, and those directly connected with the project. In addition, the French East India Company, which acted as an intermediary and shipping agent, may have obtained a few sets. Despite the emperor's express wishes, the images were soon for sale in Europe under the title *Conquêtes de l'empereur de la Chine* (1785) (cat. no. 29). The suite's publisher, Isidore-Stanislaus-Henri Helman, not only reduced the size of the engravings but also captioned and ordered them to accord with his idea of their content.[23]

The series begins with the submission of the peoples of the Yili region in 1755 and culminates with three imperial military rituals accorded the victors in Beijing (see fig. 81).[24] If the *Yuzhi gengzhi tu* reflects the highly sinicized pole of Sino-Western styles, the *Pingding Zhunga'er Huibu desheng tu* stands at the opposite pole, where European pictorial elements dominate. *Hu'erman da jie* (Triumph at Qurman), engraved by Augustin de Saint-Aubin after Damasceno's drawing, represents a battle on 3 February 1759, when General Fude with only six hundred men relieved General Zhaohui, whose camp was besieged by five thousand Muslims.[25] Compared to a fragment of a Chinese treatment of the same subject, which choreographs the tiny battling figures within a traditional landscape,[26] the engraving focuses firmly on detailing the actions of the human figures while the landscape serves as a distant backdrop (figs. 42, 43). It employs such European picturesque devices as a darkened foreground that frames the lighter, open zones of the middle portion, which recedes toward a vanishing point in the upper third of the picture. The rhythm of the conflict is echoed by the three dark trees that jut from the bottom edge: the leftmost leans back, like the reserve troops ranked beyond it; the tree in the middle leans right, mimicking the attacking Qing; and the rightmost stands upright, where the battle is joined. The two prominent mountains in the background, whose shading emphasizes their dimensionality, are likewise poised symbolically: the one on the left, with the Qing troops, leans forward as the one on the right, near the enemy, rears back. The terrain and flora reproduce the forms of northern Italian landscapes and would have appeared alien to the Chinese — appropriate given the distance between Beijing and Qurman. The soldiers are packed together and appear to trample the ground, rather than flow along with it, as in the Chinese version. Some march in serried rows, shoulder-to-shoulder with fixed bayonets in contemporary European fashion, and they are accompanied by cannon, both horse-drawn and carried by a row of camels.

In this engraving, and even more in the other battle scenes, there is an abundance of factual detail and local narrative incident. Other plates make considerable use of architecture that is recognizably either Chinese or Mongolian — pavilions and yurts — or else employ generic Italianate forms to suggest a local, Central Eurasian style (fig. 44). Some plates introduce half-naked bodies that writhe in baroque, agonistic poses (fig. 45).

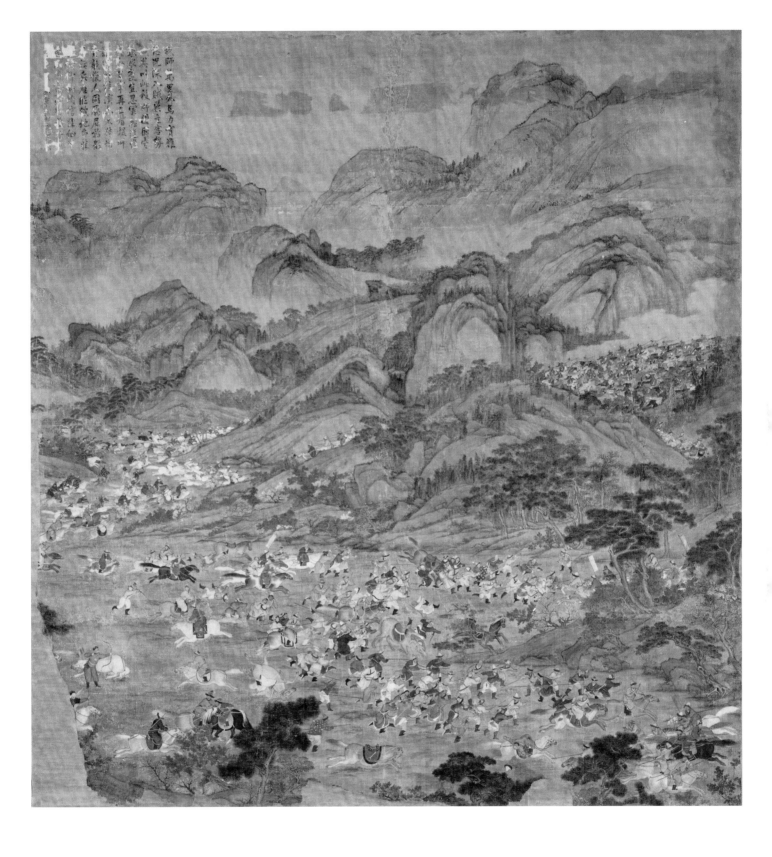

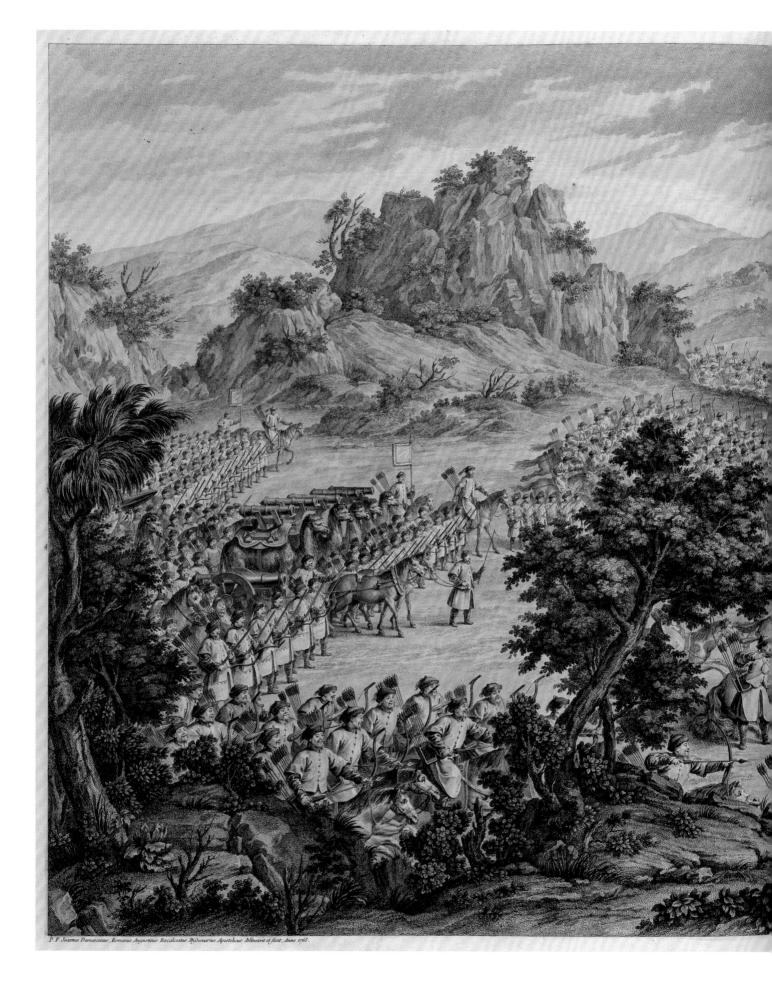

P. F. Joannes Damascenus, Romanus Augustinus Excalceatus Missionarius Apostolicus delineavit et fecit Anno 1765.

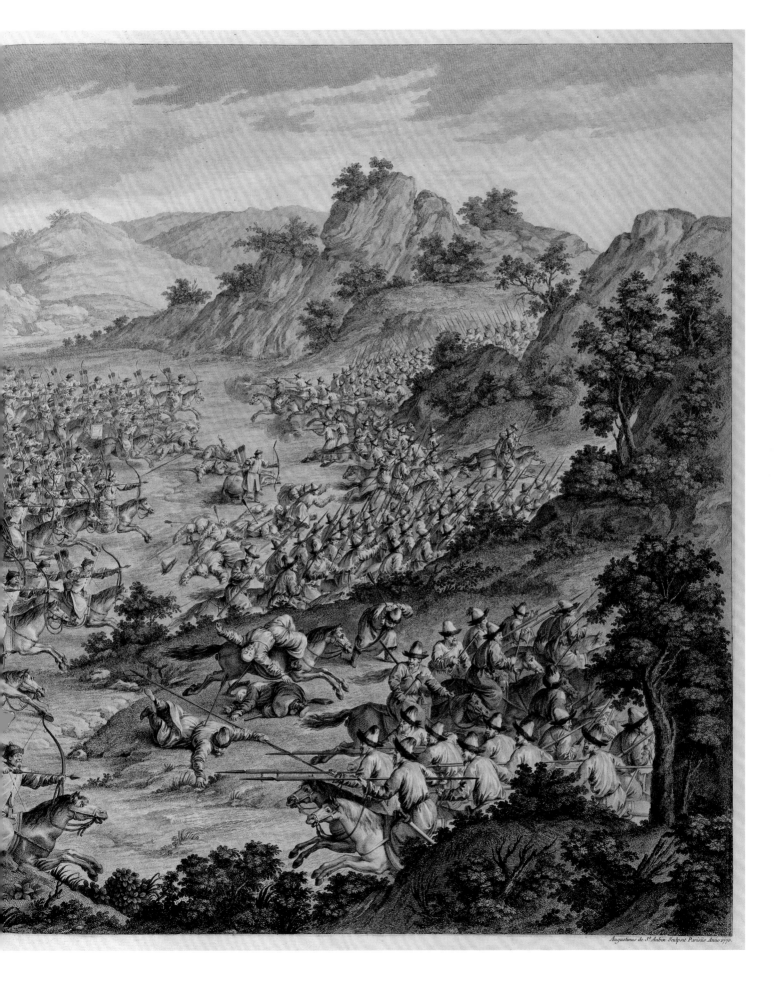

Augustinus de St Aubin Sculpsit Parisiis Anno 1770.

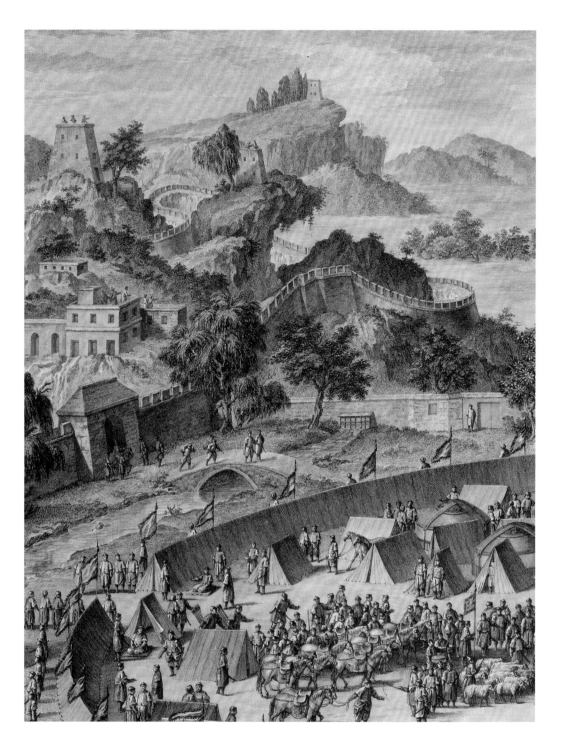

FIGURE 44
Pierre-Philippe Choffard
(French, 1730–1809), after
Giovanni Damasceno
(Italian, d. 1781), *Wushi
qiuzhang xianchengxiang*
(The chief of Ush Turpan
surrenders with his city)
(detail), 1774, engraving,
57.9 × 94.3 cm (22¾ × 37⅛ in.)
From the suite *Pingding
Zhunga'er Huibu desheng tu*,
1765–75, no. 6

FIGURE 45
Jacques-Philippe Le Bas
(French, 1707–83), after
Giuseppe Castiglione (Italian,
1688–1766), *Elei zhalatu zhi
zhan* (The battle at Oroï-jalatu)
(detail), ca. 1770, engraving,
57.2 × 92.9 cm (22½ × 36⅝ in.)
From the suite *Pingding
Zhunga'er Huibu desheng tu*,
1765–75, no. 3

Despite the dominance of the conventions of European history painting, some tradi-
tional Chinese pictorial elements do appear in the shapes of some of the foothills and
the twisting pine trees and junipers, for instance, and the horses galloping in midair, a
motif often found in Qing military art. And, in the final three engravings, with the shift
to peace and the return to "civilized" China, the rugged alpine terrain denoting foreign-
ness and chaos gives way to the gentler hills found in the orthodox style of Chinese
landscape painting favored by the Qing court. Both the compositional depth and drama-
tized action depicted in these engravings must have seemed striking to Manchu and Han
Chinese eyes. Viewers in Europe would have taken note of these images of the Qing as a
continental military power successfully expanding westward.

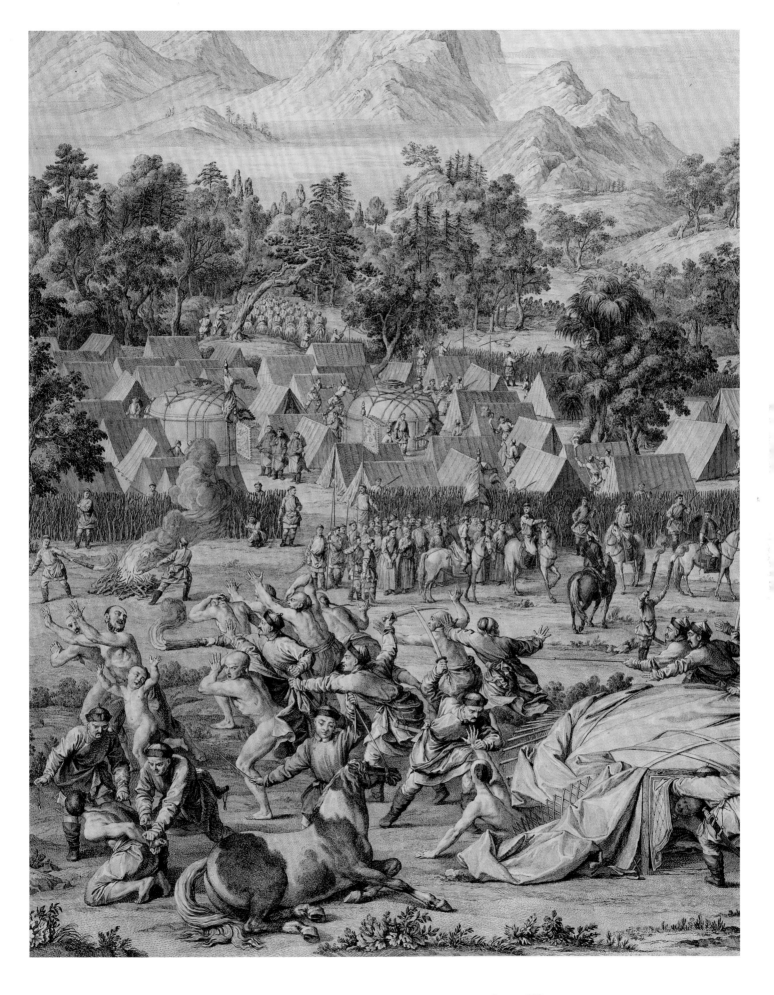

THE LANDSCAPE OF HYBRID PERSPECTIVES: THE EUROPEAN PAVILIONS AT THE GARDEN OF PERFECT CLARITY

In parallel development, the growth of royal autocracy in some European nations and in Qing China went hand in hand with the creation of new and more extensive palace estates that expressed the ruler's sense of his place at the center of a symbolic microcosm of the universe. The design of these monumental constructions primarily embodied native cosmographical concepts; but, as empires expanded and faced new challenges from foreign lands, rulers increasingly sought to inscribe domesticated versions of these other places in the form of exotic gardens. The Chinese emperors were intrigued by engravings of Versailles sent by the French kings and by images in books imported by the missionaries serving at their court, while general descriptions and some images of Chinese imperial palaces and gardens gradually filtered into Europe. At the same time that Europeans were enjoying the fashion for chinoiserie decoration and Chinese-style pavilions, the Qianlong emperor's similar fascination with objects from the West resulted in the European Pavilions (Xiyanglou, built 1747–83), a unique complex that fused baroque and Chinese aesthetic elements within the Garden of Perfect Clarity (Yuanmingyuan, 1709–1860).

The Garden of Perfect Clarity has been called the most celebrated yet least known of the Qing imperial palace-estates.[27] This is mainly due to successive waves of physical destruction, which have razed or reduced to rubble (fig. 46; cf. 48, no. 1) most of the garden and its structures since October 1860, when the complex was looted and burned by Anglo-French forces. But it is also due to the revival of interest in the complex in China that since 1949 has transformed its ruins into an icon of anti-imperialist nationalism.[28] Both the Garden of Perfect Clarity, on the outskirts of Beijing, and the even more extensive Mountain Hamlet for Escaping the Summer Heat (Bishushanzhuang, built 1702–90), an imperial summer palace in Chengde, about one hundred miles northeast of Beijing, were originally developed as alternatives to the Forbidden City. Beginning with the Kangxi emperor, Qing rulers realized that prolonged residence in country estates offered them an opportunity to lead freer and more healthful outdoor lives and escape the cloistered and ritualized palace lifestyle that had weakened their Ming-dynasty predecessors. From 1722 until its destruction, more than any other place, the Garden of Perfect Clarity served as the effective center of imperial power for five successive Qing monarchs.

Originally, the Kangxi emperor chose a flat area just northwest of the Forbidden City noted for the freshness of its air and water as well as the scenic beauty of the surrounding hills to construct a residence, the Garden of Joyful Spring (Changchunyuan, built ca. 1679–1708). In 1709, he gave a nearby estate to his fourth son, Yinzhen, and bestowed the name "Yuanming" on it. Literally meaning "round and bright," connoting perfection and excellence, and later translated by the artist-missionaries as "clarté parfaite," "Yuanming" was an allusion to a buddha's complete, all-encompassing state of wisdom.[29] In 1725, early in his reign as the Yongzheng emperor, Yinzhen wrote a defense of his decision to reside and conduct government affairs there rather than in the Forbidden City. In this essay, he augmented the name with a Confucian meaning whereby *yuan* signified the perfect, spiritual equilibrium of a noble person and *ming* denoted the illuminating wisdom of a universal man.[30] The garden complex reached its apogee of splendor under the Qianlong emperor, who grew up within its confines and involved himself in even the minutest aesthetic decisions regarding its construction during his sixty-year reign. It finally measured more than eight hundred acres after two neighboring estates—the

FIGURE 46
Thomas Child (British, 1841–98), *No. 201 Principal Palace Southside, Yuen Ming Yuen,* ca. 1875–85, photographic print (albumen), 21.3 × 24.1 cm (8⅜ × 9½ in.)

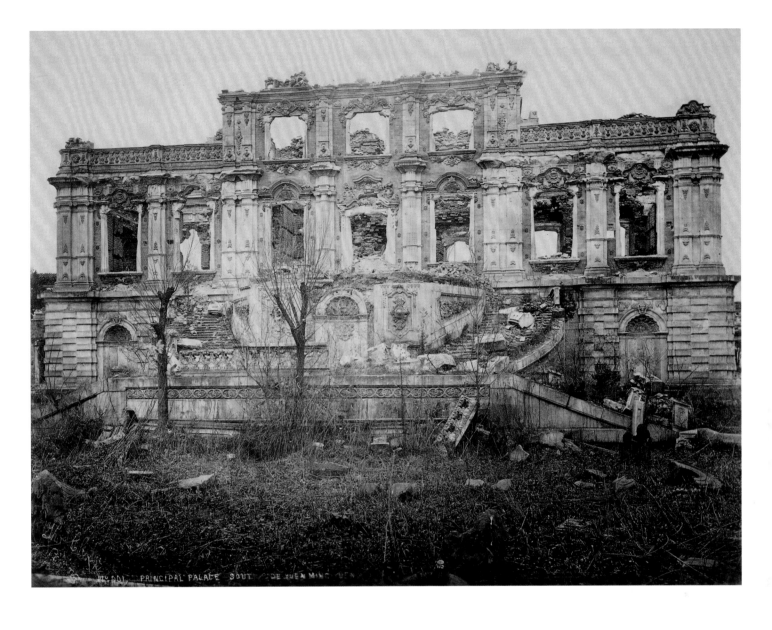

No. 601. PRINCIPAL PALACE SOUTH SIDE YUEN MING YUEN

Garden of Eternal Spring (Changchunyuan, ca. 1745–1860) and the Garden of Variegated Spring (Qichunyuan, ca. 1770–1860)—were added.

The expanded Garden of Perfect Clarity was an intricately structured, man-made landscape of hills, ponds, watercourses, islets, terraces, groves, flowering plants, rocks, and a full array of garden architecture, from corridors and gazebos to halls and temples. It contained more than six hundred fifty individually named structures and some one hundred thirty formal views.[31] It represented a transformation of the traditional plan of an imperial palace with formal reception halls in front and private gardens in the back, all arranged along a north-south axis. A new kind of modular plan was adopted based on the refined aesthetics of the Han scholar garden of the Jiangnan area, with its ideal of retirement in nature. Each complex was composed of numerous smaller structures that created a sense of multiple enclosures as well as distant space beyond. These areas were linked by winding paths, bridges, waterways, and lakes to create what has been described as "a garden of ten-thousand gardens."[32] Their disposition produced continuous sensations of surprise and delight as one traveled through an idealized landscape where the essential components of the Qing empire were represented.

The Garden of Perfect Clarity was an organic microcosm that evolved along with the Qing empire. It was appropriate that in the eighteenth century, it should come to include a representation of the Qianlong emperor's expanding vision of the West. His growing contact with Europeans and their culture, the embassies that to his mind brought tribute, and his immense collection of imported treasures reinforced a belief that, however distant the countries of Europe might be, they formed part of one universe that was increasingly encompassed within his purview. Indeed, the Qianlong

emperor's desi[...] [co]mmanding its particu-
lar mode of ob[...] [...] [d]esign, and function of
the European [...]

This compl[...] [...]or viewed an image of
mechanical fou[...] [...]n palace.[33] Captivated,
the emperor r[...] [...]ruct a similar scene for
him. It was the[...] [...]n of a thin strip of land
about seven a[...] [...]) at the northwestern
corner of the (̇[...] [...]of Perfect Clarity built
between 1745 a[...] [...]ble for the architecture,
and Michel Be[...] [...]ed the fountains. They
were joined by Attiret and Sichelbart, who oversaw the architectural plans and interior decoration; Pierre d'Incarville, a botanist who designed the landscaping;[34] and Gilles Thébault, who forged the wrought-iron grilles based on Castiglione's designs. Castiglione relied on the European books available at court and from the missionaries' own library, finding inspiration in illustrations of Italian baroque villas, the royal palace and grounds at Versailles, and classical architecture.[35] Yet, the final vision of a series of architectural tableaux bears little relation to any European garden. It was an entirely original arrangement of structures to form a theme park where printed and painted images of the West were translated into a three-dimensional reality.

The construction of the European Pavilions proceeded in three phases for, after the completion of the first group (fig. 47, nos. 1–7; see also fig. 48), in autumn 1751, the emperor's enthusiasm for the results led him to authorize further expansions. The final

FIGURE 47
Plan of the European Pavilions
From Jin Yufeng, "Yuanming yuan xiyanglou pingxi" (A critical analysis of the European Pavilions at the Garden of Perfect Clarity), *Yuanmingyuan* 3 (1984): after p. 21 [Yi Lantai's plate numbers added; see fig. 48]

addition to the section, the Observatory of Distant Oceans (no. 14), was built to house a set of six Beauvais tapestries of scenes set in a chinoiserie China, *Les tentures chinoises* (Chinese tapestries), designed by François Boucher. Ordered by Louis XV about 1759, the set was given to the Qianlong emperor by the Jesuit mission in 1767.[36] By 1783, the European complex comprised over forty structures, including four major pavilions (nos. 1–2, 8, 10–13, 14) and three major fountains (visible in fig. 48, nos. 1, 10, 15) that were set within a string of framed areas, each screened off from the rest to varying degrees by trees, walls, and gates (nos. 4, 17, 19). The overall spatial plan ultimately formed a T-shape totaling about twenty acres that was about 1,050 feet at the western end and 230 feet at the eastern end, north to south, and some 2,800 feet, east to west.[37]

Even more than the other complexes in the Garden of Perfect Clarity, the European Pavilions evolved as a site where potentially conflicting ideologies were accommodated through a strategy of intercultural hybridity. The missionary-artists who designed the complex for the Qianlong emperor sought to showcase European accomplishments, and thus the Catholicism that they argued was the bedrock for Western triumphs, by appealing to his taste for magnificence and his eclecticism. Having largely failed thus far to arouse the interest of four Qing rulers in Western religion, despite decades of tireless service, they now endeavored to attract the Qianlong emperor's attention to the higher spiritual truth embodied in Western linear perspective through a series of wide vistas and single-focus views of monumental architecture and ingenious fountains.[38] On a practical level, though, the project was never a genuine transplant of a European environment. Hundreds of Chinese workers directed by members of the Lei family of architects and garden designers interpreted the plans, combining Chinese and European building methods and materials.[39] Most important, both the plans and their execution were subject to close review and revision throughout the process by the Qianlong emperor himself. The Hall of Fulfilled Wishes (Ruyiguan), where Jesuit artists worked alongside Manchu and Han court painters and other artisans, was located near the Qianlong emperor's personal quarters so that he could visit daily and assess ongoing construction and decoration projects. The emperor not only requested the inclusion of certain non-European features—the meandering streams, dragon imagery, and hipped and tiled roofs being the most notable—but ultimately utilized the European Pavilions in accordance with his own perception of the proper role of the West within the Qing empire.

Despite the harmonious architectural blend, the complex offered an exotic experience because of the way it was intended to function: it was designed as a series of stage sets, most of which the Qianlong emperor was supposed to view frontally in order to experience the power of linear perspective to pull the viewer into the illusion of a totalizing reality. When transmitting European geometry and linear perspective to China, the missionaries employed an accommodationist strategy whereby their basic principles were shown to demonstrate existing Chinese cosmological and artistic concepts. The convergence of all lines in a picture plane on a central vanishing point or "counter-eye," which enhanced the perception of depth through foreshortening, revealed to Europeans the glory of God on a metaphysical plane. Developed during the Renaissance, this *perspectiva artificialis* was regarded by Europeans as an artistic means of disclosing the higher truth that went beyond the normal human vision of the tangible world. In the process of translation into Chinese, however, the metaphysical dichotomy between the apparent and the real—that is, between somewhat deceptive appearances and a higher,

spiritual truth—was dissolved by equating perspective with the neo-Confucian concept of *li,* or the "immanent principle" that was imbedded in material things, governing yet also transcending them. As Nian Xiyao stated in his *Shixue* (The study of observation, 1729; rev. ed., 1735), the first book on perspective published in Chinese, there already existed the practice of locating a single vanishing point in Chinese landscape painting, which created depth through the use of a bird's-eye view. Linear perspective, he noted, achieved the goal of drawing the viewer even closer to the real by using straight lines as well as by depicting volume through chiaroscuro shading. It was apparently Nian who gave the name *xianfa* (literally, "line-method") to linear perspective as translated into Chinese conceptual categories, and *xianfa* was increasingly recognized as a distinct artistic style as exemplified by the paintings by the missionaries that were displayed not only in the imperial palaces but also as trompe l'oeil murals in the Catholic churches in Beijing.[40]

The design of the European complex was a demonstration of *xianfa* perspective and emphasized the experience of observation, as the names of some of the structures indicate. The buildings were not intended to serve as residences nor were their rooms suitable venues for any of the usual activities of imperial life. Some of the buildings were filled with European objects and furniture from the emperor's collection, including large mirrors, tapestries, clocks, and mechanical toys, so that the experience of the interiors was one of viewing a magnificent display of foreign curiosities.[41] The main function of the buildings was to present the emperor with a series of striking three-dimensional versions of the engravings and paintings that he had admired. Several of the pavilions were really just backdrops to or vantage points for the elaborate fountains. The Hall of Calm Seas (Haiyantang), for example, frames the Zodiac Fountain, which featured a complex water-driven clock in which the twelve animals of the Chinese zodiac spouted plumes of water to mark the hours (no. 10; see also pages 138–39). As the emperor progressed along the straight paths, he arrived at fixed points for observing the architecture frontally from without or the complex expansively from within, so as to experience the optical force of the converging lines of sight. Because the Jesuits could count on the Qianlong emperor's inquisitiveness about every detail of his new complex, it is plausible that they calculated not only the deep vistas but also some decorative elements (fish and lambs, for example) to serve as possible openings for discussions about Christianity.[42] Whether the emperor ever choose to inquire about religion while at the European Pavilions has not been recorded. But the privileged vantage points and panoramic views afforded him by this garden complex no doubt confirmed his imperial role as a divinely mandated ruler at the center of the world who was intent on comprehending "perfect clarity" in his garden.

The set of twenty engravings of the European Pavilions (1783–86) (cat. no. 30) (fig. 48) that the Qianlong emperor commissioned in 1783 affords some insight into just how he viewed his garden of perspectives. Like the design of the complex itself, these works are a product of aesthetic hybridity. Produced by the Manchu court artist Yi Lantai, who probably studied under Castiglione at the Hall of Fulfilled Wishes, the scenes utilize both Western and Chinese modes of artistic depiction. To capture wide-angle views within insufficiently panoramic frames, for example, Yi combined the central vanishing point of Western perspective with additional vanishing points that give the viewer a feeling of ascent similar to that achieved by the moving perspective of Chinese

FOLLOWING TEN PAGES

FIGURE 48
Yi Lantai (Manchu, fl. 1749–86), **The European Pavilions at the Garden of Perfect Clarity,** 1783–86, suite of twenty engravings, mounted on heavy paper, each: 50 × 87.5 cm (19¾ × 34½ in.)

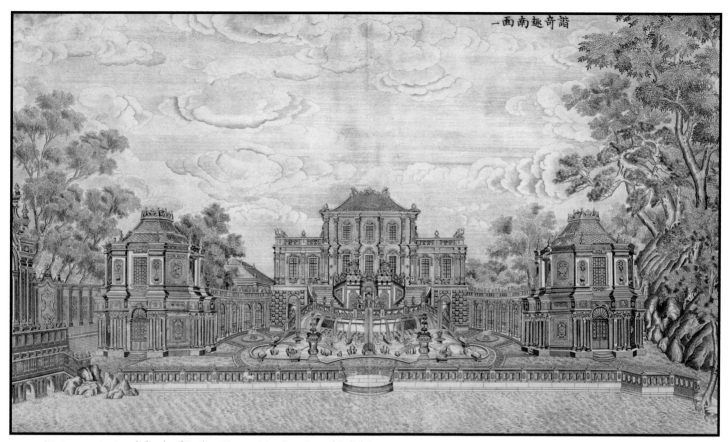

NO. 1 *Xieqiqu nanmian* (south facade of Pavilion Harmonizing Surprise and Delight)

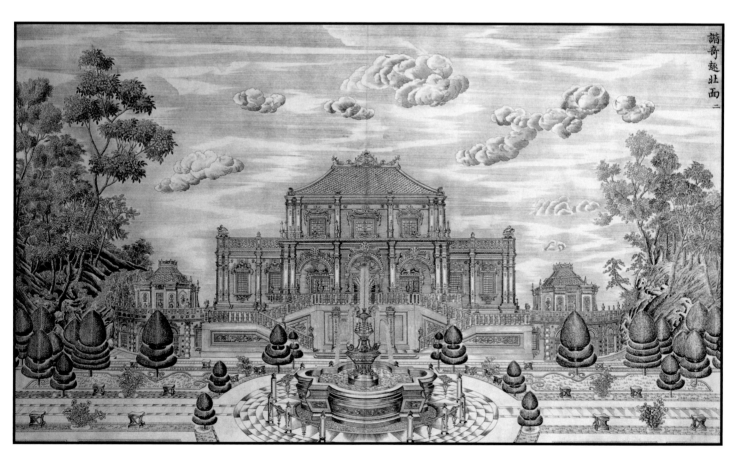

NO. 2 *Xieqiqu beimian* (north facade of Pavilion Harmonizing Surprise and Delight)

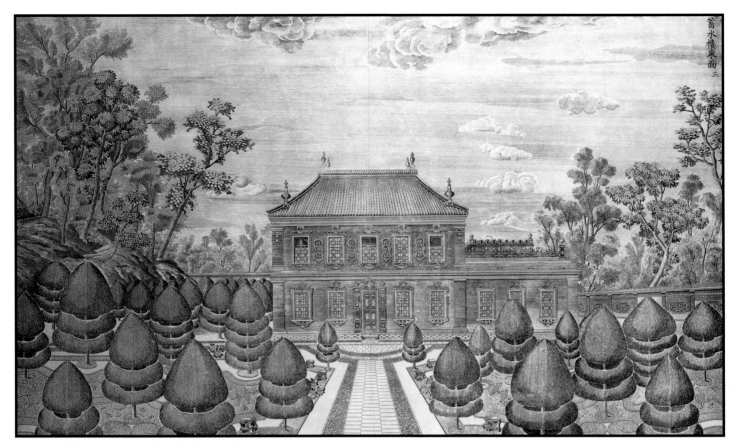

NO. 3 *Xushuilou dongmian* (east facade of Reservoir)

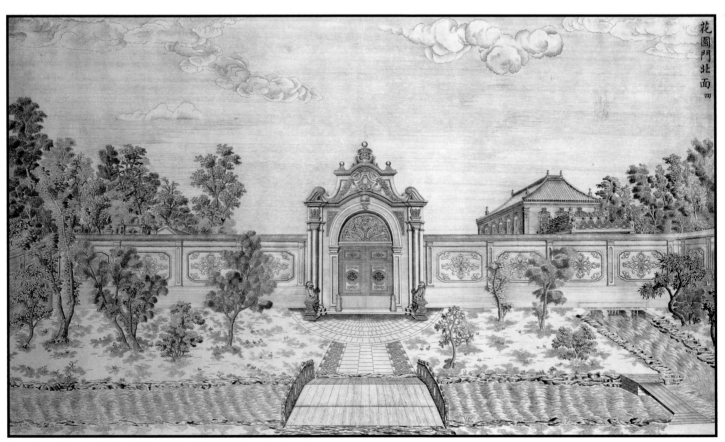

NO. 4 *Huayuanmen beimian* (north facade of Gate to the Garden)

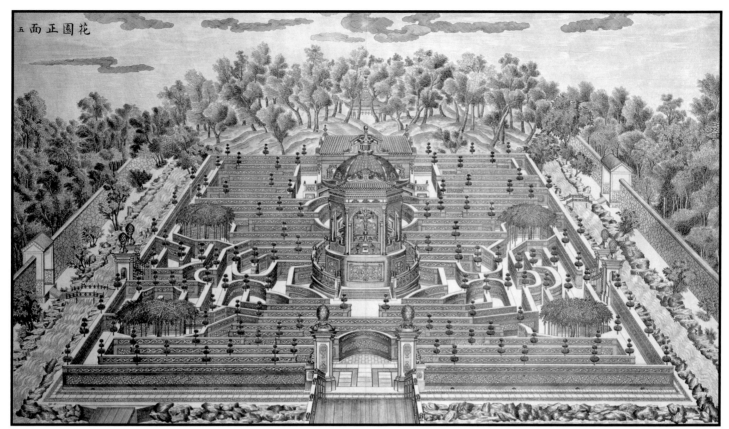

NO. 5 *Huayuan zhengmian* (front view of Garden)

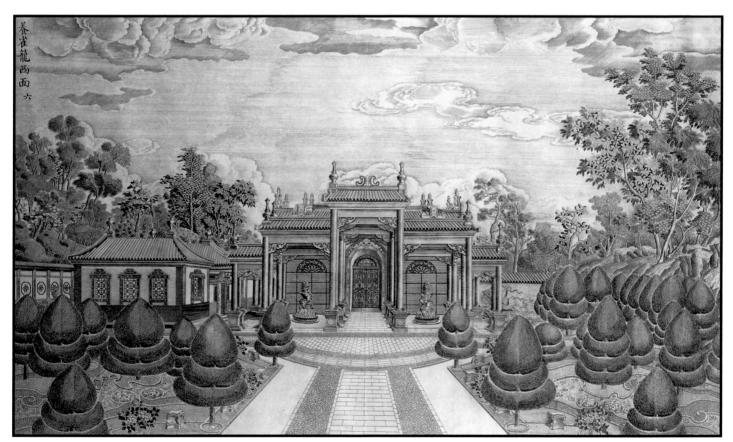

NO. 6 *Yangquelong ximian* (west facade of Aviary)

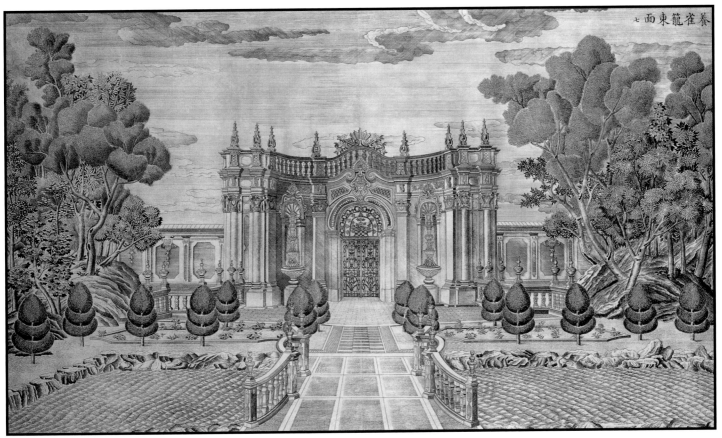

NO. 7 *Yangquelong dongmian* (east facade of Aviary)

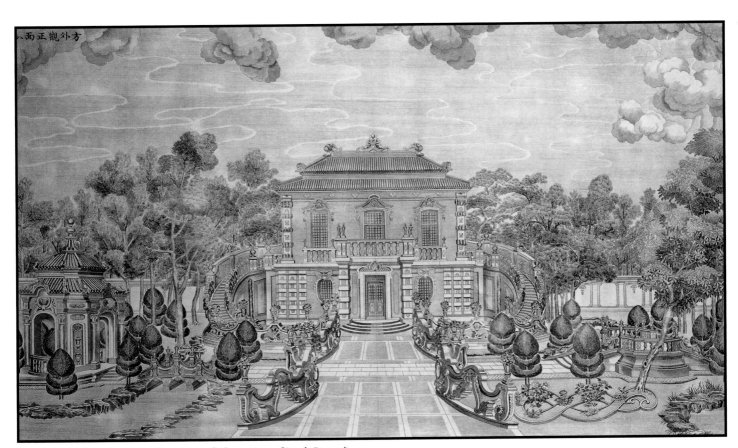

NO. 8 *Fangwaiguan zhengmian* (front view of Observatory of Lands Beyond)

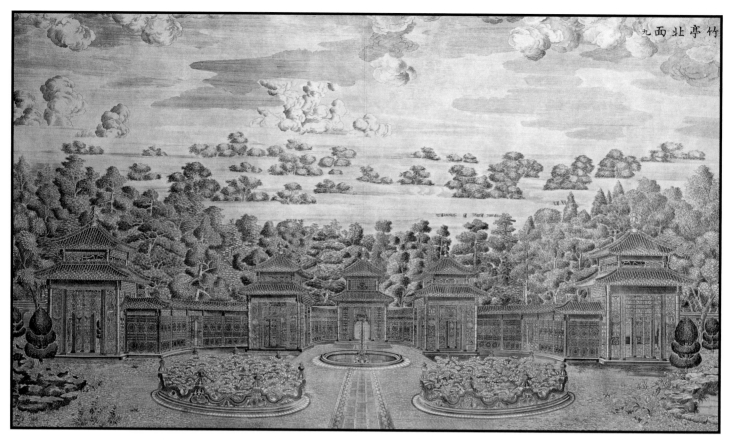

NO. 9 *Zhuting beimian* (north facade of Bamboo Gazebo)

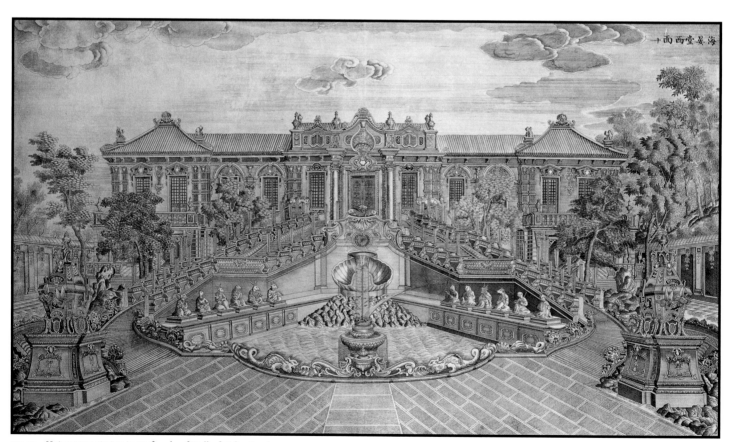

NO. 10 *Haiyantang ximian* (west facade of Hall of Calm Seas)

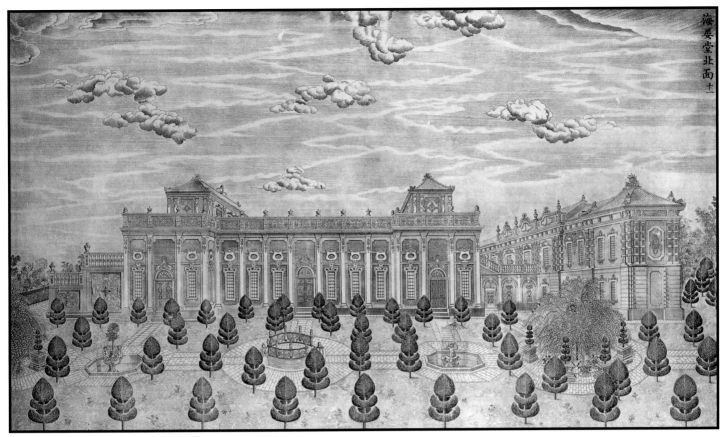

海晏堂北面十一

NO. 11 *Haiyantang beimian* (north facade of Hall of Calm Seas)

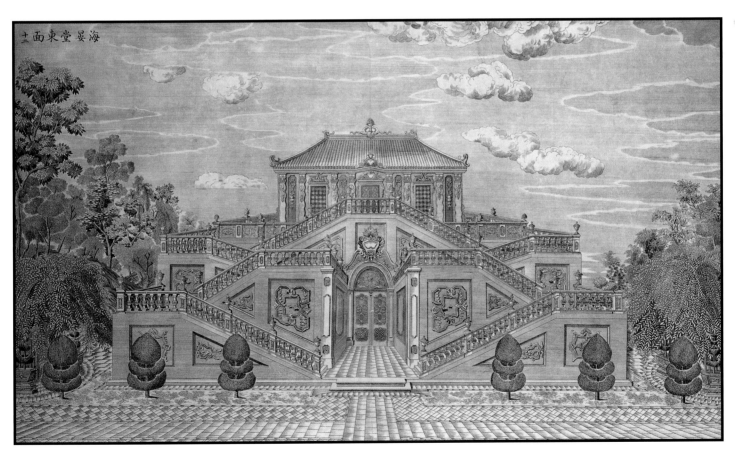

海晏堂東面十二

NO. 12 *Haiyantang dongmian* (east facade of Hall of Calm Seas)

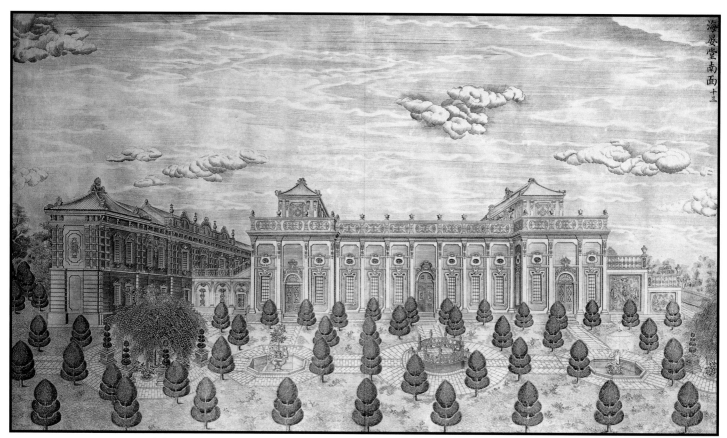

NO. 13 *Haiyantang nanmian* (south facade of Hall of Calm Seas)

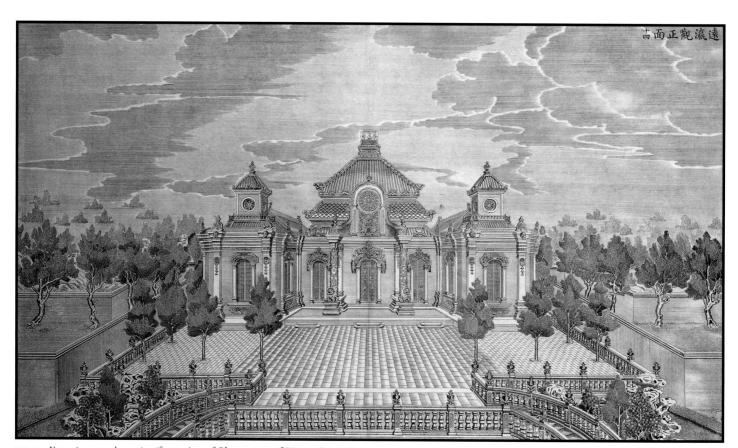

NO. 14 *Yuanyingguan zhengmian* (front view of Observatory of Distant Oceans)

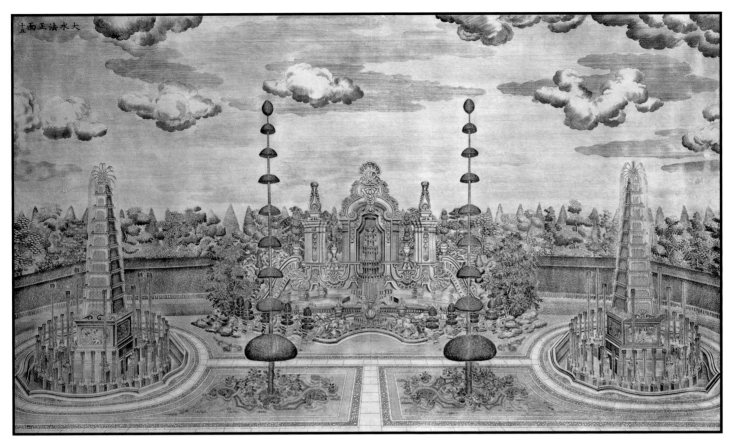

NO. 15 *Dashuifa zhengmian* (front view of Grand Fountain)

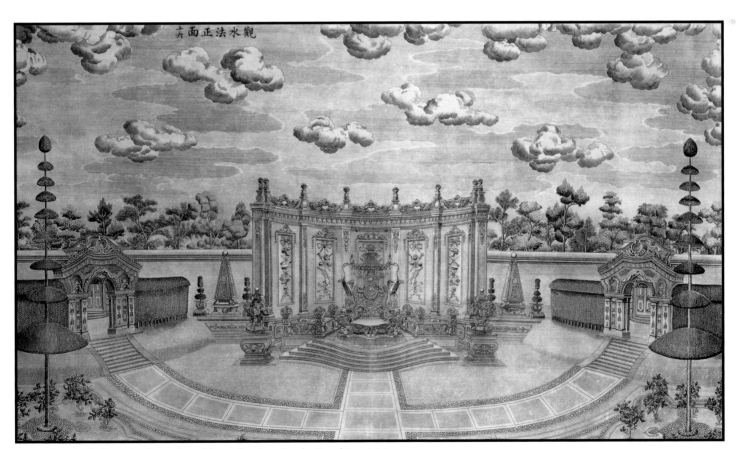

NO. 16 *Guanshuifa zhengmian* (front view of throne for observing the Grand Fountain)

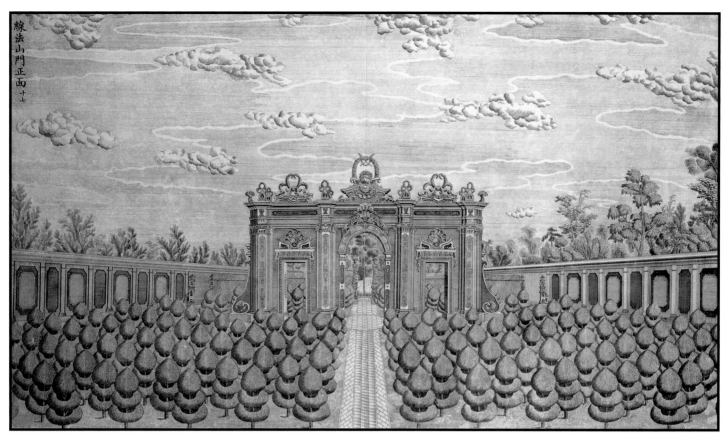

NO. 17 *Xianfashanmen zhengmian* (front view of Gate to Perspective Hill)

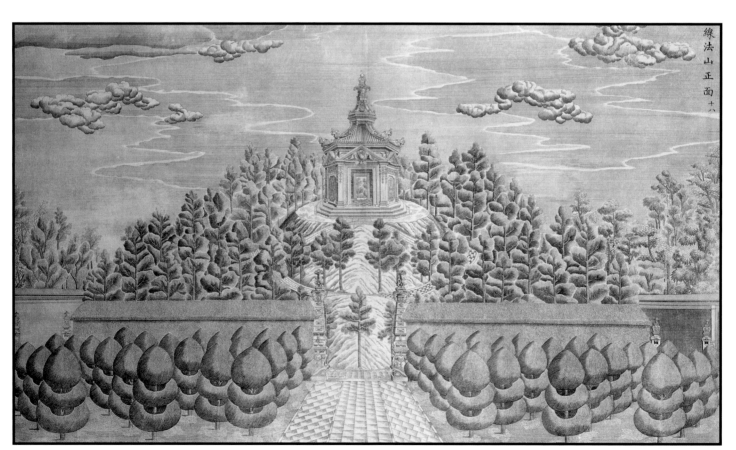

NO. 18 *Xianfashan zhengmian* (front view of Perspective Hill)

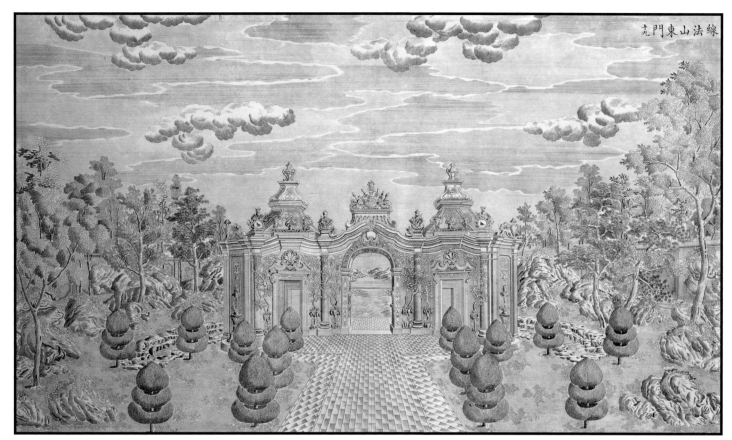

NO. 19 *Xianfashan dongmen* (East Gate of Perspective Hill)

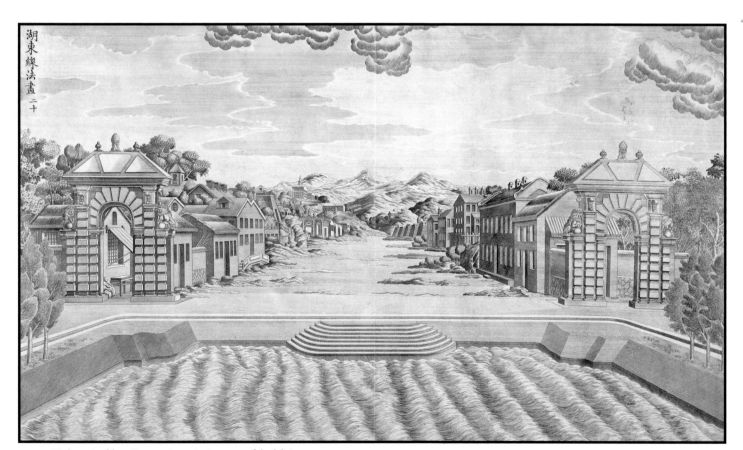

NO. 20 *Hudong xianfahua* (Perspective paintings east of the lake)

landscape painting yet foreign to that tradition because of the use of geometric sight lines. Thus, in the engraving of the Grand Fountain (Dashuifa), there is a central focal point in the fountain, just below the middle of the picture plane, that reflects the emperor's line of sight from the outdoor throne located directly opposite (see fig. 48, nos. 15, 16). But slightly above the middle of the plane, there are two more vanishing points, in the upper finials to the right and left of the central fountain, whose lines of sight connect to the obelisks, creating a bird's-eye view so that the imperial eye can rise from a terrestrial to a more celestial level.[43] The proportions of the Observatory of Lands Beyond (Fangwaiguan) (see fig. 48, no. 8) are slightly distorted so that the building appears more vertical and majestic.[44] Finally, the engraving titled *Hudong xianfahua* (Perspective paintings east of the lake) shows a Western street as it would have been perceived by the approaching emperor as he steps off a boat after crossing a symbolic ocean (see fig. 48, no. 20). This effect was achieved in the actual garden by hanging painted backdrops over a series of walls on the right and left that receded into the distance.[45]

The European Pavilions were not widely known either within or beyond China until their destruction in 1860. The engravings are empty of people, and while the Qianlong emperor wrote thousands of poems, including many on the Garden of Perfect Clarity, only a few celebrated this complex. It remained an essentially private reserve, never becoming a space in which the emperor aimed to inspire the deference of an audience of officials and vassals. It was even more exclusive than the Chinese sections of the garden, for no European other than the artist-missionaries who worked on it ever visited it.[46] The Qianlong emperor did order sets of the engravings depicting the European Pavilions to be kept in several of his palaces, and he distributed some of the two hundred sets to imperial relatives, high officials, and other favorites, but there is no indication that he wished any be distributed in Europe, though some did find their way out of China. The Jesuit missionary François Bourgeois sent one set apiece to the French sinophiles Louis-François Delatour, a publisher, and to the former secrétaire d'Etat and contrôleur général des finances Henri-Léonard-Jean-Baptiste Bertin.[47] Delatour, who later wrote the first full-length study of Chinese architecture, *Essais sur l'architecture des Chinois* (Essay on the architecture of the Chinese, 1803), there pronounced the most influential judgment. A promoter of the neoclassical revival then popular in France, he valued Chinese architecture for possessing qualities he associated with ancient Egypt, Greece, and Rome. But he refused to acknowledge the emperor's pavilions as genuinely European, dismissing their hybrid design as "italo-gothico-chinois."[48] Only in the past few decades has a new receptivity both to the phenomenology of the European Pavilions and to the originality of the missionary-artists' conception appeared. The Qianlong emperor succeeded in importing a window onto Europe, which he enclosed within his garden without sacrificing its exotic appeal, just as the Qing contained the expansive force of the Europeans themselves during the eighteenth century, largely confining them to the imperial court and the tiny trading enclaves at Macau and Canton. However unattainable the goal of "perfect clarity" might appear in the light of subsequent developments in the relations between China and Europe, it cannot be said that during the Qianlong emperor's lifetime the European Pavilions failed to perform their primary function for him: to provide a theatrical experience of the West that placed it firmly within the expanding global order of the Qing dynasty.

THE LANDSCAPE OF INTERCULTURAL CITATION:
THE CHINESE-STYLE GARDEN IN EUROPE The Chinese-style garden in

Europe incorporated China into the Western landscape by strategies very different from
those used by the Qianlong emperor for representing the West within his imperial gar-
den. Until the last years of the eighteenth century, Europeans received very few unadul-
terated images or detailed descriptions of actual Chinese gardens, and there were no
natives in their part of the world comparable to the Jesuit artist-missionaries in Beijing
who could help them approximate one. In their enthusiasm for exotica, they were recep-
tive to partial knowledge as well as misinformation. "The Chinese garden" in Europe
thus was based on certain aesthetic concepts, specific scenic features, and structures
with architectural components that signified "Chineseness"—natural asymmetry, large
rocks, serpentine paths, and fanciful pavilions, for example. Such elements were often
situated alongside other examples of the antique and the exotic that represented notions
about Greek, Roman, Egyptian, Mogul, Moorish, and Gothic cultures. Moreover, the
orientalist category of "China," like "India" and "Japan," could at the time reference
any number of things Asian as well as carry associations ranging from political virtue to
hedonism. The main quality that most authorities agreed on was that Chinese gardens
and architecture did not seem to follow a system of set rules or proportions like that
underpinning the artistic canons of European academic classicism, and this perceived
freedom, or at least organized irregularity, was invoked to help sanction (rather than
invent) new European ideals of a more natural garden.

By the late seventeenth century, reaction had set in against the severe geometry of
the baroque garden, with its symmetry, vistas, and grandiose fountains. This was espe-
cially true in Great Britain, where such formal landscapes were associated with French
and other continental influences, and especially with the royal absolutism exemplified
in the monumental palaces and expansive gardens of Versailles, which were designed
to display the power and grandeur of the centralized state. Garden designers began to
add areas that were considered "wild," that is, characterized by shaded spots, rockeries,
grottos, and fountains that did not follow any geometric plan. One person who had
viewed such a site and connected this new kind of beauty with Chinese aesthetics was
Sir William Temple, an English diplomat who had served as ambassador to the Hague
during the reign of Charles II. Temple is credited with initiating the moral discourse on
the Chinese-style garden in 1690 in his widely read essay *Upon the Gardens of Epicurus;
or, Of Gardening, in the Year 1685.*[49] He invokes the superiority of Chinese taste to scorn
the formal gardens of Europe, for, to him, this distant people possessed an expertise for
artfully contriving irregular arrangements of the terrain that were the very opposite of
the European insistence on geometry, proportion, and symmetry. In Chinese gardens,
the winding walks and imaginative plantings that created striking views resulted in an
aesthetic quality that appeared to be without conscious design or easily observed order.
Temple claimed that the Chinese called this sort of beauty "sharawadgi," a term that
may have been a Japanese word meaning "not symmetrical" or "irregular" that filtered
through the Dutch to Temple.[50]

Temple's broader intellectual horizons exemplified certain connections among
political and aesthetic ideas from Greek and Roman antiquity, a Confucian China ruled
by a philosopher king, and the role of the garden estate in the life of the politically
active British gentleman. In 1690, the same year that *Upon the Gardens of Epicurus* was
printed, he issued *Of Heroic Virtue,* in which Confucius and the Chinese imperial state

were held up as models for Britain. These ideals formed an ideological nexus based on the moral virtues attributed to the Chinese elite and realized in their gardens. They were used to sanction opinions among a set of the British elite in favor of a program of greater meritocracy, personal liberty, and political influence within the existing framework of the constitutional monarchy. At the beginning of the eighteenth century, these ideas were further elaborated by writers such as Joseph Addison, Richard Steele, and Alexander Pope.[51]

In 1738, the first Chinese-style building appeared in an English garden when a small, whimsical, one-room hut, the so-called Chinese House, was constructed at Stowe, the family estate of Richard Temple, 1st Viscount Cobham.[52] By then, Batty Langley's *New Principles of Gardening* (1728) had proposed the serpentine path—an element that Europeans would particularly associate with Chinese aesthetics—as the dominant feature of a more natural garden, and Jean-Baptiste Du Halde's encyclopedic *Description géographique, historique, chronologique, politique, et physique de l'empire de la Chine et de la Tartarie Chinoise* (1735) (cat. no. 8), with its illustrations of Chinese architecture and a short but positive account of the Chinese garden by the Jesuit missionary Jean-François Gerbillion, had become well known in England.[53] Stowe was a showcase for the new fashion in aristocratic gardens as themed landscapes parks where an array of emblematic architecture enunciated philosophical and classical themes. The Chinese House was part of an exotic ensemble that included an Egyptian Pyramid, a classical Temple of Ancient Virtue, a Saxon Temple, and a Temple of British Worthies, as well as a Palladian bridge, a Dido's cave, and an Elysian Fields. William Kent, widely credited with defining the European "natural garden," to a large extent designed the grounds, and he may have been the designer of the Chinese House as well.[54] As would become typical for such structures, it was located in relation to water: built on stilts in a pond containing two mechanical Chinese birds, it was connected to the shore by a bridge decorated with vases.

Amid the prevailing European ignorance during the first half of the eighteenth century of specific Chinese gardens, one documentary source arrived unexpectedly in 1724. Matteo Ripa, a Neapolitan priest who served as an artist at the courts of the Kangxi and Yongzheng emperors, stopped briefly in London on his return to Italy from Beijing. Ripa had been asked by the Kangxi emperor to engrave a Western interpretation of the woodcut views in *Yuzhi Bishushanzhuang shi* (Imperially authored poems on the Mountain Hamlet for Escaping the Summer Heat, 1712). Completed in 1713, Ripa's views were the first copperplate engravings produced in China and carefully represented the architecture of various complexes in the Kangxi emperor's newly built summer palace. Though the set did not include a plan of the entire summer palace, each view captured genuine details of Chinese garden design. Ripa brought a number of sets with him from China, and he presented or sold some of them in England. One was acquired by Richard Boyle, 3rd Earl of Burlington, another patron of William Kent, whose renovations to the earl's garden at Chiswick were as renowned as those at Stowe. Despite the presence of Ripa's images in England, there is little indication that they were widely seen or significantly influenced English conceptions of the Chinese-style garden.[55]

Another set of Ripa's engravings would come into the possession of Robert Wilkinson, who in 1753 decided to reengrave and publish them as *The Emperor of China's Palace at Pekin, and His Principal Gardens* (cat. no. 31).[56] This anonymous work may well have been the first book in Europe to offer images of a Qing imperial garden. Eigh-

teen of its twenty etchings reproduced Ripa's views, but added to each are entertaining figures. These include fantastic flying phoenix (*feng*) birds, ducks, cranes, rabbits, deer, horses, oxen, workers, farmers, cormorant fishers, palace women, and assorted mandarins. Numerous boats sail the lakes, though most are based, incongruously, on the large coastal and oceangoing vessels found in Canton.

Beneath each plate is a poetic caption. Some of the sets of engravings that Ripa brought to Europe, including Wilkinson's, contained the priest's handwritten notes, which included an Italian translation of the Kangxi emperor's Chinese title for each view.[57] The English captions in *The Emperor's Palace* are translations of Ripa's stilted Italian renderings of Chinese names, resulting in awkward phrases that sound strange and ethereal. For example, according to Ripa, one plate depicts the apartments where Europeans working at the court stayed. The Chinese name for this complex is, literally, Ten Thousand Valleys with Pine Breezes (Wanhe songfeng), after a conventional theme in landscape painting. The English caption reads "The Many Rivers and Air, that Breaths from the Pine Tree, Its Partner" (see fig. 83). Little in these curious images would have struck eighteenth-century British readers as an implausible representation of Qing China, not even the naked man happily swimming while clinging to a sea-serpent in plate 15. Perhaps it was precisely these fantastic elements that deprived *The Emperor's Palace* of any authority among serious garden theorists.

Undoubtedly, the most widely read and best source for information about gardens in China at this time was Attiret's lengthy letter, which was sent from Beijing to Paris in 1743 and included a description of the Garden of Perfect Clarity. It was published in French in 1749 and in English translation in 1752. Without mentioning specific scenes or complexes, the letter provided an overview of the garden's design and aesthetic principles, confirming, with the authority of an eyewitness, the essential elements of Chinese-style garden design: winding paths, bridges, and small, colorful pavilions situated among waterways, ponds, valleys, hills, and abundant plantings, with an infinite variety of forms, asymmetrical and irregular arrangements, the use of contrasting elements, and a delightful atmosphere of charm and fantasy.[58]

The mainstream of Chinese-style architectural design for European gardens is best represented by the pattern books that appeared in England in the 1750s. These presented model plans for pavilions and other structures, together with various images to be applied to a range of surfaces and decorative objects. Such collections were probably intended for a wide audience ranging from garden owners, architects, builders, and readers of taste interested in current fashions to designers and manufacturers of chinoiserie products. Such designs were advanced as general proposals and were not expected to be realized literally. Rather, they were an opportunity for their authors to give free rein to their inventiveness and showcase their ability to enchant and delight.[59] *Chinese Architecture, Civil and Ornamental, Being a Large Collection of the Most Elegant and Useful Designs of Plans and Elevations, etc., from the Imperial Retreat to the Smallest Ornamental Building in China* (cat. no. 32), which was published in 1759 under the name of P. Decker, is a good example of this genre. Some of its images were pirated from other publications of the day, and they were plagiarized in turn.[60] Decker's work claimed to present designs of real buildings in China, albeit adapted to the British climate. The assertion of verisimilitude was enhanced by the odd measurement or floor plan. Decker's images of intricately ornamented Chinese structures represent the rococo pole of the chinoiserie imagination, suitable for the hedonistic theme of China as a land of carefree gaiety.

Judging by the Chinese-style structures that were actually built in British gardens, these attractive renderings with their abundance of fantasy accord with the general taste of the era.

It was not until William Chambers's arrival on the scene that the other pole of the chinoiserie imagination, where Chinese beauty was associated with heroic virtue, found its greatest exponent. Throughout his lifetime (he died in 1796), Chambers was virtually the only architect in Europe who had actually seen Chinese gardens. Chambers is known as a preeminent exponent of Franco-Italian neoclassicism who served the British royal family and rose to the highest public post in his profession, acting as surveyor general and comptroller of the Office of Works under George III. His lifelong fascination with the Orient followed two prosperous voyages to Canton (1743–44 and 1748–49, while he was in his twenties) as a supercargo with the Swedish East India Company. Beginning in fall 1749, his six years of architectural study, spent first in Paris under Jacques-François Blondel at the progressive École des arts, considered the first professional architectural school, and then in Rome, were formative influences on his theories, which bridged British and continental sensibilities.

Among the influential figures Chambers met early on, probably in England in 1749, was Frederick, Prince of Wales, who was an enthusiast of exotic garden architecture and subscribed to Enlightenment ideas about China as a model of universality and sage government. Chambers may have played a role in the design of the House of Confucius (see fig. 86) that was built at the prince's estate at Kew in 1749.[61] The House of Confucius was the most overt illustration in an English Chinese-style garden of the Enlightenment idea of China as a model empire. It was a small, two-story octagonal structure with a room on each level that offered, according to Chambers's own account, "a very pleasant prospect over the lake and gardens." He continues, "Its walls and ceiling are painted with grotesque ornaments, and little historical subjects relating to Confucius, with several transactions of the Christian Missions in China."[62] Despite its fanciful fretwork and design, it was akin to Greek and Roman temples in its proclaiming of serious moral virtue at Kew, which has been described as a "logo for the enlightened vision of the Prince of Wales."[63]

Upon returning to England in 1755, Chambers gained the patronage of Augusta, Dowager Princess of Wales, who wished to redesign Kew as a monument to her husband, Frederick, who had died unexpectedly in 1751. Capitalizing on his unique, though limited, experience of China, Chambers released *Designs of Chinese Buildings* in May 1757, presenting it as both a response to the desires of art lovers, no doubt Augusta in particular, and a corrective to the inauthentic chinoiserie designs found in the popular pattern books. A French version of the book (cat. no. 33) was issued simultaneously, for Chambers sought to address both British and continental audiences. The range of topics in *Designs* is similar to that found in pattern books. In addition to proposals for various garden structures and designs for interior objects, Chambers provided cultural information through images of Chinese boats, machines, writing, and dress. While his depictions were advanced for their day, modern readers can readily identify inaccuracies, such as the distortions in the forms and proportions of the buildings, the fanciful architectural ornamentation, the incomprehensible samples of Chinese and allegedly Manchu writing, and the Westernized facial features of the human figures. Nonetheless, *Designs* was the first serious attempt to present Chinese architecture as a subject on a par with the architecture of Western antiquity. Among the book's most valuable contributions was

the section of a Cantonese merchant's home (see fig. 85). This image shows not only the floor plan, the structural elements that support Chinese roofs, and a glimpse of the interior but typical plants and rocks used in landscaping as well. Overall, in this book Chambers's designs for buildings display a stately sobriety similar to the seriousness of Greek and Roman temples. There is even a plate analyzing the forms of Chinese columns as if they were classical orders. The proposed designs, which subject the popular rococo ornamentation of the Chinese style to the severe discipline of Palladian neoclassicism, were not influential in England, and with the exception of subsequent work at Kew, Chambers did not actually build much in the Chinese style. However, the designs generated much interest on the continent, especially in France, Germany, and Sweden, where some of his temples and pavilions were imitated.[64]

Among garden theorists, it was the five-page essay "Of the Art of Laying Out Gardens among the Chinese" in the *Designs* that had the most influence. Despite its brevity, it introduced many of the fundamental ideas that reappear in Chambers's later writings as it summarized Chinese gardening techniques, both actual and imaginary. Iterating Temple's praise for "sharawadgi," he stated that in Chinese gardens "Nature is their pattern, and their aim is to imitate her in all their beautiful irregularities."[65] Elaborating Attiret's letter, he noted that the Chinese garden was "laid out in a variety of scenes, and you are led, by winding passages...to the different points of view, each of which is marked by a seat, a building, or some other object...which, from their use, point out the time of day for enjoying the scene in it's perfection,"[66] whether morning, afternoon, or evening. He discussed the importance of bodies of water in unifying the design and the use of intermediary plants and objects to create an element of surprise as well as manipulate perceptions of distance. In addition, Chambers transmitted one of the aesthetic tenets central to Chinese garden theory—the application of principles of Chinese landscape painting to the design ("they consider a plantation as painters do a picture")—which played into the contemporary debates about the cult of the picturesque and the role of painting in European garden design.[67]

But Chambers also attributed to Chinese gardens certain of his own ideas. These were largely derived from Addison's theories on the effects of the union of art and nature on the emotions as well as from Edmund Burke's aesthetic of the sublime.[68] Chambers maintained that the Chinese "distinguish three different species of scenes...pleasing, horrid, and enchanted" which were introduced to produce specific responses in the viewer.[69] The idea of experiencing horror or terror in a garden is without any foundation in Chinese theory or practice. But in this essay and subsequent writings, China served as a sanction for Chambers's own aesthetic focus on designing an interactive, dramatic landscape of contrasting scenic effects to provoke emotional responses that were ultimately ennobling. At the time of its publication, this essay, with its emphasis on the happy balance between nature and art, was favorably received and immediately reprinted.

The *Designs* appeared in May 1757, and by summer Augusta had appointed Chambers architect of her project at Kew and architectural tutor to her son, the future George III. It was at Kew that Chambers was able to apply his theories on garden design to the theme of heroic virtue. He transformed the relatively flat and narrow hundred-acre site of mostly meadows into a patriotic park that showcased the ideals of Prince Frederick and the British monarchy through an artfully choreographed assemblage of Eastern and Western architectural styles. From 1757 to 1763, Chambers designed and built twenty-three structures at Kew, of which several were in the Chinese style.[70] Two of his new

structures—the Aviary and the small open pavilion situated in the Menagerie—were comparatively restrained adaptations of the more whimsical or rococo Chinese-style architecture, while a third was a belvedere composed of the House of Confucius relocated to the top of a newly constructed bridge next to Kew's artificial lake. The most important among these edifices, and the one that became emblematic of the entire garden, was a ten-story pagoda standing 163 feet high (fig. 49).

Of all the Chinese-style buildings constructed in Europe, Chambers's Pagoda maintained the closest fidelity to an actual Chinese model. Though clearly a product of invention rather an accurate reconstruction, in general outline it resembled the so-called Porcelain Pagoda in Nanjing, a structure illustrated in the various editions of Johannes Nieuhof's account of the Dutch embassy to China between 1655 and 1657 (fig. 50) (cf. cat. nos. 2, 3) but never seen by the architect himself (he had been to Canton but not Nanjing). Chambers's design set off a spate of pagoda construction in the West.[71] The Pagoda at Kew was situated between two other exotic buildings, the garden pavilions known as the Alhambra and the Mosque, a trio that conjured up a global geography (fig. 51). Moreover, as one of the tallest structures of its time, it commanded a grand view of the landscape for some forty miles around, opening the mind's eye on the far reaches of the British Empire and celebrating an expansive imperial vision of the world.[72] The Pagoda signified at least two additional themes: it represented a symbolic possession of Chinese culture on a scale so large that only a great monarch could achieve it; and it announced to both British and other European visitors that Great Britain was determined to become the paramount colonial and commercial power in East Asia. In 1763, all these designs appeared in a folio edition, *Plans, Elevations, Sections, and Perspective Views of the Gardens and Buildings at Kew in Surry* (cat. no. 34), which was published with the support of Augusta, to whom it was dedicated.

As Chambers was establishing himself during the 1750s and 1760s, he increasingly faced competition from Lancelot "Capability" Brown, who was regarded by his supporters as the preeminent landscape-garden designer in Britain. Brown developed an extreme version of the natural garden, eliminating many of the features Chambers believed were essential to the garden as a work of art. Instead of Chambers's dramatic sequence of scenes containing exotic architecture with cultural references, Brown created open vistas of smooth lawns punctuated by clumps of trees in the distance, which invoked a nativist pride in a purely English landscape. Chambers protested against what he felt was a banal environment devoid of variety and interest, and he looked upon Brown as a mere artisan who lacked both professional training and taste. Meanwhile, Kew was held up by anti-Tory partisans as an exemplar of royal extravagance and was attacked for being overcrowded with buildings as well for its artifice. In 1772, Chambers issued *A Dissertation on Oriental Gardening* (cat. no. 35), a more polemical expansion of the theories he sketched in "Of the Art of Laying Out Gardens" that, unfortunately, was read by some as an attack on his rival and dismissed by others for its exaggerated claims about Chinese garden design. Like *Designs,* it was simultaneously issued in French, for Chambers realized that he was likely to get a more sympathetic reception on the continent, where the Chinese-style garden continued to be fashionable.

A Dissertation attributes even more fantastic elements to the Chinese to support Chambers's three sublime scenes, now called "the pleasing, the terrible, and the surprising."[73] Especially the fantastical statements regarding the zone of "the terrible" as filled with famished wild beasts, gibbets and other instruments of torture, fire-

belching foundries, and temples dedicated to "the king of vengeance" strained his readers' credibility. Chambers unwisely responded to the many critics of this book by hastily issuing in 1773 a second edition of *A Dissertation* (cat. no. 36) that featured a riposte disguised as an explanatory discourse by Tan Chet-qua, a Cantonese sculptor who had departed for home in 1772, after spending three years in London.[74] At the same time as this new edition, William Mason, a partisan of Brown, published a widely read lampoon of Chambers's theories.[75] The controversy obscured the major portion of Chambers's views in *A Dissertation* and the many authentic ideas he expounded that not only supported Attiret's observations but also were consistent with those of Chinese garden theorists.[76] It was not until the end of the eighteenth century, during Lord Macartney's mission to China of 1792 to 1794, that some of Chambers's countrymen were able to observe for themselves not only Cantonese gardens but also the two imperial palaces in Beijing and the summer palace at Chengde.[77]

On the continent, where the collecting of Chinese art or the commissioning of chinoiserie decoration did not provoke nationalistic responses and the pursuit of a more natural garden did not lead to a rejection of baroque and rococo aesthetics, *A Dissertation* proved more influential. Chambers's aesthetic ideas were well received by many, though not uncritically by others. C. C. L. Hirshfeld, a German garden theorist of the day, argued that Chambers's primary flaw was that he was overreaching for rhetorical effect: "he planted English ideas in a Chinese terrain so that it would give them a more striking appearance and render them more seductive."[78] To Hirschfeld's mind, Chambers's natural landscape garden was an English phenomenon that at best was a derivation of the gardens of China. By contrast, in his "Essai sur les jardins de plaisance des Chinois" (Essay on Chinese pleasure gardens, 1782), Pierre-Martial Cibot, a Jesuit who had worked on the European Pavilions, would allude to Chambers's "happy mélange of Chinese and European ideas."[79]

By the time of the appearance of *A Dissertation,* the French had become increasingly aware of the new developments in gardening and agriculture in England, and they regarded Kent and Chambers as the most influential representatives of what was called the "jardin anglais."[80] A number of French tourists had published favorable accounts of English sites such as Chiswick, Stowe, and Kew.[81] Parc Monceau, Jardin bagatelle, Folie Saint-James, Parc de la pagode de Chanteloup, Parc de Cassan, and Désert de Retz were among the landscape gardens constructed in France during the latter half of the eighteenth century that rivaled earlier English constructions. Not surprisingly, French garden theorists generally gave priority to one of their own, Charles Dufresny, over Kent in inventing the new style of gardening, and some considered the *jardin anglais* an inauthentic attempt by the English to imitate the Chinese.[82] After 1750, when the fashion for such gardens began to decline in England, it was France that provided the latest examples of the Chinese-style garden, stimulating further efforts in other parts of the continent.

This chapter in French garden history was copiously documented at the time in the monumental series of engravings *Détail des nouveaux jardins à la mode* (cat. no. 37), published by Georges-Louis Le Rouge. Issued sporadically from about 1776 to 1789, this series was referenced throughout Europe. Its content ranged widely and included views of notable contemporary gardens in England, France, Italy, and Germany; the French version of Chambers's *Designs of Chinese Buildings;* copies of Chinese paintings and prints of imperial gardens and palaces; and designs for new garden elements, including exotic pavilions and decorative motifs in the Chinese style. In *cahier* 12, for example, one plate

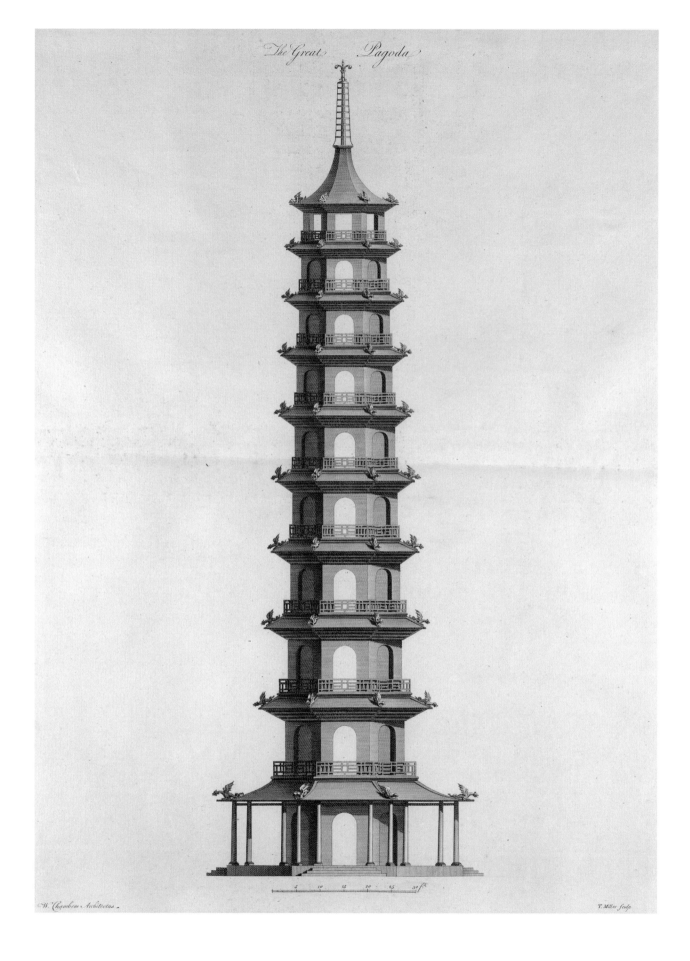

The Great Pagoda

W. Chambers Architectus.

T. Miller Sculp.

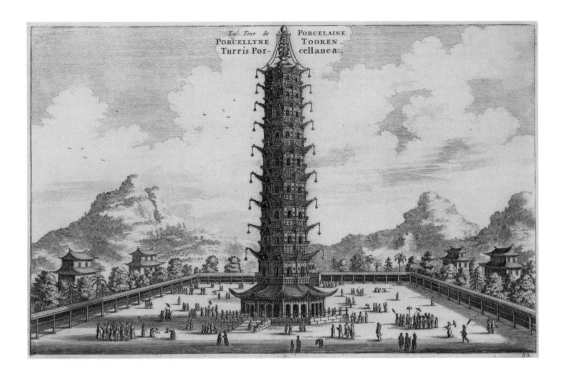

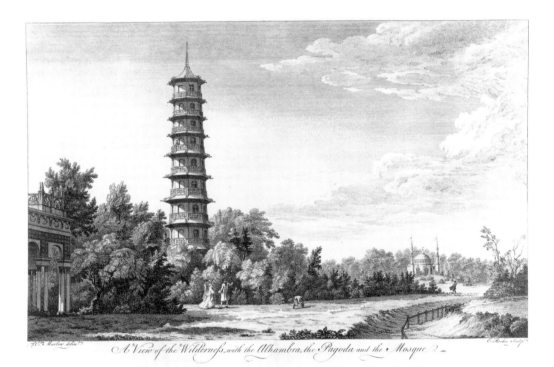

FIGURE 49
T. Miller (British, fl. ca. 1725), after William Chambers (British, 1723–96), *The Great Pagoda,* 1763, engraving, 58.4 × 42.9 cm (23 × 16⅞ in.) From William Chambers, *Plans, Elevations, Sections, and Perspective Views of the Gardens and Buildings at Kew in Surry...* (London: printed by J. Haberkorn, published for the author, 1763), pl. 25

FIGURE 50
La Tour de porcelaine (The Porcelain Pagoda), 1665, etching, 19.3 × 29.8 cm (7⅝ × 11¾ in.) From Johannes Nieuhof, *Legatio Batavica ad Magnum Tartariae Chamum Sungteium, Modernum Sinae Imperatorem...,* trans. Georg Horn (Amsterdam: apud J. Meursium, 1668), before p. 97

FIGURE 51
Edward Rooker (British, 1711–74), after William Marlow (British, 1740–1813), *A View of the Wilderness with the Alhambra, the Pagoda, and the Mosque,* 1763, engraving, 31.4 × 47.6 cm (12⅜ × 18¾ in.) From William Chambers, *Plans, Elevations, Sections, and Perspective Views of the Gardens and Buildings at Kew in Surry...* (London: printed by J. Haberkorn, published for the author, 1763), pl. 43

depicts a rockery, which was already an important part of the European picturesque imagination, while another plate shows a plan for a proposed "jardin anglo-français-chinois" by the Italian architect Francesco Bettini that features a drawing of a *hoie-ta* (sea pagoda), a fantastical underwater apartment that Chambers described only in the French edition of his *Dissertation*.[83] Le Rouge's series repeatedly reveals how the French looked to the English for existing models while seeking to surpass them in realizing the essential qualities of the authentic Chinese garden.

Détail des nouveaux jardins à la mode also provides crucial documentation for sites that no longer exist or that exist in a dilapidated or transformed state. Among the most extraordinary examples of the Chinese-style garden in France was the Désert de Retz, now in shambles. It was created by the bon vivant François Nicolas Henri Racine de Monville between 1774 and 1792, the year he sold all his real estate as a consequence of the French Revolution. At its prime, the Désert was visited by a variety of famous figures interested in architecture and gardens, including Gustav III of Sweden, Marie-Antoinette, Benjamin Franklin, and Thomas Jefferson. Le Rouge's twenty-six prints of the Désert, which formed *cahier* 13, highlight this garden's unique examples of exotic architecture, which included the elegant Maison chinoise (see fig. 88), built in 1776 and set in landscaping then regarded as authentically Chinese. Constructed of teak, the Maison chinoise was the first such structure intended and used as a residence rather than just a decorative pavilion. Among its Chinese references were its fretwork-covered facades, inscriptions in pseudo-Chinese characters, and tiered bellcast concave-to convex-hip roofs covered with shingles suggesting tiles. Le Rouge devoted thirteen plates to recording aspects of its architecture. The gate to the Maison chinoise was modeled on Chambers's rendition of a "pay-leau" (*pailou*, or Chinese triumphal arch).[84]

But Le Rouge's series also gave rise to a transformative moment in the intercultural transmission of the Chinese garden to the West. *Cahiers* 14 through 17 presented the first images of actual Chinese gardens to be widely disseminated in Europe, and they finally provided visual evidence to support the eyewitness accounts by Attiret and others. In these four *cahiers* were re-engraved images from the Qianlong emperor's *Yuanmingyuan sishijing shi* (Poems on the forty views of the Garden of Perfect Clarity, 1745) and from Ripa's version of the thirty-six engravings of the summer palace in Chengde, as well as views of various other imperial palaces and famous scenic places, many taken from illustrations in the *Nanxun shengdian* (Account of the Qianlong emperor's southern tours, 1771).

In the inscription on the title page of *cahier* 15 (fig. 52), Le Rouge claimed that the group of images of the Garden of Perfect Clarity belonged to the Swedish sinophile Count Carl Fredrik Scheffer, advisor to Gustav III and a patron of Chambers, adding that the count had permitted them to be engraved so that "they may serve the progress of the art of gardening, since everybody knows that the English gardens [*jardins anglais*] are nothing but imitations of those in China."[85] Le Rouge's versions were remarkably faithful to the architecture, though he was not above "improving" the perspective and, like Ripa in his engravings of Chengde, adding texture and contrast to the woodcut originals; he also exhibited the European artist's tendency to redraw trees and foliage as more individuated forms.[86] Nonetheless, concerned that his clientele would consider these plates below contemporary French standards for fine prints, he inserted a note explaining that what may appear as inartistic techniques were actually characteristic of the Chinese style of illustration.[87]

FIGURE 52
Georges-Louis Le Rouge (French, ca. 1712–ca. 1792), **View of Simple Life in Quietude (Danbo ningjing) at the Garden of Perfect Clarity,** 1786, engraving, 26.4 × 31.4 cm (10⅜ × 12⅜ in.) From Georges-Louis Le Rouge, *Detail des nouveaux jardins à la mode,* pt. 15, *Cahier des jardins chinois: Jardins de l'empereur de la Chine* (Paris: Le Rouge, 1786), pl. 1

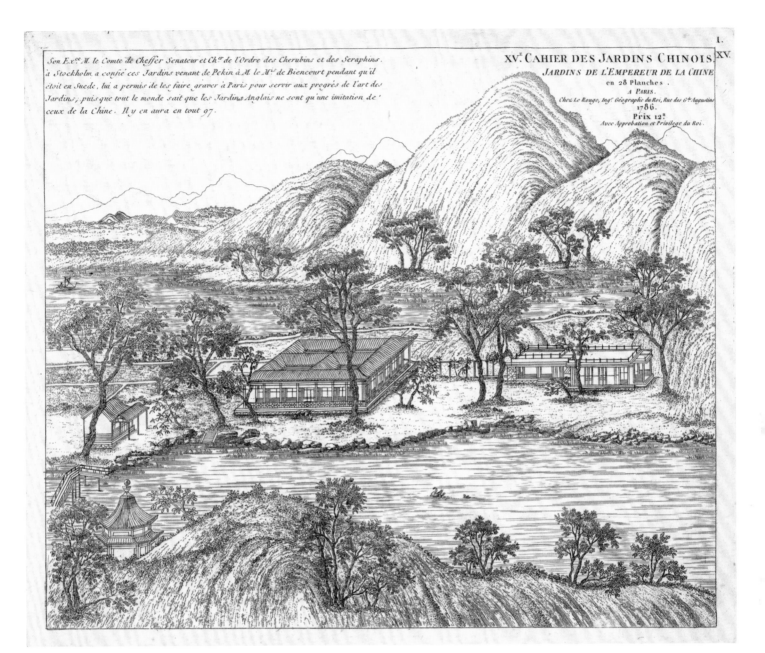

Son Ex.ce M. le Comte de Cheffer Senateur et Chr de l'Ordre des Cherubins et des Seraphins. à Stockholm a confié ces Jardins venant de Pekin à M. le Mis de Biencourt pendant qu'il étoit en Suede, lui a permis de les faire graver à Paris pour servir aux progrès de l'art des Jardins, puis que tout le monde sait que les Jardins Anglais ne sont qu'une imitation de ceux de la Chine. Il y en aura en tout 97.

XV.e CAHIER DES JARDINS CHINOIS. XV.
JARDINS DE L'EMPEREUR DE LA CHINE
en 28 Planches.
A PARIS.
Chez Le Rouge, Ingr Géographe du Roi, Rue des Gds Augustins
1786.
Prix 12.s
Avec Approbation et Privilege du Roi.

In comparing the Chinese-style garden in Europe with the European Pavilions at the Garden of Perfect Clarity, certain asymmetries are apparent. Despite its hybridity, the Qianlong emperor's complex represented a foreign world and achieved a consistent style. Moreover, because it was entirely contained within an imperial palace estate, the complex was never intended to have any cultural influence, and few people outside palace circles ever knew about it. By contrast, the Chinese-style garden was never a coherent attempt to transplant an entire Chinese garden to European soil, despite various claims of authenticity. From the start, the Chinese elements were incorporated into a multicultural assemblage that evoked a set of ideas or emotions in larger, designed landscapes that referenced various times and places. Yet, even as brief citations, these visions of China percolated into the wider European culture and were embraced by broad segments of society, from monarchs and aristocrats on down. Today, replicas of authentic Chinese gardens have been and continue to be constructed in major Western cities. Most of these modern gardens are versions of the Han scholar gardens of the Jiangnan region. They suggest parallels with the Qianlong emperor's duplication at the Garden of Perfect Clarity and other imperial palace estates of especially beautiful scenes and gardens encountered during his southern tours. At the same time, over twenty modern theme parks can be found in China, the descendants of Kew and the Désert de Retz as well as the Garden of Perfect Clarity. Would the eighteenth-century Chinese and European progenitors of these contemporary constructs recognize them as expressing a similar desire to comprehend the Other? Or would they be struck by the even greater complexities of cultural transmission in our own age of globalization?

Notes

1. "Hybridity" is used here to mean a third form that emerged from the combination of Chinese and Western elements. For a theoretical consideration of intercultural dimensions in China, see Jonathan Hay, "Toward a Theory of the Intercultural," *Res* 35 (1999): 5–9.

2. See Mark Elvin, *The Retreat of the Elephants: An Environmental History of China* (New Haven: Yale Univ. Press, 2004), esp. 19–85.

3. Philip K. Hu, comp. and ed., *Visible Traces: Rare Books and Special Collections from the National Library of China,* exh. cat. (Beijing: Morning Glory, 2000), 72–78 (cat. no. 17); and Weng Lianxi, ed., *Qingdai gongting banhua* (Qing-dynasty imperial printed works) (Beijing: Wenwu Chubanshe, 2001), 30–31.

4. Xiang Ta, "European Influences on Chinese Art in the Later Ming and Early Ch'ing Period," trans. Wang Teh-chao, in James C. Y. Watt, ed., *The Translation of Art: Essays on Chinese Painting and Poetry* (New Territories, Hong Kong: Center for Translation Projects, Chinese University of Hong Kong, 1976), 153–61; and Mayching Kao, "European Influences in Chinese Art, Sixteenth to Eighteenth Centuries," in Thomas H. C. Lee, ed., *China and Europe: Images and Influences in Sixteenth to Eighteenth Centuries* (Hong Kong: Chinese Univ. Press, 1991), 253–61, 271–74. See also John Lust, *Western Books on China Published up to 1850, in the Library of the School of Oriental and African Studies, University of London: A Descriptive Catalogue* (London: Bamboo, 1987); James Cahill, *The Compelling Image: Nature and Style in Seventeenth-Century Chinese Painting* (Cambridge: Harvard Univ. Press, 1982); Michael Sullivan, "Some Possible Sources of European Influence on Late Ming and Early Qing Painting," in *Proceedings of the International Symposium on Chinese Painting* ([Taipei: National Palace Museum, 1972]), 595–633; and Michael Sullivan, *The Meeting of Eastern and Western Art from the Sixteenth Century to the Present Day* ([Greenwich, Conn.]: New York Graphic Society, [1973]).

5. The Kangxi emperor's preface is translated in Hu, *Visible Traces* (note 3), 74–75 (cat. no. 17).

6. Reproduced in Nie Chongzheng, ed., *Qingdai gongting huihua = Paintings by the Court Artists of the Qing Court* (Hong Kong: Commercial Press, 1996), 74–90 (no. 11).

7. The late-thirteenth-century album by Cheng Qi is now in the Freer Gallery of Art, Washington, D.C. A complete set of rubbings from the engraved stones was published in Paul Pelliot, "A propos du *Keng Tche T'ou*," *Mémoires concernant l'Asie Orientale (Inde, Asie Centrale, Extrême-Orient)* 1 (1913): 65–122, pls. x–lx. See also Wang Chaosheng, ed., *Zhongguo gudai gengzhitu = Farming and Weaving Pictures in Ancient China* (Beijing: Chinese Agriculture, 1995), 126–48. The surviving twenty-three stones of the original forty-five are preserved at the National Museum of Chinese History, Beijing.

8. See the vase and dishes in *From Beijing to Versailles: Artistic Relations between China and France,* exh. cat. (Hong Kong: Urban Council of Hong Kong, 1997), 217–21 (cat. nos. 80–82); and six panels in Wu Chunyan, "Graceful Appreciation in the Imperial Study," in *The Life of Emperor Qian Long,* exh. cat. ([Macau]: Aomen Yishu Bowuguan, 2002), 280–81.

9. John Bowles (fl. 1724–79) was a member of a London-based family of publishers and printsellers that was active for 170 years. Established in his own right in 1723, he traded from a variety of addresses in and around Cheapside and Cornhill in London. Bowles was active in producing maps not only under his own name but also for other successful English map publishers.

10. Lothar Ledderose, "Chinese Influence on European Art, Sixteenth to Eighteenth Centuries," in Thomas H. C. Lee, ed., *China and Europe: Images and Influences in Sixteenth to Eighteenth Centuries* (Hong Kong: Chinese Univ. Press, 1991), 230; Frank Fiedeler, "Himmel, Erde, Kaiser: Die Ordnung der Opfer," in *Europa und die Kaiser von China,* exh. cat. (Frankfurt: Insel, 1985), 66–67, figs. 61–63, pl. 129; and Dora Wiebenson, *The Picturesque Garden in France* (Princeton: Princeton Univ. Press, 1978), 101–2.

11. The Eight Banners (*baqi*) began in the early seventeenth century as a Manchu system of military organization and evolved under the Qing dynasty as a social, administrative, and ethnic institution as well. It primarily included the Manchu population, allied Mongol tribes, and selected Han Chinese and greatly facilitated Manchu rule over the vastly more numerous Han population of China. For a detailed discussion, see Mark C. Elliott, *The Manchu Way: The Eight Banners and Ethnic Identity in Late Imperial China* (Stanford: Stanford Univ. Press, 2001).

12. For recent studies on the Manchus, see Pamela K. Crossley, *The Manchus* (Cambridge: Blackwell, 1997); Pamela K. Crossley, *A Translucent Mirror: History and Identity in Qing Imperial Ideology* (Berkeley: Univ. of California Press, 1999); Elliott, *The Manchu Way* (note 11); and Evelyn S. Rawski, *The Last Emperors: A Social History of Qing Imperial Institutions* (Berkeley: Univ. of California Press, 1998).

13. For recent studies of this and other Manchu military campaigns in Central Eurasia, see Nicola Di Cosmo, "Military Aspects of the Manchu Wars against the Čaqars," in idem, ed., *Warfare in Inner Asian History (500–1800)* (Leiden: Brill, 2002), 337–65; Peter C. Perdue, "Fate and Fortune in Central Eurasian Warfare: Three Qing Emperors and Their Mongol Rivals," in Nicola Di Cosmo, ed., *Warfare in Inner Asian History (500–1800)* (Leiden: Brill, 2002), esp. 387–90; and Peter C. Perdue, *China Marches West: The Qing Conquest of Central Eurasia* (Cambridge, Mass.: Belknap, 2005).

14. Joanna Waley-Cohen, "Commemorating War in Eighteenth-Century China," *Modern Asian Studies* 30, no. 4 (1996): 869 n. 20.

15. Perdue, "Fate and Fortune" (note 13), 391, 393 n. 45.

16. For studies of the military culture of the Qing, see Waley-Cohen, "Commemorating War" (note 14), 869–99; and Joanna Waley-Cohen, "Military Ritual and the Qing Empire," in Nicola Di Cosmo, ed., *Warfare in Inner Asian History (500–1800)* (Leiden: Brill, 2002), 405–44.

17. On the Qing court's concern over the loss of what was called the Manchu Way (in Manchu, *Manjusai doro*), see Elliott, *The Manchu Way* (note 11), 275–304.

18. Perdue, *China Marches West* (note 13), 291.

19. For reproductions of a painting documenting this banquet, see Gugong Bowuyuan, ed., *Qingdai gongting huihua = The Collection of the Palace Museum: Court Painting of the Qing Dynasty* (Beijing: Cultural Relics Publishing House, 1992), 156–57 (no. 82); and Nie, *Qingdai gongting huihua* (note 6), 222–25 (no. 58). For some of the military portraits, see Herbert Butz, ed., *Bilder für die "Halle des Purpurglanzes": Chinesische Offizierporträts und Schlachtenkupfer der Ära Qianlong (1736–1795)*, exh. cat. (Berlin: Museum für Ostasiatische Kunst, 2003), 47–51 (cat. nos. 12–17). Photographs of the Hall of Imperial Glory appear in Osvald Sirén, *Gardens of China*, trans. Donald Burton (New York: Ronald, 1949), pl. 159.

20. Christoph Müller-Hofstede and Hartmut Walravens, "Paris-Peking: Kupferstiche für Kaiser Qianlong," in *Europa und die Kaiser von China*, exh. cat. (Frankfurt: Insel, 1985), 164–66; Butz, *Bilder für die "Halle"* (note 19), 54–55; and Paul Pelliot, "Les conquêtes de l'empereur de la Chine," *T'oung pao* 20 (1921): 270–71.

21. Müller-Hofstede and Walravens, "Paris-Peking" (note 20), 164–66; and Butz, *Bilder für die "Halle"* (note 19), 54.

22. Weng, *Qingdai gongting banhua* (note 3), 35; see also Cécile Beurdeley and Michel Beurdeley, *Giuseppe Castiglione: A Jesuit Painter at the Court of the Chinese Emperors*, trans. Michael Bullock (Rutland, Vt.: Charles E. Tuttle, 1971), 79–88.

23. For a list of the engravings, see this volume, pp. 198–99 (cat. no. 28); see also Pelliot, "Les conquêtes" (note 20).

24. The complete series is reproduced in Gugong Bowuyuan, *Qingdai gongting huihua* (note 19), 209–16 (no. 131); Nie, *Qingdai gongting huihua* (note 6), 183–91 (no. 41); Nie Chongzheng, ed., *Qingdai yuzhi tongban hua = Palace Copperplate Etchings of the Qing Dynasty* (Beijing: Guoji Wenhua Chuban Gongsi, 1999); and Michèle Pirazzoli-t'Serstevens, *Gravures des conquêtes de l'empereur de Chine K'ien-Long au Musée Guimet* (Paris: Musée Guimet, 1969), 21–36. Eight are reproduced in *From Beijing to Versailles*

(note 8), 226–43 (cat. nos. 85–93; Pelliot nos. 1, 2, 6, 7, 9, 10, 14, 16); thirteen appear in *Europa und die Kaiser von China*, exh. cat. (Frankfurt: Insel, 1985), 167–72, 337 (Pelliot nos. 1, 3–7, 9–11, 13–16).

25. On this battle, see James A. Millward, *Beyond the Pass: Economy, Ethnicity, and Empire in Qing Central Asia, 1559–1864* (Stanford: Stanford Univ. Press, 1998), 31–32.

26. Reproduced in Müller-Hofstede and Walravens, "Paris-Peking" (note 20), 164; see also *Europa und die Kaiser* (note 24), 339 (cat. no. 12/37).

27. Chiu Che Bing, "Droiture et clarté: Scène paysagère au Jardin de la clarté parfaite," *Studies in the History of Gardens and Designed Landscapes* 19 (1999): 365.

28. For a study of the afterlife of the Garden of Perfect Clarity as a ruin and as a nationalist symbol, see Geremie R. Barmé, "The Garden of Perfect Brightness, a Life in Ruins," *East Asian History* 11 (1996): 111–58. For photographs of the ruins of the European Pavilions, see Teng Gu, ed., *Yuanmingyuan oushi gongdian canji* (Remnants of the European-style pavilions in the Garden of Perfect Clarity) (Shanghai: Shangwu Yinshuguan, 1933); and Régine Thiriez, *Barbarian Lens: Western Photographers of the Qianlong Emperor's European Palaces* (Amsterdam: Gordon & Breach, 1998).

29. Young-tsu Wong, *A Paradise Lost: The Imperial Garden Yuanming Yuan* (Honolulu: Univ. of Hawai'i Press, 2001), 1. For a source of *yuanming* as the wisdom of a buddha, see *Huayanjing* (Flower garland sutra), in *Taishō shinshu daizōkyō* (Taishō edition of the Tripitaka) (Tokyo: Taishō Issaikyō Kankokai, 1924–32), 1733:35.216a.

30. The Yongzheng emperor, "Yuanmingyuan ji" (Record of the Garden of Perfect Clarity), in *Yuzhi Yuanmingyuan tuyong* (Imperially authored poems on the Garden of Perfect Clarity, with illustrations) (Nanjing: Jiangsu Guji Chubanshe, 2003), 8ab; and Chiu, "Droiture et clarté" (note 27), 368.

31. He Zhongyi and Zeng Zhaofen, *Yuanmingyuan yuanlin yishu* (The artistry of the Garden of Perfect Clarity) (Beijing: Kexue Chubanshe, 1995), 120–25; and Wong, *A Paradise Lost* (note 29), 16–23.

32. Chen Congzhou, *Shuo yuan = On Chinese Gardens*, trans. Chen Xiongshan et al. (Shanghai: Tongji Univ. Press, 1984), 5.

33. Vincent Droguet, "Les Palais européens de l'empereur Qianlong et leurs sources italiennes," *Histoire de l'art* 25/26 (1994): 15; and Carroll B. Malone, *History of the Peking Summer Palaces under the Ch'ing Dynasty* (Urbana: University of Illinois, 1934), 139.

34. The landscaping of the European Pavilions is discussed in Gilles Genest, "Les Palais européens du Yuanmingyuan: Essai sur la végétation dans les jardins," *Arts asiatiques* 49 (1994): 82–90.

35. See Droguet, "Les Palais européens" (note 33), for a study of these Italian sources; see also *Le Yuanmingyuan: Jeux d'eau et Palais européens du XVIIIe siècle à la cour de Chine* (Paris: Éditions Recherche sur les Civilisations, 1987), 14–18; and Victoria M. Siu, "China and Europe Intertwined: A New View of the European Sector of the Chang Chun Yuan," *Studies in the History of Gardens and Designed Landscapes* 19 (1999): 386, for suggestions as to possible French sources. A list of books on architecture and gardens in the Jesuit libraries in Beijing appears in Hui Zou, "The *Jing* of a Perspective Garden," *Studies in the History of Gardens and Designed Landscapes* 22 (2002): 317–20.

36. Michèle Pirazzoli-t'Serstevens, "A Pluridisciplinary Research on Castiglione and the Emperor Ch'ien-lung's European Palaces (Part 1)," *National Palace Museum Bulletin* 24, no. 4 (1989): 4–5. This set of tapestries—*The Chinese Meal, The Chinese Fair, The Chinese Dance, Chinese Fishing, Chinese Bird Hunting,* and *The Chinese Garden*—is discussed in some detail in Candace J. Adelson, *European Tapestry in the Minneapolis Institute of Arts* (Minneapolis: Minneapolis Institute of Arts, 1994), 322–42 (cat. no. 19). A note in the Archives nationales de France (O¹ 2037) describes the tapestries that were sent to China; see Pascal-François Bertrand, "La second 'Tenture chinoise' tissée à Beauvais et Aubusson—Relations entre Oudry, Boucher et Dumons," *Gazette des beaux-arts*, 6th ser., 116 (1990): 177, 182 n. 33.

37. He and Zeng, *Yuanmingyuan* (note 31), 442.

38. For the relationship between the Qianlong emperor and the artist-missionaries, see Beurdeley and Beurdeley, *Giuseppe Castiglione* (note 22); see also "A Letter from a Jesuit Painter in Qianlong's Court at Chengde," trans. Deborah Sommer and Louis Dupont, in James A. Millward et al., eds., *New Qing Imperial History: The Making of Inner Asian Empire at Qing Chengde* (New York: Routledge, 2004), 171–84.

39. On the Lei family of imperial architects, see Shu Mu, Shen Wei, and He Naixian, eds., *Yuanmingyuan ziliaoji* (Source materials about the Garden of Perfect Clarity) (Beijing: Shumu Wenxian Chubanshe, 1984), 95–104; and Zhang Enyin, *Yuanmingyuan bianqianshi tanwei* (An investigation into the historical changes at the Garden of Perfect Clarity) (Beijing: Beijing Tiyuxueyuan Chubanshe, 1993), 178–208.

40. See Hui Zou, "Jesuit Perspective in China," *Architectura* 31 (2001): 157–58, for a translation of Nian's preface in the 1729 edition.

41. Malone, *History of the Peking Summer Palaces* (note 33), 160.

42. Siu, "China and Europe Intertwined" (note 35), 387–88.

43. Antoine Durand and Régine Thiriez, "Engraving the Emperor of China's European Palaces," *Biblion: Bulletin of the New York Public Library* 1, no. 2 (1993): 98.

44. For a reconstruction, see Antoine Durand, "Restitution des Palais européens du Yuanmingyuan," *Arts asiatiques* 43 (1988): 129–30; and *Le Yuanmingyuan: Jeux d'eau* (note 35), 25–27. See also Michèle Pirazzoli-t'Serstevens, "A Pluridisciplinary Research on Castiglione and the Emperor Ch'ienlung's European Palaces (Part 2)," *National Palace Museum Bulletin* 24, no. 5 (1989): 2–3.

45. Maurice Adam, *Yuen ming yuen: L'oeuvre architecturale des anciens jésuites au XVIIIe siècle* (Beijing: Imprimerie des Lazaristes, 1936), 36; Malone, *History of the Peking Summer Palaces* (note 33), 159; and *Yuanmingyuan oushi tingyuan* (The European-style garden in the Garden of Perfect Clarity) (Beijing: Yuanmingyuan Guanlichu, 1998), 101.

46. Sirén, *Gardens of China* (note 19), 126. See also Zhang Enyin, "Xiyang yuanlin tongbantu" (The copper engravings of the European garden), in idem, *Yuanming daguan hua shengshuai* (A discussion of the rise and fall of the Garden of Perfect Clarity) (Beijing: Zijincheng Chubanshe, 1998), 77; and Chrétien Louis Joseph de Guignes, *Voyages à Peking, Manille et l'Île de France, faits dans l'intervalle des années 1784 à 1801* (Paris: Imprimerie Impériale, 1808), 1:407.

47. Pirazzoli-t'Serstevens, "A Pluridisciplinary Research (Part 1)" (note 36), 5.

48. Louis François Delatour, *Essais sur l'architecture des Chinois, sur leurs jardins, leurs principes de médecine, et leurs moeurs et usages; avec des notes* (Paris: De Clousier, 1803), 186–87. See also Daniel Rabreau, "Une méthode d'analyse stylistique des 'Palais européens' du Yuanming yuan," in *Yuanmingyuan yizhi de baohu he liyong . . . = Protection et mise en valeur du site du Yuanmingyuan* (Beijing: Zhongguo Linye Chubanshe, 2002), 157–69.

49. For this section of Temple's essay, see John D. Hunt and Peter Willis, eds., *The Genius of the Place: The English Landscape Garden, 1620–1820* (London: Elek, 1975; reprint, Cambridge: MIT Press, 1988), 96–99.

50. See Ciaran Murray, "*Sharawadgi* Resolved," *Garden History* 26, no. 2 (1988): 208–13.

51. Osvald Sirén, *China and Gardens of Europe of the Eighteenth Century* (New York: Ronald, 1950; reprint, Washington, D.C.: Dumbarton Oaks, 1990), 16–18.

52. Patrick Conner, *Oriental Architecture in the West* (London: Thames & Hudson, 1979), 45–46; and Dawn Jacobson, *Chinoiserie* (London: Phaidon, 1993), 158.

53. On reviews in the *Gentleman's Magazine,* see Marcia Reed, "A Perfume Is Best from Afar: Publishing China for Europe," this volume, p. 27 n. 34.

54. Connor, *Oriental Architecture* (note 52), 45.

55. On Ripa's work and its influence, see Basil Gray, "Lord Burlington and Father Ripa's Chinese Engravings," *British Museum Quarterly* 22 (1960): 40–43; and Patrick Conner, "China and the Landscape Garden:

Reports, Engravings and Misconceptions," *Art History* 2 (1979): 429–40. However, see the interpretations of some of Ripa's prints in P. Decker, *Chinese Architecture, Civil and Ornamental* (1759) (cat. no. 32).

56. This connection is made in George Loehr, "L'artiste Jean-Denis Attiret et l'influence exercée par sa description des jardins impériaux," in *La mission française de Pékin aux XVIIe et XVIIIe siècles: Actes du Colloque international de sinologie, Centre de recherches interdisciplinaire de Chantilly, 20–22 septembre 1974* (Paris: Belles Lettres, 1976), 76. See also Conner, *Oriental Architecture* (note 52), 31–43.

57. Gray, "Lord Burlington" (note 55), 41–42; and Loehr, "L'artiste Jean-Denis Attiret" (note 56), 76.

58. See Jean-Denis Attiret, "Lettre à M. de Assaut, 1er novembre 1743," in Charles Le Gobien, ed., *Lettres édifiantes et curieuses, écrites des Missions étrangères, par quelques missionnaires de la Compagnie de Jésus,* vol. 27 (Paris: les freres Guerin, 1749), 1–49; excerpted and translated in Sirén, *Gardens of China* (note 19), 123–26.

59. For a discussion of chinoiserie pattern books, see Conner, *Oriental Architecture* (note 52), 57–75.

60. Conner, *Oriental Architecture* (note 52), 62.

61. For opinions on Chambers's role in designing the House of Confucius, see John Harris, *Sir William Chambers: Knight of the Polar Star* (London: A. Zwemmer, 1970), 33–34; John Harris, "Sir William Chambers and the Kew Gardens," in John Harris and Michael Snodin, eds., *Sir William Chambers, Architect to George III,* exh. cat. (New Haven: Yale Univ. Press, 1996), 57; and Conner, *Oriental Architecture* (note 52), 78–80.

62. William Chambers, *Plans, Elevations, Sections, and Perspective Views of the Gardens and Buildings at Kew in Surry . . .* (London: printed by J. Haberkorn, published for the author, 1763), 4.

63. Richard Quaintance, "Toward Distinguishing among Theme Park Publics: William Chambers's Landscape Theory vs. His Kew Practice," in Terence Young and Robert Riley, eds., *Theme Park Landscapes: Antecedents and Variations* (Washington, D.C.: Dumbarton Oaks, 2002), 33.

64. See Harris, *Sir William Chambers* (note 61), 148.

65. William Chambers, *Designs of Chinese Buildings, Furniture, Dresses, Machines, and Utensils . . . to which Is Annexed a Description of Their Temples, Houses, Gardens, etc.* (London: published by the author, 1757), 15. The essay is reprinted in Hunt and Willis, *The Genius of the Place* (note 49), 283–88.

66. Chambers, *Designs of Chinese Buildings* (note 65), 15, 16.

67. Chambers, *Designs of Chinese Buildings* (note 65), 18. There were various views by European theorists on how painting should be used to create the "picturesque"; see, for example, Wiebenson, *The Picturesque Garden* (note 10), 45, 83.

68. See Eileen Harris, "Burke and Chambers on the Sublime and Beautiful," in Douglas Fraser, Howard Hibbard, and Milton J. Lewine, eds., *Essays in the History of Architecture Presented to Rudolf Wittkower* (London: Phaidon, 1967), 207–13.

69. Chambers, *Designs of Chinese Buildings* (note 65), 15.

70. Those still standing are the Ruined Arch, the Orangery, the Pagoda, and the temples of Bellona, Arethusa, and Eolus.

71. Ledderose, "Chinese Influence" (note 10), 234; and Jacobson, *Chinoiserie* (note 52), 209.

72. See Quaintance, "Toward Distinguishing" (note 63), for a discussion of the ideology embodied in Kew Gardens.

73. William Chambers, *A Dissertation on Oriental Gardening* (London: W. Griffin, 1772), 39.

74. On Tan Chet-qua, see Janine Barrier, Monique Mosser, and Chiu Che Bing, *Aux jardins de Cathay: L'imaginaire anglo-chinois en Occident* (Paris: Éditions de l'Imprimeur, 2004), 59–60.

75. For a study of Mason's poem, *An Heroic Epistle to Sir William Chambers* (1773), see Isabelle W. Chase, "William Mason and Sir William Chambers' Dissertation on Oriental Gardening," *Journal of English and Germanic Philology* 35 (1936): 517–29. The poem and an excerpt from *A Dissertation on Oriental Gardening* (1772) are reprinted in Hunt and Willis, *The Genius of the Place* (note 49), 318–25. The Research Library at the Getty Research Institute holds the first, third, seventh, and fourteenth editions of Mason's poem.

76. For a recent reassessment of Chambers's theories, see Barrier, Mosser, and Chiu, *Aux jardins de Cathay* (note 74), 11–129.

77. See Norah Titley and Frances Wood, *Oriental Gardens* (London: British Library, 1991), 79, 83, for two watercolor sketches of local Chinese gardens by the artist William Alexander. See also the opinions on Chinese imperial gardens expressed in George Macartney, *An Embassy to China: Being the Journal Kept by Lord Macartney during His Embassy to the Emperor Ch'ien-lung, 1793–1794,* ed. J. L. Cranmer-Byng (London: Longmans, 1962), 116–17; and John Barrow, *Travels in China: Containing Descriptions, Observations, and Comparisons, Made and Collected in the Course of a Short Residence at the Imperial Palace of Yuen-Min-Yuen, and on a Subsequent Journey through the Country from Pekin to Canton,* 2nd ed. (London: printed for T. Cadell & W. Davies, 1806), 126–28.

78. C. C. L. Hirschfeld, *Théorie de l'art des jardins* (Leipzig: Les Heritiers de M. G. Weidmann & Reich, 1779–85; reprint, Geneva: Minkoff Reprint, 1973), 1:113–14: "En un mot, il planta des idées angloises dans un terrein chinois, afin de leur donner une apparence plus frappante, et de les rendre plus séduisans"; cited in Harris, *Sir William Chambers* (note 61), 162.

79. [Pierre-Martial Cibot], "Essai sur les jardins de plaisance des Chinois," *Mémoires concernant l'histoire, les sciences, les arts, les moeurs, les usages, etc. des Chinois; par les missionnaires de Pe-Kin* 8 (1782): 326: "l'ingénieux Auteur d'un Essai sur l'architecture, a avancé depuis, qu'en faisant un heureux mêlange des idées chinoises et des idées européennes, on réussiroit à avoir des jardins gais et rians, où la belle nature se trouveroit avec toutes ses graces"; cited in Harris, *Sir William Chambers* (note 61), 161 n. 115.

80. A. Gournay, "Jardins chinois en France à la fin du XVIIIe siècle," *Bulletin de l'École française d'Extrême Orient* 78 (1991): 259.

81. Wiebenson, *The Picturesque Garden* (note 10), 23–38.

82. Gournay, "Jardins chinois" (note 80), 264; and Wiebenson, *The Picturesque Garden* (note 10), 8–9, 35.

83. Georges-Louis Le Rouge, *Détail des nouveaux jardins à la mode* (Paris: Le Rouge, [ca. 1776–89]), *cahier* 12 (1784), pl. 22 ("Idées pour la construction des rochers dans les jardins anglais," said to be based on an earlier drawing from 1734); see also Barrier, Mosser, and Chiu, *Aux jardins de Cathay* (note 74), 65–68, 181–82.

84. For photographs of the Maison chinoise in its dilapidated state before its later collapse, see Sirén, *China and Gardens* (note 51), pls. 88, 89. For Le Rouge's views of the Maison chinoise, see Le Rouge, *Détail des nouveaux jardins* (note 83), *cahier* 13 (1785), pls. 10–21, 25. Chambers's Chinese triumphal arch is in his *Designs of Chinese Buildings* (note 65), pl. 11 (bottom); and reprinted in Le Rouge's *Détail des nouveaux jardins* (note 83), *cahier* 5, pl. 10 (left half). For the gate to the Maison chinoise based on Chambers's arch, see Le Rouge, *Détail des nouveaux jardins* (note 83), *cahier* 13, pl. 10.

85. Cited and translated in Sirén, *China and Gardens* (note 51), 169.

86. For a reprint of the original Chinese woodblock image of the pavilion that appears on the title page of Le Rouge's *cahier* 15 (this volume, fig. 52), see *Yuzhi Yuanmingyuan tuyong* (Imperially commissioned illustrations and imperially authored poems on the Garden of Perfect Clarity) (1887; reprint, Nanjing: Jiangsu Guji Chubanshe, 2003), vol. 1, "Danpo ningjing." For the pavilion as depicted in a Chinese painted album, see Nathalie Monnet, *Chine: L'empire du trait: Calligraphies et dessins du Ve au XIXe siècle,* exh. cat. (Paris: Bibliothèque Nationale de France, 2004), fig. 133b.

87. Le Rouge, *Détail des nouveaux jardins* (note 83), *cahier* 15 (1786), pl. 2.

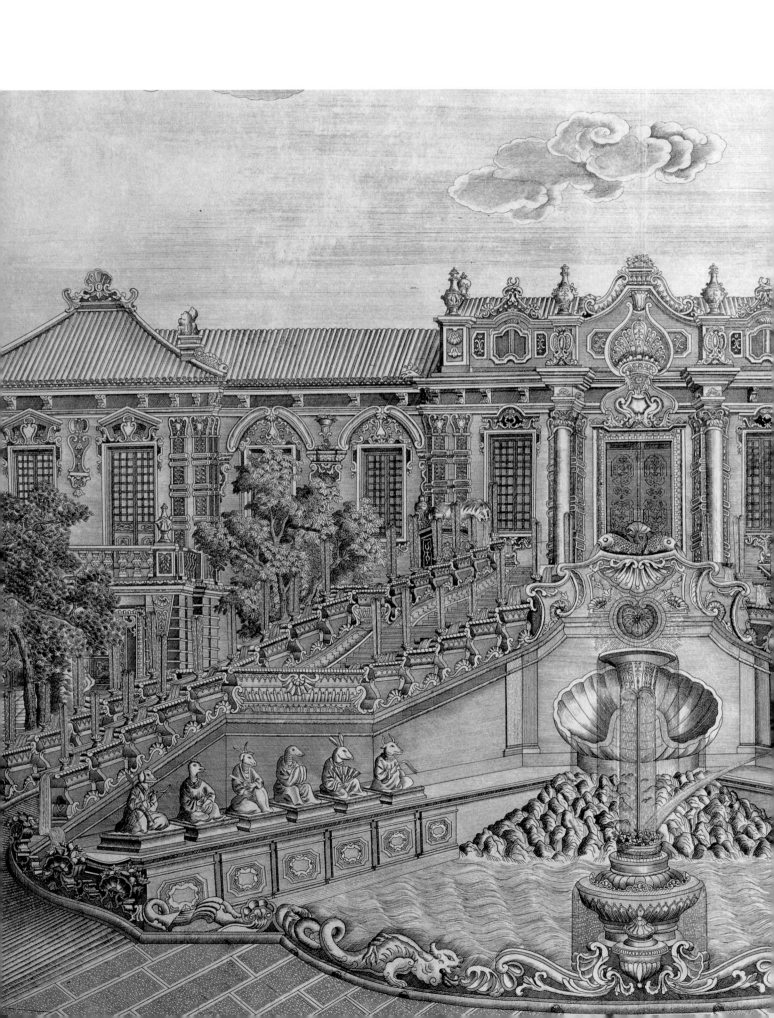

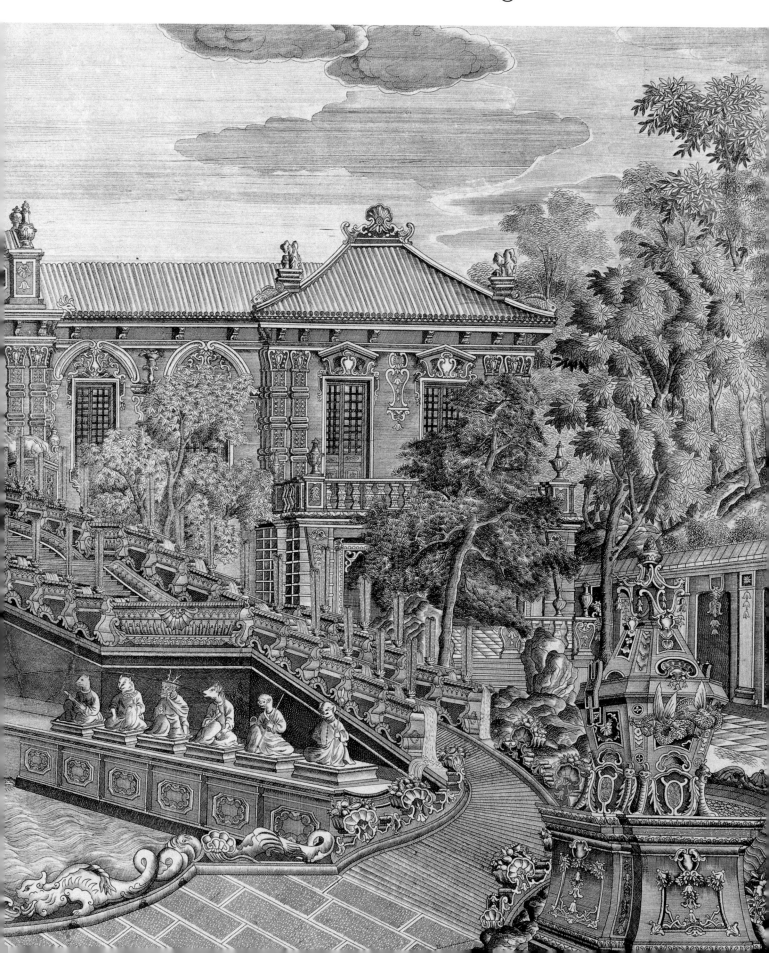

CAT. NO. **1**

**JUAN GONZÁLEZ
DE MENDOZA**

(Spanish, 1545–1618)

Dell'historia della China...
(On the history of China),
trans. Francesco Avanzi
(Rome: appresso Bartolomeo
Grassi, 1586)
2664-771

FIGURE 53. Title page with heral-
dic device of Pope Sixtus V

This is the first Italian edition of one of the most influential early books on China to be published in Europe. Written under the auspices of the sixteenth-century Catholic Church, which saw Asia as a land of spiritual opportunity, Juan González de Mendoza offered a detailed but unillustrated description of China together with lengthy accounts of several recent missionary voyages. Dedicated to Pope Sixtus V and Philip II, king of Spain, the book was originally issued by Bartolomeo Grassi in Spanish in 1585.

Mendoza was an Augustinian missionary who had been to Mexico and corresponded regularly with his confrères in the Philippines. At the request of Philip II, he had planned a mission to China, but this never transpired. Though he had not been to the Far East, Mendoza was considered knowledgeable enough about China for Pope Gregory XIII to order him in about 1583 to compose a comprehensive work on the subject. The book's first section is a survey in three sections that introduces China's history, antiquities, architecture, populace, religious beliefs and ceremonies, agriculture, military organiza-tion, and government. His principal sources were the published *Tractado em que se côtam muito por estêso as cousas da China* (Treatise that relates a great many things about China, 1569–70) by the Portuguese Dominican Gaspar da Cruz (in turn reliant on the account published by Galeote Pereira in 1565) and the manuscript account "Relación de las cosas de China que propriamente se llama Taybin" (Relation of things about China, which is properly called *Taybin,* 1576) by the Augustinian Martín de Rada. Mendoza's volume also contains descriptions of Japan and the Philippines and a chronicle of Spanish missions in the New World, for which Mendoza drew on his own experience in Mexico. The twenty-four page "Tavola della cose notabili" (Index of notable things) captures many of the diverse but distinctive features of China on which later works would focus, includ-ing its religions with their rituals, superstitions, idols, and curiosities. From rhinoceros to rhubarb, many of these subjects became the characteristic and recognizable emblems of China described and illustrated in later books.

This was the first book on China to become well known throughout Europe. By the end of the century, it had been translated into most European vernaculars and into Latin. Paving the way for similar works about missions and voyages, its topical coverage set the standard for subsequent European descriptions of China up to the eighteenth century.

In its slightly tattered original vellum binding, the Getty Research Institute's copy contains annotations and marks of ownership that provide evidence of interest in this book. Names inscribed on the title page and bookplates indicate that this copy had arrived in England by the early seventeenth century. The book was owned by William Anstruther in 1630 and had passed to Daniel Whyte of Liverpool in 1844. An extensive annotation in English on the front endpaper, dated 1748, concerns religious monuments and ceremonies, particularly those of the Jains. (MR)

LITERATURE: Boxer 1953; Cordier [1968], 8–16; Girard 1995; Lust 1987, nos. 23–28.

PREVIOUS SPREAD

Detail of FIGURE 48, no. 10

William Anstruther

DELL'HISTORIA
DELLA CHINA
DESCRITTA DAL P. M. GIO. GONZALEZ DI
Mendozza dell'Ord.di S.Agoſt.nella lingua Spagnuola.

*Et tradotta nell'Italiana dal Magn. M.Franceſco
Auanzo, cittadino originario di Venetia.*

PARTI DVE,
Diuiſe in tre libri,& in tre viaggi fatti da i Padri Agoſtiniani,
& Franciſcani in quei paeſi.
DOVE SI DESCRIVE IL SITO, ET LO STATO
di quel gran Regno, & ſi tratta della religione, de i coſtumi,&
della diſpoſition de i ſuoi popoli,& d'altri luochi più
conoſciuti del mondo nuouo.

Con vna copioſiſſima Tauola delle coſe notabili, che ci ſono.

ALLA SANTITA DI N. S. PAPA SISTO V.

*Gulielmus Anstrutherus
emit Apr: 12. anno
1630.*

CON PRIVILEGIO ET LICENZA DE' SVPERIORI.
IN ROMA.
Appreſſo Bartolomeo Graſſi. M.D.LXXXVI.

*Daniel Whyte
Liverpool, 31 August 1844.*

FIGURE 53

Catalog **141**

CAT. NO. **2**

JOHANNES NIEUHOF
(Dutch, 1618–72)

Het gezandtschap der Neêrlandtsche Oost-Indische Compagnie, aan den grooten Tartarischen Cham, den tegenwoordigen keizer van China... (The embassy of the Dutch East India Company to the great Tartar khan, the present emperor of China), 3rd ed., ed. Hendrik Nieuhof (Amsterdam: Wolfgang, Waasberge, Boom, van Someren, & Goethals, 1693)
84-B22315

FIGURE 54. *Beschryving van 't gesandschap der Nederlandsche Oost-Indische Compagnie aen den grooten Tartarischen cham nu keyser van China* (Description of the embassy of the Dutch East India Company to the great Tartar khan, now emperor of China), engraved title page

CAT. NO. **3**

JOHANNES NIEUHOF
(Dutch, 1618–72)

Legatio Batavica ad Magnum Tartariae Chamum Sungteium, Modernum Sinae Imperatorem... (Dutch embassy to the great khan of Tartary Shunzhi, the present emperor of China), trans. Georg Horn (Amsterdam: apud J. Meursium, 1668)
86-B27195

FIGURE 55. *Ananas, Musa* (Pineapple, plantain), after p. 106

See also FIGURES 3, 50

Johannes Nieuhof's extensively illustrated book documented the Dutch trade mission to the emperor of China in the years 1655 to 1657. It was sponsored by the Dutch East India Company (byname of the Vereenigde Oost-Indische Compagnie) and led by two of the company's overseers, the merchants Pieter de Goyer and Jacob Keyzer. As a member of the mission (he was its steward, artist, and chronicler), Nieuhof traveled first by sea from the Dutch colony at Batavia (Jakarta, Java), where the Dutch East India Company was headquartered, to Canton and then by interior waterways to Beijing. There the Dutch mingled with embassies from the Mongols, Tibetans, and Southern Tartars likewise negotiating trade agreements with the Chinese court.

Nieuhof's volume is notable for its descriptions and etchings based on the author's travel diary and sketches of the topography, principal cities and buildings, people, animals, plants, and mineral resources that he encountered over the course of the mission. It also contains a map charting the route taken from Java to Beijing. The journals and watercolors from which Nieuhof's book derives were intended to be presentation copies to the so-called Gentlemen Seventeen, the controllers of the Dutch East India Company. Although the original watercolors have been lost, copies exist in the Bibliothèque nationale de France in Paris. They are reproduced in Leonard Blussé and R. Falkenburg's *Johan Nieuhofs beelden van een Chinareis, 1655–1657*.

The first edition of *Het gezandtschap* was published in Amsterdam by the bookseller and art dealer Jacob van Meurs in 1665. Translations into French (1665), German (1666), Latin (1668), and English (1669) appeared in rapid succession, as did additional editions in Dutch. A touchstone for books on China, the book was excerpted and reprinted through the early eighteenth century. Many editions and translations used the same copperplates or close copies. In the English editions of 1669 and 1673, which were translated and produced by the English publisher and mapmaker John Ogilby, the original prints were copied (some in reverse) by the graphic artist Wenceslaus Hollar (Bohemian, 1607–77), who was working in England. Nieuhof's prints were standard visual sources for images that defined China for Europeans, and in the West they were frequently copied, in part or in whole, in other media and genres, notably lacquer and porcelain.

In the history of travel literature, Nieuhof is noted for his eyewitness accounts from Asia and Latin America. During his first voyage to Brazil, which took place between 1640 and 1644, he was an official in the service of the Dutch West India Company (byname of the West-Indische Compagnie), and this sojourn was the source for his illustrated volume on Brazil, *Gedenkweerdige Brasiliaense zee- en lantreize* (A memorable Brazilian sea and land journey), edited by his brother Hendrik and published posthumously by Meurs in 1682. In 1671, Nieuhof had embarked on what would be his last voyage: on his way from Amsterdam to the East Indies, he died on the island of Madagascar. (MR)

LITERATURE: Blussé and Falkenburg 1987; *China* 1973, 158–60 (no. E12); Corbett 1986; Cordier [1968], 2344–48; Eeghen 1972; *Europa und die Kaiser von China* 1985, 235–37 (cat. nos. 5/12–5/16); Grigsby 1993; Landwehr 1991, no. 539; Lust 1987, nos. 539–41; Nieuhof 1693/1985; Odell 2001; Odell 2003; Ulrikes 2003; Walravens 1987, 142–44 (cat. nos. 62–64).

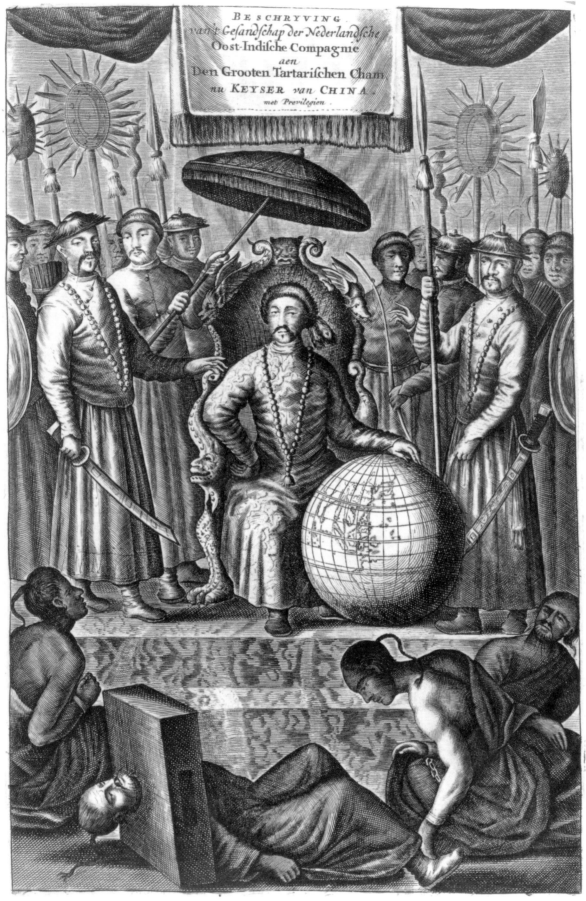

Within the illustration:

BESCHRYVING
van 't Gesandschap der Nederlandsche
Oost-Indische Compagnie
aen
Den Grooten Tartarischen Cham,
nu KEYSER van CHINA.
met Previlegien.

FIGURE 54

ANANAS

FIGURE 55

144 Catalog

MUSA

11.

CAT. NO. 4

OLFERT DAPPER
(Dutch, 1639–89)

Gedenkwaerdig bedryf der Neder-landsche Oost-Indische Maetschap-pye, op de kuste en in het keizerrijk van Taising of Sina...(Memorable mission of the Dutch East India Company up the coast and into the empire of Taising or China) (Amsterdam: Jacob van Meurs, 1670)
84-B22302

FIGURE 56. *Tweede en derde gesandschap na het keyserryck van Taising of China* (Second and third embassy to the empire of Taising or China), engraved title page

Olfert Dapper was trained as a medical doctor, but he is best known today as the seventeenth-century Dutch humanist and writer for whom the Musée Dapper in Paris—which features a superb collection of African art—is named. Dapper was the author of *Historische beschryvinge der stadt Amsterdam* (Historical description of the city of Amsterdam, 1663), about his home city, and several illustrated works describing Africa, Asia, and the islands adjacent to those continents—none of which he saw in person. His *Naukeurige Beschrijvinge der Afrikaensche gewesten van Egypten, Barbaryen, Libyen, Biledulgerid, Negroslant, Guinea, Ethiopiën, Abyssinie* (Accurate description of the Africans regions of Egypt, Barbary, Libya, Biledulgerid [western Sahara?], Negroslant [West Africa?], Guinea, Ethiopia, Abyssinia, 1668) was one of the first extensive studies of that region.

Dapper's *Gedenkwaerdig bedryf* follows in the footsteps of Johannes Nieuhof's account of the first trade mission to China sponsored by the Dutch East India Company (cat. nos. 2, 3). In this influential work, Dapper describes the Dutch admiral Balthasar Bort's expeditions along the coast of southern China in 1663 and 1664 as well as the third Dutch trade mission to Beijing, which was led by Pieter van Hoorn in 1666 to 1668. It is based on journals and sketches from the voyage that are presently held by the Algemeen Rijksarchief de La Haye and the Stichting Atlas Van Stolk in Rotterdam. The book's engraved title page shows the emperor dressed in ceremonial garb and seated cross-legged beneath a canopy. He is surrounded by Chinese engaged in stereotypical activities (calligraphy, hawking goods such as pearls and lacquerware), and Chinese products (a caged bird, a steaming teapot) are arrayed beside him, almost as if he were a merchant. The emperor was rarely seen by foreigners, and this depiction of him as a vendor in a public marketplace is completely fictitious. In the foreground, below the emperor, a young European woman wearing a pearl necklace steps from a shell that holds a compass (symbolizing Western navigational triumphs) into a small boat whose muscular Chinese oarsman seems to have felled the warriors thrashing in the water. Read from top to bottom, the full-page print is a visual summary of the political hierarchy in China, the economic interest of Europe, and the Chinese cultural milieu from a European perspective.

The images in Dapper's volume, which are similar in style to those in Nieuhof's volume (both sets of illustrations were engraved by Jacob van Meurs and his workshop), depict cityscapes and monuments seen along the route through China shown on a well-labeled map. The images also mark specific events during the Dutch mission, such as the arrival in Beijing, the banquet with the emperor, and the unpacking of presents for the emperor in a courtyard of the Forbidden City. An English translation of Dapper's *Gedenkwaerdig bedryf* (titled *Atlas Chinensis* and credited to Arnoldus Montanus) was issued by John Ogilby first in 1671 and then in 1673 to accompany the second edition of Ogilby's English translation of Nieuhof's book. Wenceslaus Hollar's new versions of the illustrations for Ogilby's edition of Dapper's book are very close to the original engravings (albeit sometimes reversed). (MR)

LITERATURE: *China 1973*, 161 (no. E20); Corbett 1986; Cordier [1968], 2348–49; Eeghen 1972; *Europa und die Kaiser von China* 1985, 238–39 (cat. nos. 518–21); Jones 1989; Landwehr 1991, nos. 544–46; Lust 1987, no. 507; Walravens 1987, 144–45 (cat. no. 65).

Tweede en Derde
GESANDSCHAP
na het
KEYSERRYCK
van
TAYSING of CHINA.
met Previlegien
A: 1671.

T'AMSTERDAM
By Jacob van Meurs, Plaatsnyder en Boeckverkooper, op de Keysers graft in de Stadt Meurs.

FIGURE 56

CAT. NO. **5**

ATHANASIUS KIRCHER
(German, 1602–80)

*China Monumentis, qua Sacris
quà Profanis, nec non Variis Natu-
rae et Artis Spectaculis, aliarumque
Rerum Memorabilium Argumentis
Illustrata . . .* (China illustrated
with monuments, sacred as well
as profane, and also by diverse
sights, and by artistic evidence
of other memorable things)
(Amsterdam: apud Joannem
Janssonium à Waesberge &
Elizeum Weyerstraet, 1667)
85-B12590

FIGURE 57. Headpiece to chapter
4: *Modus scribendi* (Method of
writing), p. 233

CAT. NO. **6**

ATHANASIUS KIRCHER
(German, 1602–80)

*Toonneel van China, door veel, zo
geestelijke als weereltlijke geheug-
teekenen, verscheide vertoningen van
de natuur en kunst, en blijken van
veel andere gedenkwaerdige dingen,
geopent en verheerlykt . . .* (Theater
of China, presented and glorified
by many monuments, both
sacred and profane, various sights
from nature and art, and proofs
of many other memorable
things), trans. Jan Hendrick
Glazemaker (Amsterdam:
Johannes Janssonius van
Waesberge, 1668)
1382-254

FIGURE 58. *Athanasii Kircheri Soc.
Jesu China Illust.* (China Illustrated
by Athanasius Kircher, Society
of Jesus), engraved title page

FIGURE 59. *Schematismus Secundus
Principatia Sinensium Numina
Exhibens* (Second schema show-
ing the principal Chinese divini-
ties), foldout after p. 168

See also FIGURES 5, 6

The engraved (and in the Dutch edition, hand-colored [fig. 58]) title page to this influential treatise on China by the Jesuit polymath Athanasius Kircher pays homage to the Jesuit order and the accomplishments of the Jesuit mission in China, then nearly a century old. Its composition, which echoes the engraved title page in the Augsburg edition of 1615 of Matteo Ricci's *De Expeditione Christiana apud Sinas* (On the Christian mission among the Chinese) (see fig. 2), features the Jesuit monogram IHS prominently displayed between saints Ignatius Loyola, founder of the order, and Francis Xavier, a founding member of the order who died on the Chinese island of Shangchuan. The rays of light streaming down from the monogram point to Ricci, who led the early Jesuit mission in China, and Adam Schall von Bell, who served as an astronomer at the Qing court. Emblematic instruments (quadrant, pantograph, armillary sphere, and compass) used by the Jesuits to introduce Western science to the Chinese are piled at the lower right, near Ricci's feet. The two missionaries are shown in full-length Chinese robes and hold a map of China unfurled between them. This map is similar to that held by putti on the illustrated title page of in Martino Martini's *Novus Atlas Sinensis* (cat. no. 25).

Athanasius Kircher's application to work in China was turned down by the Jesuits' superior general in 1629. In 1634, he was called from France (having fled the religious strife of his native Germany) to Rome, where he would serve as a professor of mathematics at the Collegio Romano and write an impressive number of wide-ranging and noteworthy books on antiquities and science. Published late in his career, *China Monumentis* is not an original work but a secondary study based on the writings of fellow Jesuits, including Ricci, Martini, Schall, Johann Grueber, and Heinrich Roth, and on Kircher's personal correspondence with these and other priests who had traveled to China. The illustrations of plants and animals are based on Michel Boym's *Flora Sinensis* (Plants of China, 1656), and a few images are obviously derived from Chinese originals (fig. 59). Doubtless Kircher wrote the book to promote the missionaries' work in China, but he also had a strong personal interest in Chinese language and culture, and he collected Chinese objects for display in the his museum, the vast and varied natural history collection that he assembled in Rome.

The frontispiece in *China Monumentis* is a portrait of Kircher in his library dressed in robes like those worn by Schall on the engraved title page. The entire book, like his portrait, is an illustration of Kircher the scholar seeking to extend his understanding of a complex and highly developed intellectual world that presented an alternative to the European model. A compendium and virtual voyage, this volume is a cultural exposition of China, a compilation of what was known to Kircher that ranges across China's religious practices, costumes, and languages as well as its natural wonders, plants, and animals. Several chapters focus on the Chinese language (fig. 57) because Kircher believed that the characters of its writing system were related to Egyptian hieroglyphics. Like other volumes among Kircher's more than forty works, the book on China is notable for the detailed illustrations that elucidate the vivid descriptions found in the texts. (MR)

LITERATURE: Backer and Backer 1960, 4:1046–78; *Catalogue* 1949/1969, nos. 373, 374 (Fr. ed.), 1909 (Lat. ed.); *China* 1973, 129 (no. A10), 156–58 (no. E10); Cordier [1968], 26–27; Findlen 2004; Fletcher 1968; Godwin 1979; González-Palacios [1981], xvii–xix; Lust 1987, nos. 37, 39; Merrill and Larsen 1989; Mungello 1985, 134–73; Reilly 1974; Rosenkranz 1852; Saussy 2001; Walravens 1987, 94–98 (cat. nos. 17, 18).

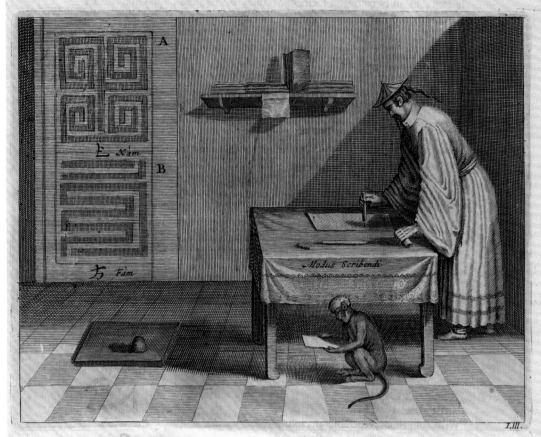

FIGURE 57

CAPUT IV.

Differentia inter Sinenses & Hieroglyphicos Ægyptiorum Characteres.

Iximus in præcedentibus, ve-
risimile esse, posteros *Chami* co-
loniis in ultimam usque *Sinarum*
Regionem propagatis unà quoque &
literas propagasse; non tamen tantò,
quantò *Ægyptiorum* hieroglyphica, my-
steriorum apparatu adornatas, sed quan-
tum sufficiebat ad conceptus mentis ex-
ponendos, rudi Minerva comparatas.
Certè inter Sinenses characteres Crux,
quæ tanto apud *Ægyptios* honore habe-

tur sæpissimè spectatur, uti Figura O do-
cet, quæ non secus ac apud *Ægyptios* de-

to decem xĕ

narium numerum significat, perfectio-
nis symbolum. Huic si subjiciant aliam
lineam

Crux de-
narium
numerum
notat a-
pud Sinas.

G g

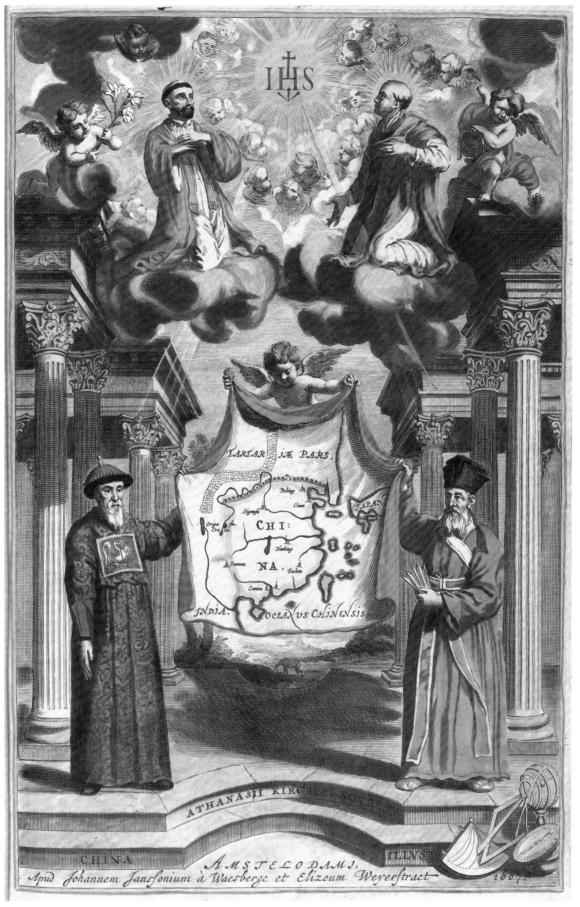

Within the illustration:

IHS

TARTAR IÆ PARS.

CHI:
NA.

JAPAN

INDIA. OCEANUS CHINENSIS

ATHANASII KIRCHERI

CHINA

AMSTELODAMI,
Apud Johannem Janssonium à Waesberge et Elizeum Weyerstraet.

FIGURE 58

FIGURE 59

CAT. NO. *7*

*Ceremonies et coutumes religieuses
des tous les peuples du monde...*
(Ceremonies and religious cus-
toms of all the peoples of the
world), vol. 2, *Ceremonies et
coutumes religieuses des peuples
idolatres* (Ceremonies and
religious customs of the idola-
trous peoples) (Amsterdam:
J. F. Bernard, 1728)
1387-555

FIGURE 60. Bernard Picart, *Convoi
funebre d'un grand de la Chine*
(Funerary cortege of a Chinese
noble), after p. 264

The prolific artist Bernard Picart (French, 1673–1733) was trained in the graphic arts by his father Étienne Picart, but the son's acumen as a draftsman, printmaker, and print-seller far surpassed his father's. In the early 1690s, as a student of Sébastien Le Clerc the Elder, Picart worked in Paris, but in 1711, after some years working in Antwerp and the Netherlands, he moved from France to Amsterdam. This fortuitous change of scene brought Picart into the accomplished orbit of Dutch publishing and printmaking, which was then at its zenith, producing both exemplary editorial projects and beautifully illustrated luxury editions in the seventeenth-century tradition of the atlases issued by Willem Janszoon Blaeu and his successors and the travel series published by Jacob van Meurs and Johannes Jansson Waesburg.

Picart's illustrated nine-volume set, titled *Ceremonies et coutumes religieuses des tous les peuples du monde* (1723–43), focused on popular ceremonies and religious customs from around the world. Under the rubric of idolatrous peoples, volume 2, part 1, includes the lengthy section *Dissertation sur les cérémonies religieuses des peuples de la Chine et du Japon, etc.* (Dissertation on the religious practices of the peoples of China and Japan and so forth). This turns out to be a mélange drawn from earlier authors, including Martino Martini, Louis Le Comte, Athanasius Kircher, Charles Le Gobien, Samuel Purchas, Johannes Nieuhof, and Olfert Dapper, among others. In a sense, it is a compendium of earlier compendiums. The prints depict all aspects of Chinese religious life: ceremonies, festivals, banquets, buildings, costumes, and vehicles. Picart based his images on illustrations in books by Kircher, Nieuhof, and Dapper but cleverly elaborated them with landscapes and other details. He generally transformed rather sketchy prints into masterful scenes, all of which, it should be stressed, are composed images. Not based on the artist's direct experience of China, they blend details and transform the subjects of earlier prints in ways that make them more visually appealing but far less useful as visual documentation of China itself. In the *Convoi funèbre d'un grand de la Chine* (fig. 60), which is based on a double-page engraving from Dapper's *Gedenkwaerdig bedryf* (1670) showing the funeral of a high-ranking Chinese individual, as indicated by the size of the procession, Picart's graphic skill is evidenced by his interpolation at the right of the juggler who balances on one foot atop a pole. The juggler is from an etching of various entertainers (including dancing rats) in Nieuhof's *Het gezandtschap der Neêrlandtsche Oost-Indische Compagnie* (1665); in other illustrations, Picart likewise isolates figures from groups drawn by Nieuhof and other printmakers to create separate portraits. Notably, the papier-mâché sculptures of ancestors and local deities at the front of the procession in Dapper's image have been transformed in Picart's engraving into pictures on banners. The way Picart has rendered such three-dimensional figures in two dimensions could indicate that he had access to authentic Chinese prints or paintings. (MR)

LITERATURE: *China* 1973, 162–63 (no. E27); Faliu 1988, 9–30; Portalis 1877, s.v. "Picart (Bernard)."

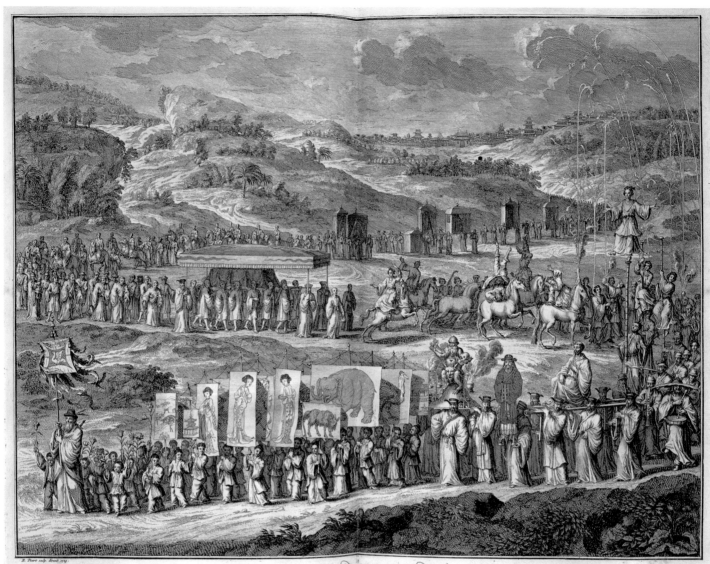

CONVOI FUNEBRE d'un GRAND de la CHINE.

FIGURE 60

**JEAN–BAPTISTE
DU HALDE**
(French, 1674–1743)

*Description geographique, histo-
rique, chronologique, politique, et
physique de l'empire de la Chine et
de la Tartarie Chinoise; enrichie des
cartes generales et particulieres de
ces pays, de la carte générale et des
cartes particulieres du Thibet, et de
la Corée, et ornée d'un grand nombre
de figures et de vignettes gravées en
taille-douce* (Geographical, his-
torical, chronological, political,
and physical description of the
empire of China and Chinese
Tartary; amplified by general
and specific maps of that country,
by a general map and specific
maps of Tibet and Korea, and
ornamented with numerous
engraved illustrations and
vignettes), 4 vols. (Paris: P. G.
Le Mercier, 1735)
87-B6617

FIGURE 61. Charles de La Haye;
and Jean-Baptiste Antoine
Guélard, after Antoine Humblot,
*Carte la plus generale et qui com-
prend la Chine, la Tartarie Chinoise,
et le Tibet* (The most general map,
which includes China, Chinese
Tartary, and Tibet), vol. 1, after
half-title page

See also FIGURE 11

This positive view of Chinese culture published by Jean-Baptiste Du Halde in four illus-
trated folios was enhanced considerably by forty-three maps and ten city plans drawn by
the distinguished mapmaker Jean-Baptiste Bourguignon d'Anville (French, 1697–1782)
based on maps recently produced by missionary cartographers in China. Du Halde's
preface tells the story of the Kangxi emperor's commission for the Jesuits to survey the
cities and provinces of China. The resultant maps, which were first published in China
in 1718, were used by d'Anville not only for Du Halde's *Description* but also for his own
Nouvel atlas de la Chine (New atlas of China, 1737).

Du Halde, who was a Jesuit, based the text of the *Description* on the reports of the
seventeen missionaries whose names he lists at the end of the preface. Though he had
not been to China and did not know Chinese, Du Halde's erudite volumes brought
together an array of European travel accounts, early reports by Jesuits such as Ferdinand
Verbiest, correspondence from missionaries in China, translations of Chinese texts, and
short works by the Kangxi emperor. The encyclopedic *Description* became known as
the standard source on China, whether the reader was in search of geographic descrip-
tion, historical or literary information, accurate maps, or illustrations. In the "Approba-
tion" (vol. 1, "Table," p. iii), the abbé Gilles Bernard Raguet wrote in glowing terms of
the reach of Du Halde's work: its coverage ensured that no country would be better
known than China. Readers could comprehend both what China could give to Europe
and what Europe could give back, namely, the knowledge of the true religion brought
to China by the Jesuits, in particular, by the French fathers, working under the protec-
tion provided by the two great rulers of the century, Louis XIV and the Kangxi emperor
(vol. 1, "Epitre," p. iii).

The design of Du Halde's volumes includes chinoiserie-style printer's marks, ini-
tials, and headpieces that express the reputed luxury and elegance of all things Chinese.
Du Halde wrote that nothing had been spared in the selection of the paper and type
or in the production of the engravings. These were designed by the illustrator Antoine
Humblot (French, ca. 1700–58) in the taste of original Chinese works given to him
by Du Halde, some which were sent by Monsieur de Velaer who lived many years in
Canton as the director of the Compagnie des Indes (that is, the French East India Com-
pany) (vol. 1, "Preface," p. xlix). Rather than a typical author's portrait or emblematic
composition, the frontispiece to volume 1 is a large folding map, emphasizing the impor-
tance of geography.

Not surprisingly, the work was popular throughout Europe and was quickly trans-
lated into other vernaculars. It was also pirated: a spurious, ostensibly revised edition of
the *Description* was published in Amsterdam a year after the first French edition. English
editions contained significantly fewer maps, and rather than cartography, they stressed
the Jesuit missionaries' contributions, as signaled by frontispieces featuring portraits of
the priests after images in Du Halde's original edition. (MR)

LITERATURE: Backer and Backer 1960, 4:34–38; *Catalogue* 1949/1969, 257–58; *China* 1973, 163 (no. E29); Cordier
1905; Cordier [1968], 46–48; Hostetler 2001; Landry-Deron 2002; Lust 1987, no. 12; Walravens 1987, 106–10 (cat.
nos. 26, 27).

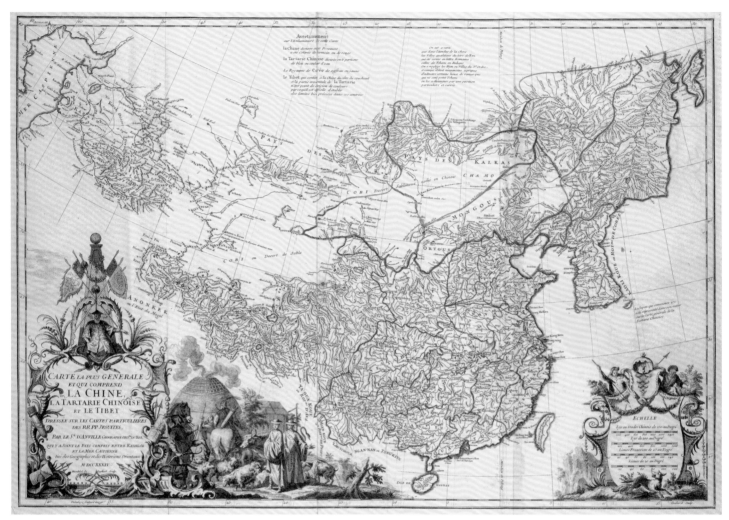

FIGURE 61

CAT. NO. **9**

GEORGE LEONARD STAUNTON
(British, 1737–1801)

An Authentic Account of an Embassy from the King of Great Britain to the Emperor of China: Including Cursory Observations Made, and Information Obtained, in Travelling through that Ancient Empire, and a Small Part of Chinese Tartary; together with a Relation of the Voyage Undertaken on the Occasion by His Majesty's Ship "The Lion" and the Ship "Hindostan," in the East India Company's Service, to the Yellow Sea, and Gulf of Pekin, as well as of Their Return to Europe, 3 vols. (London: printed for G. Nicol, 1797)
86-B18709

FIGURE 62. Thomas Medland, after William Alexander, *Economy of Time and Labor, Exemplified in a Chinese Waterman*, vol. 3 (plates), pl. 42

This set of two quarto volumes containing text and twenty-eight engravings and one folio volume of forty-four maps and plates describes the British diplomatic mission to China in the years 1792 to 1794. The embassy traveled with a sixty-four-gun ship as a military escort, to add dignity to the embassy, and it was led by Viscount Macartney, who had been an envoy to Russia, the chief secretary for Ireland, the governor of the Caribbee Islands (Grenada, the Grenadines, and Tobago), and the governor of Madras. Sir George Leonard Staunton was a doctor who had traveled widely for the British government as a diplomat. He had met Sir George Macartney in the West Indies and became his secretary, continuing in this position in India. While a member of the embassy to China, Staunton was the secretary of the legation as well as its envoy extraordinary and minister plenipotentiary. He brought along his twelve-year-old son, George Thomas Staunton, who would write numerous books on China in the nineteenth century. Other members of the embassy included the painter William Alexander, who became famous for his sketches, paintings, and prints of China; Lieutenant Henry William Parish, who made sketches on which some of the prints in Staunton's book are based; and John Barrow, who wrote his own book about the embassy, *Travels in China* (cat. no. 10).

An Authentic Account was based on the papers of Staunton, Macartney, Sir Erasmus Gower, who was the naval commander of the mission, and other members of the embassy. The plates, most after drawings by Alexander, are preceded by a precise map that includes the daily readings from the barometer and the thermometer in tiny print along the path of the ships. The appealing and informative plates show mainly views from the ship, panoramic vistas, natural phenomena, and local customs. The engraved frontispiece portraits of the Chinese emperor (in volume 1) and Macartney (in volume 2) hint at the British failure to acknowledge the Chinese emperor as George III's superior and thus to conform to court protocols that figured Great Britain as a tributary state rather than a power equal to China. The cultural disconnect is summed up in the title of one print: *Economy of Time and Labor, Exemplified in a Chinese Waterman* (fig. 62). One can almost imagine the raised eyebrows of the British visitors as the Chinese boatman floated by.

This large-format work is the first of several publications by members of the embassy that detailed the mission's reception in China and associated events. Their experiences were not all negative nor was the venture a complete failure, as some have said. Though the embassy obtained neither new trade concessions from the Chinese nor the hoped for face-to-face negotiations with the Qianlong emperor, its secondary goal, for the British to learn more about China, was accomplished, even if individuals' comprehension of Chinese customs was not entirely positive or necessarily correct. Volume 1 of the Getty Research Institute's set contains a prospectus for Alexander's *Costume of China, Sketches from Nature Made in China, in the Year 1793* (eventually published in 1804, with a different subtitle). These prints by Alexander were intended as an appendix to Staunton's work and heralded the popularity of Chinese subjects. (MR)

LITERATURE: Cordier [1968], 2381–83; Hevia 1995; Legouix 1979; Legouix-Sloman 1985; Lust 1987, no. 545; Walravens 1987, 158–60 (cat. nos. 75–77); Wood 1998.

W. Alexander del. J. Medland sculp.

ECONOMY of TIME and LABOR, exemplified in a CHINESE WATERMAN.

London, Published April 12.1796, by G. Nicol.

FIGURE 62

CAT. NO. **10**

JOHN BARROW
(British, 1764–1848)

Travels in China: Containing Descriptions, Observations, and Comparisons, Made and Collected in the Course of a Short Residence at the Imperial Palace of Yuen-Min-Yuen, and on a Subsequent Journey through the Country from Pekin to Canton..., 2nd ed. (London: printed for T. Cadell & W. Davies, 1806)

2651-380

FIGURE 63. Thomas Medland, after William Alexander, after Henry William Parish, *View in the Eastern Side of the Imperial Park at Gehol,* after p. 128

John Barrow journeyed to China as Sir George Leonard Staunton's private secretary and a member of the British embassy to China led by Viscount Macartney from 1792 to 1794. Barrow's *Travels in China* was meant to offer an account of that diplomatic venture fuller and more accurate that than published by Staunton. This work by Barrow would be followed by several others describing distant lands and adventurous travels, including books on South Africa, Pitcairn Island, the mutiny on the *H.M.S. Bounty,* and voyages in search of the Northwest Passage. Barrow would serve as second secretary to the Admiralty for nearly four decades, and in this connection he wrote several biographical sketches of significant figures in the British Navy. He was also a principal founder of the Royal Geographical Society.

The Getty Research Institute holds a copy in a modern binding of the second edition of Barrow's *Travels in China* (the first edition was published in 1804). A motto on the title page reads, "It is the lot of few to go to Pekin"—a play on Horace's "Non cuiuis homini contingit adire Corinthum" (No man just happens to go to Corinth; Horace, *Epistles* 1.17.36), which also appears there. Barrow was one of those privileged few who were able to travel not only to China but also across its interior to Beijing, but his report back was far from favorable. Stung by the hostility and unpleasantness that the British embassy felt they had encountered, Barrow sought to provide a "corrective" portrait of China and the Chinese, in which they appeared "not as their own moral maxims would represent them but as they really are" (p. 3). Barrow continued that he wished to divest the imperial court of "the tinsel and the tawdry varnish" with which the Jesuits had "found it expedient to cover it in their writings" (p. 3).

The title page suggests that Barrow's stance toward China will be neutral or even positive: "In which it is attempted to appreciate the rank that this extraordinary empire may be considered to hold in the scale of civilized nations." The reader is soon disabused. The book begins with a barbed diatribe concerning the treatment of foreign embassies by the Chinese. Barrow writes about all that those travelers who left Britain with a favorable impression of the Chinese subsequently encountered to contradict this. He even adduced parallels to the Chinese court's treatment of the English from Dutch accounts of their embassy's treatment. Yet the text is far from completely critical of China, and it offers a fascinating day-by-day account of the journey. Indeed, none of the images in *Travels in China* supports Barrow's words. The conundrum of this critical book is that its prints do not reflect the author's negative views. The illustrations—a hand-colored frontispiece portrait of Van-ta-gin, whom Barrow calls "our worthy conductor"; five hand-colored aquatints of people, landscapes, and genre scenes, four of which are after drawings by William Alexander; and three uncolored engravings of artillery, musical instruments, and the arch of a bridge—are uniformly engaging and decorative. Music to a Chinese song that was sung together with the crew appears in Western notation. Rather than painting China and its people in the occasionally harsh light thrown by Barrow's words, Alexander persisted in depicting them as alluringly picturesque.

In 1807, Barrow's account was published as *Voyage en Chine, a la suite de l'ambassade de Lord Macartney,* with a translation by Jean Baptiste Joseph Breton de la Martinière. (MR)

LITERATURE: Abbey 1972, no. 531; Cordier [1968], 2388–89; Lust 1987, nos. 365, 366; Walravens 1987, 161–63 (cat. no. 81).

Drawn by W.ᵐ Alexander, from a Sketch by Capt.ᵗ Parish, Roy.ˡ Artil.ʸ

Engraved by T. Medland

View in the Eastern side of the Imperial Park at Gehol.

Publish'd by Mes.ʳˢ Cadell & Davies, Strand, London.
May 2. 1804.

FIGURE 63

CAT. NO. **11**

**CHRÉTIEN LOUIS JOSEPH
DE GUIGNES**
(French, 1759–1845)

*Voyages à Peking, Manille et l'Île de
France, faits dans l'intervalle des
années 1784 à 1801* (Voyages to
Peking, Manila, and Mauritius,
made in the years from 1784 to
1801), 3 vols. and atlas (Paris:
Imprimerie Impériale, 1808)
87-B2931

FIGURE 64. Jacques Eustache de
Sève, after Chrétien Louis Joseph
de Guignes, *Fête chinoise qui à lieu
en automne* (Autumnal Chinese
festival), atlas, no. 6

The sinologist and lexicographer Chrétien Louis Joseph de Guignes's account in his *Voyages* of his journey with the Dutch embassy to Beijing in 1794 and 1795—which followed on the heels of the British embassy led by Viscount Macartney—was informed by impressions obtained not only during that diplomatic mission but also in the course of his seventeen years in China. He went to China initially in 1783, as resident of France in China and consul at Canton, and when the consulate was suppressed in 1787, he stayed on. In 1794, de Guignes accompanied the Dutch embassy led by Isaac Titsingh and Andreas Everardus van Braam Houckgeest to Beijing, serving as an interpreter. The delegation's mission was to congratulate the Qianlong emperor on his sixtieth birthday. De Guignes stayed in China until January 1796; he then traveled through the Philippines in 1796 and 1797 before returning home to Paris in 1801.

De Guignes's *Voyages* offered a more personal perspective on the embassy than van Braam's official report, *Voyage de l'ambassade de la Compagnie des Indes orientales hollandaises, vers l'empereur de la Chine, dans les années 1794 et 1795* (Voyage of the embassy of the Dutch East India Company to the emperor of China in the years 1794 and 1795, 1797–98). In addition to the four-volume *Voyages,* de Guignes wrote *Observations sur le voyage de M. Barrow à la Chine, en 1794* (Observations on Barrow's voyage to China in 1794, 1804). In 1813, realizing a project conceived during the reign of Louis XIV, de Guignes published *Dictionnaire chinois, français et latin* (Chinese, French, and Latin dictionary), which he edited from a manuscript by Basilio Brollo da Gemona (Italian, 1648–1704).

China was in de Guignes's blood. His father Joseph de Guignes held the chair of Syriac at the Collège de France and adamantly believed that China was originally a colony of Egypt. Grounded in comparisons of Chinese characters with Egyptian hieroglyphics, this idea had been in circulation since the seventeenth century (see fig. 57). In addition to collaborating with Jesuit writers on *Le Chou king* (The *Shujing*) (cat. no. 18), the elder de Guignes published a three-volume political history of the Huns, Turks, Mongols, and other western Tartars. Unlike his son, he never visited China.

In contrast to the abstract polemics undertaken by intellectuals such as the elder de Guignes, the younger de Guignes's *Voyages* is a true travel journal. It recounts his experiences working and traveling around the country: "Je décris les choses à mesure que je les vois, je les représente telles qu'elles existent, et j'ose croire que la lecture de mon journal fera voir que les Chinois sont loin d'être tels qu'on nous les a dépeints" (I describe things as I see them, I represent them such as they are, and I dare to think that a reading of my journal will show that the Chinese are far from being such as they have been depicted; vol. 1, p. ix). And its illustrations are based on the author's sketches of what he saw in China. He writes modestly, "Je donne dans l'atlas une partie des dessins que j'ai faits à la Chine: ce n'est pas la production d'un artiste habitué dès l'enfance à copier la nature, c'est le travail d'un amateur" (I include in the atlas some of the drawings I made in China: they are not the work of an artist trained from an early age to copy from nature [but] the work of an amateur; vol. 1, p. xiii). Following a lengthy "Tableau d'histoire ancienne de la Chine" (Sketch of the ancient history of China), *Voyages* describes the embassy's seven-week journey from Canton to Beijing and six-week stay in the capital. De Guignes comments from an insider's perspective on the mistakes of both the British and the Dutch embassies, but his account is most engaging when he writes about particular sights and events, such as seasonal festivals and the younger Dutch men ice-skating in the gardens of the imperial palace in Beijing (vol. 1, p. 379). (MR)

LITERATURE: Cordier [1968], 2351–52; Lust 1987, no. 336.

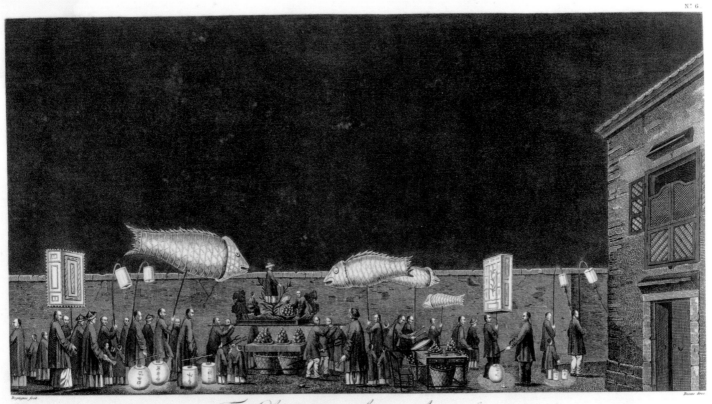

Fête Chinoise qui à lieu en Automne.

FIGURE 64

CAT. NO. **12**

GEORGE HENRY MASON
(British, fl. 1800)

The Costume of China, Illustrated by Sixty Engravings: With Explanations in English and French (London: printed for W. Miller, 1800) 89-B11237

FIGURE 65. J. Dadley, after Pu-Quà, *A Woman Making Stockings,* pl. 3

CAT. NO. **13**

GEORGE HENRY MASON
(British, fl. 1800)

The Punishments of China, Illustrated by Twenty-two Engravings: With Explanations in English and French (London: printed for W. Miller, by W. Bulmer, 1801) 89-B4080

FIGURE 66. J. Dadley, *A Culprit before a Magistrate,* pl. 1

See also FIGURE 10

George Henry Mason's preface to *The Costume of China* delivers a strong yet not completely attractive portrait of China. While an officer in the 36th (Herefordshire) Regiment of Foot, which was deployed in India between 1782 and 1793, Mason had stayed in Canton for several months in or around 1790, during which time he went into the city proper with a party of his fellow Englishmen who wished to go sight-seeing. A rowdy crowd, no doubt curious about Europeans, harassed the tourists in the streets. When one of the Englishmen went off alone, he was arrested, detained, and released only after the intervention of the Hong merchants of Canton through whom foreigners dealt with the Chinese civil administration. On the basis of this unpleasantness, Mason concluded:

> The very circumscribed limits which are marked out for foreigners at Canton, have rendered the natives of China so completely isolated from the rest of human kind, that only a very superficial acquaintance has been hitherto obtained about the Religion, the Laws, the Manners, or the Arts of a people the most ancient in the discovered world; and it is exceedingly to be regretted, that either habitual caution, ungenerous suspicion, or experienced necessary circumspection, should influence the Chinese ... to restrain the observing traveller within this narrow compass.
>
> Insult is the common lot of those foreigners who extend their walk beyond the few yards appointed for their temporary residence (*Costume,* preface, p. [1]).

While he was not so fond of Chinese customs, Mason appreciated the arts of China. He was a collector, and he stresses the distinction of the examples he has chosen: "the Editor obtained correct drawings of the Chinese in their respective habits and occupations; the itinerant mechanics and handicraftsmen, in particular: fac-similes of which are exhibited on the subsequent pages. Not intended, originally, for public inspection, they are thus, at the instance of some learned and ingenious friends, issued from his portfolio after ten years privacy" (*Costume,* preface, p. [3]).

In *The Costume of China,* the colored stipple engravings depicting individual Chinese in the dress appropriate to their occupation or rank are purportedly based on originals by the Cantonese export artist Pu-Quà, but no mention is made of the originals on which engravings of the punishments might have been based. That the Chinese would produce prints of costumes and trades is predictable, but the pendant volume, comprising images of the Chinese judicial system and the physical punishments exacted under its penal code, is unique for such a collection. The principals in each series are shown theatrically, with attention paid not to the setting but to the persons, their dress, their actions, and the most characteristic implements or furnishings to indicate his or her occupation or crime or punishment. Situating these images in the history of descriptive literature on China, the texts printed facing the prints reference Sir George Leonard Staunton's account of the British embassy led by Viscount Macartney, Mason's own recollections, and "careful selections from the narratives of almost every traveller," including those by Staunton (cat. no. 9), Johannes Nieuhof (cat. nos. 2, 3), Domingo Fernández Navarette, and Andreas Everardus van Braam Houckgeest (*Costume,* preface, p. [3]). Watercolor originals for the prints or close versions thereof are held by the Victoria and Albert Museum in London and the Ashmolean Museum in Oxford, among others. (MR)

LITERATURE: Abbey 1972, nos. 532, 533; Clunas 1984, 33–42; Cordier [1968], 549, 1858; Lust 1987, no. 712; Vainker 2003.

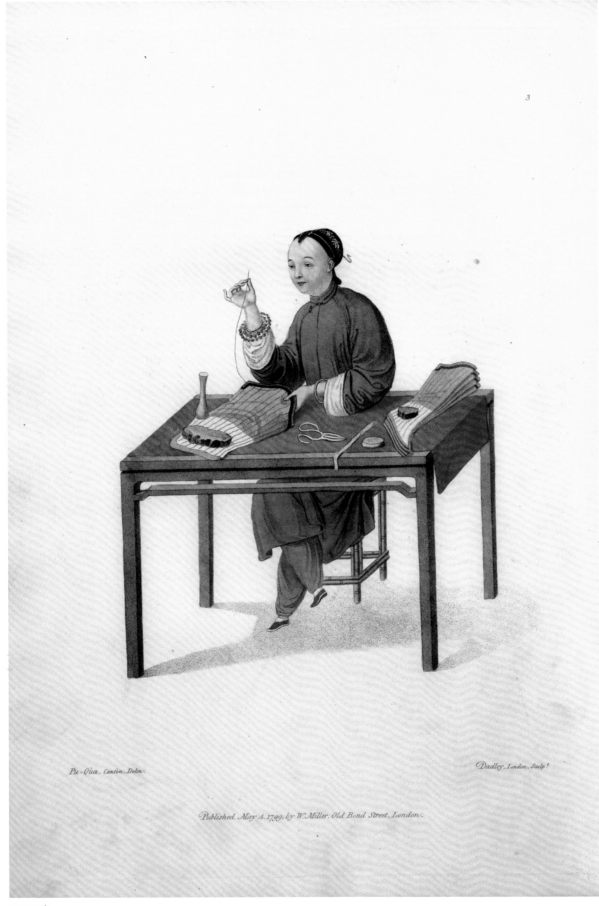

Pu-Qua. Canton. Delin. Dadley. London. Sculp!

Published May 4. 1799. by W.™ Miller. Old Bond Street. London.

FIGURE 65

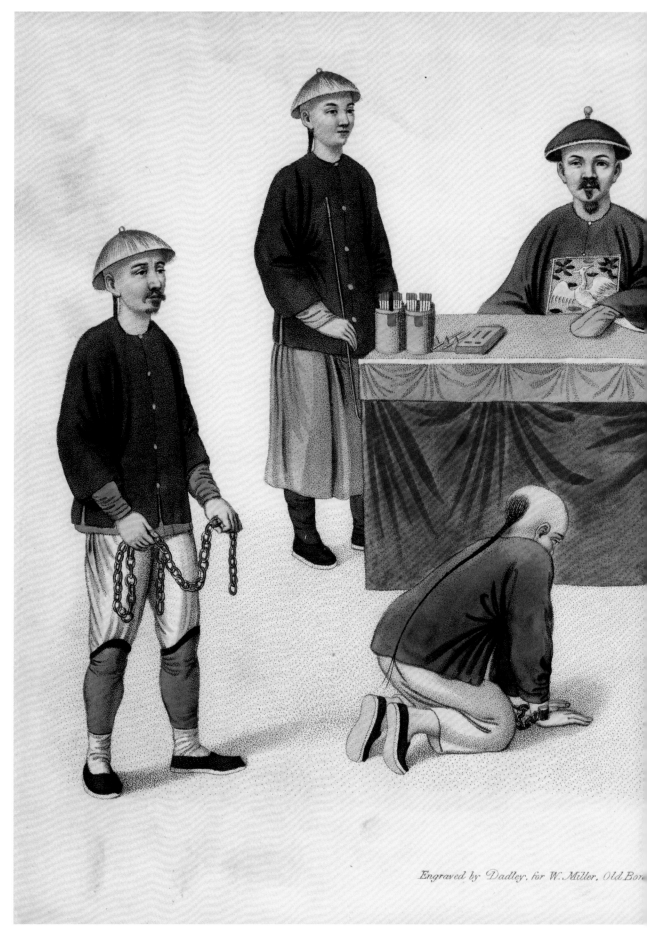

Engraved by Dadley, for W. Miller, Old Bon

FIGURE 66

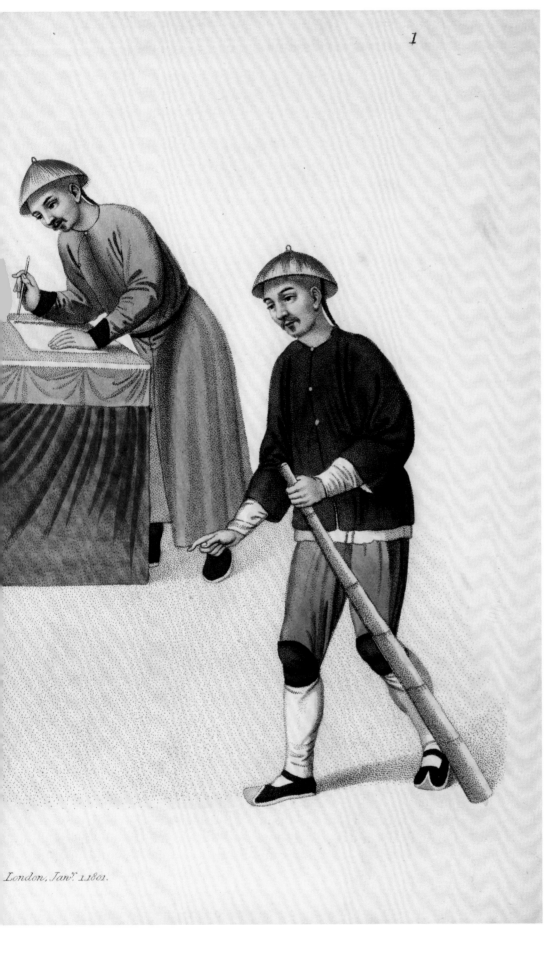

London, Jan.y 1.1801.

CAT. NO. **14**

**JEAN BAPTISTE
JOSEPH BRETON
DE LA MARTINIÈRE**
(French, 1777–1852)

China: Its Costume, Arts, Manufactures, etc. Ed. Principally from the Originals in the Cabinet of the Late M. Bertin; with Observations Explanatory, Historical, and Literary, 4 vols. (London: printed for J. J. Stockdale, 1812)
84-B25211

FIGURE 67. Antoine Cardon, *Feast of Agriculture,* vol. 1, frontispiece

Between 1811 and 1818, Jean Baptiste Joseph Breton de la Martinière published a series of compactly designed precursors to modern travel books, the first of which was a four-volume work on China (subsequent volumes were on Russia; Egypt and Syria; Spain and Portugal; and Japan). This English translation of Breton's *La Chine en miniature; ou, Choix de costumes, arts et métiers de cet empire* (China in miniature; or, Selection of dress, arts, and trades in the empire, 1811) begins with the attractive proposition that "China is more favorably situated than any country in the world" (vol. 1, p. 25), but it would be a mistake to think that this illustrated description of China was published simply so that Europeans could enjoy reading about a distant land. The book is dedicated "To the deputations From various Outports, and mercantile and manufacturing Towns of the United Kingdom, Assembled in London, to oppose the Renewal of the East-India Company's Commercial Monopoly."

Nepveu, the Parisian publisher of Breton's guides, issued a range of works describing locales on the Grand Tour, the art and monuments of the ancient world, and countries in Europe as well as Africa, the Middle East, and Asia. Shortly after publishing Breton's *Chine en miniature,* he issued Breton's two-volume supplement to that work, titled *Coup d'oeil sur la Chine; ou, Nouveau choix de costumes, arts et métiers de cet empire* (Survey of China; or, New selection of costumes, arts, and trades of that empire, 1812). He also produced, in a miniature format, a related work by the Jesuit missionary Pierre d'Incarville, *Art, métiers et cultures de la Chine, représentés dans une suite de gravures* (Art, trades, and cultures of China depicted in an suite of engravings, 1814–15), as well as *Costumes et vues de la Chine* (1815), which featured engravings after sketches William Alexander made during the first British embassy to China. Breton's *Chine en miniature* was quickly translated into English and published in London by John Joseph Stockdale, who also sold the prints separately, usually in hand-colored versions. The seventy-four stipple and line engravings in Breton's *Chine en miniature* were based not only on works in the collection of the French *petit ministre* and sinophile Henri-Léonard-Jean-Baptiste Bertin (French, 1720–92), as stated on the title page, but also on the engravings in George Henry Mason's two suites, *The Costume of China* and *The Punishments of China* (cat. nos. 12, 13).

In its time, Breton's *China* must have been a best-seller. Numerous copies from the second and third decades of the nineteenth century are held by libraries worldwide, and copies appear regularly in auction sales. That China, among the many foreign lands then being explored, was a subject of special interest is suggested by a note printed at the beginning of the third volume: "Should this Work meet the success which the Translator has some reason to expect, it is his intention to publish a Supplement, which will render the Costume, etc. of China more complete than that of any other country which has hitherto been the subject of a Publication; and to assist him in this desirable purpose, he requests the favour of the loan of any Drawings connected therewith." The projected supplement never appeared, however.

The initial illustration in Breton's *China* shows the Chinese emperor engaged in the yearly spring ritual of plowing at the Altar of Agriculture. In many copies of this book, the illustrations are hand-colored. The copy held by the Getty Research Institute has uncolored prints and is bound in original boards. (MR)

LITERATURE: Abbey 1972, no. 535; Cordier [1968], 65; Lust 1987, no. 1243.

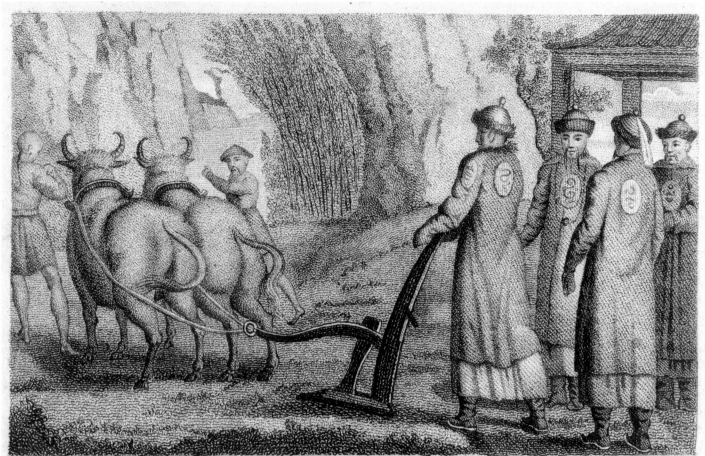

A Cardon direxit

FEAST OF AGRICULTURE.

Pub.ᵈ 25 April 1812 by I.I. Stockdale 41 Pall Mall

FIGURE 67

CAT. NO. **15**

JOÃO DA ROCHA
(LUO RUWANG)
(Portuguese, 1565–1623)

Tianzhu shengjiao qimeng (Instructions in the holy religion of the Lord of Heaven) ([Nanjing: Society of Jesus, ca. 1619–23]) 1365-379

FIGURE 68. Discussion of the soul, fol. 64b

CAT. NO. **16**

GASPAR FERREIRA
(FEI QIKUEI)
(Portuguese, 1571–1649)

but usually attributed to

JOÃO DA ROCHA
(LUO RUWANG)
(Portuguese, 1565–1623)

Song nianzhu guicheng (A method for reciting the rosary) ([Nanjing: Society of Jesus, ca. 1619–23]) 1374-445

FIGURE 69. Crucifixion, fol. 21b

See also FIGURE 12

These two Ming-period Catholic texts wood-block printed in Chinese on bamboo paper are bound together in one volume with a simple European-style vellum cover. The texts, entitled *Tianzhu shengjiao qimeng* and *Song nianzhu guicheng,* are attributed to João da Rocha, a Portuguese Jesuit who left Europe as a novice in 1586. He completed his philosophical and theological training in Goa, India, and then Macao. He arrived in China in 1598 and would spend much of his life as a missionary in the southern cities of Nanchang, in Jiangxi province, and Nanjing, in Jiangsu province.

Both texts are undated but were probably printed in Nanjing by the Society of Jesus between 1619 and 1623. The frontispiece with the Society of Jesus emblem IHS in other copies in which the two texts are bound together is wanting in the Getty Research Institute's copy. It begins with a ripped page, which is the missing half of leaf 31 of the *Song nianzhu guicheng.* Next is the table of contents on an unnumbered page with the running title *Nianzhu guicheng* (Reciting the rosary) at the outer edge. According to the table of contents, the volume is divided into two parts, each written and revised by different priests. The first part (*shang juan*) is said to have been authored by da Rocha, revised by Gaspar Ferreira and others, and approved for publication by Manuel Dias the Younger (Portuguese, 1574–1659). The second part (*xia juan*) is said to have been written by Ferreira, revised by Francisco Furtado (Portuguese, 1589?–1653) and others, and approved by Dias. The two parts are physically different: the first, comprising sixty-nine folded leaves in a wrapped-back binding, has nine columns of twenty characters per page with the running title *Shengjiao qimeng* (Instructions in the holy religion); whereas the second, comprising thirty-two folded leaves, has eight columns of twenty characters per page and the running title *Nianzhu guicheng.* This disparity in format suggests that the *Tianzhu shengjiao qimeng* was printed earlier (perhaps in 1619) than the *Song nianzhu guicheng* and the table of contents and that the three elements were later bound as a single volume. The format is similar to copies at the Archivum Romanum Societatis Iesu in Rome (Jap-Sin I, 43a–b), the Vatican Library (Borgia Cinese 336.5), the Bibliothèque nationale de France, and, reportedly, the Biblioteca nazionale centrale di Roma.

The *Tianzhu shengjiao qimeng* begins with the title and an inscription that states, in Chinese, "Translated and written by João da Rocha, priest of the Society of Jesus of the Extreme West." The text itself is in fact a creative translation of the *Doutrina Christâa ordenada a maneira de dialogo para ensinar os meninos* (Christian doctrine arranged as dialogue to instruct children, 1566), also known as the *Cartilha* of the Jesuit Marcos Jorge (Portuguese, 1524–71), later expanded by Father Ignacio Martins (Portuguese, 1530–98). Written in easy prose, this Portuguese catechism, popular in the sixteenth and seventeenth centuries, was translated into a number of vernaculars for use by Jesuit missionaries worldwide. Like the original, the *Tianzhu shengjiao qimeng* is a dialogue between a teacher and a catechumen, and, except for the transliterations of Christian terms from Portuguese or Latin—*si-pi-li-duo san-duo* from the Portuguese *Spirito Santo* (Holy Ghost), for example, or *ya-ni-ma* from the Latin *anima* (soul)—it is written in simple language. The work comprises thirteen chapters: the Christian (1a–3a); the sign of the cross (3b–8b); the Our Father (8b–14b); the Hail Mary (15a–17a); the Salve Regina (17a–20a); the creed (20b–25a); the articles of the faith (25a–32a); the Ten Commandments (32a–41b); the precepts of the Roman Catholic Church (41b–47b); the seven capital sins (47b–53b); the sacraments (53b–60a); the three theological and four moral virtues (60a–64a); the soul (64a–69b). A comparison with the original *Cartilha,* which had twelve chapters (before Martins's intervention), shows that da Rocha added the chapter on the soul.

The *Tianzhu shengjiao qimeng* is one of the earliest Chinese-language catechisms and the first written in vernacular to address a young or little-educated audience. Before its publication, there existed in China other catechisms and introductions to Christian doctrine, such as Michele Ruggieri's *Tianzhu shilu* (True relation of the Lord of Heaven, 1584), Matteo Ricci's *Tianzhu shiyi* (True meaning of the Lord of Heaven, 1603), the anonymous *Tianzhu jiaoyao* (Doctrine of the Lord of Heaven, ca. 1604–5), and Alfonso Vagnone's *Tianzhu jiaoyao jielüe* (Comprehensive exposition of the Lord of Heaven, ca. 1615). With the exception of Vagnone's, all these texts were composed in literary Chinese (*wenyan*), a formal style of written Chinese used by the educated classes.

The second part of the volume, *Song nianzhu guicheng,* explains in words and images the recitation of the rosary. The text is based on a chapter concerning rosary recitation added by Martins to the *Doutrina Christâa,* while fourteen of the fifteen wood-block illustrations are Chinese adaptations of engravings in Jerónimo Nadal's *Evangelicae Historiae Imagines* (Illustrations of the Gospel stories, 1593). The fifteen images depict the mysteries of Jesus' life and employ Chinese artistic conventions.

Song nianzhu guicheng begins (sans frontispiece or a notice of publication date or author) with a dialogue between a master and a catechumen on the meaning and practice of the rosary. The master asks, "What do you do every day to nourish your soul and to protect your virtue of the love of God?" The disciple responds, "Every day I recite the entire rosary of the Holy Mother once. I also meditate on the fifteen mysteries of the incarnated life of Our Lord Jesus." The text then explains how one is to perform this act of devotion, indicating that it entails both the recitation of ten Hail Marys and one Our Father for each of the mysteries of the life of Christ and a meditation on the significance of the mystery. After the dialogue are fifteen sections on the mysteries, each illustrated with a wood-block print and coupled with instructions on prayers, meditations, offerings, and requests. The fifteen sections are arranged into three groups: the five joyful mysteries (Annunciation, Visitation, Nativity, Presentation in the Temple, Disputation in the Temple); the five sorrowful mysteries (Agony at Gethsemane, Scourging, Crowning with Thorns, Ascent to Calvary, Crucifixion); and the five glorious mysteries (Resurrection, Ascension, Pentecost, Assumption, Coronation of the Virgin).

The question of the authorship of the *Song nianzhu guicheng* is complex. The table of contents credits Ferreira (as does Dong Yu, among others), but the text is often attributed to da Rocha. According to Louis Pfister, da Rocha is likewise the author of the *Tianzhu shengxiang lueshuo* (Short explanation of the holy images of the Lord of Heaven), which is known by the Portuguese title *Práctica de rezar o rosario* (Method for praying the rosary), a title also used for the *Song nianzhu guicheng*. And D'Elia has suggested that two versions of the *Song nianzhu guicheng* exist: this one by da Rocha and a later one by Ferreira, a copy of which is at the Biblioteca nazionale centrale di Roma (Fondo Gesuitico 72.B.298). The differences between these versions are minor: the latter lacks the introductory dialogue but adds captions to the plates. Ferreira is known to be the author of another work on the rosary, *Shengmu meigui jing shiwu duan* (The fifteen mysteries of the rosary of the Holy Mother, 1602), probably a transformation of the *Song nianzhu guicheng*. The interplay of authors and the continuous reworking and elaboration of texts were standard practices among the Jesuits working in China. (PD)

LITERATURE: Backer and Backer 1960, 3:682–83, 4:1931, 5:653; Bontinck and Nsasi 1978; Chan 2002, 70–72; M. Cohen and Monnet 1992, 110–11 (cat. no. 69); Cordier 1901, s.v. "Rocha (João da)"; Courant 1900–12, no. 6861; D'Elia 1939, 67–77, 127; Dong 1996, 80; Pfister 1932–34, notice nos. 18 (Jean de Rocha), 21 (Gaspard Ferreira).

學　是天主造的。

師　天主用甚麼物件造這亞尼瑪。

學　天主有無限的能全不用甚麼物件隨時造成

　　萬民的亞尼瑪一個一個與之。

師　天主幾時造人的亞尼瑪。

學　天主賦亞尼瑪在肉身中那時節造的。

師　天主在那裏賦與人。

學　在母親懷胎時賦與的該生男子母受胎四十

　　曰賦亞尼瑪。該生女子母受胎八十曰賦亞尼瑪

FIGURE 68

170　*Catalog*

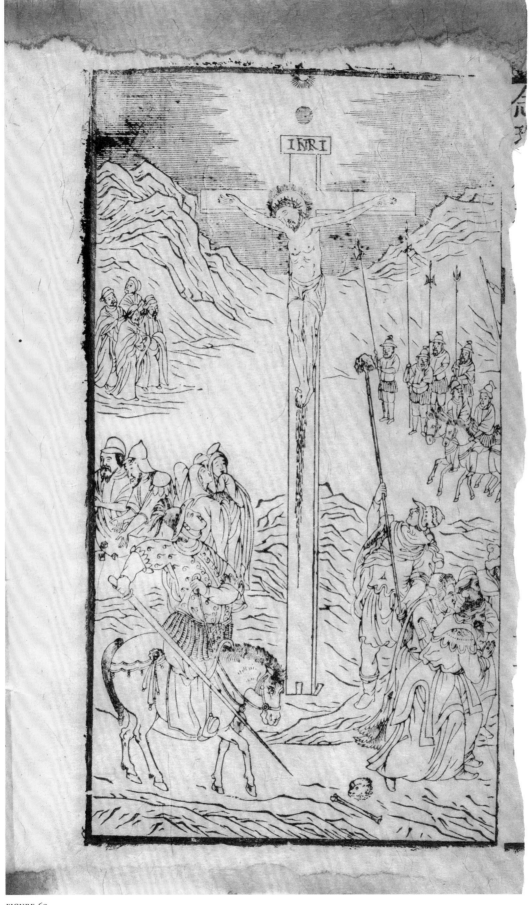

FIGURE 69

PROSPERO INTORCETTA
(Italian, 1626–96)

CHRISTIAN HERDTRICHT
(Austrian, 1625–84)

**FRANÇOIS DE
ROUGEMONT**
(Belgian, 1624–76)

and **PHILIPPE COUPLET**
(Belgian, 1623–92),
trans. and eds.

*Confucius Sinarum Philosophus;
sive, Scientia Sinensis Latine Expo-
sita...; Adiecta Est Tabula Chrono-
logica Sinicae Monarchiae ab Huius
Exordio ad Haec Usque Tempora*
(Confucius, philosopher of the
Chinese; or, Chinese knowledge
made accessible in Latin...; to
which is appended a chronologi-
cal table of Chinese monarchs
from their beginning to this
time) (Paris: apud Danielem
Horthemels, 1687)
2639-669

FIGURE 70. François de Louve-
mont, *Paradigma XV Provinciarum
et CLV Urbium Capitalium Sinensis
Imperii cum Templis et Domiciliis
S.J.* (Plan of the 15 provinces and
155 capital cities of the Chinese
empire together with the
churches and residences of the
Society of Jesus), after p. 106

See also FIGURE 14

This work is a translation with commentary of three of the *Sishu* (Four Books), a set of Confucian classics comprising the *Daxue* (Great learning), *Lunyu* (Analects of Confucius), *Mengzi* (Book of Mencius), and *Zhongyong* (Doctrine of the mean). The *Sishu* was assembled in the twelfth century by the neo-Confucian philosopher Zhu Xi (Chinese, 1130–1200) and had served since then as one of the pillars of elite education and the civil bureaucracy. The Jesuits translated the three shorter works, leaving the lengthier *Mengzi* for a later effort.

The title page to *Confucius Sinarum Philosophus* displays Louis XIV's coat of arms, and the text indicates that the work was compiled at the order of the French king and printed at Horthemels with his support. Neither was true, but Louis XIV had sponsored a French mission to China a few years earlier, and the Jesuits wanted to spur further royal patronage. This desire to please carries over to an adulatory dedication, *Ludovico Magno Regi Christianissimo* (To the most great and Christian King Louis), which appears below an etched headpiece of two angels carrying the king's coat of arms. Then follows the *Proemialis Declaratio* (Introductory exposition), a disquisition of over one hundred pages on Chinese philosophy and religions that is focused on Confucianism. The *Declaratio* is followed by a portrait of Confucius (see fig. 14) and his biography, which was based either on the standard source, the "Kongzi shijia" (Biography of Confucius) in the *Shiji* (Historical accounts) by the historian Sima Qian (Chinese, 145–86 B.C.), or on the abridged version of the "Kongzi shijia" written by Zhu Xi for his edition of the Four Books.

The translations of the *Daxue* ("Liber Primus, *Ta hio*"), *Zhongyong* ("Liber Secundus, *Chum yum*"), and *Lunyu* ("Liber Tertius, *Lun yu*"), with their associated commentary, appear next. These are grouped as books 1, 2, and 3 under the comprehensive title *Scientiae Sinicae* (Chinese knowledge). In the translations, the texts of the classics are not clearly distinguished from the words of the commentators, a fact that provoked a great deal of criticism in Europe, because it appeared that the missionaries had manipulated the originals. Exegetical evidence indicates that the Jesuits were in fact invested in supporting a view of the classics derived from the *Sishu zhijie* (Explications of the Four Books), a commentary written by Chief Grand Secretary Zhang Juzheng (Chinese, 1525–80). It is also clear, however, that they planned to publish a key that would allow the reader to separate text from commentary. This proved too complex and expensive to produce, however, and was abandoned. The superscript numbers that appear in parts of the translation are the vestigial traces of their plan. The number was supposed to take the reader to the Chinese characters of the original text in the never-appended appendix. Where present, the superscript numbers do help separate text from commentary.

The volume closes with Philippe Couplet's *Tabula Chronologica Monarchiae Sinicae* (Chronological table of Chinese monarchs), which ranges across Chinese history from the mythical earliest kings to the contemporary period—that is, 2952 B.C. to A.D. 1683, according to the dating adopted by the author. The *Tabula Chronologica* is divided into two sections, *ante Christum* (before Christ) and *post Christum* (after Christ), each preceded by a preface. Between the two sections is bound the *Tabula Genealogica Trium Familiarum Imperialium Monarchiae Sinicae* (Genealogical table of three imperial households of the Chinese monarchy) and a map of China with a geographic note headed "Imperii Sinarum et Rerum in Eo Notabilium Sinopsis" (Summary of the Chinese empire and of notable things there). The map, which is hand-colored in the Getty Research Institute's copy of the book, was engraved by François de Louvemont (French, b. 1648) on instructions by Couplet. It depicts the Chinese empire's fifteen regions and 155 cities as well as the

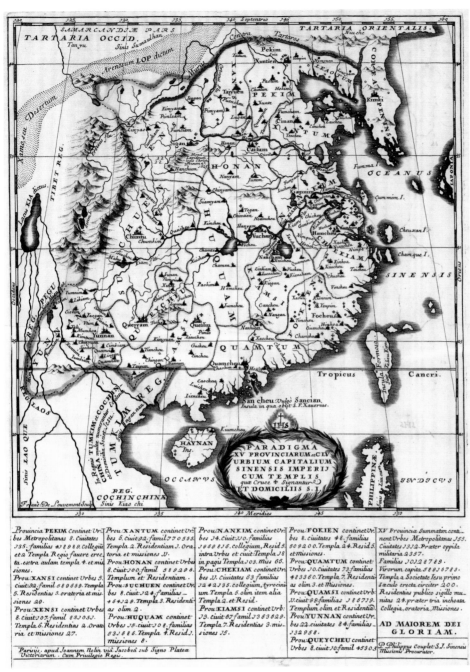

FIGURE 70

natural features of the land within a grid of latitude and longitude lines. The presence of
a Christian mission is denoted by a cross next to a place-name, and the place where the
Tang-dynasty Nestorian Christian stele described in Athanasius Kircher's *China Monu-
mentis* (cat. nos. 5, 6) was discovered in the 1620s is noted.

The *Confucius Sinarum Philosophus* was widely reviewed in Europe and today is rec-
ognized as one of the most influential texts in the Jesuit transmission of Chinese culture
to Europe. While considered a rare book, it is still extant in a large number of copies,
which testifies to its status as a best-seller — or a classic — in its own day. (PD)

LITERATURE: Backer and Backer 1960, 2:1562, 4:296, 4:6403, 7:230–31; *China* 1973, 136–37 (no. B18); Cordier
[1968], 1392–93; Lundbaek 1981; Lundbaek 1983; Lust 1987, no. 724; Mungello 1981; Mungello 1985, 287–99;
Murray 1997, 80–81; Pfister 1932–34, notice nos. 114 (Philippe Couplet), 120 (Prosper Intorcetta), 122
(François de Rougemont), 126 (Christian Herdtricht); Walravens 1987, 206–7 (cat. no. 140).

CAT. NO. **18**

Le Chou king, un des livres sacrés des Chinois, qui renferme les fondements de leur ancienne histoire, les principes de leur gouvernement et de leur morale; ouvrage recueilli par Confucius...; on y a joint un discours préliminaire, qui contient des recherches sur les tems antérieurs à ceux dont parle le Chou-king, et une notice de l'Y-king, autre livre sacré des Chinois (The *Shujing:* One of the sacred texts of the Chinese, containing the foundations of their ancient history, the principles of their government and of their morals; compiled by Confucius...; to which are appended a preliminary discourse on the time prior to that of which the *Shujing* speaks, and a note on the *Yijing,* another Chinese sacred text), trans. and ed. Antoine Gaubil, ed. Joseph de Guignes (Paris: N. M. Tilliard, 1770)
1553·917

FIGURE 71. *Hetu* (Yellow River pictures) and *Luoshu* (Luo River writing) diagrams and eight trigrams, pl. 4

This volume includes writings on Chinese classical scholarship and a translation of one of the oldest Chinese classics, the *Shujing* (Book of history). "Chou king" is an older French transliteration of the Chinese title. The book was largely the work of three French Jesuits of the mission to China — Antoine Gaubil (1689–1759), Joseph Henri-Marie de Prémare (1666–1736), and Claude de Visdelou (1656–1737) — and was edited for publication by the sinologist Joseph de Guignes (French, 1721–1800), who held the chair of Syriac at the Collège de France in Paris.

Le Chou king opens with a simple letterpress title page, followed by a preface by de Guignes. Thereafter, the "Discours préliminaire" (Preliminary discourse) by de Prémare reviews Chinese mythological and historical accounts from the beginnings of the universe to contemporary times. Following this introduction is the annotated translation of the *Shujing* by Gaubil. Like the Chinese text, *Le Chou king* is divided into four parts: "Yu-chou" (Yushu, or Book of Yu, in five chapters), "Hia-chou" (Xiashu, or Book of Xia, in four chapters), "Chang-chou" (Shangshu, or Book of Shang, in eleven chapters), "Tcheou-chou" (Zhoushu, or Book of Zhou, in thirty chapters).

The *Shujing* is an assemblage of ancient documents concerning China's earliest history, said to have been collated by Confucius in the fifth or sixth century B.C. The origin of the text is placed in the Zhou dynastic period (1046–256 B.C.), but philological studies indicate that its documents date to different phases, some earlier and some considerably later than Confucius's lifetime. The *Shujing* underwent extensive transformations over the centuries, and it is known in two versions, "New Text" and "Old Text," the latter now considered to be a forgery dating to the fourth century A.D. From the breakdown of the chapters of *Le Chou king,* it appears that the Jesuits translated the "Old Text" version.

Following the translation is a section by de Guignes explaining the book's four plates, which depict musical instruments and ritual vessels, staffs, tablets, and emblems used in Chinese ceremonies honoring the ancestors or heaven. These images do not appear in all Chinese editions of the *Shujing* and were not, as de Guignes explains in the preface, provided by Gaubil. De Guignes may have obtained them from other Jesuit works or from a Chinese illustrated ritual text such as the *Queli zhi* (Records of Queli) by Chen Hao (Chinese, fl. 1500s), which was reprinted about 1700, during the Kangxi period.

The volume concludes with a set of observations on the *Shujing* by Gaubil and an essay by de Visdelou on another Chinese classic, the *Yijing* (Book of changes).

Gaubil's *Le Chou king* seems to have been the earliest published translation into a European language of this revered Chinese classic, and it circulated in Europe for decades to come. In the nineteenth century, Guillaume Pauthier (French, 1801–73) republished Gaubil's translation as part of the collection *Les livres sacrés de l'Orient* (The sacred books of the East, 1840). (PD)

LITERATURE: Backer and Backer 1960, 3:1257–64, 6:1196–1201, 8:838–43; Cordier [1968], 1376–77; Lust 1987, no. 727; Mungello 1987; Pfister 1932–34, notice nos. 174 (Claude de Visdelou), 235 (Joseph-Henry-Marie de Prémare), 314 (Antoine Gaubil); Shaughnessy 1993.

Pl. IV.

Pag.352.

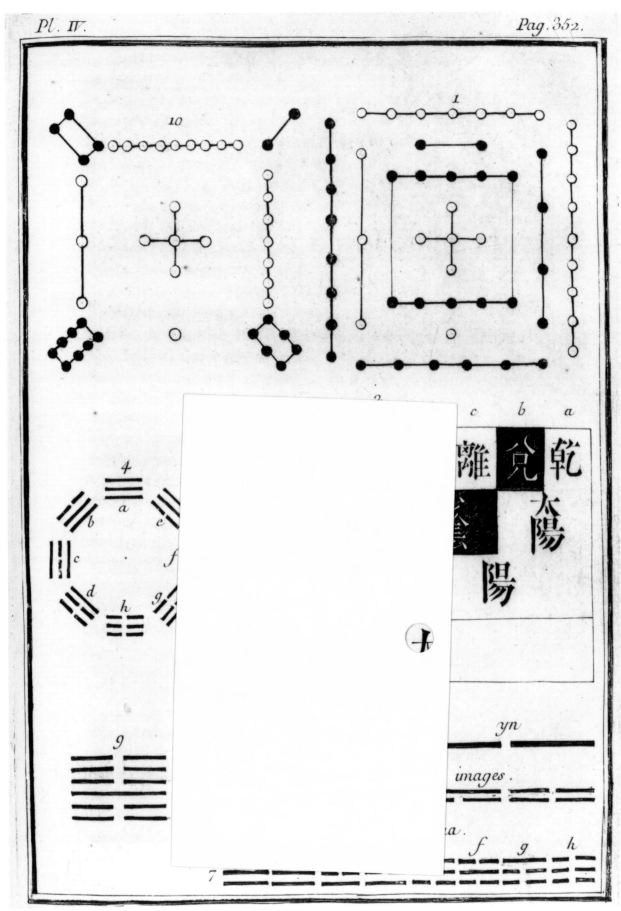

FIGURE 71

CAT. NO. **19**

Kangxi dengtu (Kangxi-era lantern patterns)

Qing dynasty, late 1700s–early 1800s, album of twenty-two ink-and-watercolor drawings, mounted on stiff paper, each page: 29.5 × 24 cm (11 ⅝ × 9 ½ in.) 2003.M.25

FIGURE 72. *Bao'en dengtu* (Repaying gratitude lantern pattern), [pl. 11]

The *Kangxi dengtu* is a concertina-bound album of twenty-two hand-painted "lantern patterns" with a handwritten preface and postface. The preface briefly reports on the celebrations held in Beijing in 1713 on the occasion of the Kangxi emperor's sixtieth birthday. It also transcribes eight couplets offered to the emperor by government officials. These poetic compositions praising the Qing emperor and his dynasty are written in skillfully rhymed classical Chinese and pivot on auspicious metaphors. The author of the *Kangxi dengtu*'s preface avers that he created the album to preserve these couplets because they do not appear in the *Wanshou shengdian* (Grand ceremony for the imperial birthday, 1717), an account of the birthday celebrations edited by Wang Shan (Chinese, 1645–1728) and illustrated by, among others, the painter Wang Yuanqi (Chinese, 1642–1715). (The phrase *Wanshou shengdian* is used to refer collectively to the text [*Wanshou shengdian chuji*] and its woodcut illustrations [*Wanshou shengdian tu*], while the phrase *Wanshou shengdian tu* may be used to refer to the original paintings or to the printed woodcuts.) In fact, while the couplets are not recorded in the text of the *Wanshou shengdian,* they are clearly visible in its woodcut illustrations. In those images of the route taken by the imperial procession through the capital, scrolls featuring the couplets hang, amid lanterns and streamers, from portals and from stages for celebratory ceremonies at various Buddhist temples. The postface describes events relating to another imperial birthday, the Qianlong emperor's eightieth, which was celebrated in Beijing in 1790. It also includes another set of couplets and poems.

Between the preface and the postface is the bulk of the album: a series of vibrant hand-painted images featuring colorful dots and auspicious symbols on bright azure backgrounds. The patterns are similar in appearance to traditional Chinese constellation layouts as found in cosmological and astrological texts of Taoist inspiration; at the same time, their written headings and some of the symbols employed indicate that the patterns symbolize gods of the Chinese folk religion and Buddhist deities or sutras. The exact meaning and the use of these lantern patterns are not explained in the album and remain unclear, but it is possible that they represented the auspicious arrangements of lanterns set up on platforms in Buddhist temples. It is not known whether these patterns were actually used during the imperial birthday celebrations or whether they were part of the imperial collection prior to being acquired by the author of the preface and postface, who presumably assembled the album.

There is no obvious relation between the texts and the images other than some indirect references. One such reference appears in the preface, where the author states that verses were lantern couplets (that is, a pair of verses on paired hanging scrolls that can be associated or illuminated with lanterns), and another appears at the end of the postface, where the author describes how he came to own the images: "I visited an antique bookstore and bought a book of lantern designs, almost like new, of a brilliant blue-green color. I then selected some lantern couplets by scholar officials to celebrate peace [in our country]."

While the identity of the person who assembled this album is unknown, most of the text of the preface and postface and all the couplets appear in the *Yinglian conghua* (Collection of couplets, 1840), published by Liang Zhangju (Chinese, 1775–1849). However, the connection between the two works cannot be determined, and it is uncertain which of the two is the earlier. (PD)

FIGURE 72

CAT. NO. **20**

**ISIDORE-STANISLAUS-
HENRI HELMAN**
(French, 1743–ca. 1809)

*Faits mémorables des empereurs
de la Chine, tirés des annales chi-
noises...* (Memorable deeds of
the emperors of China, drawn
from Chinese historical records)
(Paris: l'auteur & M. Ponce, 1788)
1573-358

FIGURE 73. Isidore-Stanislaus-
Henri Helman, after Jean-Denis
Attiret, *L'empereur Yao*, pl. 1

See also FIGURES 17, 19

This collection of twenty-four engravings with engraved narrative captions recounts signal events in the lives of worthy and unworthy Chinese emperors. Research conducted for this exhibition has established that the prints and captions were derived from a Qing-dynasty edition of a Ming-dynasty publication, the *Dijian tushuo* (Illustrated discussion of the emperor's mirror, 1573).

The *Dijian tushuo* ranges across China's past from the legendary kings of China—Yao, Shun, and Yu (traditionally dated to the third millennium B.C.)—to the Northern Song dynasty for its eighty-one examples of good imperial behavior and thirty-six examples of evil conduct, each composed of an image and a brief comment on the image. Originally a painted and handwritten album, the *Dijian tushuo* was assembled in 1573 by the imperial tutor Zhang Juzheng (Chinese, 1525–82) to instruct the Ming-dynasty Wanli emperor, who had ascended to the throne in 1572. Its objective was to instill crucial moral precepts in the ten-year-old ruler via illustrated historical parables. After presenting the hand-made album to the emperor, Zhang, who wished to influence education in China more generally, published the *Dijian tushuo* in a wood-block printed edition. The book became extremely popular and was reprinted multiple times in China and in Japan.

The *Faits mémorables des empereurs de la Chine* offers a selection of images by the engraver Isidore-Stanislaus-Henri Helman after the prints commissioned by the Qing Qianlong emperor, who wished to have a Western-style edition of the *Dijian tushuo*. The original engravings, which were much larger in size and reserved for the emperor's use, were produced in the mid-eighteenth century under the direction of Charles-Nicolas Cochin II (French, 1715–90) after a set of imperially sponsored drawings by the Jesuit painter Jean-Denis Attiret (French, 1702–68). Both Cochin and Attiret had also been involved in the creation of the suite of sixteen engravings depicting the Qianlong emperor's military victories, which Helman likewise issued in reduced form in 1788 or thereabouts (cat. nos. 28, 29). In both instances, Helman had obtained access to the set of larger prints secured by the French *petit ministre* Henri-Léonard-Jean-Baptiste Bertin (French, 1720–92).

The *Faits mémorables* begins with a dedication to "Madame" (see fig. 19), who was Marie Joséphine Louise de Savoie (Italian, 1753–1810), wife of Louis XVI's brother, Louis Stanislas Xavier de Bourbon, comte de Provence. This identification is supported by a longer dedication to Madame on the same page which also has a headpiece depicting five putti with symbols of the French monarchy and the house of Savoie, a musical instrument, and an image of Madame based on the portrait of the comtesse de Provence painted in 1778 by Elisabeth Vigée Le Brun (French, 1755–1842) (the inscription at the bottom edge of the headpiece confirms this). The dedication penned by Helman that appears below this headpiece extols the intellectual qualities of Madame, a woman known for her bookishness more than her beauty.

The *Faits mémorables* is a much-reduced version of the *Dijian tushuo,* in terms both of the size of its engravings and of its content. It offers 24 illustrated parables where the original had 117, but it preserves the moralistic intent of the Chinese text by providing examples of both good and bad emperors. The style of this entirely engraved publication (of which hand-colored versions exist) is identical to that of the life of Confucius also produced by Helman (cat. no. 21) with which the *Faits mémorables* is sometimes bound as a single volume. The copy held by the Getty Research Institute consists of loose sheets, with two prints on each page, that were formerly bound in an album. (PD)

LITERATURE: Backer and Backer 1960, 1:613–14; *China* 1973, 200–1 (no. H23); H. Cohen 1912, 479; Cordier [1968], 587–88; Lust 1987, no. 1133; Murray 2001, 65–100; Pfister 1932–34, notice no. 356 (Jean-Denis Attiret).

FIGURE 73

CAT. NO. **21**

**ISIDORE-STANISLAUS-
HENRI HELMAN**
(French, 1743–ca. 1809)

and **JOSEPH-MARIE AMIOT**
(French, 1718–93)

*Abrégé historique des principaux
traits de la vie de Confucius, célèbre
philosophe chinois . . .* (Historical
summary of the principal events
in the life of Confucius, cele-
brated Chinese philosopher)
(Paris: l'auteur & M. Ponce,
[1788?])

88-B15219

FIGURE 74. Isidore-Stanislaus-
Henri Helman, Confucius
receives a sign from Shangdi,
pl. 21

See also FIGURES 16, 21

This collection of twenty-four engraved images accompanied by narrative captions
depicts some of the notable occurrences in the life of the philosopher Confucius (Chi-
nese, 551–448 B.C.). The engraver Isidore-Stanislaus-Henri Helman selected the images
from an album containing some one hundred illustrations then in the collection of
Henri-Léonard-Jean-Baptiste Bertin (French, 1720–92). The drawings had been collected
in China by the Jesuit Joseph-Marie Amiot (French, 1718–93), a frequent correspondent
of Bertin's, and sent by Amiot to Bertin, who received them, together with Amiot's
lengthy manuscript biography of Confucius, in about 1784. The text and images were
published in volume 12 (1786) of the series *Mémoires concernant l'histoire, les sciences, les
arts, les moeurs, les usages, etc. des Chinois; par les missionnaires de Pe-kin,* under the title
Vie de Koung-Tsée, appellé vulgairement Confucius (Life of Kongzi, commonly known as
Confucius). Volume 12 also included a chronology of Confucius's life, a genealogy of his
family, and eighteen captioned plates depicting events from the philosopher's life.

In the *Vie de Koung-Tsée,* Amiot lists as his sources the *Lunyu* (Analects of Confu-
cius), Wang Su's *Kongzi jiayu* (Confucius's family records), Sima Qian's *Shiji* (Historical
accounts), *Queli zhi* (Records of Queli), and other documents but does not mention the
Shengji tu (Illustrated traces of the sage). Nonetheless, Amiot based the images and cap-
tions of the *Vie de Koung-Tsée* on this last work. A well-known illustrated biography of
Confucius, the *Shengji tu* was initially conceived as a painted hand scroll by the Ming
scholar Zhang Kai (Chinese, 1398–1460), who in about 1444 ordered between twenty-
nine and thirty-four illustrations from an anonymous painter. To these Zhang added
the standard biography of Confucius (the "Kongzi shijia" from Sima's *Shiji*) and his own
newly composed eulogies. The images and text of the scroll were subsequently carved
on stone and, eventually, printed versions, with additional images and text, proliferated,
turning the *Shengji tu* into a popular hagiographic text in China during the Ming and
Qing dynasties. Since the original scroll and stone engravings were lost, a printed book
was the most likely source for Amiot's album. It seems likely that he referred to the
popular seventeenth-century wood-block edition containing 105 images. That, in turn,
was based on the 112 stone-carved images derived from the recension of 1592, which are
still extant at Confucius's temple in Qufu.

Like its much longer Chinese source, the *Abrégé historique* is an illustrated biography
of Confucius. After the first plate, which is a portrait of the sage probably derived from
the *Queli zhi* and based on the statue of Confucius at the ancestral temple at Qufu (see
fig. 16), the remaining prints represent twenty-three noteworthy events selected from
the *Shengji tu.* These hagiographic depictions show the sage as a semi-divine being,
chronicling significant events of his life and works, from conception (pl. 2, Confucius's
mother meets an auspicious *qilin*) to death (pl. 22, the burial mound of the sage), and
later rituals in his honor (pl. 24, the Song-dynasty emperor Zhenzong performs ceremo-
nies in front of Confucius's tablet). (PD)

LITERATURE: Backer and Backer 1960, 1:294–303; *China* 1973, 199–200 (no. H22); Cordier [1968], 500–12; Lust
1987, no. 729; Murray 1997; Pfister 1932–34, notice no. 392 (Jean-Joseph-Marie Amiot); Shum 2001; Walravens
1987, 172–73 (cat. no. 93).

FIGURE 74

Helman, Sculp.

FERDINAND VERBIEST
(Flemish, 1623–88)

Qinding xinli ceyan jilüe (Short record of the official testing of the new calendar) = *Astronomia Europaea sub Imperatore Tartaro-Sinico Ca'm̄ Hȳ Appellato ex Umbra in Lucem Revocata* (European astronomy, recalled from the darkness to the light under the Manchu-Chinese emperor known as Kangxi) ([Beijing: Society of Jesus, 1669])

1392-190

FIGURE 75. Third gnomon experiment, fig. 3

See also FIGURE 23

A scientist who worked for years as an astronomer at the Imperial Observatory in Beijing, Ferdinand Verbiest joined the Society of Jesus in 1641. He studied philosophy, theology, and science at the Jesuit college in Louvain and at the Collegio Romano in Rome. In 1655, he set off for China by way of Portugal and reached Macao in 1658. There, Verbiest studied Chinese and the Confucian classics and took his final vows. In 1659, he moved to Xi'an, in northwestern China, to begin his missionary activity, but he was soon called to Beijing by Adam Schall von Bell (German, 1591–1666) to work on the Jesuits' revision of the Chinese calendar. Following the Oboi regency (1661–69), during which the missionaries were ostracized and several were convicted of crimes against the state, the Kangxi emperor named Verbiest to the position of director of the Calendar Section at the Directorate of Astronomy. He held this position until his death in 1688. The emperor, with whom Verbiest had developed an unusually close bond notwithstanding his status as a foreigner, granted him an official funeral.

The *Qinding xinli ceyan jilüe* is an account in Chinese of the astronomical contest between the Jesuit astronomers headed by Verbiest and their Chinese counterparts led by the Muslim astronomer Wu Minghuan and his supporter Yang Guangxian. Set up by the Kangxi emperor in 1668 and 1669, the tests were meant to determine which group was more competent at calendrical calculations. As a result of the contest, the Jesuits were reinstated at the Directorate of Astronomy, from which they had been ousted in 1664, and Wu Minghuan and Yang Guangxian were dismissed and punished.

Rather than a linear account of events, the *Qinding xinli ceyan jilüe* is a pastiche. It blends sections by Verbiest with portions borrowed from the *Xichao ding'an* (Official documents of the Kangxi court), including memoirs on astronomical matters submitted to the throne by Manchu and Chinese officials. After the text are twelve woodcuts showing instruments and diagrams relating to the astronomical experiments performed during the contest.

The *Qinding xinli ceyan jilüe* opens with a Latin title page that xylographically reproduces Verbiest's handwriting and outlines the scope of the book. The ensuing texts, in Chinese, describe the three experiments that Verbiest and others carried out between 26 and 28 December 1668 in Beijing at the Imperial Observatory and the Forbidden City. Figures 1 through 3 (see fig. 75) show the length of the shadows cast by gnomons on three different test days. Thence follows a memoir by Verbiest to the throne explaining the errors in the calendar promulgated by his adversary Wu Minghuan (pp. 8–10; that is, pp. 4–6 of *Xichao ding'an*); a detailed month-by-month account of such mistakes (pp. 11–19); and an explanation of why the mistakes were made and how to correct them (pp. 20–28). In relation to this last section, figures 11 and 12 show the differences between ecliptic and equatorial calculations, explain refraction in stars observation at the horizon, and depict, in figure 12 (see fig. 23), the phases of Venus within a Tychonian scheme.

Two memoirs follow: in the first, court ministers sanction Wu Minghuan for his mistakes and recommend Verbiest for appointment to the Directorate of Astronomy (pp. 29–31; that is, pp. 7–9 of *Xichao ding'an*); the second, which was signed by court officials, outlined methodological issues for calendrical calculations and provided Verbiest's answers to the Kangxi emperor's questions on astronomical observation (pp. 32–39). This section references figures 4 through 9, which show how the quadrant, sextant, armillary spheres, and celestial globe were used for the experimental observations and calculations done in February 1669. The text closes with another attack on Yang

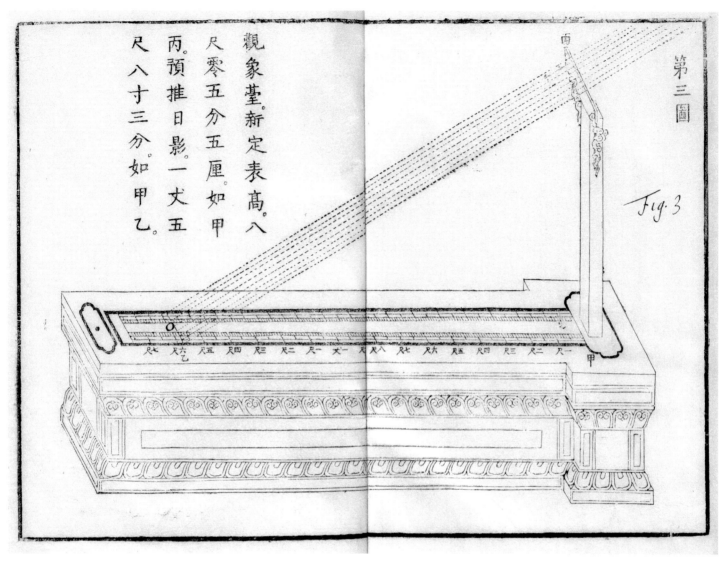

观象台新定表高八
尺零五分五厘如甲
丙预推日影一丈五
尺八寸三分如甲
乙。

第
三
圖

Fig. 3

FIGURE 75

Guangxian and Wu Minghuan for their failure to understand the difference between calendar making and the astrological prediction of lucky or unlucky days (pp. 40–42).

This extremely rare text is wood-block printed on bamboo paper and butterfly-bound in a seventeenth-century red-and-gold silk brocade cover. The title label on the cover bears the words *Observationes Astronomicae*. In addition to the Getty Research Institute's copy, six others are known to exist. They are at the Universiteitsbibliotheek Gent, Ghent (Res. 1510.1); Bibliothèque nationale de France, Paris (Chinois 4992); Archivum Romanum Societatis Iesu, Rome (Jap.-Sin. II, 42A); Biblioteca nazionale centrale di Roma (72 C 554); Österreichische Nationalbibliothek, Vienna (Sin. 80); and Universitätsbibliothek, Munich (20 P. or. 27). (PD)

LITERATURE: Backer and Backer 1960, 8:574–87; Chan 2002, 343–44; Courant 1900–12, no. 4992; Dudink 2001; Golvers 2003, 99–100, ills. 4–7; Pfister 1932–34, notice no. 124 (Ferdinand Verbiest); Witek 1994.

The *Yixiang tu*—also known as the *Liber Organicus,* from the Latin title page inserted
in copies destined for Europe—is a visual record associated with the refurbishing by
the Jesuits of the Imperial Observatory in Beijing and the establishment of Western
astronomy in China between 1669 and 1674. The book consists of the Latin title page,
a brief preface in Chinese on one folded leaf, a view of the observatory, and one hundred
seventeen woodcuts with Chinese captions on 105 folded leaves. (Some copies of the
Yixiang tu are supposed to have eight additional figures, and some, like the Getty Research
Institute's version, have Latin figure numbers pasted in, suggesting that they were to
be perused with Verbiest's *Compendium Latinum* [cat. no. 24].) The illustrations focus
on astronomical instruments and charts but also present visual explanations relating to
other sciences (mechanics, hydraulics, ballistics, optics, etc.), whose mastery was neces-
sary to build, install, and use the instruments.

The first illustration (fig. 76) in the *Yixiang tu* is a bird's-eye view of the roof of the
Imperial Observatory (originally built in the fifteenth century, during the Ming period)
that shows the arrangement of the six instruments that Verbiest and his assistants built
and installed at the Imperial Observatory. The woodcut—which became popular in
Europe and was copied in publications by Louis Le Comte and Jean-Baptiste Du Halde,
among others—sets the stage for the scope of the book. Starting from the upper right
corner and moving clockwise, it depicts the retiring house (where astronomers could
rest between observations), the equatorial armillary sphere, the celestial globe, the
ecliptic armillary sphere, the horizontal azimuth, the voluble quadrant, and the sextant.

These instruments are the centerpiece around which the *Yixiang tu* revolves: they
are shown individually in the next six figures (see figs. 24, 26, 28), their stone bases are
illustrated in the following four figures (four because the azimuth had no base and the
two armillary spheres used the same type), and the tools and methods necessary for
their construction and installation are visually explained in the remaining ninety-seven
images. The focus on accuracy in the making of the instruments is apparent in images
elucidating the multiple steps required to manufacture each. For instance, Verbiest's fig-
ures 23, 35 through 45, and 49 detail the construction of an armillary sphere, taking the
viewer from the casting of a bronze ring to the polishing of the surface of the newly cast
ring with a donkey-powered mill (see fig. 29) to the finished armillary sphere.

In the *Yixiang tu,* text is virtually nonexistent. As Verbiest noted in its preface, he put
the explanations in Chinese in a companion volume—the *Xinzhi lingtai yixiang zhi*
(Essay on the newly constructed instruments for the observatory, 1674), which is not
in the Research Institute's holdings—because he thought it more convenient for those
unacquainted with Western science to have text and images in separate books to be used
together. The *Xinzhi lingtai yixiang zhi* is also referred to by the Latin title *Liber Organicus.*

The content of the *Yixiang zhi* and the *Yixiang tu* indicate that they were instructional
and propagandistic tools aimed at Chinese officials and the members of the court with
whom the Jesuits interacted. In fact, the figures of the *Yixiang tu* became so well known
that they were later included in the Qing-dynasty encyclopedia *Gujin tushu jicheng* (Com-
pendium of books and illustrations from ancient to present times, 1726), in Chinese ritual
compendia, and even in European books such as Louis Le Comte's *Nouveaux mémoires
sur l'état présent de la Chine* (New reports on the present state of China, 1696).

The *Yixiang tu* is a crucial text in the history of East and West intellectual exchanges
that marks an early stage in the introduction of European science to China. Because
parts of the *Yixiang tu* were reworked in Verbiest's Latin masterwork, *Astronomia*

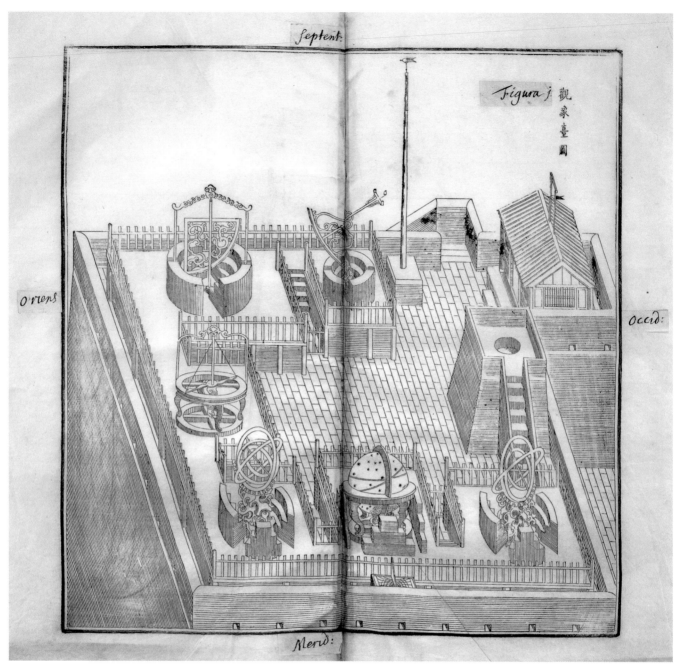

FIGURE 76

Europaea (European astronomy, 1687), it was also a fundamental step in the development of literature supportive of the missionary scientific enterprise in China.

Though reprints are common, the original *Yixiang tu* is known in a limited number of copies. The Research Institute's copy consists of two butterfly-bound volumes with red-and-gold silk brocade covers. The title label on the cover bears the words *Liber Organicus Astronomiae apud Sinas Restitutae* (Book of instruments of astronomy restored in China). (PD)

LITERATURE: Backer and Backer 1960, 8:574–87; Chapman 1984; *China* 1973, 142 (no. B30); M. Cohen and Monnet 1992, 125 (cat. no. 78); Golvers 2003, 102–131, ills. 17, 44; Iannaccone 1994, 93–117; Pfister 1932–34, notice no. 124 (Ferdinand Verbiest); Verbiest 1993.

CAT. NO. **24**

FERDINAND VERBIEST
(Flemish, 1623–88)

Compendium Latinum Proponens XII Posteriores Figuras Libri Observationum Nec Non Priores VII Figuras Libri Organici (Latin compendium presenting the last twelve figures of the book of observations, as well as the first seven [*sic*] figures of the *Liber Organicus* [Book of instruments]) ([Beijing: Society of Jesus, 1671–74])
1392-685

FIGURE 77. First page of text

The *Compendium Latinum* is an explanation in Latin of the main figures of the *Qinding xinli ceyan jilüe* (cat. no. 22) and the *Yixiang tu = Liber Organicus* (cat. no. 23). The volume, which consists of the title page and seventeen pages of text (nine double leaves) but no images, is divided in two parts. The first part, which contains a brief preface and the discursive captions to the twelve figures from the *Qinding xinli ceyan jilüe,* recounts the experiments that returned European astronomy to the Chinese court. The second part briefly describes in a series of discursive captions the first eight figures of the *Yixiang tu* (namely, the overview of the Imperial Observatory, the six new instruments installed there by the Jesuits, and their marble stands).

The *Compendium Latinum* was sent to Europe along with the *Qinding xinli ceyan jilüe* and the *Yixiang tu* as a summary translation of those two Chinese texts and a preliminary explanation of the scientific work the Jesuits were carrying out in China. In the Getty Research Institute's copies of the two Chinese texts, the captions to the figures discussed in the *Compendium Latinum* carry pasted-in labels in Verbiest's handwriting.

Verbiest inserted the *Compendium Latinum* virtually unchanged into his *Astronomia Europaea* (European astronomy, 1687) as chapter 12. Like that more comprehensive work, the *Compendium Latinum* addressed its European readers with the express motivation of glorifying the scientific achievements of the Jesuit mission in China.

An interesting aspect of the Research Institute's copy of the *Compendium Latinum* is its hybrid physical format. Bound in a cover of red wool fabric with yellow motifs and printed on bamboo paper, the volume looks at first like a Chinese book, but because the content is in Latin, the front opens from right to left as a Western publication (rather than left to right as a traditional Chinese book). The original title label with the words *Compendium Astronomiae Organice* is pasted on the inside of the upper cover. The title label, title page, and texts are wood-block printed in Verbiest's cursive handwriting, rather than with Western-style movable type or with woodblocks of single printed letters.

The unusual presentation stemmed from the Chinese artisans' lack of familiarity with the Latin alphabet as well as the want of materials for European-style printing. The Jesuits probably could have obtained a Western printing press, but they would still have encountered problems: the paper available locally was too thin to withstand metal type, and Chinese ink was thicker than Western ink and also incompatible with Western type. Movable type, while known in China, was little used at this time and different from its Western counterpart. The traditional xylograph was therefore an obvious choice, because handwriting (though incomprehensible to the wood carvers) could be transferred directly from the manuscript to the printing block. The process was probably as follows: Verbiest wrote the text on bamboo paper with Chinese ink; the paper was pasted with its positive face against the woodblock; the block was dried; and the thin paper was rubbed away, leaving the ink impressions on the surface of the block, such that the carvers could simply cut out the negative block used for printing. (PD)

LITERATURE: Backer and Backer 1960, 8:574–87; Chan 2002, 557–59; Golvers 1998; McDermott 2002, 44; Pfister 1932–34, notice no. 124 (Ferdinand Verbiest).

Astronomia Europæa
sub Imperatore Cám Hÿ
ex umbra in lucem
reuocata —

Sequúntúr obseruationes Astronomicæ anno 1668. et
anno 1669 habitæ à P. Ferdinando Verbiest Flandro-belga
Soct⁹ Jesu, in Specula Astronomica Pequinensi, coram Cælui
et plurimis isque præcipuis totius Aulæ Magnatibus, ab ipso
Imperatore Sino-Tartarico, Cám Hi appellato, eo consilio
missis, ut testes oculares obseruationibus interessent, quas
ubi exactissimè cum calculo suo convenire demonstratum est,
Astronomia Europæa ab inuidia et calumnia Astronomorum
Sinensium et Maurorum sine Arabum triumphauit, constituto
P. Ferdinando Supremo Academiæ Astronomicæ apud Sinas Præ-
fecto, in consilio Regulorum, Magnatum, et totius Curiæ Pequi-
nensis Mandarinorum, quater hanc unam ob rem conuocato, ac
tandem Religio Christiana, quinto persecutionis suæ anno
in publicum iterum prodyt, templis in omnibus fere ust-
tissimi hujus Imperij prouincijs, ubi prius apertis.
Nunc breuiter explicabo figuras in fine libri impressas.

Figura 1.ᵃ

Columna per litteras A·B designata, est ænea quadrila-
tera, alta 8 pedibus geometricis et amplius, erecta in
turre siue Specula Astronomica Pequinensi, ad quam, tam-
quam stilum, umbras meridionas obseruant in mensa hori-
zontali ænea, longa ped: 18 lata 2, digito uno crassa. Hæc
mensa strata est super aliam mensam marmoream, 4 ped-
ultum, sicut figura eam exhibet.

FIGURE 77

Based on Chinese cartographic sources and published by the leading European cartog-
rapher Johannes Blaeu (Dutch, 1596–1673), Martino Martini's *Novus Atlas Sinensis* was
the first atlas and geography of China to be published in Europe. The seventeen maps
are noteworthy not only for their accuracy, remarkable for the time, but also for their
highly decorative cartouches featuring vignettes depicting regional Chinese dress, activi-
ties, and animals. Along with the maps, the volume contains 171 pages of Latin text by
Martini comprising a preface on the Far East and descriptions of each province in China
as well as the Liaodong and Korean peninsulas and Japan. Also included in the volume
are two separately paginated works: Jacobus Golius's *De Regno Catayo Additamentum* (An
addition on the Chinese reign) and Martini's *De Bello Tartarico Historia* (History concern-
ing the Tartar war, 1654), both of which were also published as separate titles. Though
it was published as part 6 of Blaeu's monumental series of world atlases, *Theatrum Orbis
Terrarum,* the *Novus Atlas Sinensis* is known as a separate work.

Born in Trento, Martini was educated in Rome at the Collegio Romano, where he
studied mathematics with Athanasius Kircher, and in Portugal, where he studied theol-
ogy. Martini set out for Asia in March 1640, traveling initially to India, reaching Goa
later that year, and then to China, reaching Hangzhou in 1643. After impressive mission-
ary works—baptizing hundreds of converts in Hangzhou—Martini was called back to
Rome in 1650 to represent both the accomplishments of the Jesuit mission in China and
its needs. En route to Rome, he landed in Amsterdam in 1654, where he met Blaeu, and
they worked together to create the *Novus Atlas Sinensis.* Martini had brought with him
copies of Chinese atlases, among them Luo Hongxian's *Guangyu tu* (Enlarged terrestrial
atlas, 1579), a Ming-dynasty atlas (based on the monumental Yuan-dynasty map com-
piled by Zhu Siben between 1311 and 1320) that included, apart from the general map of
China, maps of the various provinces and border regions. Martini finally reached Rome
at the end of 1655 but set out for China again in 1657. He died in Hangzhou in 1661.

The initial works on China by Juan González de Mendoza (cat. no. 1) and Matteo Ricci
were not illustrated, although the Augsburg edition of Ricci's account had an emblem-
atic title page of the Jesuit fathers of the China mission displaying a map of China (see
fig. 2). With its maps and their vignettes, Martini's atlas was the first comprehensive
visual work on China with accompanying historical texts. While it did not provide
integrated presentations of the images and texts like Johannes Nieuhof's *Het gezandt-
schap der Neêrlandtsche Oost-Indische Compagnie* (1665) (cf. cat. nos. 2, 3) or Kircher's *China
Monumentis* (cat. no. 5), Martini's *Novus Atlas Sinensis* marked the beginning of a flood
of illustrated works and translations on China in the seventeenth and eighteenth centu-
ries, many of which cite Martini's atlas as a source. In addition, it is one of the first true
Sino-European publications, based on Chinese land surveys but presenting geographic
data in a highly visual European cartographic format. Produced among the Blaeu firm's
extended series of cartographic publications and issued in many editions and as single
sheets, Martini's maps set a standard to be emulated by later cartographic works on
China such as Jean-Baptiste Du Halde's *Description géographique* (cat. no. 8).

Bound in a manner typical for a Blaeu atlas—contemporary vellum over boards
stamped with gilt decorative designs—the copy held by the Getty Research Institute is
from the library of Robert and Maria Travis, who collected widely on Asian travels. (MR)

LITERATURE: Backer and Backer 1960, 5:646–50; *China* 1973, 129 (no. A11a); Cordier [1968], 182; Lust 1987, no.
160; Martini 1978– ; Martini 2003; Pfister 1932–34, notice no. 124 (Ferdinand Verbiest); Walravens 1987, 112–15
(cat. no. 31).

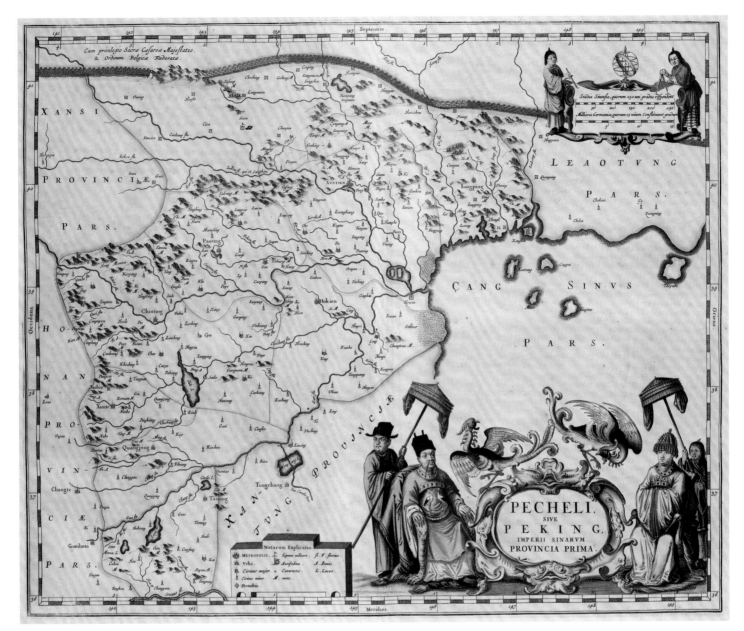

FIGURE 78

CAT. NO. **26**

**FERDINAND VERBIEST
(NAN HUAIREN)**
(Flemish, 1623–88)

Kunyu quantu (Complete map
of the world)

Seoul, ca. 1860, wood-block
print on bamboo paper, two
sheets: eastern hemisphere,
153.5 × 202 cm (60⅜ × 79½ in.);
western hemisphere, 151 × 203 cm
(59½ × 79⅞ in.)
2003.PR.63**

FIGURE 79. Ferdinand Verbiest,
Kunyu quantu, left: eastern
hemisphere, right: western
hemisphere

See also FIGURES 31, 32, 34, 35

The Getty Research Institute's copy of the world map by Ferdinand Verbiest is a rare and well-preserved black-and-white example of the Korean imprint of 1860. Like the original version of 1674, the Korean version comprises two hemispheres and fourteen explanatory cartouches (eight flanking and six internal) and was printed on sheets of bamboo paper from multiple blocks of varying sizes. The Research Institute's copy consists of two sheets, each made from four pasted-together vertical panels. Each sheet has been remounted on thick white paper and contains one hemisphere and adjacent textual explanations.

The Korean version of the map, even though printed from new blocks that were carved in Korea, is almost identical to the map as originally published in terms of overall structure, continental outlines, and text. The differences between the two are mainly stylistic. The most obvious change is the Korean imprint's slightly reduced dimensions, noticeable in the map's overall proportions, as well as in the diameter of the hemispheres (here, ca. 144 cm [56¾ in.] pole to pole, ca. 151 cm [59½ in.] at the equator; versus the diameter of 154 cm [60⅝ in.] of the original version held by the National Palace Museum, Taipei). For this reason, in the Korean version the four characters of the Chinese title (*kun yu quan tu,* as read from right to left) are printed closer to the hemispheres and the internal cartouches are not ovals but rather rectangles with their corners cut off to fit snugly around the hemispheres. Likewise, the external cartouches are closer to one other in the Korean imprint, and a few of their frames are slightly cropped. Decorative shading, such as that in the scrolled cornices of the cartouches, is simplified throughout relative to the original.

The content and placement of the author and date colophons also differ between the two maps. On the original, the date *Kangxi jiayin sui richan juzi zhi ci* (tenth month of the thirteenth year of the Kangxi emperor's reign) is placed at the lower right of the western hemisphere, while Verbiest's official function (administrator of the calendar) and his Chinese name (Nan Huairen) are similarly positioned at the lower left of the eastern hemisphere (*zhili lifa jixi Nan Huairen lifa* [Presented by the administrator of the calendar from the Extreme West, Nan Huairen]). In the Korean version, Verbiest's name and title are at the lower right of the western hemisphere, while at the lower left of the eastern hemisphere is the new publication date, *Xianfeng gengyin jianglou Haidong chongkan* (printed in Korea on the ninth month of the tenth year of the Xianfeng emperor's reign). On the copy held by the Research Institute, an impression in red of a scholar's seal appears to the lower right of the date colophon. The two characters of this seal read *sijae* in Korean (Chinese: *shizhai*), meaning "Studio of Divination." This was probably the name given by map's original owner (as yet unidentified) to the studio where he studied and met other scholars.

There are a limited number of imprints of the Korean version of 1860 in other collections. The Seoul National University Library holds several hand-colored copies, including one that is complete and mounted on a screen with the two outermost panels transposed. The Sungjon University Museum in Seoul and the Musée national des arts asiatiques-Guimet in Paris each hold a complete copy that has been mounted on an eight-panel screen; the one in Paris is hand-colored and mounted with the two outermost panels switched. Partial copies are held by the Harvard-Yenching Library at Harvard University (missing the two outermost panels) and by the British Library (two copies). While most of the extant copies of the Korean version appear to be early-

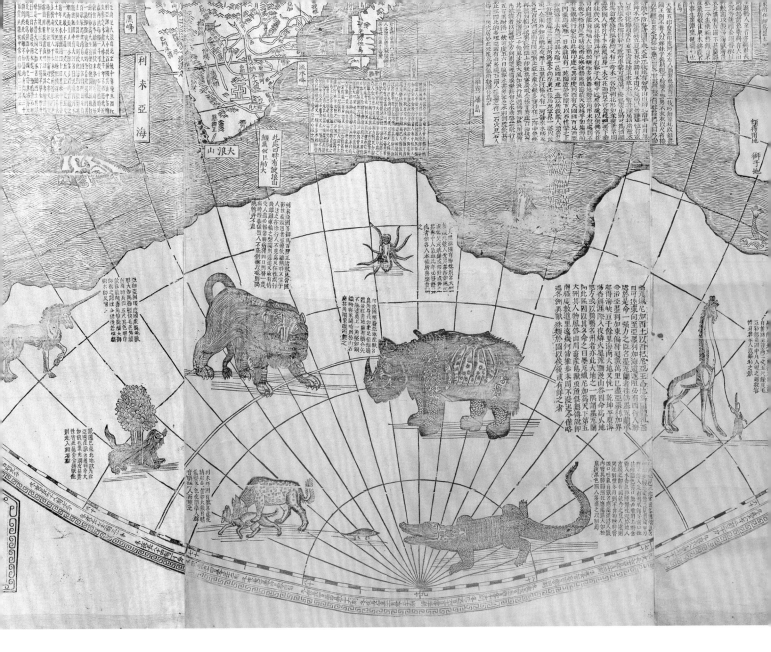

twentieth-century prints from the original blocks, the Research Institute's copy seems to be an imprint dating to 1860. The extant woodblocks are held by the Kyujanggak Institute for Korean Studies (formerly the Kyujanggak Royal Library) at Seoul National University.

Other Jesuit maps of the world had been reproduced in Korea prior to 1860. The *Kunyu wanguo quantu* (Complete map of all nations of the world) by Matteo Ricci (Italian, 1552–1610) of 1602 or 1608 was hand-copied in color in 1708 and is at the Seoul University Museum (Treasure no. 849). The world map that Giulio Aleni (Italian, 1582–1649) published in 1623 was hand-copied in color in 1770 and is in the holdings of the Kyujanggak Institute. (PD)

LITERATURE: Backer and Backer 1960, 8:574–87; M. Cohen and Monnet 1992, 126–27 (cat. no. 79); *From Beijing to Versailles* 1997, 149–50, 152–53 (cat. no. 47); Lee 1991, 17 (pl. 4), 22 (pl. 8), 32 (pl. 18), 38–41 (pls. 22–23); Li X. 1996; Lin 1993; Lin 1994; Pfister 1932–34, notice no. 124 (Ferdinand Verbiest); Vertente 1993; Wallis 1985; Yee 1994.

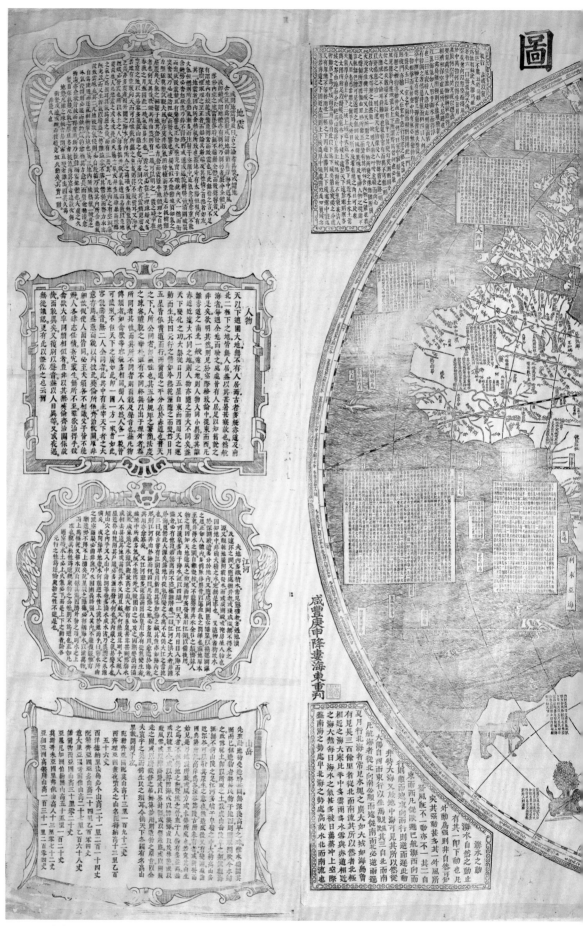

FIGURE 79 (left)

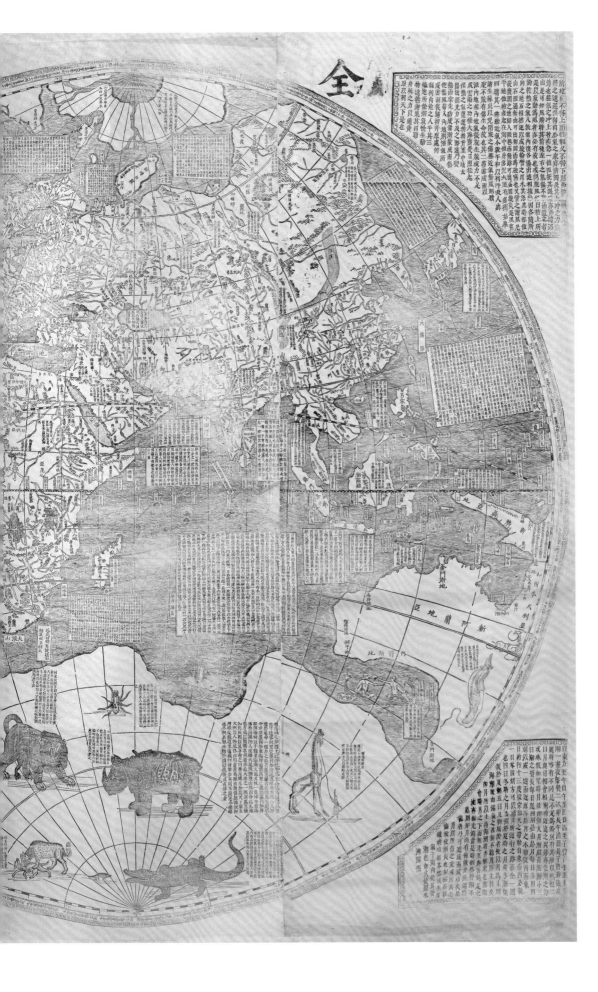

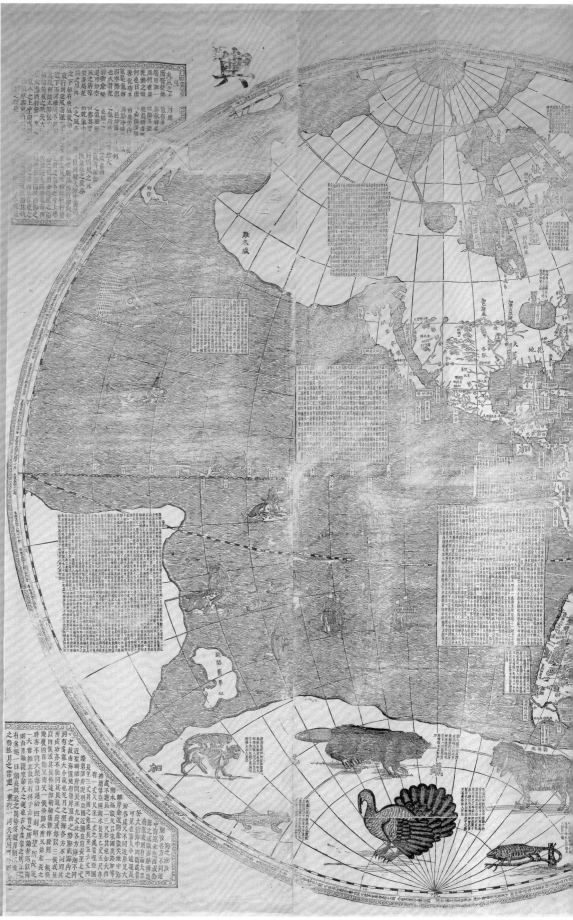

FIGURE 79 (right)

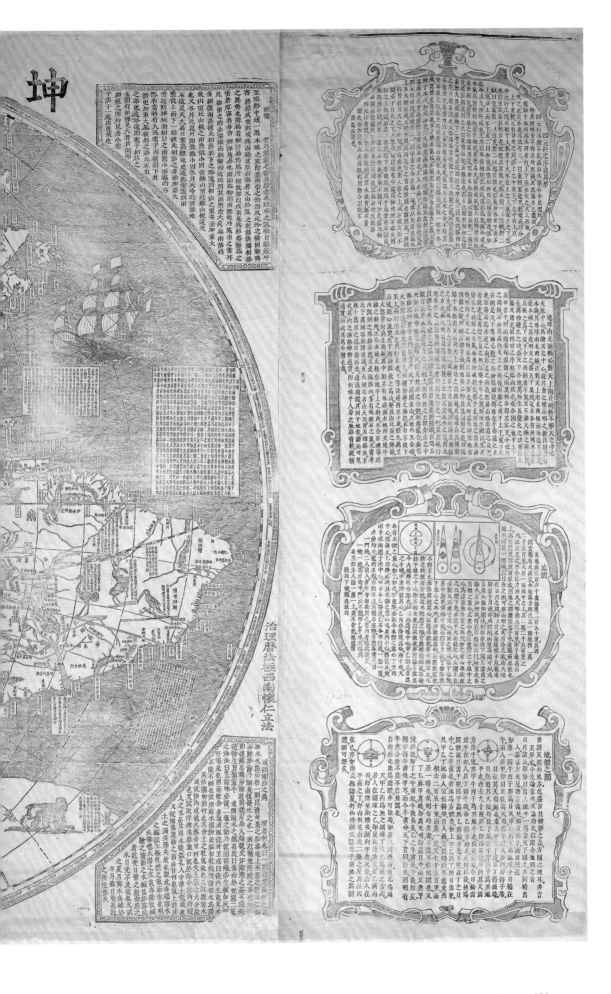

CAT. NO. **27**

JIAO BINGZHEN
(Chinese, 1662–1720)

with poems by

THE KANGXI EMPEROR
(Manchu, 1654–1722)

and **LOU SHOU**
(Chinese, 1090–1162)

Yuzhi gengzhi tu (Imperially commissioned illustrations of farming and weaving) (Beijing: Wuyingdian, 1696)
2650-128

FIGURE 80. Zhu Gui or Mei Yufeng, after Jiao Bingzhen, *Geng* (Plowing), [pl. 2]

See also FIGURE 36

This illustrated book on the cultivation of rice and making of silk was one of the most widely reproduced imperial publications of the Qing dynasty. When the Kangxi emperor ordered the court artist Jiao Bingzhen to paint a new version of the thirteenth-century illustrated edition of Lou Shou's *Gengzhi shi* (Poems on farming and weaving, 1145), Jiao produced forty-six images—rather than the original's forty-five—divided equally between the two subjects. He added two more images about rice cultivation, deleted three of the images about sericulture, and slightly altered the sequence to better reflect the actual stages of these activities. After writing a preface to Jiao's album and a poem for each illustration, the emperor commissioned the first of a number of wood-block printed versions of this work. The Kangxi emperor's poems were transcribed in an improved imitation of his calligraphy by the scholar-official Yan Youdun (Chinese, 1650–1713). In the sericulture section, two of the emperor's poems were mismatched with their respective images ("second molting" and "choosing the mature silkworms"; see fig. 36) and several characters do not follow the prescribed rhyming categories. These faults were apparently retained in the printed version because they had originally come from the emperor's own hand.

The first printed edition, issued in 1696, was executed by Zhu Gui (Chinese, ca. 1644–1717) and Mei Yufeng (Chinese, fl. ca. 1696). Both were important palace artisans who held positions as ushers in the Court of State Ceremonial, and their names appear at the end of the volume together with Jiao's. The work was printed in the Hall of Military Glory (Wuyingdian) in the Forbidden City, which housed the Imperial Printing Office. Two copies exist in which the personal seals of the Kangxi emperor are affixed in red ink to each of his poems. These may have been the initial sets intended for the emperor himself or perhaps they were from a limited edition presented as gifts to close imperial relatives and high officials. In a subsequent edition with the same plates, the emperor's seals appear in black ink, as part of the woodblocks themselves, and this version was probably destined for wider distribution. So many printed editions exist, some with only slight variations relative to the first, that it has proven difficult to date many of them or to distinguish a precise genealogy. There are, in addition, a number of other editions in different formats.

The Getty Research Institute's copy is consistent with the original edition and retains an early brocade cover on boards and a title label. Printed in black ink with two seals in red ink at the end of the preface, this copy was hand-colored later, probably by a professional artist or talented amateur. Affixed at the lower left both at the end of the preface and on the last plate is the following collector's seal: "Chengyuzhai Caoshi zhencang" (From the collection of Mr. Cao's Studio that Receives Abundance). (RS)

LITERATURE: M. Cohen and Monnet 1992, 142–43 (cat. no. 87); Edgren et al. 1984, 120–21 (cat. no. 38); *From Beijing to Versailles* 1997, 214–15 (cat. no. 79); Fuchs 1959; Hsiang 1976, 169–70; Hu 2000, 72–78 (cat. no. 17); Laufer 1912; Li Z. 2000; Lou Shou 1913; Monnet 2004, 181–84 (cat. no. 115); Pelliot 1913; Wang C. 1995; Weng 2001, 41–53, 269–70 (cat. no. 2).

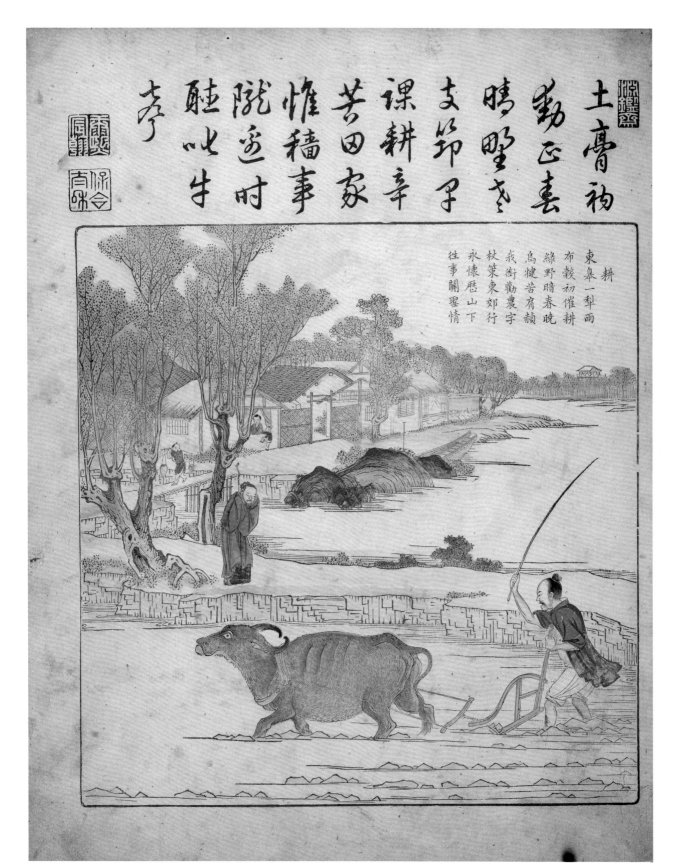

土膏初動正耒
晴畦去
支節子
課耕辛
苦田家
惟稼事
隴逐時
馳此牛
孝

耕
東臯一犁雨
布穀初催耕
綠野暗春曉
烏犍苦有賴
我衙勤農宇
杖策東郊行
永懷歷山下
往事關聖情

FIGURE 80

JACQUES ALIAMET
(French, 1726–88)

**PIERRE-PHILIPPE
CHOFFARD**
(French, 1730–1809)

NICOLAS DELAUNAY
(French, 1739–92)

**JACQUES-PHILIPPE
LE BAS**
(French, 1707–83)

**LOUIS JOSEPH
MASQUELIER I**
(French, 1741–1811)

FRANÇOIS DENIS NÉE
(French, 1732–1817)

BENOIT LOUIS PREVOST
(French, 1747– ca. 1804)

and **AUGUSTIN DE
SAINT-AUBIN**
(French, 1736–1807);

after

JEAN-DENIS ATTIRET
(French, 1702– 68)

GIUSEPPE CASTIGLIONE
(Italian, 1688–1766)

GIOVANNI DAMASCENO
(Italian, d. 1781)

and **IGNATIUS
SICHELBART**
(Bohemian, 1707–80)

[*Pingding Zhunga'er Huibu
desheng tu*] (Images of the vic-
tories over the Zunghars and
the Muslim tribes)
Paris, 1765–75, suite of sixteen
engravings, in brown calf
binding, each: 64 × 95 cm
(25¼ × 37⅜ in.) or smaller
1369-468

FIGURE 81. Jacques-Philippe Le
Bas, after Giuseppe Castiglione,
Kaiyan chenggong zhu jiangshi
(Victory banquet for the officers
and soldiers who distinguished
themselves), no. 16

See also FIGURES 43–45

The *Pingding Zhunga'er Huibu desheng tu* (also known as *Pingding xiyu zhantu ce* [Battle scenes of quelling the rebellion in the Western Regions]) is the first and most artistically accomplished of the six sets of copperplate engravings that the Qianlong emperor commissioned to celebrate notable military victories during the latter half of his reign. At the emperor's behest, four of the leading missionary-artists at his court—Jean-Denis Attiret, Giuseppe Castiglione, Giovanni Damasceno, and Ignatius Sichelbart—created working designs after large wall paintings that they and other court artists had executed to commemorate Qing victories in campaigns fought against the Zunghars in Zungharia (northern Xinjiang, China) and the Turkic Muslim tribes of Altishahr (southern Xinjiang, China) and Badakhshan (eastern Tajikistan and northeastern Afghanistan) between 1755 and 1759. These designs were sent to Paris in 1765 and 1766, where the French foreign ministry, then under Henri-Léonard-Jean-Baptiste Bertin (French, 1720–92), oversaw the costly project. The artist Charles-Nicolas Cochin II (French, 1715–90), secrétaire et historiographe of the Académie royale de peinture et de sculpture, was placed in charge of their production. He improved the designs as he saw fit and chose the finest engravers in Paris to execute the copperplates. The custom-made paper employed, which was called "Grand Louvois," was fabricated by the paper-merchant Prudhomme, and the printer was Beauvais. Two hundred sets of the engravings were printed and delivered to Beijing between 1772 and 1775.

Though the Qianlong emperor had ordered that all prints pulled and all the engraved copperplates be sent to China, some sets of prints were kept for the king and others in France. The Getty Research Institute's bound set of these engravings bears an interesting holographic inscription on the back of the fifth plate (the first plate of the set, per the Qianlong emperor): "Donnée à M. Prévost le 29 novembre 1769 par J. P. Le Bas son ami" (Given to Monsieur Prévost on 29 November 1769 by his friend J. P. Le Bas). Later, Isidore-Stanislaus-Henri Helman, a student of Le Bas, was allowed to make reduced copies of the prints, and he issued them in 1785 as a commercial enterprise. Their success encouraged him to produce four additional prints in 1786 — one of the emperor carrying out the annual plowing ceremony and three of him processing through Beijing—and a further four prints in 1788 — one of a veterans' celebration and three of the emperor honoring his ancestors (fig. 82). Complete sets of Helman's twenty-four engravings on China are rare; the set of prints held by the Research Institute is not bound.

Helman mistakenly identified the content of the images and arranged them in an order that supported his hypotheses. The French sinologist Paul Pelliot corrected Helman's order and subjects based on a set of the original prints found in China that include a preface and poems by the Qianlong emperor (the titles of the prints are from this set; see Nie 1996 or Nie 1999):

NO. 1 *Pingding Yili shouxiang* (Receiving the surrender of the Yili [that is, Zungharia; now the Junggar Basin in northern Xinjiang]), 1755 = Helman, no. 8

NO. 2 *Gedeng ela zhou ying* (Storming the camp at Gädän-ōla [that is, Mount Gedeng, now Gora Nebesnaya, ca. 100 *li* southeast of modern Yining, Xinjiang]), 1755 = Helman, no. 5

NO. 3 *Elei zhalatu zhi zhan* (The battle at Oroï-jalatu [in the area of modern Barkol, Xinjiang]), 1756 = Helman, no. 9

NO. 4 *Helouhuosi zhi jie* (The victory at Khorgos [ca. 10 *li* west of modern Manas, Xinjiang]), 1758 = Helman, no. 14

NO. 5 *Kulonggui zhi zhan* (The battle at Khuruṅgui [that is, Mount Khuruṅgui, north of the Yili river, Xinjiang], 1758 = Helman, no. 2

NO. 6 *Wushi qiuzhang xianchengxiang* (The chief of Ush Turpan [modern Wushi (Uqturpan), Xinjiang] surrenders with his city), 1758 = Helman, no. 13

NO. 7 *Heishui wei jie* (The lifting of the siege at the Blackwater campsite [southeast of modern Yarkand (Shache), Xinjiang]), 1759 = Helman, no. 3

NO. 8 *Hu'erman da jie* (The triumph at Qurman [ca. 130 *li* southwest of Barčuq, between modern Yarkand (Shache) and Maralbaši, Xinjiang]), 1759 = Helman, no. 7

NO. 9 *Tonggusiluke zhi zhan* (The battle at Tonguzluq [near modern Posgam, ca. 50 *li* southeast of Yarkand (Shache), Xinjiang], 1758 = Helman, no. 4

NO. 10 *Huosi kuluke zhi zhan* (The battle at Qoš-qulaq [that is, Heshi Kuchuke; now Kyzylart Pass, on the border between China and Tajikistan, ca. 500 *li* west of modern Kashgar (Kashi), Xinjiang]), 1759 = Helman, no. 10

NO. 11 *A'erchu'er zhi zhan* (The battle at Arčul [ca. 300 *li* west of the modern Kyzylart Pass]), 1759 = Helman, no. 15

NO. 12 *Yixi'er ku'er zhuo'er zhi zhan* (The battle at Yešil-köl-nōr [lake ca. 200 *li* southeast of Arčul (see no. 11) and north of Badakhshan (see no. 12)]), 1759 = Helman, no. 13

NO. 13 *Badashan han na ai* (The khan of Badakhshan [now northeastern Afghanistan and eastern Tajikistan] asks to surrender), 1759 = Helman, no. 11

NO. 14 *Pingding Huibu xianfu* (Presenting the prisoners from the pacification of the Muslim tribes), 1760 = Helman, no. 1

NO. 15 *Jiaolao Huibu chenggong zhu jiangshi* (Official visit to the officers and soldiers who distinguished themselves against the Muslim tribes), 1760 = Helman, no. 6

NO. 16 *Kaiyan chenggong zhu jiangshi* (Victory banquet for the officers and soldiers who distinguished themselves), 1760 = Helman, no. 16

The title page of Helman's edition, which numbers the engravings and offers brief (often erroneous) content descriptions, is bound with the Research Institute's set, which follows Helman's order, rather than the sequence identified by Pelliot, and the set is cataloged under Helman's title, *Suite des seize estampes répresentant les conquêtes de l'Empereur de la Chine, avec leurs explication* (Suite of sixteen prints depicting the conquests of the emperor of China, with explanations thereof). Affixed to the eighteenth-century French binding is the bookplate of the collector and bibliophile Hans Fürstenberg (German, 1890–1965). Only a few complete sets of the Qianlong emperor's prints have been preserved outside China. Three of the original copperplates, all of which had been sent to Beijing with the engravings, are now in the Ethnologisches Museum in Berlin (inv. nos. 32.525–527). (RS)

LITERATURE: Backer and Backer 1960, 2:845; Beurdeley and Beurdeley 1971, 79–88; *Das Buch* 1965, 38–39 (no. 43); Butz 2003; Christie's, Hong Kong, 30 April 2000, lot 515; Cordier 1913; Cordier [1968], 641; Duboscq and van den Brandt 1939–40; *From Beijing to Versailles* 1997, 226–43 (cat. nos. 85–92); Fuchs 1939–40; Gugong Bowuyuan 1992, 209–16 (no. 131); Hänisch 1918; Hsiang 1976, 162–63; Müller-Hofstede and Walravens 1985; Nie 1996, 183–91 (no. 41); Nie 1999; Pelliot 1921; Perdue 2002; Pirazzoli-t'Serstevens 1969; Walravens 1987, 36–56, 238–39 (cat. no. 177), 240 (cat. no. 179); Weng 2004, 217, 37.

Professor James A. Millward of Georgetown University and Professor Peter C. Perdue of the Massachusetts Institute of Technology kindly supplied information concerning where and when the battles depicted in these prints took place, and we are grateful to them for sharing their expertise.

CAT. NO. **29**

ISIDORE-STANISLAUS-HENRI HELMAN
(French, 1743–ca. 1809)

Conquêtes de l'empereur de la Chine (Conquests of the emperor of China) and other images of the Chinese emperor
Paris, 1783–88, set of twenty-four engravings with etching, each: 31 × 43.5 cm (12¼ × 17⅛ in.) or smaller
2006.PR.34*

FIGURE 82. Isidore-Stanislaus-Henri Helman, *L'empereur va visiter les tombeaux de ses ancêtres* (The emperor goes to visit the tombs of his ancestors), no. 22

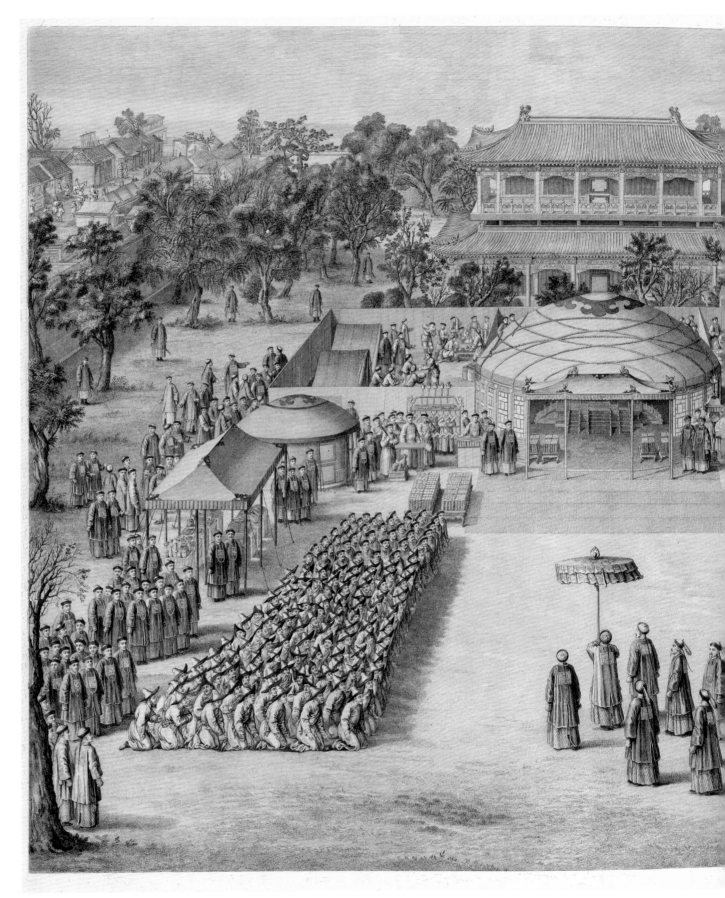

FIGURE 81

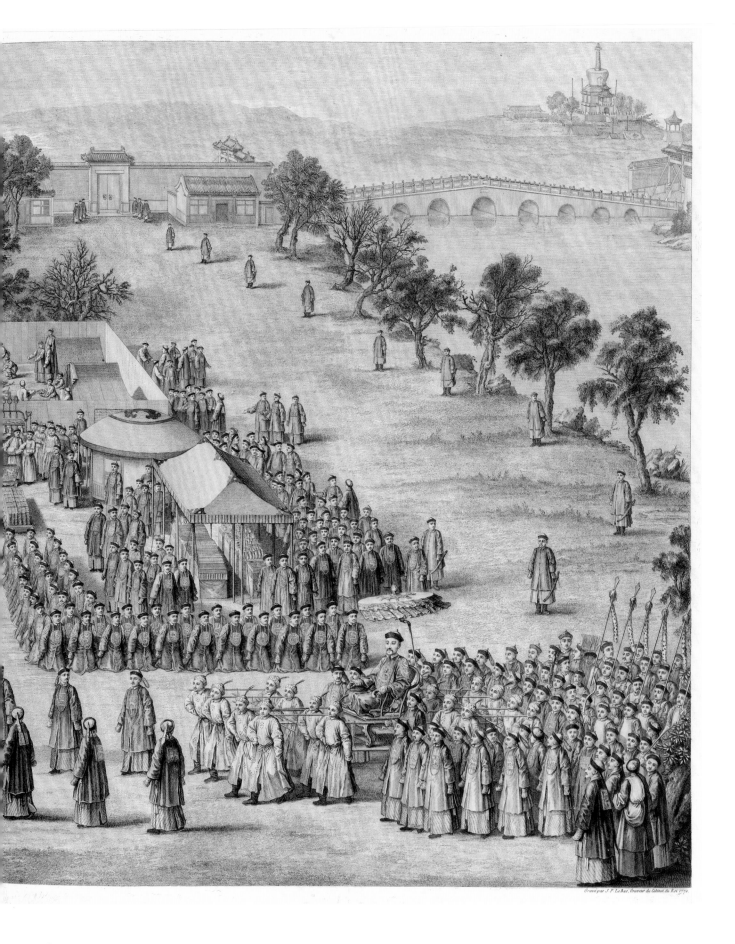

Gravé par J. P. Le Bas, Graveur du Cabinet du Roi 1770.

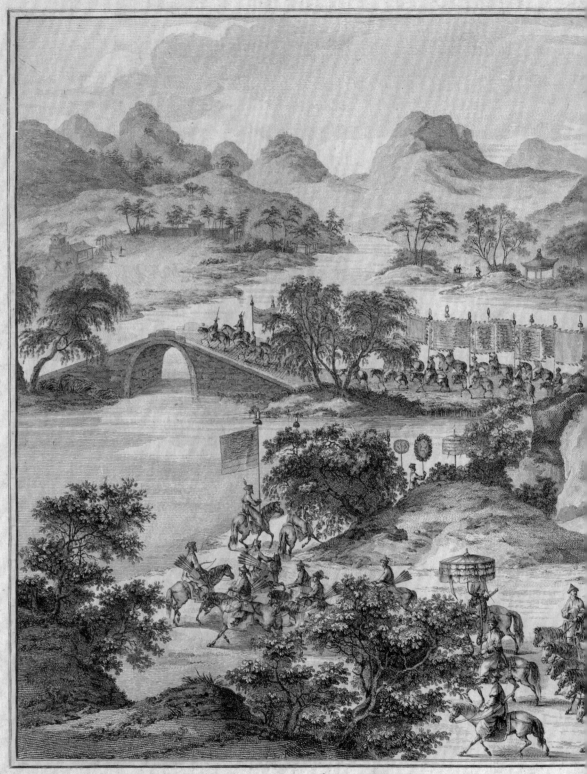

L'EMPEREUR VA VISITER L[...]

Deux Officiers précédent, à l'entrée du Pont, les deux grands Etendards qui dirigent la Marche Impériale? Ils sont suivis d'un[...]
de porter devant les Grands de l'Empire et les Officiers de la Garde, Deux Parassols très riches, en forme de Dais, dont l'un pre[...]
décorée d'ornemens symboliques. Ce Char, au quel sont attachés plusieurs Drapeaux déployés, rappelle l'idée d'un Char antique; il est e[...]
Dix Cavaliers armés de Lances, aux quelles sont suspendues des queues de Léopard, emblème du courage, l'Etendard Impéria[...]

Paris chez l'Auteur Graveur de Madame, Rue Sˢ Honoré vis-à-vis l'Hôtel de Noe[...]

FIGURE 82

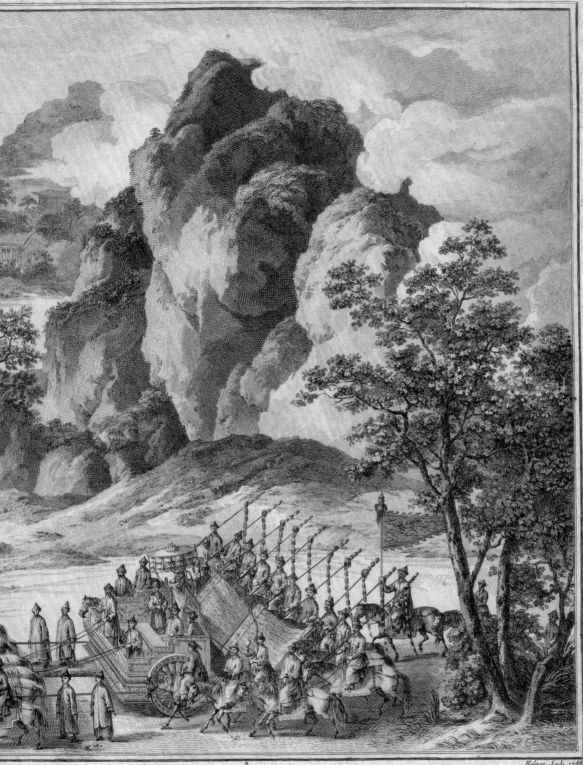

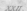

Helman, Sculp. 1788.

TOMBEAUX DE SES ANCÊTRES,

l nombre de petits Etendards de toutes couleurs, de Parassols de Satin brodé, et de deux autres grands Etendards qu'il est d'usage
Char, et l'autre le couvre, annoncent la présence de l'Empereur. On voit ce Prince dans une espèce de Voiture de forme quarrée, et
des Ministres, des Mandarins et des principaux Officiers de la Couronne. On y distingue celui qui porte l'Arc de l'Empereur.
e troupe de Gardes, ferment cette Marche solemnelle.

, 315. Et chez M. Ponce, Graveur de M.gr Comte d'Artois, Rue S.te Hyacinthe N.° 19.

CAT. NO. **30**

YI LANTAI
(Manchu, fl. 1749–86)

The European Pavilions at the Garden of Perfect Clarity (early Chinese titles include *Xieqiqu tu* [Pictures of the Pavilion Harmonizing Surprise and Delight]; and *Changchunyuan shuifa tu* [Images of the fountains in the Garden of Eternal Spring])
Beijing, 1783–86, suite of twenty prints, mounted on heavy paper, each: 50 × 87.5 cm (19¾ × 34½ in.)
86-B26695

See FIGURE 48

This set of twenty views of the European Pavilions (Xiyanglou, built 1747–83) was commissioned by the Qianlong emperor in 1783 and is the only visual source that documents the appearance of that enclosure within the Garden of Perfect Clarity (Yuanmingyuan, begun ca. 1707) before the destruction wreaked by English and French troops in 1860. The images were printed by March 1786 and are the first copperplate engravings entirely produced in China by Chinese artisans. They are also among the largest of all Qing imperial printed works and similar in size to the Qianlong emperor's suites of battle scenes (for one of these, see cat. no. 28). Each engraving has a number followed by a title in Chinese printed in the upper section. The designs (and probably the engravings) are credited to Yi Lantai, who began as an apprentice among the group of Chinese artists trained by Giuseppe Castiglione (Italian, 1688–1766) in methods of linear perspective. Yi is known to have worked with other missionary-artists on decorating the interior of the Observatory of Distant Oceans (Yuanyingguan). As a set, the twenty images form a sequence of views of the major elements in the enclosure, first proceeding from south to north on the west end and then west to east through the complex, which was designed as a series of framed scenes linked by a promenade. No attempt was made to depict the entire garden in a single view. Recent reconstructions of the overall plan have emerged by combining evidence from these prints with late-nineteenth- and early-twentieth-century photographs of the ruins and recent measurements of the site (see figs. 45, 46). The monochromic engravings do not convey the variegated hues of the facades or the dazzling effect of the multicolored tiles of the Chinese-style roofs. They also fail to capture the carefully wrought transitions between the striking set pieces that the engravings depict—but in this, they are entirely consistent with the Chinese tradition of the painted album, which parallels the tradition of the painted hand scroll.

The process of printing the engravings took about five years. The project was executed in stages, as was often the case for imperial commissions involving the court artisans working in the Garden of Perfect Clarity. Drafts of the images were made by Yi, and test printings of the plates were submitted to the emperor for approval before the final print run commenced. The Qianlong emperor ordered one hundred sets of the series, which originally may have been titled *Xieqiqu tu* (Pictures of the Pavilion Harmonizing Surprise and Delight), after the first major building. These were formally delivered to him on 28 April 1786, whereupon he ordered another one hundred sets. Of the original order, forty sets were to be displayed, along with the copperplates, in the Pavilion Harmonizing Surprise and Delight. The remaining sets were distributed to other imperial palaces. The missionary-artists sent a few sets to Europe at this time, and a few more were acquired by Western collectors after the looting of the Garden of Perfect Clarity in 1860. Printed on sheets of thin Chinese *bailu* (literally, "white dew") paper and folded down the middle, the original sets may have been stored between boards or in wooden boxes.

Presently housed in a new box, the Getty Research Institute's set, in excellent condition, was unfolded and remounted. (RS)

LITERATURE: Adam 1936; Barmé 1996; Chiu 1999; Chiu 2000a; Chiu 2000b; *Delights of Harmony* 1994; Desroches 1985; Droguet 1994; Durand 1988; Durand and Thiriez 1993; *From Beijing to Versailles* 1997, 256–65 (cat. nos. 99–102); Genest 1994; He and Zeng 1995; Huang and Huang 1985; Jin 1984; Loehr 1940, 37–108; Malone 1934; Monnet 2004, 224–31 (cat. nos. 133–35); *Palais, pavillions et jardins* 1977; Pirazzoli-t'Serstevens 1988; Pirazzoli-t'Serstevens 1989a; Pirazzoli-t'Serstevens 1989b; Rabreau 2002; Schulz 1966; Shu, Shen, and He 1984; Sirén 1926; Siu 1999; Teng 1933; Thiriez 1998; Wang D. and Fang 1999; Wong 2001; *Yuanmingyuan* 1981–92; *Yuanmingyuan* 1987; *Yuanmingyuan oushi tingyuan* 1998; Zhang 1993; Zhang 1998; Zhang 2003; Zhao 1984; Zhongguo Diyi Lishi Dang'anguan 1991; Zou 2001; Zou 2002.

Detail OF FIGURE 48, NO. 9

CAT. NO. **31**

The Emperor of China's Palace at Pekin, and His Principal Gardens, as well in Tartary, as at Pekin, Gehol and the Adjacent Countries; with the Temples, Pleasure-Houses, Artificial Mountains, Rocks, Lakes, etc. as Disposed in Different Parts of Those Royal Gardens (London: printed & sold by Robert Sayer, Henry Overton, Thomas Bowles, & John Bowles & Son, 1753)
92-B26685

FIGURE 83. After Matteo Ripa, *The Many Rivers and Air, that Breaths from the Pine Tree, Its Partner: Apartments Where the Europeans Were Employ'd by the Emperor*, pl. 15

This set of twenty engravings appeared in 1753, a year after the publication of *A Particular Account of the Emperor of China's Gardens near Pekin: In a Letter from F. Attiret to His Friend in Paris* (1752), a translation by Joseph Spence (alias Sir Harry Beaumont) of Jean-Denis Attiret's famous letter describing the palaces and gardens of China during the reign of the Qianlong emperor. The set represents one of the earliest attempts to disseminate in England images of actual Chinese gardens. Most of the prints are based on the engravings done by Matteo Ripa in 1713 of the Kangxi emperor's summer palace at Chengde. When Ripa passed through England in 1724, he brought some sets of these engravings with him, and one of these sets was later acquired by Robert Wilkinson. This set eventually came into the possession of the art historian George Loehr, who believed that it was Wilkinson who decided to publish eighteen of them, anonymously, in this book. However, Wilkinson's name does not actually appear anywhere in *The Emperor of China's Palace*. Of the four publishers listed, both John Bowles and Robert Sayer issued other works on China, such as Sayer's popular pattern book *The Ladies Amusement; or, Whole Art of Japanning Made Easy* (2nd ed., 1762) and Bowles's *The Rice Manufacture in China* (1760).

Though the unsigned adaptations of Ripa's images are the core of the book, the first and last plates are based on other sources. Plate 1, "The Emperor of China's Palace at Pekin," is a simplified version of a widely copied image of the Hall of Supreme Harmony (Taihedian) (see fig. 3) in the Forbidden City that first appeared in Johannes Nieuhof's 1665 description of the Dutch East India Company's embassy to Beijing in the years 1655 to 1657. The image of the imperial palace in Beijing is followed by eighteen views of the summer palace at Chengde, also known by its Manchu name, Jehol, here spelled "Gehol." These engravings closely follow Ripa's but add whimsical images of people, animals, and other objects. The final plate in *The Emperor of China's Palace* is purportedly a view by an Italian engineer of a Mogul throne at Delhi. Actually a roofed dais, the jewel-covered throne was destroyed in 1739. Though plate 20 is numbered and the same size as the others, the sheet is slightly smaller and glued to a stub attached to the binding. This association of an Indian throne with the Chinese emperor's palace is a reminder that in the minds of many Europeans at the time, "India" could still mean all of Asia east of India proper.

Loehr possessed a hand-colored copy of *The Emperor of China's Palace*. The Getty Research Institute's copy comprises uncolored prints in a twentieth-century binding. (RS)

LITERATURE: Conner 1979b; Forêt 2000; Gray 1960; Loehr 1976; Ripa 1846; *Tongban bishushanzhuang sanshiliu jing shitu* 2003.

The many Rivers and Air, that Breaths from the Pine Tree It's Partner.
Apartments where the Europeans, were Employ'd by the Emperor.

FIGURE 83

P. DECKER

[Part 1] *Chinese Architecture, Civil and Ornamental, Being a Large Collection of the Most Elegant and Useful Designs of Plans and Elevations, etc., from the Imperial Retreat to the Smallest Ornamental Building in China, likewise Their Marine Subjects, the Whole to Adorn Gardens, Parks, Forests, Woods, Canals, etc.... To Which Are Added, Chinese Flowers, Landscapes, Figures, Ornaments, etc., the Whole Neatly Engraved on Twenty-four Copperplates, from Real Designs Drawn in China, Adapted to This Climate, by P. Decker, Architect*
[Part 2] *Chinese Architecture, Part the Second, Being a Large Collection of Designs of Their Paling of Different Kinds, Lattice Work, etc.... the Whole Neatly Engraved on Twelve Copper-plates, from Real Chinese Designs, Improved by P. Decker, Architect,* 2 vols. in 1 (London: printed for the author, & sold by Henry Parker & Eli[z]abeth Bakewell, & H. Piers & Partner, 1759)
85-B15019

FIGURE 84. *Head of a Canal or Termination of a Visto,* [pl. 3]

In Britain, the fad for building Chinese-style garden structures reached its height during the 1740s and 1750s, when a number of pattern books were issued that featured architectural designs for pavilions, bridges, and other garden fixtures together with various patterns for a range of decorative objects. *Chinese Architecture, Civil and Ornamental,* which appeared two years after William Chambers's *Designs of Chinese Buildings* (1757) (see cat. no. 33), advertised itself on its title page as offering "most elegant and useful designs of plans and elevations." Nothing is known of the "P. Decker, Architect" whose name appears on the title pages of the two volumes of *Chinese Architecture, Civil and Ornamental,* and of the two similar volumes of *Gothic Architecture Decorated,* all issued in 1759. Because most of the designs in these volumes are derivative works after images in earlier publications, Eileen Harris suggests that P. Decker may be a fictive name, perhaps invented to disguise a bit of derivative publishing.

Such pattern books were intended for a wide audience, and their designs were representative samples rather than models to be built, even though scale measurements for each structure are included and plate 12 offers several ground plans. The titles of the plates in part 1 provide a good idea of the range of subjects appropriate to this genre, from *Imperial Retreat for Angling* and *Temple Fronting a Cascade* to *Magnificent Bridge* and *Romantic Rocks Form'd by Art to Embellish a Prospect.* Many of the architectural patterns were copied from Eva Dean Edwards and Matthew Darly's *A New Book of Chinese Designs* (1754) and were in turn pirated in *The Ladies Amusement; or, Whole Art of Japanning Made Easy* (2nd ed., 1762). The upper corners of some of Decker's plates have whimsical chinoiserie flourishes after rococo designs by artists such as Jean Baptiste Pillement (French, 1728–1808), who would publish *One Hundred and Thirty Figures and Ornaments and Some Flowers in the Chinese Style* (1767), an influential collection of his own decorative, genre, and landscape subjects. The plate numbers in *Chinese Architecture, Civil and Ornamental,* are not consecutive, and two have headers that reference, respectively, "Part 3rd" and "Part 4th." This suggests that the prints may have formed parts of other publications before they were assembled as this work. The prints were also sold individually. Part 1, which has twenty-four plates, was sold for six shillings, about a week's wages for a laborer, while part 2, with twelve plates, was priced at three shillings.

The Getty Research Institute's copy is bound, in half-leather and marbled boards, along with Decker's two volumes of designs for rococo Gothic garden structures and decorative patterns. The bookplate indicates that the book was formerly in the library of Lord Farnham, an Irish baron whose seat was the Farnham Estate in Cavan, Cavan County, Ireland. (RS)

LITERATURE: Conner 1979b; E. Harris 1990, 178–79, no. 192.

Head of a Canal or Termination of a Visto.

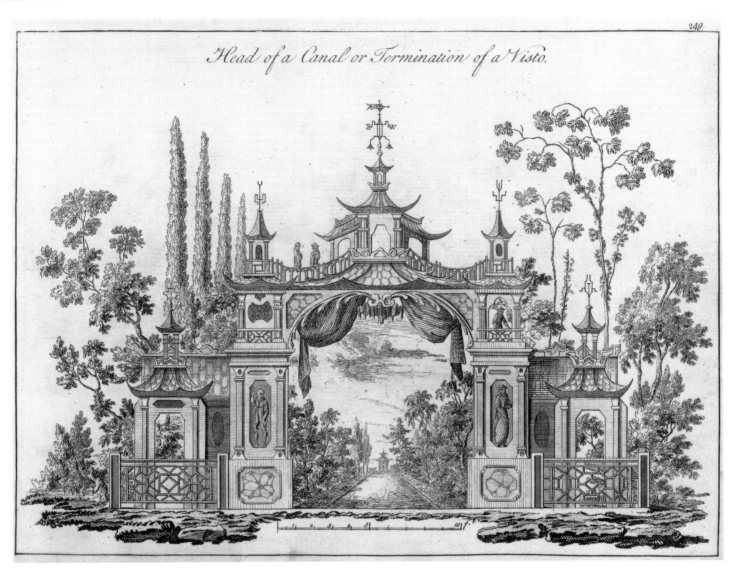

FIGURE 84

CAT. NO. *33*

WILLIAM CHAMBERS
(British, 1723–96)

Desseins des edifices, meubles, habits, machines, et ustenciles des Chinois: Gravés sur les originaux dessinés à la Chine…auxquels est ajoutée une description de leurs temples, de leurs maisons, de leurs jardins, etc. (Designs of Chinese buildings, furniture, clothing, machines, and utensils: Engraved after originals drawn in China … to which is added a description of their temples, houses, gardens, etc.) (London: J. Haberkorn, 1757)
84-B30688

FIGURE 85. Edward Rooker, after William Chambers, Section of a Cantonese merchant's house, pl. 9

The French version of William Chambers's *Designs of Chinese Buildings* was issued in London simultaneously with the English edition, which appeared in May 1757. Chambers had arrived in London two years earlier, intent on setting up a private architectural practice. Though he met with no success in his attempt to publish an album of his plans for neoclassical buildings, he was able to cultivate his prior connection with Augusta, Dowager Princess of Wales (German, 1719–72), who probably encouraged him to release this book. It proved timely for Chambers's career, for it not only positioned him as the leading authority on Chinese-style architecture but also brought him, within months, the commission to redesign the dowager princess's estate at Kew (documented in a lavish folio published in 1763 [cat. no. 34]) and, as it turned out, a lifetime of royal patronage. Like the English edition, the French version was dedicated to Augusta's eldest son, the Prince of Wales, who succeeded to the English throne in 1760 as George III.

Desseins covers a range of subject matter and consists of nineteen pages of text (descriptions of the plates followed by the first statement of Chambers's influential theory of Chinese garden aesthetics) and twenty-one engravings. The plates are divided into two groups. The first, "Les édifices des Chinois," includes temples, pagodas, pavilions, houses, columns, architectural details, interiors, furniture, teapots, and vases (pls. I–XVI). Many of these engravings present floor plans, front views, details of the structures, and structural plans. The second chapter, "Diverses autres formes de batimens usitées à la Chine," includes boats, machines, examples of Chinese writing, and fashions (pls. XVII–XXI). The prints depicting Chinese garb—which are superfluous to Chambers's main focus and seem to have been included to appeal to readers interested in learning more about China—were supposedly copied from paintings executed on glass by a Chinese painter, Siou-Sing-Saang, whom Chambers claimed to have employed in Canton to depict the costumes of China. Inaccuracies in all the images reflect Chambers's resort to memory and his own imagination. Still, some of the plates depicting architecture achieve a far greater degree of fidelity than the publications about China extant in Europe at the time.

Chambers's five-page essay, "De l'art de distribuer les jardins selon l'usage des Chinois," titled "The Art of Laying Out Gardens among the Chinese" in the English edition, was the first of several theoretical statements on the subject that he published over the next sixteen years (see cat. nos. 35, 36). In Britain, it was this essay, rather than the designs of the plates, that gained the most notice. A Russian edition appeared in 1771; and in November 1776, as the taste for Chinese-style garden was flowering in France and Germany, the *Desseins des édifices…des Chinois* was reprinted as *cahier* 5 of Georges-Louis Le Rouge's *Détail des nouveaux jardins à la mode* (cat. no. 37).

The Getty Research Institute's copy is bound in eighteenth-century brown calf. (RS)

LITERATURE: Chambers 2004; Cordier [1968], 1570; Erdberg 1936; E. Harris 1967; E. Harris 1990, 155–64, no. 114; J. Harris 1970; J. Harris and Snodin 1996; Lust 1987, no. 1124; Schmidt 2002; Snodin 1996; Vogel 2004–5; Weiss 1996.

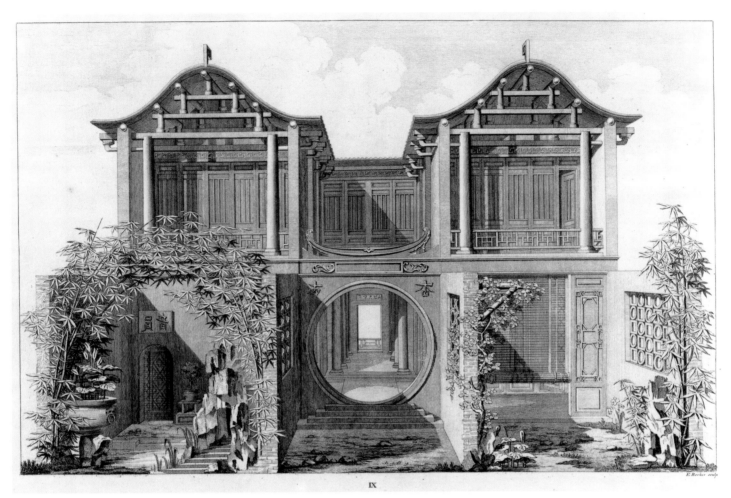

FIGURE 85

IX

CAT. NO. **34**

WILLIAM CHAMBERS
(British, 1723–96)

*Plans, Elevations, Sections, and
Perspective Views of the Gardens
and Buildings at Kew in Surry, the
Seat of Her Royal Highness, the
Princess Dowager of Wales* (London: printed by J. Haberkorn,
published for the author, 1763)
1376-795

FIGURE 86. T. Miller, after
William Chambers, *The House
of Confucius,* pl. 15

See also FIGURES 49, 51

Designed to be impressive, this large folio contains eight pages of text, under the heading "A Description of the Plates," followed by forty-three engravings of individual buildings and landscaped views at Kew documenting the redesign of the estate carried out by William Chambers between 1757 and 1763. The book was published at royal expense and dedicated to Chambers's patron, Augusta, Dowager Princess of Wales (German, 1736–51). The new architecture at Kew reflected the eclectic range of exotic styles then in fashion, from classical and Moorish to Mogul and gothic. The text comments not only on the individual architectural elements and gardens but also on Chambers's intentions and the interior furnishings and decoration executed by various collaborators—in this regard, the earlier role of William Kent (English, 1684/85–1748) is repeatedly acknowledged. The Chinese-style structures illustrated are the Aviary; the Chinese Pavilion in the Pheasant Ground, an open, octagonal interpretation of a gazebo designed by Chambers and built in 1760; the House of Confucius; and the Pagoda.

The Pagoda was originally based on the plans published in Chambers's *Designs of Chinese Buildings* (1757) (see cat. no. 33), but the dimensions of the first four stories were modified in the course of construction. Plates 22 through 24 of *Plans* illustrate the Pagoda as originally envisioned, while plate 25 shows its state upon completion. Among the alterations was the widened portico of the ground-floor level. Chambers details some elements that, unfortunately, are no longer present. In his day, the roofs of the Pagoda were covered in iron plates varnished in different colors, and poised at each of the eight angles of each of the ten roofs was a large dragon. The eighty dragons were treated with various colored glazes, and the ornament topping the structure was covered in double gilt. Chambers himself executed the drawings for all the architectural structures, which appear in plates 1 through 35. Plates 36 through 43 offer scenic views of Kew by other artists. The Pagoda appears in situ in both plate 37, *A View of the Lake and Island at Kew as Seen from the Lawn,* and the final plate, *A View of the Wilderness with the Alhambra, the Pagoda, and the Mosque* (see fig. 51).

The Getty Research Institute's edition is bound in the original marbled boards. The sequence of the plates, which are not individually numbered, follows the order Chambers provided in the "Directions to the Binder" on page 8 of the "Description of the Plates."

The Research Institute also owns a version of this work comprising a handwritten translation into Italian and reduced-scale ink-and-gray-wash drawings based on the printed copy sent by Chambers to the father of Raffaelle Stern (Italian, 1774–1820), a Roman architect. The drawings were executed in 1796 by cavaliere Gaudenzio Honorati (Italian, fl. 1790–99), a nobleman whose family seat was the Palazzo Honorati in Jesi, Ancona, Italy. The translation was provided by Valentino Bodkin, described by Honorati as a nobleman from Dublin resident in Rome. (RS)

LITERATURE: Chambers 1796; E. Harris 1990, 155–64, no. 121; J. Harris 1996; Quaintance 2002; Vogel 2004–5.

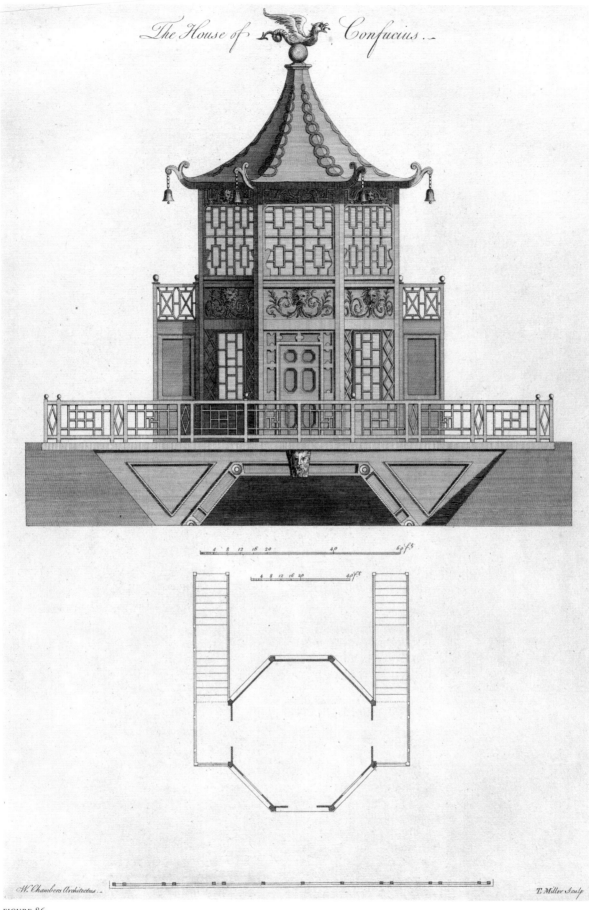

The House of Confucius

W. Chambers Architectus.

T. Miller Sculp

FIGURE 86

In the fifteen years following the publication of *Designs of Chinese Buildings* (1757) (see cat. no. 33), with its brief foray into Chinese garden aesthetics, William Chambers found himself at the center of a growing controversy in Britain over garden design generally and the Chinese-style garden in particular. It was largely to counter the trend toward gardens with a natural and completely unplanned appearance that Chambers published *A Dissertation on Oriental Gardening,* an expanded statement of his earlier ideas on the Chinese garden as a artistically enhanced natural space designed to evoke emotion. The first edition of 1772 ran to ninety-four pages. It was dedicated to George III and was printed and sold by persons associated with the Royal Academy of Arts, which Chambers had helped establish. No sooner had Chambers issued *A Dissertation* than a chorus of opposition was voiced. He quickly prepared a second edition, which ran to 164 pages, including a thinly disguised rebuttal to his critics attributed, falsely, to Tan Chet-qua (Chinese, d. 1796), a Cantonese sculptor who was in London between 1769 and 1772. Just before the second edition appeared, the poet William Mason (British, 1725–97) published, anonymously, *An Heroic Epistle to Sir William Chambers,* a lampoon that was circulated widely and met with great success (the thirteenth edition is dated 1774). Thus, the publication of the second edition of Chambers's work took place in an atmosphere even more heated than that surrounding the first edition. Chambers, now a well-established architect and a public figure, came to regret the controversy it caused.

At the time, the uproar obscured the reality that the content of *A Dissertation* was consistent with the basic principles that Chambers had articulated in *Designs of Chinese Buildings.* He had added new material, some quite fantastical, to elaborate his conviction that art and the imagination should play as important a role as unadorned nature in garden design. By this time, though, the fashion for the Chinese-style garden had waned in Britain while it was just beginning to enjoy a new vogue in France and in other countries on the continent. The French edition of *A Dissertation* enjoyed greater success than the English, though the translation by Delarochette was not to the author's complete satisfaction, as evidenced by a copy of the French edition that later belonged to the architect Sir John Soane (British, 1753–1837) in which, according to Eileen Harris, there are corrections in Chambers's own hand. (RS)

LITERATURE: Chambers 1772/1972; Chambers 2004; Chase 1936; Cordier [1968], 1534; E. Harris 1990, 155–64, no. 118 and its notes; J. Harris and Snodin 1996; Lust 1987, no. 1125; Mason 1773.

A
DISSERTATION
ON
ORIENTAL GARDENING;
BY
Sr. WILLIAM CHAMBERS, Knt.
Comptroller General of his Majesty's Works.

G.B.Cipriani inv. F.Bartolozzi sculp.

LONDON:

Printed by W. GRIFFIN, Printer to the ROYAL ACADEMY; sold by Him in *Catherine-street;*
and by T. DAVIES, Bookseller to the ROYAL ACADEMY, in *Russel-street,*
Covent Garden: also by J. DODSLEY, *Pall Mall:* WILSON and NICOLL, *Strand;*
J. WALTER, *Charing Cross;* and P. ELMSLEY, *Strand.* 1772.

CAT. NO. *37*

**GEORGES-LOUIS
LE ROUGE**
(French, ca. 1712–ca. 1792)

Détail des nouveaux jardins à la mode (Details of fashionable new gardens), 21 pts. in 22 (Paris: Le Rouge, [ca. 1776–89])
88-B1922

FIGURE 88. Georges-Louis Le Rouge, *Maison chinoise vûe du côté de l'entrée au Midy* (Chinese house, view of the south facade), pl. 12

See also FIGURE 52

The monumental series of 492 engravings in twenty-one *cahiers* (portfolios) that Georges-Louis Le Rouge issued in Paris from about 1776 to about 1789 provides the most comprehensive survey of the Chinese-style garden in eighteenth-century Europe. Issued sporadically, the titles of the *cahiers* vary, from *Détail des nouveaux jardins à la mode* for *cahier* 1 to *Jardins anglo-chinois, Jardins chinois, Jardins anglais,* or simply *Jardins* for others. Le Rouge drew on a variety of sources for his images, including European pattern books and Chinese wood-block printed books, to both document and stimulate the taste for garden designs uniting nature's irregularities with artful embellishments, a fashion that was already established in England and making inroads in France.

Le Rouge was born into a French family in Hanover, Germany, around 1712. He studied military engineering and surveying in his youth and arrived in Paris in 1740. Having obtained the position of ingénieur et géographe du roi under Louis XV, he became one of the most important publishers of maps, atlases, battle plans, and other topographical images, which he sold from his shop on rue des Grands Augustins. Among his other works, Le Rouge published *Introduction à la géographie* (Introduction to geography, 1748). Most of the topographical images he issued were obtained from other sources, principally from England, and Le Rouge was considered the major publisher of maps of North America. As early as 1750, Le Rouge began to print views of sites in France, and during the 1760s, he issued tourist guidebooks on France, England, and Holland. While Le Rouge himself did not seem to have had any particular interest in gardens, he capitalized on the growing fashion for the Chinese-style garden among French and continental audiences by issuing this series of *cahiers*. Its offerings included not only views of notable contemporary gardens in England, France, Italy, Austria, and Germany but also an edition of the French version of Chambers's *Designs of Chinese Buildings* (see cat. no. 33) and illustrations of Chinese imperial palace estates. The title page to *cahier* 15 (see fig. 52), for example, features an engraved view of a pavilion at the Garden of Perfect Clarity (Yuanmingyuan) after a Chinese woodcut printed at the Imperial Printing Office in Beijing and owned by Count Carl Fredrik Scheffer (Swedish, 1715–86). Each *cahier* contained from twenty to thirty prints and generally sold for twelve *livres tournois,* then equivalent to roughly half a British pound. Because the series was published at irregular intervals over some thirteen years, few collectors were able to obtain a complete set at the time, and such sets are even rarer today.

The Getty Research Institute holds two sets: one set is complete, while the other comprises *cahiers* 1–4, 6–10, and 13–17 on untrimmed sheets bound in their original covers of thin blue paper. The latter formerly belonged to the Belgian bibliophile Georges De Belder (1922–81). (RS)

LITERATURE: Chambers 2004; Cohn 2000; Conner 1979a; Gournay 1991; E. Harris 1990, 155–64, no. 115; Oehme 1971; Quérard 1827–64/1964; Royet 2004; Sirén 1950/1990, 107–11; Wiebenson 1978.

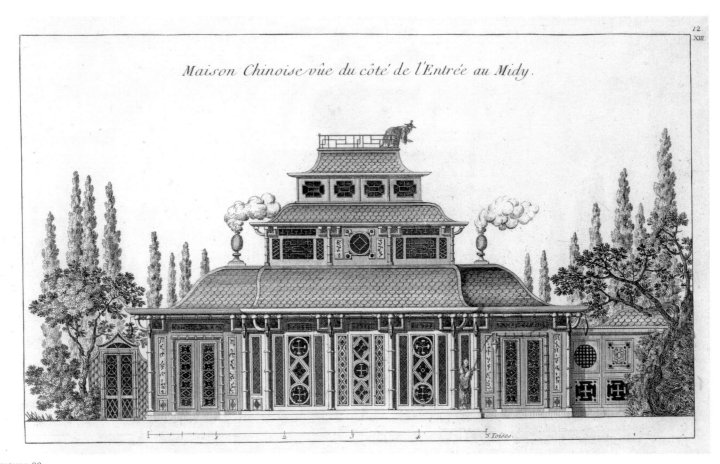

Maison Chinoise vûe du côté de l'Entrée au Midy.

5 Toises.

FIGURE 88

Abbey, John R. 1972. *Travel in Aquatint and Lithography, 1770–1860, from the Library of J. R. Abbey: A Bibliographical Catalogue.* Edited by Michael Oliver. 2 vols. Folkestone, England: Dawsons of Pall Mall.

Adam, Maurice. 1936. *Yuen ming yuen: L'oeuvre architecturale des anciens jésuites au XVIIIe siècle.* Beijing: Imprimerie des Lazaristes.

Backer, Augustin de, and Aloys de Backer. 1960. *Bibliothèque de la Compagnie de Jésus.* Edited by Carlos Sommervogel. Rev. reprint ed. 12 vols. Héverlé-Louvain: Éditions de la Bibliothèque S.J.

Barmé, Geremie R. 1996. "The Garden of Perfect Brightness, a Life in Ruins." *East Asian History* 11:111–58.

Beurdeley, Cécile, and Michel Beurdeley. 1971. *Giuseppe Castiglione, a Jesuit Painter at the Court of the Chinese Emperors.* Translated by Michael Bullock. Rutland, Vt.: C. E. Tuttle.

Blussé, Leonard, and R. Falkenburg. 1987. *Johan Nieuhofs beelden van een Chinareis, 1655–1657.* Middelburg, The Netherlands: Stichting VOC.

Bontinck, François, and D. Ndembe Nsasi. 1978. *Le catéchisme kikongo de 1624.* Brussels: Académie Royale des Sciences d'Outre-Mer.

Boxer, Charles R., ed. 1953. *South China in the Sixteenth Century: Being the Narratives of Galeote Pereira; Fr. Gaspar da Cruz, O.P.; Fr. Martín de Rada, O.E.S.A. (1550–1575).* London: printed for the Hakluyt Society.

Das Buch als Kunstwerk: Französische illustrierte Bücher des 18. Jahrhunderts aus der Bibliothek Hans Fürstenberg. 1965. Exh. cat. Stuttgart: Württembergische Landesbibliothek.

Butz, Herbert, ed. 2003. *Bilder für die "Halle des Purpurglanzes": Chinesische Offizierporträts und Schlachtenkupfer der Ära Qianlong (1736–1795).* Exh. cat. Berlin: Museum für Ostasiatische Kunst.

Catalogue de la Bibliothèque du Pé-t'ang. 1949/1969. Peking: Imprimerie des Lazaristes. Reprint, Paris: Société d'Édition Les Belles Lettres.

Chambers, William. 1772/1972. *A Dissertation on Oriental Gardening.* London: W. Griffin. Reprint, Farnborough, England: Gregg.

———. 1796. "Piante, elevazioni, sezzioni, prospettive e vedute dei giardini e delle fabbriche di Kew in Surry, palazzo di sua Altezza Reale la Principessa Vedova di Galles." Italian translation by Valentino Bodkin of Chambers's *Plans,* *Elevations, Sections, and Perspective Views of the Gardens and Buildings at Kew in Surry* (1763); with drawings by Gaudenzio Honorati after the original. Research Library, Getty Research Institute, acc. no. 850109.

———. 2004. *Aux jardins de Cathay: L'imaginaire anglo-chinois en Occident.* Edited by Janine Barrier, Monique Mosser, and Chiu Che Bing. Paris: Éditions de l'Imprimeur. Includes the texts of Chambers's *Traité des édifices* (1776), *Dissertation sur le jardinage de l'Orient* (1772), and *Discours servant d'explication* (1773).

Chan, Albert. 2002. *Chinese Books and Documents in the Jesuit Archives in Rome: A Descriptive Catalogue.* Armonk, N.Y.: M. E. Sharpe.

Chapman, Allan. 1984. "Tycho Brahe in China: The Jesuit Mission to Peking and the Iconography of European Instrument-Making Processes." *Annals of Science* 41:417–43.

Chase, Isabelle W. 1936. "William Mason and Sir William Chambers' *Dissertation on Oriental Gardening.*" *Journal of English and Germanic Philology* 35:517–29.

China und Europa: Chinaverständnis und Chinamode im 17. und 18. Jahrhundert. Exh. cat. Berlin: [Schloß Charlottenburg], 1973.

Chiu Che Bing. 1999. "Droiture et clarté: Scène paysagère au Jardin de la clarté parfaite." *Studies in the History of Gardens and Designed Landscapes* 19:364–75.

———. 2000a. "Un grand jardin imperial chinois: Le Yuanming yuan." In Léon Vandermeersch, ed., *L'art des jardins dans les pays sinisés: Chine, Japon, Corée, Vietnam,* 17–50. Saint-Denis, France: Presses Universitaires de Vincennes, Université Paris VIII.

———. 2000b. *Yuanming yuan: Le Jardin de la clarté parfaite.* Besançon, France: Éditions de l'Imprimeur.

Clunas, Craig. 1984. *Chinese Export Watercolours.* London: Victoria & Albert Museum.

Cohen, Henry. 1912. *Guide de l'amateur de livres à gravures du XVIIIe siècle.* Edited by Seymour de Ricci. 6th ed. 2 vols. Paris: Librairie A. Rouquette.

Cohen, Monique, and Nathalie Monnet. 1992. *Impressions de Chine.* Exh. cat. Paris: Bibliothèque Nationale.

Cohn, Ellen R. 2000. "Benjamin Franklin, Georges-Louis Le Rouge and the Franklin/Folger Chart of the Gulf Stream." *Imago Mundi* 52:124–42.

Conner, Patrick. 1979a. "China and the Landscape Garden: Reports, Engravings and Misconceptions." *Art History* 2:429–40.

———. 1979b. *Oriental Architecture in the West*. London: Thames & Hudson.

Corbett, Margery. 1986. "The Dutch Mission to Peking in 1655." *Quaerendo* 16:131–36.

Cordier, Henri. 1901. *L'imprimerie sino-européenne en Chine: Bibliographie des ouvrages publiés en Chine par les européens au XVIIIe siècle.* Paris: Imprimerie Nationale.

———. 1905. "Du Halde et d'Anville (cartes de la Chine)." In *Recueil de mémoires orientaux,* 391–400. Paris: Imprimerie Nationale.

———. 1913. "Les conquêtes de l'empereur de la Chine." *Mémoires concernant l'Asie Orientale (Inde, Asie Centrale, Extrême Orient)* 1:1–18, pls. I–IV.

———. [1968]. *Bibliotheca Sinica: Dictionnaire bibliographique des ouvrages relatifs à l'empire chinois.* 2nd ed. 6 vols. in 5. New York: B. Franklin.

Courant, Maurice. 1900–12. *Catalogue des livres chinois, coréens, japonais, etc.* 3 vols. Paris: E. Leroux.

D'Elia, Pasquale M. 1939. *Le origini dell'arte cristiana cinese (1583–1640).* Rome: Reale Accademia d'Italia.

Delights of Harmony: The European Palaces of the Yuanmingyuan and the Jesuits at the Eighteenth Century Court of Beijing. 1994. Exh. cat. Worcester, Mass.: The Gallery.

Desroches, Jean-Paul. 1985. "Yuanming Yuan: Die Welt als Garten." In *Europa und die Kaiser von China,* 122–28. Exh. cat. Frankfurt am Main: Insel.

Dong Yu. 1996. *Catalogo delle opere cinesi missionarie della Biblioteca apostolica vaticana (XVI–XVIII sec.).* Vatican City: Biblioteca Apostolica Vaticana.

Droguet, Vincent. 1994. "Les Palais européens de l'empereur Qianlong et leurs sources italiennes." *Histoire de l'art* 25/26:15–28.

Duboscq, André, and J. van den Brandt. 1939–40. "Un manuscript inédit des *Conquêtes de K'ienlong.*" *Monumenta Serica* 4:85–115.

Dudink, Adrian. 2001. "Chinese Primary Sources: Published Collections of Edicts and Memorials." In Nicolas Standaert, ed., *Handbook of Christianity in China,* 1:131–34. Leiden: Brill.

Durand, Antoine. 1988. "Restitution des Palais européens du Yuanmingyuan." *Arts asiatiques* 43:123–33.

Durand, Antoine, and Régine Thiriez. 1993. "Engraving the Emperor of China's European Palaces." *Biblion: Bulletin of the New York Public Library* 1, no. 2:81–107.

Edgren, Sören, et al. 1984. *Chinese Rare Books in American Collections.* Exh. cat. New York: China Institute in America.

Eeghen, Isabella H. van. 1972. "Arnoldus Montanus's Book on Japan." *Quaerendo* 2:250–72.

Erdberg, Eleanor von. 1936. *Chinese Influence on European Garden Structures.* Edited by Bremer W. Pond. Cambridge: Harvard Univ. Press.

Europa und die Kaiser von China. 1985. Exh. cat. Frankfurt: Insel.

Faliu, Odile. 1988. *Cérémonies et coutumes religieuses de tous les peuples du monde dessinées par Bernard Picart.* Paris: Herscher.

Findlen, Paula, ed. 2004. *Athanasius Kircher: The Last Man Who Knew Everything.* New York: Routledge.

Fletcher, John. 1968. "Athanasius Kircher and the Distribution of His Books." *The Library* 23:108–17.

Forêt, Philippe. 2000. *Mapping Chengde: The Qing Landscape Enterprise.* Honolulu: Univ. of Hawai'i Press.

From Beijing to Versailles: Artistic Relations between China and France. 1997. Exh. cat. Hong Kong: Urban Council of Hong Kong.

Fuchs, Walter. 1939–40. "Die Schlachtenbilder aus Terkestan von 1765 als historische Quelle, nebst Bemerkungen zu einigen späteren Serien." *Monumenta Serica* 4:116–24.

———. 1959. "Zum Keng-chih-t'u der Mandju-Zeit und die japanische Ausgabe von 1808." In Inge-Lore Kluge, ed., *Ostasiatische Studien,* 67–80. Berlin: Akademie.

Genest, Gilles. 1994. "Les Palais européens du Yuanmingyuan: Essai sur la végétation dans les jardins." *Arts asiatiques* 49:82–90.

Girard, Pascale. 1995. "La Chine de Mendoza d'après son *Historia del gran reyno de la Chine:* Entité géographique ou motif prophetique?" In Edward J. Malatesta, Yves Raguin, and Adrianus C. Dudink, eds., *Échanges culturels et religieux entre la Chine et l'Occident: Actes du VIIe Colloque international de sinologie de Chantilly, 8–10 septembre 1992,* 163–73. Paris: Institut Ricci.

Godwin, Joscelyn. 1979. *Athanasius Kircher: A Renaissance Man and the Quest for Lost Knowledge.* London: Thames & Hudson.

Golvers, Noël. 1998. "Ferdinand Verbiest's *Compendium Latinum* (Peking, 1678)." *Quaerendo* 28:85–127.

———. 2003. *Ferdinand Verbiest, S.J. (1623–1688) and the Chinese Heaven: The Composition of the Astronomical Corpus, Its Diffusion and Reception in the European Republic of Letters.* Leuven, Belgium: Leuven Univ. Press.

González-Palacios, Alvar, ed. [1981]. *Objects for a "Wunderkammer."* Exh. cat. London: P. & D. Colnaghi.

Gournay, A. 1991. "Jardins chinois en France à la fin du XVIIIe siècle." *Bulletin de l'École française d'Extrême Orient* 78:259–73.

Gray, Basil. 1960. "Lord Burlington and Father Ripa's Chinese Engravings." *British Museum Quarterly* 22:40–43.

Grigsby, Leslie B. 1993. "Johan Nieuhoff's *Embassy:* An Inspiration for Relief Decoration on English Stoneware and Earthenware." *The Magazine Antiques,* January, 172–83.

Gugong Bowuyuan (Palace Museum), ed. 1992. *Qingdai gongting huihua = The Collection of the Palace Museum: Court Painting of the Qing Dynasty.* Beijing: Cultural Relics Publishing House.

Hänisch, E. 1918. "Der chinesische Feldzug in Ili im Jahre 1755 (mit zwei zeitgenössischen französischen Kupferstichen)." *Ostasiatische Zeitschrift* 7:57–86.

Harris, Eileen. 1967. "Burke and Chambers on the Sublime and Beautiful." In Douglas Fraser, Howard Hibbard, and Milton J. Lewine, eds., *Essays in the History of Architecture Presented to Rudolf Wittkower,* 207–13. London: Phaidon.

———. 1990. *British Architectural Books and Writers, 1556–1785.* Cambridge: Cambridge Univ. Press.

Harris, John. 1970. *Sir William Chambers, Knight of the Polar Star.* London: A. Zwemmer.

———. 1996. "Sir William Chambers and Kew Gardens." In John Harris and Michael Snodin, eds., *Sir William Chambers, Architect to George III,* 55–67. Exh. cat. New Haven: Yale Univ. Press.

Harris, John, and Michael Snodin, eds. 1996. *Sir William Chambers, Architect to George III.* Exh. cat. New Haven: Yale Univ. Press.

He Zhongyi and Zeng Zhaofen. 1995. *Yuanmingyuan yuanlin yishu* (The artistry of the Garden of Perfect Clarity). Beijing: Kexue Chubanshe.

Hevia, James L. 1995. *Cherishing Men from Afar: Qing Guest Ritual and the Macartney Embassy of 1793.* Durham, N.C.: Duke Univ. Press.

Hostetler, Laura. 2001. *Qing Colonial Enterprise: Ethnography and Cartography in Early Modern China.* Chicago: Univ. of Chicago Press.

Hsiang Ta. 1976. "European Influences on Chinese Art in the Later Ming and Early Ch'ing Period." Translated by Wang Teh-chao. In James C. Y. Watt, ed., *The Translation of Art: Essays on Chinese Painting and Poetry,* 152–78. Renditions Special Art Issue. New Territories, Hong Kong: Center for Translation Projects, Chinese University of Hong Kong.

Hu, Philip K., comp. and ed. 2000. *Visible Traces: Rare Books and Special Collections from the National Library of China.* Exh. cat. Beijing: Morning Glory.

Huang Taopeng and Huang Zhongjun, eds. 1985. *Yuanmingyuan* (The Garden of Perfect Clarity). Hong Kong: Sanlian Shudian.

Iannaccone, Isaia. 1994. "Syncretism between European and Chinese Culture in the Astronomical Instruments of Ferdinand Verbiest in the Old Beijing Observatory." In John W. Witek, ed., *Ferdinand Verbiest (1623–1688): Jesuit Missionary, Scientist, Engineer and Diplomat,* 93–121. Nettetal, Germany: Steyler.

Jin Yufeng. 1984. "Yuanmingyuan xiyanglou pingxi" (A critical analysis of the European pavilions in the Garden of Perfect Clarity). *Yuanmingyuan* 3:21–24.

Jones, Adam. 1989. "Olfert Dapper et sa description de l'Afrique." Translated by Jeanne Bouniort. In *Objets interdits,* 73–81. Exh. cat. Paris: Fondation Dapper.

Landry-Deron, Isabelle. 2002. *La preuve par la Chine: La Description de J.-B. Du Halde, jésuite, 1735.* Paris: Éditions de l'École des Hautes Études en Sciences Sociales.

Landwehr, John. 1991. *VOC: A Bibliography of Publications Relating to the Dutch East India Company, 1602–1800.* Edited by Peter van der Krogt. Utrecht: HES.

Laufer, Berthold. 1912. "The Discovery of a Lost Book." *T'oung pao* 13:97–106.

Lee Chan (Yi Ch'an). 1991. *Han'guk ui ko chido = Old Maps of Korea.* Seoul: Pomusa/Bumwoo Publishing.

Legouix, Susan. 1979. "Lord Macartney's Audience with the Emperor of China." *Connoisseur,* February, 122–27.

Legouix-Sloman, Susan. 1985. "William Alexander." In *Europa und die Kaiser von China,* 173–86. Exh. cat. Frankfurt: Insel.

Li Xiaocong. 1996. *Ouzhou shoucang bufen zhongwen guditu xulu = A Descriptive Catalogue of Pre-1900 Chinese Maps Seen in Europe.* Beijing: Guoji Wenhua Chuban Gongsi.

Li Zhizhong. 2000. "Yingyin Qingke moyin caihuiben *Gengzhi tushi* ba" (Postscript to the facsimile reproduction of a black-and-white, hand-colored Qing-dynasty printed edition of the *Illustrations of Farming and Weaving*). In Jiao Bingzhen, ed., *Gengzhi tu* (Illustrations of Farming and Weaving), 1–5. 2nd ed. Beijing: Beijing Tushuguan Chubanshe.

Lin Tongyang. 1993. "Aperçu sur le mappemonde de Ferdinand Verbiest le *K'un-yü-ch'üan-tu.*" In Edward J. Malatesta and Yves Raguin, eds., *Succès et échecs de la rencontre Chine et Occident du XVIe au XXe siècle*, 145–73. San Francisco: Ricci Institute for Chinese-Western Cultural History, University of San Francisco.

———. 1994. "Ferdinand Verbiest's Contribution to Chinese Geography and Cartography." In John W. Witek, ed., *Ferdinand Verbiest (1623–1688): Jesuit Missionary, Scientist, Engineer and Diplomat*, 135–64. Nettetal, Germany: Steyler.

Loehr, George R. 1940. *Giuseppe Castiglione (1688–1766), pittore di corte di Ch'ien-Lung, imperatore della Cina.* Rome: Istituto Italiana per il Medio & Estremo Oriente.

———. 1976. "L'artiste Jean-Denis Attiret et l'influence exercée par sa description des jardins impériaux." In *La mission française de Pékin aux XVIIe et XVIIIe siècles: Actes du Colloque international de sinologie, Centre de recherches interdisciplinaire de Chantilly, 20–22 septembre 1974*, 69–83. Paris: Belles Lettres.

Lou Shou, the Kangxi Emperor, and the Qianlong Emperor. 1913. *Keng tschi t'u = Ackerbau and Seidengewinnung in China: Ein kaiserliches Lehr- und Mahn-Buch.* Edited and translated by Otto Franke. Hamburg: L. Friederichsen.

Lundbaek, Knud. 1981. "Chief Grand Secretary Chang Chü-cheng and the Early China Jesuits." *China Mission Studies (1550–1800) Bulletin* 3:2–11.

———. 1983. "The Image of Neo-Confucianism in the *Confucius Sinarum Philosophus.*" *Journal of the History of Ideas* 44:19–30.

Lust, John. 1987. *Western Books on China Published up to 1850, in the Library of the School of Oriental and African Studies, London University: A Descriptive Catalogue.* London: Bamboo.

Malone, Carroll B. 1934. *History of the Peking Summer Palaces under the Ch'ing Dynasty.* Urbana, Ill.: University of Illinois.

Martini, Martino. 1978– . *Opera Omnia.* Gen. ed. Franco Demarchi. 3 vols. to date. Trento: Università degli Studi di Trento.

———. 2003. *Novus Atlas Sinensis: Tavole.* Edited by Riccardo Scartezzini, Giuliano Bertuccioli, and Federico Masini. Trento: Centro Studi Martino Martini, Università degli Studi di Trento.

Mason, William. 1773. *An Heroic Epistle to Sir William Chambers, Knight, Comptroller General of His Majesty's Works, and Author of a Late Dissertation on Oriental Gardening, Enriched with Notes, Chiefly Extracted from That Elaborate Performance.* London: printed for J. Almon.

McDermott, Joseph. 2002. "Woodblock Carvers of the Ming Period." *Orientations* 33, no. 9:43–47.

Merrill, Brian L., and A. Dean Larsen. 1989. *Athanasius Kircher (1602–1680), Jesuit Scholar: An Exhibition of His Works in the Harold B. Lee Library Collections at Brigham Young University.* Exh. cat. Provo, Utah: Friends of the Brigham Young University Library.

Monnet, Nathalie. 2004. *Chine: L'empire du trait: Calligraphies et dessins du Ve au XIXe siècle.* Exh. cat. Paris: Bibliothèque Nationale de France.

Müller-Hofstede, Christoph, and Hartmut Walravens. 1985. "Paris-Peking: Kupferstiche für Kaiser Qianlong." In *Europa und die Kaiser von China*, 163–72. Exh. cat. Frankfurt: Insel.

Mungello, David E. 1981. "The Jesuits' Use of Chang Chü-cheng's Commentary in Their Translation of the Confucian Four Books (1687)." *China Mission Studies (1550–1800) Bulletin* 3:12–22.

———. 1985. *Curious Land: Jesuit Accommodation and the Origins of Sinology.* Honolulu: Univ. of Hawaii Press.

———. 1987. "Aus den Anfängen der Chinakunde in Europa 1687–1770." In Hartmut Walravens, *China Illustrata: Das europäische Chinaverständnis im Spiegel des 16. bis 18. Jahrhunderts*, exh. cat., 67–78. Weinheim: VCH.

Murray, Julia K. 1997. "Illustrations of the Life of Confucius: Their Evolution, Functions, and Significance in Late Ming China." *Artibus Asiae* 57, no. 1/2:73–129.

———. 2001. "From Textbook to Testimonial: *The Emperor's Mirror, an Illustrated Discussion (Di jian tu shuo/Teikan zusetsu)* in China and Japan." *Ars Orientalis* 31:65–101.

Nie Chongzheng, ed. 1996. *Qingdai gongting huihua = Paintings by the Court Artists of the Qing Court.* Hong Kong: Commercial Press.

———. 1999. *Qingdai yuzhi tongban hua = Palace Copperplate Etchings of the Qing Dynasty.* Beijing: Guoji Wenhua Chuban Gongsi.

Nieuhof, Johannes. 1693/1985. *Het gezantschap der Neêrlandtsche Oost-Indische Compagnie, aan den Grooten Tartarischen Cham, den tegenwoordigen keizer van China . . . na 't Leven.* Amsterdam: Wolfgang, Waasberge, Boom, van Someren, & Goethals. Reprint, Frankfurt: Delphi.

Odell, Dawn. 2001. "The Soul of Transactions: Illustration and Johan Nieuhof's *Travels in China.*" In Karel Bostoen, Elmer Kolfin, and Paul J. Smith, eds., *"Tweelinge eener dragt": Woord en beeld in de Nederlanden (1500–1750)*, 225–41. Hilversum, Holland: Verloren.

———. 2003. "Clothing, Customs, and Mercantilism: Dutch and Chinese Ethnographies in the Seventeenth Century." In Jan de Jong et al., eds., *Het exotische Verbeeld, 1550–1950 . . . = Picturing the Exotic, 1550–1950: Peasants and Outlandish Peoples in Netherlandish Art*, 139–59. Zwolle, Netherlands: Waanders.

Oehme, R. 1971. "A French World Atlas of the Eighteenth Century: The *Atlas général* of G. L. Le Rouge." *Imago Mundi* 25:55–64.

Palais, pavillons et jardins construits par Giuseppe Castiglione dans le domaine impérial de Yuan ming yuan au Palais d'été de Pékin: Vingt planches gravées de 1783 à 1786 par des artistes chinois, représentant les constructions, jardins et fabriques édifiés de 1737 à 1766 pour l'empereur K'ien-Long par les jésuites de la cour.... 1977. Paris: Jardin de Flore.

Pelliot, Paul. 1913. "A propos de *Keng Tche T'ou*." *Mémoires concernant l'Asie Orientale (Inde, Asie Centrale, Extrême Orient)* 1:65–122, pls. X–LX.

———. 1921. "Les Conquêtes de l'empereur de la Chine." *T'oung pao* 20:183–274.

Perdue, Peter C. 2002. "Fate and Fortune in Central Eurasian Warfare: Three Qing Emperors and Their Mongol Rivals." In Nicola Di Cosmo, ed., *Warfare in Inner Asian History (500–1800)*, 369–404. Leiden: Brill.

Pfister, Louis. 1932–34. *Notices biographiques et bibliographiques sur les jésuites de l'ancienne mission de Chine*. 2 vols. Shanghai: Imprimerie de la Mission Catholique.

Pirazzoli-t'Serstevens, Michèle. 1969. *Gravures des Conquêtes de l'empereur de Chine Kien-Long au Musée Guimet*. Paris: Musée Guimet.

———. 1988. "The Emperor Qianlong's European Palaces." *Orientations* 19, no. 11:61–71.

———. 1989a. "A Pluridisciplinary Research on Castiglione and the Emperor Ch'ien-lung's European Palaces (Part 1)." *National Palace Museum Bulletin* 24, no. 4:1–12.

———. 1989b. "A Pluridisciplinary Research on Castiglione and the Emperor Ch'ien-lung's European Palaces (Part 2)." *National Palace Museum Bulletin* 24, no. 5:1–16.

Portalis, Roger. 1877. *Les dessinateurs d'illustrations au dix-huitième siècle*. 2 vols. Paris: D. Morgand & C. Fatout.

Quaintance, Richard. 2002. "Toward Distinguishing among Theme Park Publics: William Chambers's Landscape Theory vs. His Kew Practice." In Terence Young and Robert Riley, eds., *Theme Park Landscapes: Antecedents and Variations*, 25–46. Washington, D.C.: Dumbarton Oaks.

Quérard, Joseph-Marie. 1827–64/1964. *La France littéraire; ou, Dictionnaire bibliographique des savants, historiens et gens de lettres de la France, ainsi que des littérateurs étrangers qui ont écrit en français, plus particulièrement pendent les XVIIIe et XIXe siècles*. 12 vols. Paris: Firmin Didot, père et fils. Reprint, Paris: G. P. Maisonneuve & Larose.

Rabreau, Daniel. 2002. "Une méthode d'analyse stylistique des 'Palais européens' du Yuanming yuan." In *Yuanmingyuan yizhi de baohu he liyong . . . = Protection et mise en valeur du site du Yuanmingyuan*, 157–69. Beijing: Zhongguo Linye Chubanshe.

Reilly, P. Conor. 1974. *Athanasius Kircher, S.J.: Master of a Hundred Arts, 1602–1680*. Wiesbaden, Germany: Edizioni del Mondo.

Ripa, Matteo. 1846. *Memoirs of Father Ripa, during Thirteen Years' Residence at the Court of Peking in the Service of the Emperor of China; with an Account of the Foundations of the College for the Education of Young Chinese at Naples*. Translated by Fortunato Prandi. 2nd ed. New York: Wiley & Putnam.

Rosenkranz, G. J. 1852. "Aus dem Leben des Jesuiten Athanasius Kircher, 1602–1680." *Zeitschrift für vaterländische Geschichte und Alterthumskunde* 13:11–59.

Royet, Véronique. 2004. *Georges Louis Le Rouge, jardins anglo-chinois*. Vol. 15 of Bibliothèque nationale, Cabinet des estampes, *Inventaire du fonds français: Graveurs du dix-huitième siècle*. Paris: Bibliothèque Nationale.

Saussy, Haun. 2001. "*China Illustrata:* The Universe in a Cup of Tea." In Daniel Stolzenberg, ed., *The Great Art of Knowing: The Baroque Encyclopedia of Athanasius Kircher*, 105–14. Exh. cat. Stanford: Stanford University Libraries.

Schmidt, Freek H. 2002. "Expose Ignorance and Revive the *Bon Goût:* Foreign Architects at Jacques-François Blondel's École des Arts." *Journal of the Society of Architectural Historians* 61:4–29.

Schulz, Alexander. 1966. *Hsi Yang Lou: Untersuchengen zu den "europäischen Bauten" des Kaisers Ch'ien-lung*. Isny, Germany: Schmidt & Schulz.

Shaughnessy, Edward L. 1993. "Shang shu (Shu ching)." In Michael Loewe, ed., *Early Chinese Texts: A Bibliographic Guide*, 376–89. Berkeley: Society for the Study of Early China.

Shu Mu, Shen Wei, and He Naixian, eds. 1984. *Yuanmingyuan ziliaoji* (Source materials about the Garden of Perfect Clarity). Beijing: Shumu Wenxian Chubanshe.

Shum, Chun. 2001. "*Pictures of the Sage's Traces:* A Preliminary Investigation of the Editions of the *Shengji tu*." Translated by Frederick W. Mote. *East Asian Library Journal* 10, no. 1:129–75.

Sirén, Osvald. 1926. *The Imperial Palaces of Peking*. 3 vols. Paris: G. Van Oest.

———. 1950/1990. *China and Gardens of Europe of the Eighteenth Century*. New York: Ronald. Reprint, Washington, D.C.: Dumbarton Oaks.

Siu, Victoria M. 1999. "China and Europe Intertwined: A New View of the European Sector of the Chang Chun Yuan." *Studies in the History of Gardens and Designed Landscapes* 19:376–93.

Snodin, Michael, ed. 1996. *Sir William Chambers.* Exh. cat. London: V & A Publications.

Teng Gu, ed. 1933. *Yuanmingyuan oushi gongdian canji* (Remnants of the European-style pavilions in the Garden of Perfect Clarity). Shanghai: Shangwu Yinshuguan.

Thiriez, Régine. 1998. *Barbarian Lens: Western Photographers of the Qianlong Emperor's European Palaces.* Amsterdam: Gordon & Breach.

Tongban bishushanzhuang sanshiliu jing shitu (Copperplate engravings of the *Poems and Illustrations of the Thirty-six Views of the Mountain Hamlet for Escaping the Summer Heat).* 2003. Beijing: Xueyuan Chubanshe.

Ulrichs, Friederike. 2003. *Johan Nieuhofs Blick auf China (1655–1657): Die Kupferstiche in seinem Chinabuch und ihre Wirkung auf den Verleger Jacob van Meurs.* Wiesbaden: Harrassowitz.

Vainker, Shelagh. 2003. "Costumes of China." *Orientations* 34, no. 9:52–55.

Verbiest, Ferdinand. 1993. *The "Astronomia Europaea" of Ferdinand Verbiest, S.J. (Dillingen, 1687): Text, Translation, Notes and Commentaries.* Edited and translated by Nöel Golvers. Nettetal, Germany: Steyler.

Vertente, Christine. 1993. "Nan Huai-jen's Maps of the World." In Edward J. Malatesta and Yves Raguin, eds., *Succès et échecs de la rencontre Chine et Occident du XVIe au XXe siècle,* 257–63. San Francisco: Ricci Institute for Chinese-Western Cultural History, University of San Francisco.

Vogel, Gerd-Helge. 2004–5. "Wunderland Cathay: Chinoise Architekturen in Europa." *Die Gartenkunst* 16:125–72, 339–82; 17:168–216, 387–430.

Wallis, Helen. 1985. "Die Kartographie der Jesuiten am Hof in Peking." In *Europa und die Kaiser von China,* 107–21. Exh. cat. Frankfurt: Insel.

Walravens, Hartmut. 1987. *China Illustrata: Das europäische Chinaverständnis im Spiegel des 16. bis 18. Jahrhunderts.* Exh. cat. Weinheim: VCH.

Wang Chaosheng, ed. 1995. *Zhongguo gudai gengzhitu = Farming and Weaving Pictures in Ancient China.* Beijing: Zhongguo Nongye Chubanshe.

Wang Daocheng and Fang Yuping. 1999. *Yuanmingyuan: Lishi, xianzhuang, lunzheng* (The Garden of Perfect Clarity: History, present state, debates). 2 vols. Beijing: Beijing Chubanshe.

Weiss, Thomas, ed. 1996. *Sir William Chambers und der englische-chinesische Garten in Europa.* Stuttgart: G. Hatje.

Weng Lianxi, ed. 2001. *Qingdai gongting banhua* (Qing-dynasty imperial printed works). Beijing: Wenwu Chubanshe.

———, ed. 2004. *Qingdai neifu keshu tulu* (Illustrated catalog of Qing-dynasty imperial printed books). Beijing: Beijing Chubanshe.

Wiebenson, Dora. 1978. *The Picturesque Garden in France.* Princeton: Princeton Univ. Press.

Witek, John W., ed. 1994. *Ferdinand Verbiest (1623–1688): Jesuit Missionary, Scientist, Engineer and Diplomat.* Nettetal, Germany: Steyler.

Wong, Young-tsu. 2001. *A Paradise Lost: The Imperial Garden Yuanming Yuan.* Honolulu: Univ. of Hawai'i Press.

Wood, Francis. 1998. "Closely Observed China: From William Alexander's Sketches to His Published Work." *British Library Journal* 24:98–121.

Yee, Cordell D. K. 1994. "Reinterpreting Traditional Chinese Geographical Maps." In J. B. Harley and David Woodward, eds., *The History of Cartography,* vol. 2, pt. 2, *Cartography in the Traditional East and Southeast Asian Societies,* 128–69. Chicago: Univ. of Chicago Press.

Yuanmingyuan = Collection of Papers on the Garden of Perfect Clarity. 1981–92. Vols. 1–5. Published by the Zhongguo Yuanmingyuan Xuehui (Chinese Yuanmingyuan Institute), Beijing.

Le Yuanmingyuan: Jeux d'eau et Palais européens du XVIIIe siècle à la cour de Chine. 1987. Paris: Éditions Recherche sur les Civilisations.

Yuanmingyuan oushi tingyuan (The European Pavilions in the Garden of Perfect Clarity). 1998. Beijing: Yuanmingyuan Guanlichu.

Zhang Enyin. 1993. *Yuanmingyuan bianqianshi tanwei* (An investigation into the historical changes at the Garden of Perfect Clarity). Beijing: Beijing Tiyuxueyuan Chubanshe.

———. 1998. "Xiyang yuanlin tongbantu" (The copperplate engravings of the European garden). In idem, *Yuanming daguan hua shengshuai* (A discussion of the rise and fall of the Garden of Perfect Clarity), 154–60. Beijing: Zijincheng Chubanshe.

———, ed. 2003. *Sanshan wuyuan shilüe: Fu Kangxi Qianlong yuzhi shiwen* (A brief history of the Three Imperial Mountain-Estates and Five Gardens: Including imperially composed poems and prose by the Kangxi and Qianlong emperors). Beijing: Tongxin Chubanshe.

Zhao Guanghua. 1984. "Changchunyuan jianzhu ji yuanlin huamu zhi yixie ziliao" (Some information on the architecture and landscaping in the Garden of Eternal Spring). *Yuanmingyuan* 3:1–11.

Zhongguo Diyi Lishi Dang'anguan (First Historical Archives of China), ed. 1991. *Yuanmingyuan* (The Garden of Perfect Clarity). 2 vols. Shanghai: Shanghai Guji Chubanshe.

Zou, Hui. 2001. "Jesuit Perspective in China." *Architectura* 31:145–68.

———. 2002. "The *Jing* of a Perspective Garden." *Studies in the History of Gardens and Designed Landscapes* 22:293–326.

Photographs of items in the holdings of the Research Library at the Getty Research Institute are courtesy the Research Library. Photo © J. Paul Getty Trust.

FIGURE 1
Getty Research Institute, Research Library, 2679-146

FIGURE 2
Courtesy Divinity Library, Yale University

FIGURES 3, 50
Getty Research Institute, Research Library, 86-B27195

FIGURE 4
Getty Research Institute, Research Library, 96.R.19*

FIGURES 5, 6
Getty Research Institute, Research Library, 1382-254

FIGURE 7
The J. Paul Getty Museum, Los Angeles, 83.DD.339

FIGURE 8
The J. Paul Getty Museum, Los Angeles, 83.DD.338

FIGURE 9
Getty Research Institute, Research Library, 2716-793

FIGURE 10
Getty Research Institute, Research Library, 89-B4080

FIGURE 11
Getty Research Institute, Research Library, 87-B6617

FIGURE 12
Getty Research Institute, Research Library, 1374-445

FIGURE 13
Getty Research Institute, Research Library, 86-B24301

FIGURE 14
Getty Research Institute, Research Library, 2639-669

FIGURE 15
Getty Research Institute, Research Library, 82-B2136

FIGURES 16, 21
Getty Research Institute, Research Library, 88-B15219

FIGURES 17, 19
Getty Research Institute, Research Library, 1573-358

FIGURE 18
Princeton University, East Asian Library (Gest Collection), rare book no. TB367/609. Photo: courtesy Seeley G. Mudd Manuscript Library, Princeton University

FIGURE 20
Harvard University, Harvard-Yenching Library

FIGURE 22
Getty Research Institute, Research Library, Photographs of China and Southeast Asia (ca. 1860 – ca. 1930), 2003.R.22 (box 14)

FIGURE 23
Getty Research Institute, Research Library, 1392-190

FIGURES 24, 26, 28, 29
Getty Research Institute, Research Library, 1392-684

FIGURES 25, 46
Getty Research Institute, Research Library, Thomas Child, Views of Beijing and Environs, ca. 1875 – 85, 2004.R.4

FIGURE 27
Getty Research Institute, Research Library, 87-B27175

FIGURE 30
Yale University, East Asia Library, call no. FV7188 2181. Courtesy East Asia Library, Yale University

FIGURES 31, 32, 34, 35
Getty Research Institute, Research Library, 2003.PR.63**

FIGURE 33
Getty Research Institute, Research Library, 84-B13226

FIGURE 36
Getty Research Institute, Research Library, 2650-128

FIGURES 37, 39
University of California—Los Angeles Libraries and Collections

FIGURE 38
The J. Paul Getty Museum, Los Angeles, 78.DE.358

FIGURE 40
Yale Center for British Art, Gift of Stuart Feld

FIGURE 41
Château de Versailles et de Trianon, Versailles (coll. estampes, inv. gravures 933). Réunion des Musées Nationaux/Art Resource, New York. Photo: Gérard Blot

FIGURE 42
Museum für Völkerkunde, Hamburg. Photo: Museum für Völkerkunde Hamburg

FIGURES 43 – 45
Getty Research Institute, Research Library, 1369-468

FIGURE 48
Getty Research Institute, Research Library, 86-B26695

FIGURES 49, 51
Getty Research Institute, Research Library, 1376-795

FIGURE 52
Getty Research Institute, Research Library, 88-B1922

FIGURE 53

Title page with heraldic device of Pope Sixtus V, 1586, letterpress and woodcut, 21.6 × 15.9 cm (8½ × 6¼ in.)
From Juan González de Mendoza, *Dell'historia della China...*, trans. Francesco Avanzi (Rome: appresso Bartolomeo Grassi, 1586)
Getty Research Institute, Research Library, 2664-771

FIGURE 54

Beschryving van 't gesandschap der Nederlandsche Oost-Indische Compagnie aen den grooten Tartarischen cham nu keyser van China (Description of the embassy of the Dutch East India Company to the great Tartar khan, now emperor of China), 1693, etching, 27 × 18.1 cm (10⅝ × 7⅛ in.)
From Johannes Nieuhof, *Het gezandtschap der Neêr-landtsche Oost-Indische Compagnie, aan den grooten Tartarischen Cham, den tegenwoordigen keizer van China...*, 3rd ed., ed. Hendrik Nieuhof (Amsterdam: Wolfgang, Waasberge, Boom, van Someren, & Goethals, 1693), engraved title page
Getty Research Institute, Research Library, 84-B22315

FIGURE 55

Ananas, Musa (Pineapple, plantain), 1665, hand-colored etching, 19.1 × 31.5 cm (7½ × 12⅜ in.)
From Johannes Nieuhof, *Legatio Batavica ad Magnum Tartariae Chamum Sungteium, Modernum Sinae Imperatorem...*, trans. Georg Horn (Amsterdam: apud J. Meursium, 1668), after p. 106
Getty Research Institute, Research Library, 86-B27195

FIGURE 56

Tweede en derde gesandschap na het keyserryck van Taising of China (Second and third embassy to the empire of Taising or China), 1671, engraving, 29.1 × 19.1 cm (11½ × 7½ in.)
From Olfert Dapper, *Gedenkwaerdig bedryf der Neder-landsche Oost-Indische Maetschappye...* (Amsterdam: Jacob van Meurs, 1670), engraved title page
Getty Research Institute, Research Library, 84-B22302

FIGURE 57

Headpiece to chapter 4: *Modus scribendi* (Method of writing), 1667, engraving, 16.8 × 21.5 cm (6⅝ × 8½ in.)
From Athanasius Kircher, *China Monumentis, qua Sacris quà Profanis, ... Illustrata...* (Amsterdam: apud Joannem Janssonium à Waesberge & Elizeum Weyerstraet, 1667), 233
Getty Research Institute, Research Library, 85-B12590

FIGURE 58

Athanasii Kircheri Soc. Jesu China Illust. (*China Illustrated* by Athanasius Kircher, Society of Jesus), 1667, hand-colored etching and engraving, 34.6 × 22.5 cm (13⅝ × 8⅞ in.)
From Athanasius Kircher, *Toonneel van China...*, trans. Jan Hendrick Glazemaker (Amsterdam: Johannes Janssonius van Waesberge, 1668), engraved title page
Getty Research Institute, Research Library, 1382-254

FIGURE 59

Schematismus Secundus Principatia Sinensium Numina Exhibens (Second schema showing the principal Chinese divinities), 1667, hand-colored etching, 38.2 × 25 cm (15⅝ × 9⅞ in.)
From Athanasius Kircher, *Toonneel van China...*, trans. Jan Hendrick Glazemaker (Amsterdam: Johannes Janssonius van Waesberge, 1668), foldout after p. 168
Getty Research Institute, Research Library, 1382-254

FIGURE 60

Bernard Picart (French, 1673–1733), *Convoi funebre d'un grand de la Chine* (Funerary cortege of a Chinese noble), 1729, engraving, 33.7 × 42.5 cm (13¼ × 16¾ in.)
From *Ceremonies et coutumes religieuses des tous les peuples du monde...*, vol. 2, *Ceremonies et coutumes religieuses des peuples idolatres* (Amsterdam: J. F. Bernard, 1728), after p. 264
Getty Research Institute, Research Library, 1387-555

FIGURE 61

Charles de La Haye (French, b. 1641); and Jean-Baptiste Antoine Guélard (French, 1719–ca. 1755), after Antoine Humblot (French, d. 1758), *Carte la plus generale et qui comprend la Chine, la Tartarie Chinoise, et le Tibet* (The most general map, which includes China, Chinese Tartary, and Tibet), 1734, etching and engraving, 50.2 × 70.8 cm (19¾ × 27⅞ in.)
From Jean-Baptiste Du Halde, *Description geographique, historique, chronologique, politique, et physique de l'empire de la Chine et de la Tartarie Chinoise...* (Paris: P. G. Le Mercier, 1735), vol. 1, after half-title page
Getty Research Institute, Research Library, 87-B6617

FIGURE 62

Thomas Medland (British, 1755–1823), after William Alexander (British, 1767–1816), *Economy of Time and Labor, Exemplified in a Chinese Waterman*, 1797, engraving, 23.8 × 28.9 cm (9⅜ × 11⅜ in.)
From George Leonard Staunton, *An Authentic Account of an Embassy from the King of Great Britain to the Emperor of China...* (London: printed for G. Nicol, 1797), vol. 3 (plates), pl. 42
Getty Research Institute, Research Library, 86-B18709

FIGURE 63

Thomas Medland (British, 1755–1823), after William Alexander (British, 1767–1816), after Henry William Parish (British, d. 1795), *View in the Eastern Side of the Imperial Park at Gehol*, 1804, hand-colored aquatint, page: 21 × 27 cm (8¼ × 10⅝ in.)
From John Barrow, *Travels in China . . .*, 2nd ed. (London: printed for T. Cadell & W. Davies, 1806), after p. 128
Getty Research Institute, Research Library, 2651-380

FIGURE 64

Jacques Eustache de Sève (French, fl. 1742–88), after Chrétien Louis Joseph de Guignes (French, 1759–1845), *Fête chinoise qui à lieu en automne* (Autumnal Chinese festival), 1808, etching and engraving, 24.1 × 37.3 cm (9½ × 14¾ in.)
From Chrétien Louis Joseph de Guignes, *Voyages à Peking, Manille et l'Île de France . . .* (Paris: Imprimerie Impériale, 1808), atlas, no. 6
Getty Research Institute, Research Library, 87-B2931

FIGURE 65

J. Dadley (British, fl. 1700s), after Pu-Quà, *A Woman Making Stockings*, 1800, colored stipple engraving, page: 36.8 × 25.8 cm (14½ × 10⅛ in.)
From George Henry Mason, *The Costume of China . . .* (London: printed for W. Miller, 1800), pl. 3
Getty Research Institute, Research Library, 89-B11237

FIGURE 66

J. Dadley (British, fl. 1700s), *A Culprit before a Magistrate*, 1801, colored stipple engraving, page: 34.7 × 25.7 cm (13⅝ × 10⅛ in.)
From George Henry Mason, *The Punishments of China . . .* (London: printed for W. Miller, by W. Bulmer, 1801), pl. 1
Getty Research Institute, Research Library, 89-B4080

FIGURE 67

Antoine Cardon (Flemish, 1772–1813), *Feast of Agriculture*, 1812, stipple and line engraving, page: 14.3 × 22.5 cm (5⅝ × 8⅞ in.)
From Jean Baptiste Joseph Breton de la Martinière, *China: Its Costume, Arts, Manufactures, etc. . . .* (London: printed for J. J. Stockdale, 1812), vol. 1, frontispiece
Getty Research Institute, Research Library, 84-B25211

FIGURE 68

Discussion of the soul, ca. 1619–23, woodcut, 21.6 × 12.1 cm (8½ × 4¾ in.)
From João da Rocha, *Tianzhu shengjiao qimeng* ([Nanjing: Society of Jesus, ca. 1619–23]), fol. 64b
Getty Research Institute, Research Library, 1365-379

FIGURE 69

Crucifixion, ca. 1619–23, woodcut, 21.6 × 12.1 cm (8½ × 4¾ in.)
From [João da Rocha], *Song nianzhu guicheng* ([Nanjing: Society of Jesus, ca. 1619–23]), fol. 21b
Getty Research Institute, Research Library, 1374-445

FIGURE 70

François de Louvemont (French, b. 1648), *Paradigma XV Provinciarum et CLV Urbium Capitalium Sinensis Imperii cum Templis et Domiciliis S.J.* (Plan of the 15 provinces and 155 capital cities of the Chinese empire together with the churches and residences of the Society of Jesus), 1687, engraving, 31.2 × 21.3 cm (12¼ × 8⅜ in.)
From Prospero Intorcetta et al., trans. and ed., *Confucius Sinarum Philosophus; sive, Scientia Sinensis Latine Exposita . . .* (Paris: apud Danielem Horthemels, 1687), after p. 106
Getty Research Institute, Research Library, 2639-669

FIGURE 71

Hetu (Yellow River pictures) and *Luoshu* (Luo River writing) and eight trigrams, 1770, etching, 21 × 14.6 cm (8¼ × 5¾ in.)
From *Le Chou king, un des livres sacrés des Chinois . . .*, trans. and ed. Antoine Gaubil, ed. Joseph de Guignes (Paris: N. M. Tilliard, 1770), pl. 4
Getty Research Institute, Research Library, 1553-917

FIGURE 72

Bao'en dengtu (Repaying gratitude lantern pattern), ink and watercolor, drawing (to mount): 22.9 × 20.2 cm (9 × 8 in.)
From the album *Kangxi dengtu*, late 1700s–early 1800s, [pl. 11]
Getty Research Institute, Research Library, 2003.M.25

FIGURE 73

Isidore-Stanislaus-Henri Helman (French, 1743–ca. 1809), after Jean-Denis Attiret (French, 1702–68), *L'empereur Yao*, 1788, engraving and etching, 26.4 × 17.8 cm (10⅜ × 7 in.)
From Isidore-Stanislaus-Henri Helman, *Faits mémorables des empereurs de la Chine, tirés des annales chinoises . . .* (Paris: l'auteur & M. Ponce, 1788), pl. 1
Getty Research Institute, Research Library, 1573-358

FIGURE 74

Isidore-Stanislaus-Henri Helman (French, 1743–ca. 1809), Confucius receives a sign from Shangdi, ca. 1785, engraving and etching, page: 26.9 × 18.4 cm (10⅝ × 7¼ in.)
From Isidore-Stanislaus-Henri Helman and Joseph-Marie Amiot, *Abrégé historique des principaux traits de la vie de Confucius . . .* (Paris: l'auteur & M. Ponce, [1788?]), pl. 21
Getty Research Institute, Research Library, 88-B15219

FIGURE 75

Third gnomon experiment, 1669, woodcut, 19.7 × 27.6 cm (7¾ × 10⅞ in.)
From Ferdinand Verbiest, *Qinding xinli ceyan jilüe . . .* ([Beijing: Society of Jesus, 1669]), fig. 3
Getty Research Institute, Research Library, 1392-190

FIGURE 76

Guanxiangtai tu (View of the observatory), 1674,
woodcut, 31.5 × 32 cm (12⅜ × 12⅝ in.)
From Ferdinand Verbiest, *Yixiang tu*... ([Beijing:
Society of Jesus, 1674]), vol. 1, first figure (hand-
written fig. 1)
Getty Research Institute, Research Library, 1392-684

FIGURE 77

First page of text, ca. 1670, woodcut, 36 × 22 cm
(14⅛ × 8⅝ in.)
From Ferdinand Verbiest, *Compendium Latinum*...
([Beijing: Society of Jesus, 1671–74])
Getty Research Institute, Research Library, 1392-685

FIGURE 78

Pecheli sive Peking, Imperii Sinarum Provincia Prima
(Beizhili [Hebei] or Beijing, first province of the
empire of the Chinese), 1655, hand-colored engrav-
ing, 48.6 × 39.7 cm (19⅛ × 15⅝ in.)
From Martino Martini, *Novus Atlas Sinensis*
([Amsterdam: Johannes Blaeu, 1655]), before p. 27
Getty Research Institute, Research Library, 2679-146

FIGURE 79

Ferdinand Verbiest (Flemish, 1623–88), *Kunyu
quantu* (Complete map of the world), ca. 1860,
wood-block print on bamboo paper, two sheets:
eastern hemisphere, 153.5 × 202 cm (60⅜ × 79½ in.);
western hemisphere, 151 × 203 cm (59½ × 79⅞ in.)
Getty Research Institute, Research Library,
2003.PR.63**

FIGURE 80

Zhu Gui (Chinese, ca. 1644–1717) or Mei Yufeng
(Chinese, fl. ca. 1696), after Jiao Bingzhen (Chinese,
1662–1720), *Geng* (Plowing), 1696, hand-colored
woodcut, 35.6 × 27.9 cm (14 × 11 in.)
From Jiao Bingzhen, *Yuzhi gengzhi tu* (Beijing:
Wuyingdian, 1696), [pl. 2]
Getty Research Institute, Research Library, 2650-128

FIGURE 81

Jacques-Philippe Le Bas (French, 1707–83), after
Giuseppe Castiglione (Italian, 1688–1766), *Kaiyan
chenggong zhu jiangshi* (Victory banquet for the
officers and soldiers who distinguished themselves),
ca. 1770, engraving, 57.5 × 92.9 cm (22⅝ × 36⅝ in.)
From the suite *Pingding Zhunga'er Huibu desheng tu*,
1765–75, no. 16
Getty Research Institute, Research Library, 1369-468

FIGURE 82

Isidore-Stanislaus-Henri Helman (French, 1743–
ca. 1809), *L'empereur va visiter les tombeaux de ses
ancêtres* (The emperor goes to visit the tombs of
his ancestors), 1788, engraving and etching, 30.8 ×
43.5 cm (12⅛ × 17⅛ in.)
From Isidore-Stanislaus-Henri Helman, *Conquêtes
de l'empereur de la Chine* and other images of the
Chinese emperor, 1783–88, no. 22
Getty Research Institute, Research Library,
2006.PR.34*

FIGURE 83

After Matteo Ripa (Italian, 1682–1745), *The Many
Rivers and Air, that Breaths from the Pine Tree, Its
Partner: Apartments Where the Europeans Were
Employ'd by the Emperor*, 1753, engraving and etch-
ing, 31.4 × 47.6 cm (12⅜ × 18¾ in.)
From *The Emperor of China's Palace at Pekin, and His
Principal Gardens*... (London: printed & sold by
Robert Sayer, Henry Overton, Thomas Bowles, &
John Bowles & Son, 1753), pl. 15
Getty Research Institute, Research Library,
92-B26685

FIGURE 84

Head of a Canal or Termination of a Visto, 1759, engrav-
ing, 18.1 × 24.8 cm (7⅛ × 9¾ in.)
From P. Decker, *Chinese Architecture, Civil and Orna-
mental*... (London: printed for the author, & sold by
Henry Parker & Elirabeth Bakewell, & H. Piers &
Partner, 1759), [pl. 3]
Getty Research Institute, Research Library,
85-B15019

FIGURE 85

Edward Rooker (British, ca. 1712–74), after William
Chambers (British, 1723–96), Section of a Cantonese
merchant's house, 1757, engraving, 30.2 × 45.3 cm
(11⅞ × 17⅞ in.)
From William Chambers, *Desseins des edifices,
meubles, habits, machines, et ustenciles des Chinois*...
(London: J. Haberkorn, 1757), pl. 9
Getty Research Institute, Research Library,
84-B30688

FIGURE 86

T. Miller (British, fl. ca. 1725), after William
Chambers (British, 1723–96), *The House of Confucius*,
1763, engraving, 43.2 × 29.5 cm (17 × 11⅝ in.)
From William Chambers, *Plans, Elevations, Sections,
and Perspective Views of the Gardens and Buildings at
Kew in Surry*... (London: printed by J. Haberkorn,
published for the author, 1763), pl. 15
Getty Research Institute, Research Library, 1376-795

FIGURE 87

Francesco Bartolozzi (Italian, 1727–1815), after
Giovanni Battista Cipriani (Italian, 1727–85),
Vignette, 1772, engraving, 23.5 × 16.5 cm
(9¼ × 6½ in.)
From William Chambers, *A Dissertation on Oriental
Gardening* (London: printed by W. Griffin, 1772),
title page
Getty Research Institute, Research Library, 85-B15017

FIGURE 88

Georges-Louis Le Rouge (French, ca. 1712–ca.
1792), *Maison chinoise vûe du côté de l'entrée au Midy*
(Chinese house, view of the south facade), 1785,
engraving, 23.2 × 38.2 cm (9⅛ × 15 in.)
From Georges-Louis Le Rouge, *Détail des nouveaux
jardins à la mode*, pt. 13, *Des jardins anglo-chinois,
contenant les détails du Désert*, ... (Paris: Le Rouge,
1785), pl. 12
Getty Research Institute, Research Library, 88-B1922

Page references to illustrations are in italic.

CHINA ON PAPER: EUROPEAN AND CHINESE WORKS FROM THE LATE SIXTEENTH TO THE EARLY NINETEENTH CENTURY

PAOLA DEMATTÈ is associate professor of Chinese art at the Rhode Island School of Design. She has lectured and published on the origins of Chinese writing, predynastic urbanism, Chu funerary art, archaic jades, and rock art and has participated in archaeological fieldwork in China, Mongolia, Mexico, Italy, and the United States. Her recent research focuses on religion and East-West cultural exchanges. She holds a Laurea in Chinese from the Università degli Studi di Venezia and a Ph.D. in archaeology from the University of California, Los Angeles.

MARCIA REED is head of Collection Development at the Research Library at the Getty Research Institute. She joined the Getty Research Institute at its inception in 1983, where, as its first curator of rare books, she built the collection of rare books. Among the exhibitions she has curated at the Getty Research Institute are *The Edible Monument* (2000) and *Naples and Vesuvius on the Grand Tour* (2002). She has taught at the University of California, Los Angeles, and lectured and published widely on the history of illustrated books, prints, and the literature of art history, with a focus on the eighteenth century.

GANG SONG is visiting professor of Chinese language, literature, and culture at Lafayette College. In addition to B.A. and M.A. degrees in Chinese language and literature from Beijing University, he holds a Ph.D. from the Department of East Asian Languages and Cultures at the University of Southern California. His doctoral dissertation and recent research focus on the Sino-Western encounter in the seventeenth century. He has presented his work at major conferences and published scholarly articles in the *International Journal of the Humanities* and other journals and books.

RICHARD E. STRASSBERG is a scholar of Chinese art, aesthetics, and premodern literature. Since 1978, he has been a faculty member in the Department of Asian Languages and Cultures at the University of California, Los Angeles, where he teaches classical Chinese language, literature, and culture. He formerly also served as adjunct curator of traditional and contemporary art at the Pacific Asia Museum and is the author of six books, including *Inscribed Landscapes: Travel Writing from Imperial China* (1994) and *A Chinese Bestiary: Strange Creatures from the Guideways through Mountains and Seas* (2002). His current projects are a forthcoming translation of a Ming-dynasty encyclopedia of Chinese dream literature titled *Wandering Spirits* and a cultural history of the Chinese garden.

OTHER BOOKS FEATURING THE HOLDINGS OF
THE RESEARCH LIBRARY AT THE GETTY RESEARCH INSTITUTE

*Art, Anti-Art, Non-Art: Experimentations in the Public Sphere
in Postwar Japan, 1950–1970*
Edited by Charles Merewether with Rika Iezumi Hiro
ISBN 978-0-89236-866-2 (hardcover)

Lucien Hervé: Building Images
Olivier Beer
ISBN 978-0-89236-754-2 (hardcover)

Had gadya: The Only Kid: Facsimile of El Lissitzky's Edition of 1919
Edited by Arnold J. Band
ISBN 978-0-89236-744-3 (paper)

Aldo Rossi: I quaderni azzurri
Aldo Rossi
ISBN 978-0-89236-589-0 (boxed set)

The World from Here: Masterpieces from Los Angeles Libraries
Edited by Cynthia Burlingham and Bruce Whiteman
ISBN 978-0-89236-659-0 (hardcover)

Devices of Wonder: From the World in a Box to Images on a Screen
Barbara Maria Stafford and Frances Terpak
ISBN 978-0-89236-590-6 (paper)

*Making a Prince's Museum: Drawings for the Late-Eighteenth-Century
Redecoration of the Villa Borghese*
Carole Paul
ISBN 978-0-89236-539-5 (paper)

Maiolica in the Making: The Gentili/Barnabei Archive
Catherine Hess
ISBN 978-0-89236-500-5 (paper)

Incendiary Art: The Representation of Fireworks in Early Modern Europe
Kevin Salatino
ISBN 978-0-89236-417-6 (paper)

Irresistible Decay: Ruins Reclaimed
Michael S. Roth with Claire Lyons and Charles Merewether
ISBN 978-0-89236-468-8 (paper)

Russian Modernism
Compiled by David Woodruff and Ljiljana Grubišić
ISBN 978-0-89236-385-8 (paper)

Designed by Jim Drobka with Stuart Smith
Production coordinated by Anita Keys
Type composed by Diane Franco in Dante and Joanna
Printed in China through Asia Pacific Offset, Inc., on Gold East Matte